Living Books

Leonardo

Roger F. Malina, Executive Editor
Sean Cubitt, Editor-in-Chief

Synthetics: Aspects of Art and Technology in Australia, 1956–1975, Stephen Jones, 2011

Hybrid Cultures: Japanese Media Arts in Dialogue with the West, Yvonne Spielmann, 2012

Walking and Mapping: Artists as Cartographers, Karen O'Rourke, 2013

The Fourth Dimension and Non-Euclidean Geometry in Modern Art, revised edition, Linda Dalrymple Henderson, 2013

Illusions in Motion: Media Archaeology of the Moving Panorama and Related Spectacles, Erkki Huhtamo, 2013

Relive: Media Art Histories, edited by Sean Cubitt and Paul Thomas, 2013

Re-collection: Art, New Media, and Social Memory, Richard Rinehart and Jon Ippolito, 2014

Biopolitical Screens: Image, Power, and the Neoliberal Brain, Pasi Väliaho, 2014

The Practice of Light: A Genealogy of Visual Technologies from Prints to Pixels, Sean Cubitt, 2014

The Tone of Our Times: Sound, Sense, Economy, and Ecology, Frances Dyson, 2014

The Experience Machine: Stan VanDerBeek's Movie-Drome and Expanded Cinema, Gloria Sutton, 2014

Hanan al-Cinema: Affections for the Moving Image, Laura U. Marks, 2015

Writing and Unwriting (Media) Art History: Erkki Kurenniemi in 2048, edited by Joasia Krysa and Jussi Parikka, 2015

Control: Digitality as Cultural Logic, Seb Franklin, 2015

New Tendencies: Art at the Threshold of the Information Revolution (1961–1978), Armin Medosch, 2016

Screen Ecologies: Art, Media, and the Environment in the Asia-Pacific Region, Larissa Hjorth, Sarah Pink, Kristen Sharp, and Linda Williams, 2016

Pirate Philosophy: For a Digital Posthumanities, Gary Hall, 2016

Social Media Archeology and Poetics, edited by Judy Malloy, 2016

Practicable: From Participation to Interaction in Contemporary Art, edited by Samuel Bianchini and Erik Verhagen, 2016

Machine Art in the Twentieth Century, Andreas Broeckmann, 2016

Here/There: Telepresence, Touch, and Art at the Interface, Kris Paulsen, 2017

Voicetracks: Attuning to Voice in Media and the Arts, Norie Neumark, 2017

Ecstatic Worlds: Media, Utopias, Ecologies, Janine Marchessault, 2017

Interface as Utopia: The Media Art and Activism of Fred Forest, Michael F. Leruth, 2017

Making Sense: Cognition, Computing, Art, and Embodiment, Simon Penny, 2017

Weather as Medium: Toward a Meteorological Art, Janine Randerson, 2018

Laboratory Lifestyles: The Construction of Scientific Fictions, edited by Sandra Kaji-O'Grady, Chris L. Smith, and Russell Hughes, 2018

Invisible Colors: The Arts of the Atomic Age, Gabrielle Decamous, 2018

Virtual Menageries: Animals as Mediators in Network Cultures, Jody Berland, 2019

From Fingers to Digits: An Artificial Aesthetic, Ernest Edmonds and Margaret A. Boden, 2019

MATERIAL WITNESS: Media, Forensics, Evidence, Susan Schuppli, 2020

Tactics of Interfacing: Encoding Affect in Art and Technology, Ksenia Fedorova, 2020

Giving Bodies Back to Data: Image Makers, Bricolage, and Reinvention in Magnetic Resonance Technology, Silvia Casini, 2021

A Biography of the Pixel, Alvy Ray Smith, 2021

Living Books: Experiments in the Posthumanities, Janneke Adema, 2021

See http://mitpress.mit.edu for a complete list of titles in this series.

Living Books

Experiments in the Posthumanities

Janneke Adema

The MIT Press
Cambridge, Massachusetts
London, England

© 2021 Massachusetts Institute of Technology

This work is subject to a Creative Commons CC-BY-NC license.

This book was set in Stone Serif and Stone Sans by Westchester Publishing Services. Printed and bound in the United States of America.

Library of Congress Cataloging-in-Publication Data

Names: Adema, Janneke, author.
Title: Living books : experiments in the posthumanities / Janneke Adema.
Description: Cambridge : The MIT Press, 2021. | Series: Leonardo | Includes bibliographical references and index.
Identifiers: LCCN 2020047155 | ISBN 9780262046022 (paperback)
Subjects: LCSH: Scholarly publishing--Technological innovations. | Open access publishing. | Learned institutions and societies--Publishing--Technological innovations. | Publishers and publishing--Technological innovations.
Classification: LCC Z286.S37 A34 2021 | DDC 070.5--dc23
LC record available at https://lccn.loc.gov/2020047155

10 9 8 7 6 5 4 3 2 1

Contents

Series Foreword ix

Acknowledgments xi

Introduction 1

1 **Toward a Diffractive Genealogy of Book History** 41

2 **From Romantic to Posthumanist Authorship** 71

3 **The Commodification of the Book and Its Discursive Formation** 121

4 **Publishing as a Relational Practice: Radical Open Access and Experimentation** 157

5 **On Liquid Books and Fluid Humanities** 199

Notes 249

Index 325

Series Foreword

Leonardo/International Society for the Arts, Sciences, and Technology (ISAST)

Leonardo, the International Society for the Arts, Sciences, and Technology, and the affiliated French organization Association Leonardo, have some very simple goals:

1. To advocate, document, and make known the work of artists, researchers, and scholars developing the new ways in which the contemporary arts interact with science, technology, and society.
2. To create a forum and meeting places where artists, scientists, and engineers can meet, exchange ideas, and, when appropriate, collaborate.
3. To contribute, through the interaction of the arts and sciences, to the creation of the new culture that will be needed to transition to a sustainable planetary society.

When the journal *Leonardo* was started some fifty years ago, these creative disciplines usually existed in segregated institutional and social networks, a situation dramatized at that time by the "Two Cultures" debates initiated by C. P. Snow. Today we live in a different time of cross-disciplinary ferment, collaboration, and intellectual confrontation enabled by new hybrid organizations, new funding sponsors, and the shared tools of computers and the internet. Sometimes captured in the "STEM to STEAM" movement, new forms of collaboration seem to integrate the arts, humanities, and design with science and engineering practices. Above all, new generations of artist-researchers and researcher-artists are now at work individually and collaboratively, bridging the art, science, and technology disciplines. For some of the hard problems in our society, we have no choice but to find new

ways to couple the arts and sciences. Perhaps in our lifetime we will see the emergence of "new Leonardos," hybrid creative individuals or teams that will not only develop a meaningful art for our times but also drive new agendas in science and stimulate technological innovation that addresses today's human needs.

For more information on the activities of the Leonardo organizations and networks, please visit our websites at http://www.leonardo.info/ and http://www.olats.org/. The Arizona State University–Leonardo knowledge enterprise provides leadership to advance ASU's transdisciplinary art-science research, creative practice, and international profile in the field: https://leonardo.asu.edu/.

—Roger F. Malina

Advising Editor, Leonardo Publications

ISAST Governing Board of Directors: Raphael Arar, Michael Bennett, Felicia Cleper-Borkovi, Nina Czegledy, Adiraj Gupta, Greg Harper, Marc Hebert (Chair), Minu Ipe, Gordon Knox, Roger Malina, Xin Wei Sha, Joel Slayton, Tami Spector, Timothy Summers, Darlene Tong

Leonardo:

Diana Ayton-Shenker, CEO

Erica Hruby, Editorial Director

Sean Cubitt, Books Editor-in-Chief

Roger Malina, Advising Editor

Advisory Board: Annick Bureaud, Steve Dietz, Machiko Kusahara, José-Carlos Mariategui, Laura U. Marks, Anna Munster, Monica Narula, Michael Punt, Sundar Sarukkai, Joel Slayton, Mitchell Whitelaw, Zhang Ga

Acknowledgments

> There is no singular point in time that marks the beginning of this book, nor is there an "I" who saw the project through from beginning to end, nor is writing a process that any individual "I" or even group of "I's" can claim credit for. In an important sense, it is not so much that I have written this book, as that it has written me. Or rather, "we" have "intra-actively" written each other ("intra-actively" rather than the usual "interactively" since writing is not a unidirectional practice of creation that flows from author to page, but rather the practice of writing is an iterative and mutually constitutive working out, and reworking, of "book" and "author"). Which is not to deny my own agency (as it were) but to call into question the nature of agency and its presumed localization within individuals (whether human or nonhuman).
>
> —Karen Barad, *Meeting the Universe Halfway*[1]

This book and its various iterations developed out of invaluable collaborations with friends, colleagues, and companion texts. Following the preceding quote by Karen Barad, my gratitude goes out to everyone and everything entangled with this book and the ideas developed within it.

I am foremost grateful to my colleagues at the Centre for Postdigital Cultures (a further iteration of the Centre for Disruptive Media), where special thanks are due to Gary Hall for all his advice and support throughout the development of this book. Thanks also go out to my comrades at the Post Office Research Group, including Peter Conlin, Maddalena Fragnito, Valeria Graziano, Rebekka Kiesewetter, Kaja Marczewska, Marcell Mars, Tomislav Medak, Samuel Moore, Jurij Smrke, and Tobias Steiner.

I am indebted to everyone who has read or reviewed versions of this work in progress or has shared valuable advice and feedback on drafts and proposals, including Caroline Bassett, Sean Cubitt, Jean-Claude Guédon,

Martin Eve, Eileen Joy, Sarah Kember, Anna Munster, Eduardo Navas, Doug Sery, Simon Worthington, and the MIT Press's anonymous reviewers.

Thanks are also due to all the people at the MIT Press who have made the publication of *Living Books* possible, including acquisition editors Doug Sery and Noah Springer, and senior manuscript editor Kathleen Caruso and copyeditor Melinda Rankin who have overseen the production of this book and have carefully copyedited it and with that have greatly improved the text. My sincere appreciation goes to Marge Encomienda for jacket and book design, Sean Reilly for art prep, and Judy Bullent and Rachel Aldrich for publicity.

Particular thanks also go out to all the communities involved in the various publishing projects I have had the pleasure to work with and support during the development of this research, including the Radical Open Access Collective, Open Humanities Press, ScholarLed (Mattering Press, meson press, Open Book Publishers, Open Humanities Press, and punctum books), COPIM, the Culture Machine Live Podcast Series, and Post Office Press. You have all inspired me to put the ideas developed throughout this research into practice and to advocate for and experiment with alternative forms of publishing.

I am grateful for the critical engagement and intellectual inspiration that has come from fellow theorists and collaborators, including Mark Amerika, Monika Bakke, Clare Birchall, Mercedes Bunz, Johanna Drucker, Adrienne Evans, Kathleen Fitzpatrick, Federica Frabetti, Frances Groen, Lesley Gourlay, Sigi Jöttkandt, Kamila Kuc, Stuart Lawson, Silvio Lorusso, Alessandro Ludovico, Tara McPherson, Gabriela Méndez Cota, Luca Morini, Pauline van Mourik Broekman, David Ottina, Gil Rodman, Jonathan Shaw, Graham Stone, Ted Striphas, Nick Thurston, Whitney Trettien, Iris van der Tuin, Eva Weinmayr, and Joanna Zylinska.

I have also had the privilege to exchange ideas and engage with colleagues and audiences via the multiple conferences, symposia, and lectures this research in process was presented at, but also as part of the various research events I have co-organized over the years, including the Disrupting the Humanities Seminar Series, the Radical Open Access Conferences, and the Experimental Publishing Symposia, where texts and theories integral to the thinking behind this research were discussed with a motley crew of participants.

Thanks also go out to my friends and family, especially to Dirk Bakker, Marije Hristova-Dijkstra, and Jeroen Nieuwland. All my love goes to Daniel Pryde-Jarman for his ongoing support and encouragement—which has been the main reason I continued to persevere—and to Coco and Nero.

Acknowledgments

Earlier versions of some of the material in *Living Books* have appeared (albeit in a very different form, as the underlying material has been extensively revised and extended for the purposes of this book) as "On Open Books and Fluid Humanities," *Scholarly and Research Communication* 3, no. 3 (December 21, 2012); "Practise What You Preach: Engaging in Humanities Research through Critical Praxis," *International Journal of Cultural Studies* 16, no. 5 (September 1, 2013): 491–505; "Cutting Scholarship Together/Apart: Rethinking the Political-Economy of Scholarly Book Publishing," in *The Routledge Companion to Remix Studies*, ed. E. Navas, O. Gallagher, and xtine burrough (United Kingdom: Routledge, 2014), 258–269; and "Open Access," in *Critical Keywords for the Digital Humanities* (Lüneburg: Centre for Digital Cultures, 2014).

Introduction

If we still say library or *bibliothèque* to designate this kind of place to come, is it only through one of those metonymic slippages like the one that led to the Greek noun *biblion* being kept, or the Latin noun *liber*, to designate first of all writing, what is written down, and then "the book"—even though at the beginning it meant only the papyrus bark or even part of the living bark of a tree?
—Jacques Derrida, *Paper Machine*[1]

In 2011, the open access and scholar-led Open Humanities Press published the experimental book series Living Books About Life. This series, consisting of twenty-five openly editable books, was made available on an open-source wiki platform for people to reuse, remix, update, add to, and collaborate on (see figure 0.1).[2] These wiki books were designed to interrogate and break down barriers between the humanities and the sciences by repurposing previously published science research and clustering it around a specific topic (e.g., energy, air, pharmacology, or bioethics) accompanied by an editorial introduction. This experiment in connecting and reusing various open access research materials—including articles, books, texts, data, images, video, and sound—and in exploring collective writing and open editing was designed to challenge "the physical and conceptual limitations" of the codex book, but it also questioned the various institutions and material practices that accompany it (e.g., the liberal humanist author, copyright, its aesthetics of bookishness). Yet more than that, it was an experiment in reimagining the book itself as living and collaborative, as an iterative and processual form of cocreation. With this, Living Books About Life—together with its sister series, Culture Machine Liquid Books—was one of the first experiments in humanities book publishing to rigorously

Figure 0.1
Home page of the Living Books About Life book series

explore the potential implications and possibilities of the digital medium for the humanities monograph, for the humanities, and, ultimately, for the human.[3]

This book wants to similarly explore, speculate on, and experiment with the future of the scholarly book. In doing so, it raises a number of important questions for our common, print-based conceptions of the book and for the monograph in particular as a specific material and conceptual instantiation of the book.[4] Instead of seeing the monograph as a fixed object, I present it here as an elaborate set of scholarly practices, structures of knowledge production, and discursive formations, which together enact the dynamic and emergent materiality of this medium. At the same time, in a complex interplay of relations, the scholarly book helps to shape the various formats, debates, and actants that are involved in the processes of knowledge creation. This double aspect of the book, as both *enacted* and *enacting*, means that the monograph occupies an important nodal point in this meshwork of relations and thus plays a vital role in determining what kinds of knowledge are possible. It is therefore extremely important to take account of the ongoing changing materiality of the scholarly book if we are to understand its potential to enact new institutional forms and to embody and perform different scholarly practices.

Introduction

As you might have noticed from the preceding paragraphs, *Living Books* regularly uses the terms *book, scholarly book,* and *monograph* interchangeably, as their meaning tends to overlap in different contexts, making it difficult to try and establish clear boundaries between these categories. Furthermore, due to the paucity of writing on the monograph as a specific material form, this book predominantly focuses on *the scholarly book* format (which also includes edited collections, for example) and often discusses *the book* more in general—unless the context asks for the use of the term *monograph* in particular. At the same time, by using these terms interchangeably, I want to complicate attempts at solidifying (through clear-cut definitions or characterizations, for example) what a scholarly book is, was, or could potentially be.

Indeed, the need to experiment with alternatives to challenge this solidification and to highlight the dynamic materiality of the book is all the more felt in a situation in which our current (still heavily print-based) forms and practices of scholarly communication are increasingly problematic—especially in the humanities. Here, a situation has emerged wherein the present arrangements tend to sustain the interest of established stakeholders, inhibiting wider access to scholarly research and experimentation with new forms of scholarship and scholarly communication. These arrangements are predisposed to be repetitive and conservative instead of being open to alterity. In this sense, they continue to reproduce what can be perceived as essentializing aspects of the book, which include a fetishization of both the author and the book-object. .

Instead, *Living Books* both outlines and imagines more experimental, ethical, and critical futures for the monograph; futures in which scholars take greater responsibility for their continued engagement with the scholarly book's becoming.[5] This requires a critical investigation of our academic communication practices, our systems of knowledge production, and the debates that surround both scholarly publishing and the past and future of the academic monograph. *Living Books* can be seen as an example of such an investigation. In addition, it encourages scholars to rigorously explore their own relationships and entanglements with the monograph—and with scholarly communication in general, too. They should do so in order both to determine what they want the book to be *and* to examine new ways of being for themselves as critical and engaged theorists.

Alternative Futures

Exploring alternative futures for the scholarly book at this point in time specifically is important for several additional reasons—most importantly because it can be argued that the scholarly book and its further development in the humanities is at risk. In saying this, I am not referring to a dystopian future in which the printed book is replaced by its digital nemesis—the much-heralded "death of the book."[6] I am merely endeavoring to draw attention to the way it remains hard today for certain kinds of work in the humanities to obtain a formal publishing outlet, whether it be in print or digital format. The reasons for this situation are diverse and range from library budget cuts to the ongoing commercialization of the scholarly publishing industry. Nonetheless, the consequences are wide-reaching. In particular, this state of affairs influences the job prospects of early-career researchers, for whom, more often than not, it remains a challenge to get their first book published. It also affects the quality of scholarly research in that it remains difficult to publish academic monographs that are highly specialized, difficult or radical, experimental or multimodal, or that fall outside current vogues in academic publishing, making them harder to market or incorporate into a specific series or publication list. Indeed, we have grown accustomed to a situation in which a book finding a publisher tends to be determined by its marketability, not by its value or quality as a piece of scholarship.

The mechanisms behind this situation, more commonly known as the so-called monograph crisis, have by now been well-discussed and are, as chapter 3 sets out, ultimately connected to the overall neoliberalization of the university.[7] However, although developing a critique of the political economy of scholarly publishing remains important, the intention here is not to put forward a crisis narrative regarding the academic book, scholarly publishing, or the humanities in general.[8] This is for the simple reason that it can be argued that the humanities have always been in crisis and that humanities book publishing has never been financially self-sustainable.[9] Similarly, the intention here is not to overcome this condition via the route of technological utopianism (wherein innovative digital solutions will resolve the crisis) or the search for new *sustainable* business models or by defending an idealized past system of values associated with the (printed) book and the humanities. Instead, it might be more useful to embrace this "crisis" or

Introduction

messiness to some extent, in order to explore the potentialities that seep out of these ongoing and indeterminate contingencies, both for the book and for the humanities. As such, *Living Books* will focus predominantly on *affirmative projects* (and related ideas and concepts), projects that are exploring alternative futures for the book, the difficulties mentioned thus far notwithstanding.[10]

Yet in addition to its potential to provide affirmative alternatives to intervene in the current political economy of publishing, there are further reasons that it is important to explore the scholarly book as it is presently unfolding. The book's changing materiality also offers us an opportunity to question and critique the repetitive print-based habits that continue to dominate scholarly communication. Although shorter forms—from articles to mid-length monographs—along with collaboration and teamwork, are becoming increasingly common, and indeed could be said to have always been an essential aspect of humanities scholarship, the authority of the printed long-form argument and all that it entails (e.g., fixity, stability, the single author, originality, copyright) continues to dominate the humanities.[11] This is not surprising, as from its early beginnings the printed book format has been of the utmost importance, as a specific material form, for scholarly communication—especially for the monograph as a particular physical embodiment of the concept of the book. Since the rise of modern science and scholarship, the scholarly monograph, in common with the academic journal, has for the most part been produced, distributed, and consumed in printed and bound codex formats. For the majority of scholars, the printed book format produced in an academic setting (i.e., published and distributed by an academic publisher) has thus become synonymous with formal scholarly communication. With the development of digital and multimodal forms of communication, this analogous relationship between print (and all that it entails) and formal scholarly communication is becoming less determined, and the future of the scholarly book is once again heavily debated.[12] Whether the monograph of the future will exist in print, digital, hybrid, or postdigital print forms is therefore something that is currently being struggled over by the various constituencies that surround the production, distribution, and consumption of academic books.

It is clear that if we want to explore the potential future(s) of the scholarly monograph in an increasingly digital environment, it is essential to examine the history of the book in relationship to the practices and institutions

that have accompanied the monograph; to analyze the specific contexts out of which the book as a technology coemerged.[13] This asks for a closer look at how the book form has developed, from writing systems such as wax tablets and scrolls to codices and e-books—to cite a few of the most obvious examples—and to explore how, as a specific material form, the scholarly monograph came to be what it is today, influencing and shaping scholarly communication at the same time.[14]

The monograph, as a specific media technology, is continuously reproduced in specific contexts: by academic professional and disciplinary structures, where the printed monograph serves as the dominant vehicle for promotion and tenure; and by the publishing industry, where the bound book format remains its main commodity form for the humanities. This partly explains why the digital, with its perceived affordances of openness, fluidity, and disintermediation, is seen by many as posing such a disruptive threat both to the traditional values of the humanities and to the business models of academic publishing. In this respect, the dichotomous nature of many of the debates over the future of the book (i.e., print vs. digital) can be traced back to a much larger struggle related to power structures and to who controls (new) knowledge and communication systems within academia.

That said, it is perhaps worth emphasizing that in my critique of this print-based legacy that continues to structure academia, it is not my intention to position the printed book *in opposition to* the digital book.[15] However, I am interested in how this often highly polemic battle over the future of the book (which also tends to draw on the crisis rhetoric mentioned previously—i.e., "the death of the printed book") leads to a situation in which essentialized mythical affordances such as individual authorship, fixity, authority, originality, and trust have come to be connected to a specific format—that is, print. This is the case even though book historian Adrian Johns, for example, has argued extensively that the elements of trust invested in print publications were in large part the result of social structures and systems that were negotiated and put in place (including an elaborate disciplining regime set up and maintained by publishers and booksellers) and thus were not natural or essential to print at all.[16] This defensive stance on the future of the book, based on an idealized print past, is something that *Living Books* investigates and critiques. It does so first and foremost in order to emphasize the non-self-identical condition of texts: print is not fixed and stable—not in its production, its dissemination, or its

Introduction 7

reception—and it has also never been stable.[17] Witness our need for bibliographical studies and critical editing to try to recover the presumed original state of a work (from Shakespeare to the Bible). Furthermore, this critique also aims to expose the power struggles, the politics, and the value systems that lie behind our hegemonic print-based habits and debates and aims to explore whether, through our practices and actions, we can offer alternatives to perform the book differently, in potentially more ethical ways.

Let me reiterate here that print-based communication is evenly capable of promoting more ethical and experimental forms of scholarly communication. Print is not the problem here, nor is digital the solution. What I am referring to when I write about *print-based forms of communication* is the way print has been commodified and essentialized: through a *discourse* that prefers to see print as linear, bound, and fixed (as a "work" with an "author") and through a system of material production within publishing and academia—which includes our institutions and practices of scholarly communication—that today certainly prefers quantifiable objects as auditable performance indicators. Even more, it is this "print complex," with its power structures and stakeholders, that is being increasingly supplanted in a digital environment, while the book is being rethought as an object and commercial product within digital publishing.

This critique of our print-based systems and practices notwithstanding, digital books are similarly encapsulated in formative processes and structures. As a result, essentializing attributes or properties, such as openness and fluidity, are also accorded to the digital format. I therefore also do not want to claim that the potential for increased collaboration and open forms of publishing will be a guaranteed outcome of "digital innovation." Experimenting with new forms of communication is hard work, involving more than only the overcoming of technological barriers. As I outline throughout *Living Books*, it also entails a critical redesign of scholarship. Digital promises and utopias will similarly face scrutiny. It is my intention to examine those aspects that might *actually* be exciting, experimental, and perhaps more ethical in digital scholarship. This includes analyzing digital publishing projects that explore in an ongoing manner what a new digital ethics and politics might entail. In this respect, I concur with Johanna Drucker, when she argues that "we can't rely on a purely technological salvation, building houses on the shifting sands of innovative digital platforms, with all the attendant myths and misconceptions. Which aspects of

digital publishing are actually promising, useful, and/or usefully innovative for the near and long term?"[18]

This book presents the argument that, on the whole, both sides in this debate (around print and digital) still very much cling to concepts connected to the bound and printed book and remain overwhelmingly *humanist*. Even when it comes to experiments with the book that are proposed by those working in an online context, most of the time digital substitutes are being sought for stability, authority, and quality. This can be seen as an attempt to structure the digital according to the academic arrangements and value systems that, as scholars, we have grown accustomed to with print. Some examples of the kind I come back to throughout this book: Wikis, seen by some as *the* exemplary fluid and collaborative technology of the digital environment, are set up in such a way that any edits that are made to them, as well as information concerning who made these edits, are easily retrievable. Creative Commons licenses, designed to make the sharing and reuse of materials easier, are still based on underlying liberal notions of authorship and ownership, and instead of offering an alternative to copyright only really reform it.[19] And finally, the remixer, curator, or collector, often positioned as offering a radical critique of the individual and original author, has merely succeeded in adopting the latter's position and authority. In other words, instead of experimenting with the new medium and rigorously examining the systems and values on which the book is based (including notions of individual authorship, ownership, and originality), many experiments with digital monographs are emulating print. The fact that digital books are finding it difficult to move beyond these kinds of print-based aspects is further fueled by a discourse and a system of power relations that has invested heavily in this print-based system. For instance, think of the (initial) reluctance among publishers to experiment with open access and their continued use of digital rights management (DRM) on digital books and platforms to mimic print-based copyright mechanisms. *Living Books* showcases experiments that explore the book, its debates, and its practices and systems affirmatively—no matter what kind of format, whether it be manuscript, print, digital, hybrid, or postdigital. Experiments, in other words, that imagine the book itself as a space of experimentation, as a space to intervene in the fabric of our scholarship, and as a space to question the hegemonies in scholarly book publishing with the aim of performing scholarship differently.

Introduction 9

Who, then, is currently experimenting with the book in these ways, and why? One example is scholars who want to change the way quality is established through experiments with new forms of (open) peer review or who want to critique the myth of single, individual authorship by exploring forms of collaborative and even anonymous authorship. But there are also scholars (and publishers) who want to question the commodification of the book by exploring both gift economies and the opening up of the book through forms and institutions of open access publishing and commoning or, related to that, who want to explore the fixity of the book through experiments with reuse and the remixing of material, or those who intend to critique the objectification and bound nature of the book by working with processual works, with liquid books, and with versioning.[20] Yet most interesting of all, perhaps, are scholars who see the book as laying at the basis of our system of knowledge production in the humanities and for whom changing, rethinking, and reimagining the book is seen as an important and perhaps even essential (first) step toward reimagining a different, more ethical humanities—albeit a humanities that is messy and processual, contingent, unbound, and unfinished, something we could perhaps start to perceive as a *posthumanities*.

Posthumanities

As part of its overall argument, *Living Books* wants to contribute to a further decentering of the humanist tendencies still dominant in the humanities today. These tendencies are clearly reflected in humanities' communication and publishing practices, especially in the perceived "salient features" attributed to the printed book. These reflect a clear anthropocentrism, a reassertion of the primacy of man, which comes to the fore in the fetishization of the rational, individual, original, liberal humanist author, perceived as an autonomous agent responsible for knowledge creation. But beyond this romantic focus on the author-subject, these humanist essentialisms are also performed through the medium of the book, reflected as they are both in the book as object and in the social practices forged around it— that is, in the way the book is perceived as a fixed and bound commodity, as an original work that can be owned and copyrighted by a proprietary author-owner. Within such a humanist framework, agency is perceived as

a property of individual, indivisible, unified entities, something a clearly defined author or book-object has.

In general, this reflects the authority of certain essentialist ideas related to the universal sovereign "human," ideas that continue to underlie the humanities. A critique of this authority and, with that, of the universal definition of man adopted within these fields has been developed for over a century now, but nonetheless this authority remains strongly ingrained in humanities knowledge production. This critique has shown that what has been instilled is a normative and severely restrictive definition of *man* and of what it means to be human, which has turned into a social convention about what the category *human* includes, establishing strong binaries based on exclusion to maintain its privileged position in opposition to the nonhuman other (e.g., the female, animal, machinic, algorithmic, environmental). We can see this reflected in what practices of authoring have been allowed and are regulated (e.g., the individual self-identical author) and which have been excluded (e.g., plagiarism, piracy, distributed authorship). *Living Books* contributes to breaking down these supposedly natural and normative practices—exploring that which has been excluded in this process—and with that challenges the primacy of the human in humanities knowledge production. How can we think of foundational concepts and practices such as authorship, texts, the book, copyright, and the university differently, while questioning the political economy, the aesthetics, and the methodologies that came to accompany these humanistic institutions?

One way to start breaking down this authority is by a wider reconsideration of the multiple intertwined agencies (human and nonhuman, technological and medial) involved in the production of research. This would include a recognition of the multiple forms and modes of authorship, taking into consideration the relationship between the author and the technologies or tools involved in knowledge production—as has been explored in depth in the (critical) digital humanities and media studies, for example. This is to emphasize how our tools or technologies of mediation (including the book) are often othered, too—for example, when the relation between humans and tools is defined as external. In this context, this would indicate that technologies (e.g., the book, writing) are set up in a binary relationship to authorship (i.e., the author-subject vs. the book-object) instead of being seen as playing an integral agentic role in meaning production. Working with expanded concepts of agency in this respect—such as those brought

Introduction

forward in theories of feminist new materialism and posthumanism—might aid in recognizing the diversity of relations at work in publishing and knowledge production. This includes a recognition that technology is part of what it means to be human, of how humans are entangled with their technologies, constituted in and through them. Following Derrida and Stiegler, technics are *originary*, meaning that we as humans have been posthuman from the very beginning.

In formulating, performing, and expanding this critique of the idea of the human around which so much of the humanities has been built, *Living Books* connects to a larger movement toward formulating a *posthumanities*. *Post* here is not intended to be oppositional; it also does not denote *after*. It rather reflects a questioning and deconstructing of humanities' humanist legacy, wherein a posthumanities has always already been preinscribed in the humanities; it has always been part of the humanities' humanist *other*. A "becoming-posthumanities" then involves a critical exploration of how new (digital) tools and technologies offer opportunities to rethink and reperform our humanist fixtures, institutions, and practices (including authorship, the book as a fixed object, and copyright), questioning our standard (print-based) parameters within the humanities, and asking why they have become hegemonic. Why have we provided them (and continue to provide them) with so much power and legitimacy within our systems of knowledge production? As part of this, a posthumanities explores more in depth our relationships to tools and technologies, examining the agency of the technologies we interact with and how we can take into consideration the agentic nature of our tools, including as part of experiments with more distributed and multiagentic authorship practices. Extending from this, taking on insights from posthumanism, this involves conceptualizing the book as an *apparatus*, constituted of various agencies and subjectivities (e.g., human, animal, environmental, machinic, organic) and ways of thinking and being.[21]

But perhaps most importantly, a posthumanities asks what it would mean to create spaces for alternative posthumanities' ways or methods to create, perform, and distribute research. How can we design ways of communicating that better accommodate a plurality of different actors and actants, acknowledging the agency of nonhumans and material objects in research practices, while at the same time not taking the binary human/nonhuman as a given? Ways that decenter the human and, with that, creatively and affirmatively reperform our ideas of the humanities, asking how

research can be more inclusive with respect to present, past, and potential future intermediaries? In this sense, a posthumanities has to include both a theoretical *and* a practical critique. In other words, next to a theoretical investment, it should also involve our scholarly practices, methods, and approaches with respect to authorship, with respect to producing, circulating, and disseminating research, and with respect to the aesthetics of our scholarship (beyond text and toward the visual and graphical, for example). How can we aid in a practical posthumanist critique of ingrained humanist notions? Within *Living Books*, this is particularly explored as part of the development of a form of posthumanist authorship, as described in chapter 2, and of a scholarly poethics, as described in chapter 4. At the same time, practically, a posthumanities approach has been an integral part of the development of this research project throughout its various versions. In this sense, *Living Books* asks: How can we perform knowledge-making practices differently, to the point where we actually begin to take on (rather than take for granted, repress, or ignore) the implications of the posthuman on how we live, work, and act as academics and researchers? What can the humanities become in all these entangled constellations?

With this reassessment of the agencies of knowing comes a reacknowledgement that the *I* or *we* that knows can no longer be taken in simply by an individual human *I* (including the supposedly static and stable authorial *I* and communal *we* used throughout this book). An opening up of the *we* involved in knowledge production allows then for a problematization and an expansion of the frame of knowledge subjectivities (beyond a narrow human or humanistic frame), to include a complex network of various different voices, elements, and perspectives, and agentic relations with which *we* are entangled and produced out of. The *I*s and *we*s this book is composed off are thus already always plural, consisting of a manifold multiplicity of actors, groups, relations, and networks. These *I*s and *we*s signal membership of an indeterminate community, yet a community which this book nonetheless—paradoxically, perhaps—makes an appeal to throughout to take up responsibility for its publishing practices. Normally *we* is used in a reflexive way to signal membership of a certain community, but in this case it is a *we* that doesn't necessarily from the outset delineate the boundaries of a community in a specific way. In this sense, *Living Books* appeals to all of you: to the community to come.

Book Future and Book Past

Focusing on alternative futures for the scholarly book specifically doesn't mean the book's past or present condition should be neglected; both stages are fundamentally wrapped up in the book's further becoming. Challenging unilinear representations of past, present, and future enables us to instead focus more on the book's ongoing development—the book to come, in Blanchot's words—which is always unfolding in an enveloping move with its past and future.[22] Past, present, and future are here seen as relative concepts, where a different reading of the past reconfigures the book's future and vice versa.[23] *Living Books* therefore focuses equally on the history of the book and on its discursive formation, taking into account how a specific reading and (re)reading of that history shapes the book's present and future.

The importance of the book's history (i.e., the influence of the book's past materiality and systems of material production) on the medium's present and future condition has always been acknowledged within book studies. However, as set out in chapter 1, not enough attention has been given in past and current models of book history to how book history *writing* has shaped the book's becoming. Hence it is important to analyze the specific manner in which book history has been written and to explore the vision of the book that has been brought forward by the prevailing discourse on book history.[24] For example, this discourse is highly dichotomous, based on various sets of oppositions (e.g., the causal relation between the book on the one hand and culture or society on the other hand) related to the description of the book. Furthermore, the book itself is mostly described in an *objective* way—disconnected from us as scholars and unrelated to our communication practices—as an object that either has agency or has agency inflicted upon it. In addition, there is also an object-centered approach that lies at the heart of book history—an approach that envisions the book as an object instead of as an interconnected and relational process, or event.[25]

Contrary to this, the second part of chapter 1 highlights how the book and society cannot be disconnected so easily in this kind of oppositional thinking as both are always already entangled. In this respect, the argument is made that book historians and media theorists need to give due recognition to the inherent connectedness of the various elements and plural agencies involved in the becoming of the book. This includes our own discursive as well as material entanglement with the book as scholars, wherein

our book histories are inherently *performative*, meaning that our specific depiction of the book's history is incremental in shaping its future to come. This becomes even more pertinent if we take into consideration the way that we as academics are not only influencing the becoming of the book through our *discursive* actions—that is to say, through our descriptions of the book's past, our reflections on its current condition, and our speculation on its potential future—but also simultaneously shaping the book through our *material* scholarly practices, through our usage of the book as a specific medium to publish and communicate our findings about its being and development.

Living Books therefore intervenes in this book historical discourse—which up to now has mainly adhered to forms of *representationalism* and binary thinking—and reframes it by focusing on its inherent *performativity* and by paying extra attention to how studies of the book in their description of the book-object, its history and becoming, have influenced its present and future incarnations.[26] This involves exploring the genealogy of the book and the assumptions that lie behind our historical descriptions of the book medium. In doing this, connections are made with the material-discursive genealogies of Michel Foucault and the agential realism of Karen Barad, with contemporary (materialist) media theories of (re)mediation and media archaeology, and with theories of feminist new materialism. These theories support the performative materialist approach toward the scholarly monograph that is adopted in this book, as part of which the monograph is positioned within a wider meshwork of processual relations.

Foucault's concepts of archaeology and genealogy provide key reasons for the relevance of analyzing the history of the scholarly book here. Foucault's historiographical methodology allows us to explore and understand the emergence and development of book discourses from within certain contexts and practices, while simultaneously highlighting the critical and performative possibilities of (re)reading these discourses differently. Foucault has used his archaeological method to investigate how a certain object or discourse has originated and sustained itself, how its conditions of existence have been shaped by discourses and institutions and the rise of certain cultural practices, and how this exploration of the past of a certain object or discourse aides us in understanding its present condition better and enables us to rethink the new in the light of the old. He emphasized the way in which our historical descriptions are necessarily ordered by the

present state of knowledge and thus how our foundational concepts can be seen as the effects and the outcomes of specific formations of power.[27] In his later genealogical strategy, Foucault critiqued readings of origin in his search for minor knowledges arising from local discursivities, drawing attention to neglected, alternative, and counter histories that have developed in the subconscious of a discourse's development. As Dreyfus and Rabinow point out, in his archaeological practice, Foucault initially focused more on how a discourse organizes itself and the practices and institutions it is directed at, while neglecting the way a discourse is itself embedded in and affected by these practices and institutions. In his genealogical approach, this original focus on an autonomous discourse is subjected to a thorough critique.[28] Origins are here seen as embedded in political stakes, wherein genealogy investigates the institutions, practices, and discourses that come to determine a hegemonic origin against multiple and diffuse points of origin. Foucault's interest here lies in how truth claims emerge and how we can read them differently. With his critique of established historical readings or discourses—which thus function as systems of authority and constraint— Foucault wanted to focus on the heterogeneity of histories, to emancipate historical knowledges from subjection and to enable them to struggle against a hegemonic unitary discourse.[29]

The overview of the histories of the book provided in *Living Books* similarly present archaeology and genealogy as related and in many ways complementary concepts and strategies.[30] In this respect, this study is archaeologically informed as it is interested in the origins and development of both the current dominant discourse surrounding the printed book (and more specifically the scholarly monograph) in its transition to the digital environment and the book format under the influence of this discourse (and vice versa). But it is genealogical, too, in the sense that it pays specific attention to the formations of power that influence and determine both this discourse and the dominant descriptions and analyses of this discourse, and with that the book as object as it has developed and continues to develop in an increasingly digital environment.

From a specific media historical viewpoint, excavating the histories of the book is also important in order to illustrate how "new media" (e-books, printed books) have historically remediated "old media" (printed books, manuscripts) and to explore the influence of other new media, such as film, television, and digital media, on the development of the printed book and

the e-book. Remediation, as understood by Jay David Bolter and Richard Grusin, is one of the theoretical frameworks that has been developed to conceptualize some of the continuities between media and to explain the continuous resurfacing of the old in the new (and, vice versa, the adaptation of the old to the new).[31] As media theorists Sarah Kember and Joanna Zylinska point out, remediation does not emphasize a separation between the past and the present and between new and old media in the form of technological convergence.[32] Rather, Bolter and Grusin critique visions of history as linear and teleological and favor the idea of history as a contingent genealogy: nonlinear and cyclical. To expand on this, it is important to stress the political, cultural, and economic forces that (re)mediate media and to emphasize—with respect to the constructive power of scholarly practices, for instance—the performative power of our own daily practices in reproducing and remediating the printed monograph in the digital domain. As Bolter and Grusin state: "No medium today, and certainly no single media event, seems to do its cultural work in isolation from other media, any more than it works in isolation from other social and economic forces. What is new about new media comes from the particular ways in which they refashion older media and the ways in which older media refashion themselves to answer the challenges of new media."[33]

Living Books therefore pays attention to the emergence of scholarly practices and institutions in the Western academic world that influenced the development of specific discourses surrounding the book and its various material manifestations. Furthermore, it also pays close attention to alternative readings of the history of the book and its institutions. How did they emerge and for what reasons? How can we already find these alternative readings *within* the dominant discourses, instead of presenting them as dialectically opposed?[34] Throughout *Living Books*, ruptures and discontinuity from within are searched for and highlighted through a transversal discursive reading, emphasizing the heterogeneous character of the discourse on the history of the book and how it has been constructed. As part of this reframing of the discourse, this book proposes a *diffractive* reading to capture the book's historical debate as it evolves.

Based on a practice and concept of reading introduced by Donna Haraway and subsequently taken up further predominantly by feminist new materialist scholars such as Karen Barad and Iris van der Tuin, a *diffractive reading* reads insights and positions through one another to acquire an

Introduction

overview of the debate from multiple positions. In this sense, it is not based on a comparison between philosophies as closed, isolated entities; instead, a diffractive reading moves away from (presenting) humanist position-taking in opposition to other statements, readings, or schools of thoughts. I position diffraction as an affirmative, dynamic reading method or strategy instead, as a specific posthumanities practice of critique, one that is embedded and productive, one which "breaks through the academic habit of criticism and works along affirmative lines."[35]

I am thus not installing what Van der Tuin has called "a new master narrative," in the sense of putting forward a new performative or feminist new materialist reading of the book historical debate in opposition to earlier readings.[36] Instead, this diffractive method is used to read established narratives through each other to emphasize their entanglement, to explore where differences arise and are constituted, and to (begin to) move beyond the binaries that have structured the discourse—breaking through, as Van der Tuin has argued, "a politics of negation."[37] At the same time, the performative character of the debate is highlighted to show the continued influence it has on the present and future material manifestations of the book.

Throughout *Living Books*, this diffractive reading involves a reframing of the history of the book and the material formations and practices that have accompanied it (from authorship to openness): by *diffractionally reading* the oppositional discourses through each other, to emphasize their connectedness and to push them to their limits by juxtaposing them; by laying more emphasis on the *humanist tendencies* in this discourse, their ongoing influence and the performative attempts to critique them; and finally, by drawing more attention to the *performativity* of these material-discursive formations and our own involvement as scholars in their becoming. This will highlight the multiple, mutually interwoven aspects of the discourse in its becoming, as well as leave space for heterogeneous discursivities within this framework.

Material-Discursive Practices

A specific focus on a genealogy of the book, focusing on its historicity and temporality, needs to simultaneously consider the book's emergent materiality, which encompasses both the systems of material production that have surrounded the book in its ongoing development (including our institutions

and scholarly practices), as well as the specific material formats of the book (i.e., manuscript, digital), with all their potentials and limitations. I am particularly interested here in the way the material agency of the book influences how we think and act as scholars and how we communicate our findings. This also includes a recognition of how the materiality of the codex book is actively structuring the digital becoming of the book, for example. On the other hand, the specific affordances of the digital book simultaneously create conditions for new forms of knowledge and new scholarly practices (or at least they have the potential to do so). The book is thus an embodied entity, materially established through its specific affordances in relationship to its production, dissemination, and reception; that is, the specific materiality of the digital book is partly an outcome of these ongoing processes. As Katherine Hayles states, materiality is a "dynamic quality . . . joining the physical and mental, the artifact and the user."[38]

Hayles is an important theorist to have argued for the importance of a more robust notion of materiality in media studies in this respect, especially in the realm of print and hypertext. Hayles's campaign for *media-specific analysis* (MSA) is very valuable in this context, too, as part of which she emphasizes that the meaning of a text is integrally entwined with its materiality, or *physicality*. Texts are thus embodied entities and materiality an emergent property, "existing in a complex dynamic interplay with content" (and additionally contingent through the user's interactions with the work).[39] She is sensitive to the influence of what D. F. McKenzie calls the *social text* on the materiality of the book, in this sense extending her notion of materiality toward "the social, cultural, and technological practices that brought it into being" and the practices it enacts.[40] Hayles focuses less, however, on the historical discourses and narratives that she herself and her scholarly colleagues have constructed on the meaning, the definition, and the future and past of the book, and on the continued performative influence of these discourses on the evolving materiality of the book (and vice versa). As stated previously, this reflexive act of being aware of and critical of one's own practices and contributions to the larger discourse, while rethinking and reperforming them, is what *Living Books* is in large part about, extending from the tradition of feminist rereadings and rewritings of (masculine) discourses.[41]

Therefore, first of all, I conceptualize the material development of the book as being inseparable from its discursive becoming, where the argument

Introduction 19

this book presents is that discourse is always already material, and material always already discursive—instead of positioning the two in opposition to each other or exploring in which way the one influences the other, which has been the dominant tendency in the discourse on book history. We need to be aware of how discourse organizes social practices and institutions, while our discursive practices are at the same time affected by the practices and institutions in which they, and we, are embedded. Drawing inspiration from—as well as showing some of the inconsistencies in—among others, the work of Roger Chartier, Adrian Johns, Robert Darnton, and Paul Duguid (book theorists who have all tried to de-emphasize in more or less successful ways the oppositional nature of the book-historical debate), and diffractively reading them with Karen Barad's theories of agential realism and Donna Haraway's notion of the material-semiotic, I view these material-discursive practices as *entanglements*.[42]

In addition, I want to emphasize that media discursive practices are *performative*. Based on a reading of the later work of Foucault, its understanding of power and discourse as productive and affirmative (i.e., performative), and its insistence on the entangled nature of matter/bodies and discursive structures (*dispositif* or *apparatus*), *Living Books* attempts to think beyond these dualisms. Applying Foucault's work on discursive formations, practices, and power struggles, I want to draw more attention to how scholars' own discursive practices—specifically with respect to the scholarly book—materially produce, rather than merely describe, both the subjects and objects of knowledge practices and thus partly determine the dynamic and complex nature of the history and becoming of scholarly practices. In this respect, this study is performative, too: it is actively involved in and takes responsibility for the becoming of the scholarly book and wants to explore how it can enable different incisions in its development, incisions that might promote a more ethical involvement (from scholars) with the book as it unfolds.

To further support this, the work of various feminist new materialist theorists is engaged. As a theoretical project, (feminist) new materialism can be seen as displaying an antipathy to oppositional, dialectical thinking; instead, it emphasizes emergent, productive, generative, and creative forms of material becoming.[43] Important in this respect is that it sees embodied humans or theorists as immersed in these processes of materialization.[44] These insights are used to underscore the need to understand the book as a process of mutual becoming, as an entanglement of plural agencies (both human and

nonhuman). The separations, or *agential cuts*, as Barad calls them, that are created out of these entanglements have created inclusions and exclusions, book-objects and author-subjects, readers and writers. But cuts (or, using an alternative vocabulary, *incisions*, *decisions*, or *interventions*) need to be made, in order to enact boundaries, make concepts meaningful, and attach properties to objects. Following Barad, these cuts are enacted by the larger material arrangement of which we are a part, but we are still accountable for the cuts that are made, for the inclusions and exclusions that are woven, for the relationalities and forms of emergence that are established, and—in the words of Haraway—for the specific *world building* that we as scholars do.[45] Cutting thus involves taking responsibility for the boundaries and the separations and dualities we create through our discursive position-taking (in book historical debates, for example) and our material practices (by publishing a printed and bound book with a reputable publisher, for example).

As is argued more extensively in chapter 5, during the course of their history, scholarly books (and we as scholars are involved in this too, through our scholarly book publishing practices) have functioned as specific material-discursive practices, as *apparatuses* that cut into the real and make distinctions between, for example, objects of study and the subjects that research them (scholars or authors). At the same time, these practices produce these subject and object positions—in the way that, for example, scholars as discoursing subjects are being (re)produced by the book and by the dominant discourses and practices that accompany it. Books are thus performative; they are reality-shaping, not just a mirroring of objective knowledge.

Based on this idea of the performativity of both the book and our discursive practices, the intention is to move beyond the dichotomies that have structured the debate on the history of the book in the past, by focusing on the entanglement of material-discursive (Barad) or material-semiotic (Haraway) practices that shape the form of the scholarly book, as well as the institutions accompanying it.[46] This study thus acknowledges the entangled agentic nature of books, scholars, and readers and of the discursive practices and the systems and institutions of material production that surround them (from the publishing house and the university to peer review and copyright).

Introduction

Versioning and Version Control

One of the main incisions that (historically) are made in relation to the process of the becoming of the book is one in which the book is cut into different iterations, editions, or *versions* (i.e., from drafts and typescripts to proofs, published versions, print runs, editions, and revised editions). As a concept and practice, *versioning*, as it has come to be used within academic research and publishing, refers to the frequent updating, rewriting, or modification of academic material that has been published in a formal or informal way. As a practice, it has affinity with software development, in which it is used to distinguish the various installments of a piece of software. Similarly, within music, versioning is a specific form of copying that relates to the practice of creating (cover) versions of "original" songs.[47] Versioning is also a common feature of many web-based publication forms, from blogs to wikis, based on the potential to quickly revise and save a piece of written material.

With versioning comes version or revision management and control, which can be seen as an important (inbuilt) aspect of versioning. In a software environment, for example, the various platforms and pieces of software that allow for updating most of the time also enable the tracking and archiving of the various modifications that are made to a work or project.[48] In collaborative environments such as wikis, this makes it possible to establish who is responsible for a specific edit and provides the possibility of comparing various revisions with one another.

Although related to software development, versioning and version control have been around for a long time and can even be seen as an essential aspect of writing (e.g., word processors), publishing (e.g., Victorian serial publications), editing, and scholarly communication more in particular.[49] Think about the practice within the sciences and increasingly in the humanities to publish preprints and postprints, but also online first versions, versions of record, corrected or updated versions, and revised editions. And even earlier research stages, including discussions on mailing lists, working papers, and conference presentations, can be regarded as different renditions of an academic publication in progress, reflecting various stages of development. However, where in a print context the communication or sharing of research in process mainly took place in small community settings (e.g., papers at conferences, postal exchanges, personal communications between colleagues), what has

changed most recently is that, depending on the scholarly field and context, these forms showcasing evolving scholarship are increasingly publicly available online. Witness the rising use of online social networks such as Twitter and Facebook (enabling the live-tweeting and streaming of research events, for example) and platforms such as Academia.edu and SlideShare, next to the prevalence of personal websites, blogs, and microblogs on which drafts and first research ideas are posted. Together these developments have led to research being shared publicly at a much earlier stage, often years before its formal publication, without the associated time lags formal publishing brings with it, not to mention the paywalls and copyright restrictions—but it also allows scholars to update, add to, and change their research as it progresses. For example, media theorist Lev Manovich published different iterations of his monograph *Software Takes Command* (2013) online on his website as the book developed. As he outlines with respect to this practice: "One of the advantages of online distribution which I can control is that I don't have to permanently fix the book's contents. Like contemporary software and web services, the book can change as often as I like, with new 'features' and 'big fixes' added periodically. I plan to take advantage of these possibilities. From time to time, I will be adding new material and making changes and corrections to the text."[50]

Versioning also highlights the inherent collaborative nature of scholarship as more than often we publish drafts to solicit feedback from our colleagues, via which texts get redrafted and revised with the aid of our extended research communities, be this via comments at a conference or annotations on a draft paper posted online.[51] Within the humanities, it is fairly common for certain versions (i.e., the blog post, the conference presentation) to be clearly presented, communicated, and published as such during different points in a research work's development. Yet only the so-perceived final (book or journal article) version as published by a press or publisher is held to be the *version of record*, authored by a specific author or set of authors as an original piece of work—even though, as highlighted, versions often emerge in and out of highly collaborative settings.

What I am mainly interested in with respect to this development is how these forms of processual and collaborative research have the potential to critique our current essentialized and object-based scholarship and publishing systems. Its increasing proliferation triggers a thorough rethinking of what both scholarship and publishing are; it encourages us to reevaluate at

Introduction

what point and for what reasons we want to, should, or are required to cut down our ongoing research and how we can guarantee that these closures do not bind its further development. Instead of primarily emphasizing the end result as part of such an object-centered approach, could a focus on the various renditions of an academic work also involve a shift in our attention toward the collaborative and more *processual* nature of research? And might this lead us to start paying more attention to the performativity of our practices: that it matters *where* we bring out our various versions (what platforms we use or which publishers), *how* we do so (open or closed and with which license), and the different formats our versions appear in (print, HTML, video, PDF, podcast, EPUB)? Will it help us to look more closely, for instance, at how different platforms and formats influence the way we produce a specific version and how it is further used and interacted with? Could versioning also involve more recognition being given to the various groups of people that are involved in research creation and dissemination, as well as to the various materialities, technologies, and media that we use to represent and perform our research, from paper to software? Would a focus on the continuously evolving nature of research make us more aware of the various cuts we can and do make in our research and for what reasons? And might this involve us making more informed and meaningful decisions about which incisions we want to make, what kind of versions we would like to bring out, and with what intention (to communicate, collaborate, share, gift, attribute, credit, improve, brand, etc.)?

Versioning might in many ways better mirror the scholarly workflow research goes through. However, experimenting with different versions (including using different formats, platforms, and media) also offers us an opportunity to reflect critically on the way this workflow is currently (teleologically and hierarchically) set up, institutionalized, and commercialized within scholarly communication and how we might generate and communicate our work differently at the various stages of its development. It might, for example, encourage us to ask questions about the role of publishers and about what the publishing function entails exactly, as well as about the authority of a specific text and who does (and does not) get to have a role in establishing this authority. What currently counts as a formal version and for what reason? At what point has a text been reviewed by our peers, by our community of scholars, when in a public setting it can potentially be "reviewed" in a continuous manner, even after it has been

formally published? Collectively, as researchers, we have tried to organize our research and writing around fixed and authoritative texts, presumed consistent and stable from copy to copy, based on the technology of the printing press. Could we arrange our research differently around the processes of writing in a digital environment? As Kathleen Fitzpatrick suggests, for example: "What if we were freed—by a necessary change in the ways that we 'credit' ongoing and in-process work—to shift our attention away from publication as the moment of singularity in which a text transforms from nothing into something, and instead focus on the many important stages in our work's coming-into-being?"[52]

Rethinking this organization involves taking a critical look at the way versioning is currently set up on web-based research platforms and services (and is also increasingly being conceived in academic publishing—think of digital object identifiers, for example). This includes an investigation of revision management and control (including which revisions and author edits are archived), which can be seen as an essential aspect of versioning. In other words, not only does this encourage thinking about what constitutes a version, at what point and for what reason, it also solicits further reflection on the ways in which we deal with these versions and conceptualize versioning within academia. Consider the idea of the materiality of different versions, for example, which becomes important if we look at scholarship in particular: the way research is versioned is hardly neutral, and there remains a clear difference between a text published in a blog post and a text published as a printed article, even if the text or content remains exactly the same.[53] Furthermore, versioning in scholarly communication mainly seems to refer to the continuous updating of one single text, post, page, or topic (i.e., it assumes an original and a final version). What happens, though, if the updates and changes are ongoing and content is brought in from elsewhere; when texts are merged, remixed, and cut-up, abandoned, and taken up again; or are simultaneously published on a variety of platforms or in plural formats?[54] Even more, if these updates are ongoing and collaborative, is it really necessary to keep all the various versions? And for how long do we keep them? What is the use of revision control in highly collaborative environments and wikis? Could insisting on this be perceived as yet another sign of our fear of letting go of (certain forms of) stability and fixity? Version control could again lead to the reinstalling of print-based and humanist mechanisms when each version becomes a clearly

Introduction

recognizable fixed and stable unit with a single author and clear authority. Does this signify how versioning could become a new way of objectifying scholarship as part of its processual becoming, similar to current publishing business models based on selling various book formats, from hardcover to paperback and EPUB?[55] Can we in some way balance our need for both fixity and process? As *Living Books* argues, doing so will involve an in-depth exploration of when and at what points fixity is needed and for what reasons. In this respect, it is important that we are "thinking about how ideas move and develop from one form of writing to the next, and about the ways that those stages are represented, connected, preserved, and 'counted' within new digital modes of publishing," as Fitzpatrick has argued.[56]

Critical Praxis and Scholarly Poethics

Over the course of its development, the research for *Living Books* has been openly published in various versions or iterations itself. By positioning the book as a pivotal, yet struggled over, element shaping the future of knowledge production within the humanities, *Living Books* argues for the importance of experimenting with alternative ways of thinking about and performing the scholarly monograph. In particular, it argues for the importance of experiments that go beyond simply reproducing established practices of knowledge production, dissemination, and consumption. Therefore *Living Books* itself functions as an intervention and experiment; starting with the long-form argument that is the book itself, it actively critiques, in form, practice, and content, established print-based notions, politics, and practices within the humanities in a performative way. As such, its critical exploration into the materiality of the scholarly book and potential alternative futures for scholarly communication has included being openly published and versioned as part of its own emergence. Content has been (and will continue to be) made available by means of various social media, open archiving platforms, remixed and distributed multimodal and multiauthored publications, and interactive online versions—all interconnected in different ways. As part of its conduct and format, exploring and experimenting with (while at the same time remaining critical of) the possibilities of the digital medium, the way *Living Books* has been produced and distributed has become an integral part of its critical, interventionist, and performative stance. Making the research for this book available for reuse, comment, and interaction online as

it developed, in the form of blog posts, papers, articles, tweets, presentations, draft chapters, remixes, and various bound and printed as well as multimodal versions, was done with the specific intention of questioning and disturbing the existing scholarly publishing model—which is still focused on predominantly publishing the final outcomes of research, on proprietorial authorship, and on fixed text-objects.[57]

Following a methodology of what I have called elsewhere *critical praxis* and develop in this book further (in chapter 4) as part of the development of a *scholarly poethics*, *Living Books* has been envisioned as an experiment in making affirmative incisions into the book apparatus.[58] As I argue, engaging in a methodology of critical praxis can prevent the simplistic repetition of established practices without analyzing critically the assumptions on which they are based. *Critical praxis* then refers to the awareness of and the reflection on how our ideas and ideologies become embodied in our practices, making it possible to start to transform them. What this book tries to challenge is how certain structures and practices underlying knowledge production determine what counts as legitimate knowledge, while at the same time (re)producing a specific kind of subject position or social identity—namely, that of the academic scholar. Hence developing critical praxis can be seen as a method to critically analyze the dominant sociocultural conditions and relationships that constitute academia, as well as our own subject positions within the same.[59]

Experimenting with new practices to produce and distribute theory can serve as a direct critique of the material conditions under which humanities research is being produced. Cultural studies has been at the forefront here, exploring its own interventionist potential as a field, which, beyond a set of institutional practices, we can understand—with Ted Striphas—as a set of critical "writing practices."[60] Scrutinizing the way these practices are currently set up and function underlines both systemic power relations at play and our own responsibilities in either repeating these practices or, alternatively, choosing different options. Having better access to the instruments of the production of cultural studies (i.e., the publishing system) and to the content that gets produced includes exploring and also taking control of "the conditions under which scholarship in cultural studies can—and increasingly cannot—circulate."[61] Emphasizing our roles as scholars *within* this system would be an example of critical praxis in action, exploring how we can, as Striphas puts it, "contemplate anew what we may want out of

Introduction

it, and as appropriate to reengineer the publishing system so as to better suit our needs."[62] Yet beyond our practices and institutions, the (dominant) discourses relating to knowledge production similarly have strong subjectification effects, which contribute to what Alan O'Shea has called our "tendencies towards self-reproduction," the effects of which are not pregiven but outcomes of specific struggles.[63] As O'Shea points out, "the practices in which we engage constitute us as particular kinds of subjects and exclude other kinds. The more routinised our practices, the more powerfully this closure works."[64]

To maintain the position of the interventionist potential of the processual book, I do not theorize this closure imposed by the dominant discourses within academia and the subjectification effects they have in an "overemphasized way," as O'Shea puts it. Rather, I draw on Foucault's later work, in which he advances the ways in which subjects develop agency within constraining and subordinating systems. Subjects reproduce (hegemonic) power in a positive, productive way (e.g., by reproducing the liberal humanist author as part of our publishing practices); however, they also have the ability to modify power in a different, creative way, through reflexive technologies of the self that resist power's normalizing effects.[65] If we envision critical praxis as both a critical method and a creative, transforming, and transformative one, part of this creative impulse then lies in the potential to, as Striphas puts it, "perform scholarly communication differently—that is, without simply succumbing, in Judith Butler's words, to 'the compulsion to repeat.'"[66] The (print-based and humanist) norms of scholarly communication that we perform today (and reproduce in a digital environment) through a routine set of practices were forged under historically specific circumstances, Striphas emphasizes—circumstances that might not apply in their entirety today. This triggers us to ask new questions about these practices and to start performing them more creatively and expansively (expanding our repertoire) than we currently do.[67]

It is important to stress however, as cultural and media theorist Gary Hall has argued extensively, that in our experiments with the digital, our ethics and politics should not be fixed from the start.[68] We need to leave room to explore our ethics and politics *as part of* our experiments, as part of the process of conducting our research and of producing living books. Critical praxis not only serves to critique established notions of how to write a book within the humanities, to provide just one example. As an affirmative

practice, it also has the potential to develop new (digital) research practices and to experiment with new forms of politics and ethics as part of that—including, in this specific case, practices that experiment with sharing, versioning, and reuse, as well as simultaneously remaining critical of these methods.

Chapter 4 extends this idea with respect to a scholarly poethics. It outlines how, next to having discussions about the contents, theories, or methods that make up and structure our scholarship, developing a scholarly poethics would include having in-depth deliberations about the way we *do* research, about the ways in which we perform and communicate it, which in this context involves paying more attention to how we craft our own research aesthetics and poetics as scholars, exploring the forms and material incarnations (as well as the specific relationalities of publishing these would embody) that would best suit our contingent scholarship. Taking its inspiration from earlier explorations of the aesthetics and poetics of the book in art, poetry, new media, and electronic literature, *Living Books* encourages the uptake of the experimental ethos and practices that have driven material explorations in these fields in an academic research and publishing context. *Living Books* can therefore be seen as an experiment in developing a scholarly poethics as part of its digital, open research practice.

Publishing versions of this research on different platforms, and then remixing and gathering these dispersed versions together in various other forms and outputs—of which this book is one—raises, as mentioned previously, questions about the bound and objectified nature of the book and of scholarly research more in general. This practice—not uncommon in (digital) humanities scholarship—relates to the production of what Marjorie Perloff has called *differential texts*, which she defines as "texts that exist in different material forms, with no single version being the definitive one."[69] In this specific case, *Living Books'* differential method has been designed to draw attention to the processual and collaborative nature of this research in its various settings and through its multiple institutions of informal and formal communication, from social media and conferences to mailing lists and journals. Instead of being just a single, linear, long-form argument, *Living Books* has been designed in such a way that the majority of its multiple distributed versions can be traversed, read, rewritten, and reperformed in manifold ways. The different forms and shapes the previous versions of this book and their (multiple) arguments have taken on, framed and embedded

Introduction

as they are within other debates, shows the reusability and remixability of the different strands of this argument in different contexts, highlighting how the specific manner and order in which this argument is narrated within this book is not the only way in which it can (possibly) unfold.

My choices for the specific versions outlined previously have further been based on an intention to explore those platforms, technologies, and pieces of software that favor experimentation, openness, interaction, multimodality, and interdisciplinarity, as these are the features of scholarly communication that I wanted to highlight and examine in this book. To what extent can these features, in combination with the various material incarnations of this book, help reimagine the bounded nature of the monograph? How do these versions differ from each other, and how are they shaped by the specific material affordances of the software, platforms, and media that support them, in intra-action with our scholarly practices and the structuring discourses and institutions surrounding these?

Versioning has also served as a method to highlight how problematic it is to connect the idea of (myself as) the individual humanist author to the monograph more in general and to this book in specific, as many of the texts from which *Living Books* has emerged have been coauthored, commented upon, reviewed, and/or annotated in various settings by different (groups of) people and are thus necessarily the results of (reworkings of) inherently collaborative work. This is of particular importance when we take into account that a monograph is commonly thought to consist of all original work written by the book's proprietorial author.[70] *Living Books* has wanted to instead focus on the processual and collaborative nature of this research in development, to provide credit to the various people and groups (but also the various posthuman agencies) that have been contributors to this research; who have shaped it, enabled it, commented upon it, critiqued it, adapted it, or shared it, among others. With this, *Living Books* simultaneously calls into question the nature of agency, as presumed to be attached to and localized within individual human authors or material (book) objects.

Living Books is therefore also accompanied by an extensive *endnotes section*, in which I further elaborate some of the ideas and concepts developed in this book, connect to and acknowledge existing literature, and highlight specific developments. My choice to use explanatory endnotes in this extended way is partly because endnotes and footnotes are one of the more

established ways in which linear narratives can be broken down within print publishing, highlighting its networked and hypertextual capabilities. But more importantly, it allows me to relate to and establish relationships with the communities of scholars, practitioners, and activists this research is connected with and indebted to, to emphasize the significance of their contributions to the development of this research and the ideas it is based upon. It highlights how this research is always already collaborative and in progress.

In this sense, echoing what Karen Barad outlines in her introduction to *Meeting the Universe Halfway*, *Living Books* is the outcome of an ongoing entanglement of agencies: "Friends, colleagues, students, and family members, multiple academic institutions, departments, and disciplines, the forests, streams, and beaches of the eastern and western coasts, the awesome peace and clarity of early morning hours, and much more were a part of what helped constitute both this 'book'; and its 'author.'"[71]

A Nonfinal Version

Yet it is impossible to ignore how this book has also, as one of its main iterations, been published as a conventionally bound, printed book. Monographs remain the customary requirement (especially with first books) toward acquiring tenure and permanent positions within humanities fields—and this book in particular needs to fulfill the requirements of the UK's Research Excellence Framework (REF).[72] This formally published version is perceived to be a single-authored written piece of original work in long format, narrating a linear argument, bound and made available both in print and digitally (as a PDF). This will most likely be regarded as the final or original version, or the version of record. However, as I have wanted to point out by versioning this book in the ways I outlined earlier, this "bound" version is not necessarily the most important, interesting, or valuable version of the book, nor is it necessarily the "final" version. Not only are the different versions of this book connected to each other, they are also connected to the other works they reference. The intention behind *Living Books* has always been to create different instantiations of the book's argument, existing on distinct yet connected platforms, to experiment with what these different forms and formats can bring to the argument, its reception and interaction, how they change it and form it. These iterations then function as nodes in

Introduction

a multiformat, interlinked, distributed network of texts, notes, drafts, references, and remixes, wherein no part is necessarily more or less important than the other parts, nor will one text form the end point or final version of the book project. Yet, and this is what *Living Books* wants to critically reflect upon, certain versions do become more important due to the value and importance awarded to them within our scholarly communication and reputation systems.

A further reason I am therefore focusing on a variety of versions as part of this book, from blog posts to interactive versions, wiki versions, and multimodal remixed versions—all types of publishing that are currently being experimented with within humanities publishing and communication—is to challenge the continued emphasis on the end result of our research as being the most valuable, to stress that different cuts are possible in the publishing process—cuts that perform various functions for the scholar, the research, and the platforms that carry them (i.e., registration, collaboration, feedback, annotation, reuse, critique). Experiments in recutting, versioning, and remixing research materials are one potential means to extend our notions of the book and to gather our research together and re-envision it in alternative ways, exploring what other kinds of publishing are possible. Gary Hall has made this clear with respect to the new strategy for academic writing and publishing that he himself and others are critically and creatively experimenting with at the moment—in particular, through his openly produced series of performative media projects or "media gifts" (cut down in one of its iterations as a book, *Pirate Philosophy*): "The book version should not be positioned as providing the overarching, final, definitive, most systematic, significant, or authentic version of any material that also appears in other iterations, forms, and places; nor should it be taken as designating a special or privileged means of understanding the media projects with which it is concerned. It is, rather, one knot or nodal point in this meshwork, one possible means of access to or engagement with it."[73]

Living Books has been published in open access with a license that allows further derivatives (i.e., versioning, reuse, and remix). The MIT Press has been experimenting with a variety of models over the years to raise and secure funds to publish its books in open access.[74] In 2019 MIT Press Direct was launched, the Press's own dedicated platform for ebook distribution to libraries, and in 2021 the MIT Press announced the launch of Direct to Open (D2O)—a consortial funding model—a collaborative, library-supported

model to enable the publication of open access books. Starting in 2022 all new MIT Press monographs and edited collections will be openly available on MIT Press Direct, funded through the participation fees of supporting partner libraries (in exchange for access to the Press's back catalog).[75]

These kinds of membership models to support open access publishing are a promising alternative to the model increasingly used to support open access for books—namely, book processing charges (BPCs). This so-called author-pays model, which has proved increasingly popular among commercial presses and university presses, puts in additional monetary barriers for humanities scholars (and their institutions) willing to publish open access. This makes it especially hard for publications that have developed without external funding connected to them or which have developed out of postgraduate or early career research (as *Living Books* has) to be published openly. It also introduces additional competition for already scarce funding into the humanities fields—next to creating further global inequity with respect to who gets to publish. Beyond questions of whether a BPC-based open access model is necessary to recover costs (with most BPC models, the processing charge seems to be based on the perceived loss of print sales when a book is available in open access, when it is not necessarily the case that there will be a loss of sales), the question remains whether academics or universities paying for these kinds of high BPCs to cover the costs for making a book openly accessible is the right decision to make (always and in all cases).[76] For example, in the context of commercial publishing, BPCs take away any risk for the publisher and hence become nothing more than glorified subsidies for a commercial system.[77] In addition to BPCs covering publishing costs, publishers can still make additional profits through the sales of printed books and freemium services on top of a free open access edition—a practice more commonly known as *double-dipping*.[78] This question, whether to pay a BPC to publish a book in open access, is especially problematic in cases in which, as with *Living Books*, its various earlier versions were already available in open access before it was formally published as a scholarly monograph. In addition to that, not (formally) publishing a book in open access does not necessarily mean it will not be openly available.[79]

My focus in *Living Books* is, however, less on thinking about open access as something that only applies to the *products* or *outcomes* of publishing, to published books and articles, but instead, in the spirit of open notebook science, as something that applies to the various different ways in which we can share our research openly as it develops, on "developing a (pre- and

Introduction 33

post-) publishing economy characterized by a multiplicity of different, and at times conflicting, models and modes of creating, binding, collecting, archiving, storing, searching, reading, and interacting with academic research and publications."[80] Even more, for this particular bound and fixed book or (online) PDF version, it being published in open access is arguably less important than for those versions (e.g., the CommentPress version or the wiki version) that are designed to promote and directly solicit open interaction with the arguments presented in this book. Most of the more experimental aspects (both conceptually and design-wise) of this research have been developed as part of previous versions, mainly due to the fact that most presses currently do not have the means, skills, and expertise (or willingness, given the perceived lack of revenue from these kinds of experiments) to support experimental, multimodal, and processual forms of publishing. However, the way the current attention system and politics of valuation in academia is set up is that these kinds of more experimental iterations (which, when not formally published by a journal or publisher— although often community-reviewed—are seen as informal or gray publications) are most often only interacted with by specialized communities, and it is still through the medium of a closed access book published by a reputable publisher that a wider and different public are made aware of this research.

In this context, the choice for the MIT Press, and for the Leonardo book series in particular, has been a deliberate one, given the forerunner position the MIT Press has always taken in the realm of experimental and open access publishing.[81] As outlined previously, *Living Books* has from its first instantiation attempted to rethink, reimagine, and reperform the scholarly book and a scholarly communication system that continues to prefer clear-cut, bound, and fixed objects to emerge from our research; a preference based on a print paradigm and the structures and practices that have grown up around this. It explores the different cuts or incisions possible in our scholarship, ones that are potentially more ethical and that highlight the processual, iterative, collaborative, and distributed nature of scholarship. In this respect, its aims are aligned with those of the Leonardo community: to promote critical explorations of established material forms and media histories and to draw connections between fields and disciplines across art, scholarship, and technology. With its focus on new media, media poetics, and media performativity; its uptake of new intellectual paradigms (such as media archaeology); its attention to the genealogy and materiality of media

and technology; but most of all its focus on activism, experimentation, ethics, and change across these fields and topics, the Leonardo journal and book series has been an important inspiration for what this book tries to argue and achieve, and it constitutes a valuable context and community for its ideas to be taken up and to be developed further.

To cut down and gather this processual research in a bound book format published by the MIT Press has therefore been a specific choice, though not one that should be perceived as an endpoint but rather as a cleaving, a gathering together of some of its earlier iterations. This experiment in versioning *Living Books*—which is ongoing—is intended to raise awareness of the specific incisions that we make when we publish research (and the ones that are made for us) and to explore whether we can potentially make different, more informed and meaningful intermissions in our research, at different stages during its development. How can we make critical cuts in our scholarship while at the same time promoting a politics of the book that is open and responsible to change, to difference, and to that which is excluded? When and why do we declare a work done? When do we declare ourselves authors? And how do we establish our connections with others in this respect? These remain intrinsically ethical questions, especially when we perceive ethics not as something that is external to us, established from the outside by preestablished norms and principles, but as something that is always already present in our practices and institutions and performed through them.[82] Experimenting critically with the materiality of the scholarly book, with its accompanying "aesthetics of bookishness," and with the way our system of scholarly communication currently operates is, as *Living Books* argues, a meaningful step toward such a continuous ethical engagement.[83]

One could argue that the coming of a new medium offers us a gap, a moment within which—through our explorations of the new medium—dominant structures and practices become visible and we become aware of them more clearly. The discourse, institutions, and practices that have come to surround our printed forms of communication and that we have grown accustomed to have not only fortified certain politics and ethics that we need to remain critical toward; these politics and ethics are also being transported into the digital, where our practices and institutions are being reproduced online.[84] To enable us to remain critical of the power structures and relations that shape knowledge, I argue throughout *Living Books*

Introduction 35

for the importance of experimentation with different forms of knowledge production during and as part of the research process. Doing so presents an opportunity to rethink and analyze critically certain traditional skills and research practices that have become normalized or have become the dominant standard—both within humanities research and within the process of writing and producing a humanities publication—and, where needed, to start performing them differently.

Forms and Forces of (Un)binding

To explore the potential of the book to embody and perform alternative scholarly practices and new institutional and aesthetic forms, *Living Books* first examines the ways in which the scholarly book has been bound together and fixed in the course of its development. To do this, chapter 1 starts with an in-depth analysis of the book-historical discourse and the divisions it embodies, which continue to influence and structure the book's material formation. To explore the reasoning behind the positions adopted within the book historical discourse, the influential debate in the *American Historical Review* between Elisabeth Eisenstein and Adrian Johns, two of book history's key figures, is analyzed critically. This debate illustrates some of the important oppositions (e.g., book vs. society, evolution vs. revolution, media vs. human agency) that continue to overshadow the on some occasions highly agonistic wider discourse. To trace back this continued oppositional thinking, chapter 1 explores book history's disciplinary genealogy—as initially an amalgam of literary studies and historiography (new historicism)—and puts forward an alternative performative vision of the history of the book, one that endeavors to go beyond some of the earlier identified dichotomies. Based on a reading of Haraway, Barad, and new materialist (media) theories, it focuses on the entanglement of plural agencies (i.e., technological *and* cultural, human *and* nonhuman, discursive *and* material) as part of the processual becoming of the apparatus of the book.

Chapter 1 thus provides the groundwork toward exploring, in the next three chapters, how various agencies enforced *forms of binding* on the book while drawing attention to the ways in which these disciplining regimes are currently being reiterated in a digital context. Three forms of binding in particular—representing some of the highly contentious practices and concepts that have come to define the book—make up the framework applied

in this book. They are *authorship*, the *book as commodity* within systems of knowledge production, and the perceived *fixity or stability* of the book as an inherently bound material and aesthetic object.

These three interconnected examples of material-discursive *book formations* have been envisioned within and developed throughout the book-historical discourse as part of a struggle to define the scholarly book's past and future and have been important in promoting and advancing the book's print-based features. To explore critically the material changes the monograph has experienced, *Living Books* looks at these book formations in depth throughout chapters 2–5, which together constitute the main body of this book. These three material-discursive practices and formations will be read transversally through the reframed discourse on book history proposed in chapter 1. Hence each subsequent chapter starts with an introduction that explores the respective book formation from a historical perspective.

Parallel to these examples of book formation or forms of binding—which have been fundamental to the way print-based features and practices were commodified and essentialized—*Living Books*, importantly, also looks at alternative ways to both think and perform the book, highlighting various forms of *unbinding* that are being examined in digital environments at the moment. What forms might a politics of the book based on unbinding take in this respect? Three practices and/or concepts of unbinding are analyzed in particular in *Living Books*—while emphasizing that both these triads of book formation and unbinding represent what can be perceived as *essentializing aspects* of the print and digital medium—namely, (radical) openness, liquidity, and remix, with an overarching focus on experimentation. These key terms are explored throughout this book in order to critique and examine the main forms of humanist and print-based binding that, I argue, have worked to turn the book into a fixed and stable object of scholarly communication. *Openness* can be understood as a disruptive force with respect to existing models in academic publishing, whereby open forms of book publishing enable public sharing of scholarly research, which (in certain models) forms a potential threat to the commodification of scholarship. *Liquidity* is perceived to put the supposed fixity and stability of scholarly communication at risk, through experiments with the versioning, linking, and updating of scholarly publications, for example. Finally, *remix* can be regarded as a critique of originality and individual authorship, simultaneously exploring the interconnectedness and networked relationships of scholarly texts.

However, the concepts of openness, remix, and liquidity, together with some of their current implementations, are also scrutinized in this book, where both the potential and the shortcomings of the various experiments that are currently being conducted along the lines of these three practices and concepts are critically analyzed. Yet even though these forms of unbinding also still tend to adhere to many of the previously mentioned humanist and essentialist aspects of the book, *Living Books* highlights the ongoing potential for experimentation that these forms of knowledge expression also embody, emphasizing their potential as forms and practices of critique and resistance to the object formation of the book. To explore this potential, *Living Books* looks at experiments in scholarly book publishing with new forms of anonymous collaborative authorship, radical open access publishing, and processual, living, and remixed publications, among others. It shows how by cutting the book together and apart differently and by exploring experimentation as a specific discourse and practice of critique, these publishing ventures have the ability to challenge and rethink both the book as a fixed and stable commercial object and the political economy and practices surrounding our systems of scholarly communication.

Chapter 2 explores the first book formation, *academic authorship*, a specific scholarly practice that is intrinsically connected to the scholarly book and which binds it together through the notion of the work. This chapter examines authorship from a historical, theoretical, and practical perspective and analyses the role humanist authorship has played and continues to play within scholarly communication. It does so by exploring the different ways in which authorship functions within academic networks and how authorial roles have historically been formed through our publication practices. An analysis of several recent experiments with both authorship critique (hypertext, remix, collaboration) and antiauthorship practices (plagiarism, anonymous authorship) leads to an exploration of the potential for a posthumanist critique of authorship and, as an extension of this, possible forms of posthumanist authorship. Chapter 2 ends by proposing to expand and critique the author function to take into regard alternative, potentially more ethical notions of authority and responsibility, based on distributed forms of both human and nonhuman agency.

Chapters 3 and 4 examine scholarly publishing as a specific material formation accountable for the *commodification of the book object*—among other means, through the formal publication of scholarly materials. Chapter 3

explores the narratives that have surrounded the material production and commodification of the book object in publishing and academia, looking at ways to reframe this discourse at specific points. It does so, for example, by challenging the perceived opposing logics structuring publishing and academia—one seen to operate via an economic logic and the other via a cultural logic—highlighting how the commercialization and globalization of scholarly publishing is directly related to the neoliberal marketization of the university. It further reframes this discourse by providing an alternative genealogy of openness, analyzing some of the different values and politics that have underlain the uptake of open access in different settings, countering the idea that open access and neoliberalism are intrinsically connected.

Chapter 4 continues by looking at potential opportunities to more directly intervene in the current cultures of knowledge production, both in the system of material production surrounding the book and in our own scholarly practices related to the book as commodity. It focuses in particular on examples of book publishing projects that have explored strategies of radical open access, experimentation, and care as forms of intervention and critique. Based on a reading of works in feminist poetics of responsibility and theories related to mattering and the ethics of care, this chapter showcases how various academic-led publishing endeavors are currently moving away from a predominant focus on the outcomes of publishing, instead drawing attention to the relationalities of publishing. Based on this reading of current practices and theories of care, ethics, and relationality in scholarly publishing, this chapter concludes with a plea for the development of a scholarly poethics.

Finally, chapter 5 takes an in-depth look at what is perceived to be one of the codex format's specific material attributes—namely, *fixity*—and the forces of binding created and imposed upon this format. Here the printed book has been fixed down by being bound in a physical and material sense, but also by creating stability and fixity over time due to printing technologies that promoted the easy duplication of copies—and with that the durability of print as a preservation strategy—and due to practices and discourses (e.g., copyright, authorship) that gathered the contents of a work together. Issues of stability and process are explored in more depth by looking at the concept of *the cut* as theorized in new materialism, continental philosophy, and remix studies. Here the question of stability is examined from a different angle, asking, from a perspective of cutting and iterative boundary-making, *why* it is that we cut and bind our research together.

Alongside this, a number of recent digital experiments focused on more processual forms of scholarly research are examined, most notably in the form of fluid, remixed, and modular books, remixed authorship, and digital archives. As part of this, two book publishing projects are explored—Living Books About Life and *remixthebook*—which experiment with remix and reuse and try to rethink and reperform the book apparatus by specifically taking responsibility for the cuts they make in an effort to cut well.

The chapters in this book are intrinsically connected as part of a connected line of argumentation—and many different transversal relations exist between them—yet they have been written in such a way that they are not dependent upon one another for understanding their argument. Care has been taken to make each chapter—at the expense of some (sometimes intentional) repetition—into something that can in principle be read independently.

In the lead-up to the four chapters that discuss the previously mentioned forms of binding, chapter 1 first embarks on the process of analyzing the book historical debate as it has developed over the last few decades.

1 Toward a Diffractive Genealogy of Book History

> How can science studies scholars take seriously the constitutively militarized practice of technoscience and not replicate in our own practice, including the material-semiotic flesh of our language, the worlds we analyze?
> —Donna Haraway, "A Game of Cat's Cradle"[1]

Although the book as idea and form has played a seminal role within our culture, book history as a separate subject or discipline of study was not established until the 1950s and 1960s.[2] While the nineteenth century saw the rise of the study of the book as a material object as part of the development of analytical bibliography, book history as a discipline involving the study of print *culture* draws heavily on the methodology of the French Annales school of historiography. It was here—and in specific, in Lucien Febvre and Henri-Jean Martin's *L'Apparition du livre* (*The Coming of the Book*; 1958)—that a strand of book history (*histoire du livre*) developed that focused more on the role played by books in social and cultural contexts. Around the same time that book history started to develop as a field, some of the first experiments with electronic books and with digital textual transmission were taking place. Michael Hart, the founder of Project Gutenberg (an online e-book database), is often credited for "inventing" the e-book in 1971.[3] However, experiments with e-books and hypertexts were already taking place in the 1960s—if not earlier—with Alan Kay's *Dynabook*, which he described as "a portable interactive personal computer, as accessible as a book."[4] In this sense, even though book history is only a relatively young discipline, its object of study has already seen some remarkable material changes since it was established. The field itself has developed rapidly too: the rise of book historical titles over the last few decades has been considerable, which can

be connected to the increasingly interdisciplinary character of book studies, examining the book in all its past, present, and future forms. Where it was initially an amalgam of history, bibliography, and literary studies, book history today draws its inspiration from a wide range of disciplines and methods, from media and communication studies to even newer fields such as the digital humanities, media archaeology, and software studies.[5]

Its wide and ever-expanding scope notwithstanding, I want to focus in this chapter on some of the most characteristic features to have structured the discourse of book history. As such, this discourse is not discussed in its entire diversity here; instead, some of its key aspects and leading participants are examined to show how and in what way these have been decisive in influencing and shaping the book historical field and, with that, the future of the book. In addition, some of the *oppositions* are highlighted that continue to dominate this often highly agonistic discourse, which have equally influenced and structured the book as a material and aesthetic object, as well as the practices that accompany it. Doing so implies exploring under what circumstances this discourse emerged and what it has focused on: What have been its topics of contestation and which oppositions does it (continue to) embody?

In the analysis of this discourse, attention is mainly given to those histories that describe the transition from manuscript to print (and to a lesser extent, from orality to literacy) and which, in doing so, follow the printed book's further development until the end of the nineteenth century. Having this historical cutoff point serves to bracket this introductory chapter with its more historical overview from the remaining chapters of this book, which focus more directly on the current shift from print to digital and on the more recent history and development of the scholarly book in particular. Yet this cutoff point is also meant to emphasize the importance of this specific cluster of print-culture-focused historical studies—and of the specific theorists and historians it incorporates—for book history as a field. Furthermore, it is intended to highlight the continuing influence of these studies on the *structure* of the discourse that surrounds the future of the book and recent histories of e-books and digital textual transmission.

When sketching this general framework to capture the debate as it has progressed and is still progressing, it is important to acknowledge that it takes place on three levels simultaneously and transversally. The discourse occurs on the level of historical reality (primary sources), on that of history writing (secondary sources), and on a third, metahistorical level of writing

Toward a Diffractive Genealogy of Book History

about history-writing (historiography, or, what is book history?). An analysis of the book historical debate should take all three levels of description into account, focusing specifically on the reasoning, the politics and power struggles, and the value systems that lie behind the choices made for a particular perspective.

I want to specifically highlight as part of this analysis that a rethinking of our book historical past has a direct influence on—and reflects how we envision—the future of the book. In other words, the way the past of the book is perceived by a specific thinker or group of thinkers not only casts a light on how they perceive what the present and future of the book could or should be, or which issues will be most important in determining its future; it *also* influences directly, materially and aesthetically, both the object of the book and the discursive practices accompanying it (and with that, it directly influences scholarly communication in the case of the monograph). For example, if we stress that fixity is an inherent property of the printed book and thus something that has partly come to define and stand at the basis of modern science and scholarship, this can have the effect of positioning this property as essential for the future of the book and digital scholarship. This way of thinking comes to the fore in efforts directed toward recreating the fixity and stability associated with print text within a digital book format (i.e., the continuing search for ways to stabilize the book and keep its integrity intact online via DOIs, persistent identifiers, DRM and copyright, author IDs [ORCID IDs], etc., but also aesthetically via book covers, pages, and page numbers, all aspects that mimic the bound and stable printed book online).[6]

To explore what lies behind the continued emphasis on oppositional thinking within the book historical discourse, this chapter subsequently takes a closer look at book history's disciplinary history and the developments literary studies and historiography (in particular new historicism) went through during the rise of book history as a specific disciplinary niche. Following this analysis of the book historical discourse, the oppositions it engenders, and its disciplinary genealogy, an alternative vision for the history of the book is proposed: one that endeavors to go beyond some of the oppositions that continue to structure the debate on the book's history and that can be seen to function as "false divisions."[7] Instead, the *entanglement* of plural agencies (i.e., technological and cultural, human and nonhuman, discursive and material) as part of the processual becoming of the book is emphasized here. As I will explain, these entanglements get cut up as part of the discursive position-taking that surrounds the history of the book.

The oppositions within the book historical discourse function here as forms of ethical position-taking then, as struggles to try to define (the identity of) the book and with that the future shape of academia. For the discourse on the book's history—and this is especially the case with respect to the scholarly monograph—not only encompasses a fierce debate about how to represent and historicize the past of the (scholarly) book but also can be seen as a struggle to determine its future. To reimagine and perform the future of the book differently, an alternative vision of the history of the book is therefore put forward, one that endeavors to go beyond some of the earlier identified dichotomies in an effort to reframe them, asking how we can "write" an alternative, *diffractive* genealogy of the book.

Topics and Dichotomies

Although the book historical field has been described as "scattered in approach" and "so crowded with ancillary disciplines that one can no longer see its general contours," there are a few major focal points within the debate on book history that can be discerned.[8] Although it is by now quite dated (especially with respect to the practicalities of digital scholarly communication and book production), Robert Darnton's highly influential publishing communication chain remains a useful model to capture the various aspects of the book's production, dissemination, and consumption that the book-historical discourse has focused on.[9] First presented in an article for *Daedalus* in 1982, Darnton's communication circuit proposes a general model for analyzing the way books come into being and spread through society. At the same time, Darnton uses this circuit or chain to make sense of and disentangle the sprawling field of studies in book history. Despite the fact that various attempts at improved versions to Darnton's circuit have surfaced in the decennia after it was first designed, and even though this model is based on the lifecycle of the *printed* book, one can argue that it still forms an important element in the discourse on the history of the book as it stretches into the digital domain, if only as a system with which to compare and contrast. For example, take those theorists who foreground the disintermediation of functions in the digital production cycle of the book. Often a reference is made to Darnton's communication circuit (see figure 1.1)—or a more abstracted version of the *publishing value chain*—to emphasize which of

Toward a Diffractive Genealogy of Book History

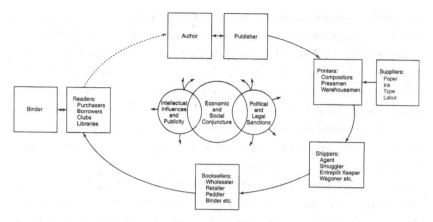

Figure 1.1
Robert Darnton's communication circuit

the traditional publishing or communication functions are becoming obsolete or have been taken over by one and the same person, company, or institution in "the digital age."[10]

The communication chain focuses on the roles played by authors, publishers, printers, distributors, booksellers, and readers in the production, dissemination, and consumption of the printed book. Readers become authors themselves again—hence the circle—something that is even more apparent within scholarly communication. In addition, the communication chain emphasizes the social, political, and economic influences on these agents within the process of value production. Book historians mostly focus on one part of this process as part of specific specializations, but for Darnton it is essential that "the parts do not take on their full significance unless they are related to the whole"; for him, "book history concerns each phase of this process and the process as a whole, in all its variations over space and time and in all its relations with other systems, economic, social, political, and cultural, in the surrounding environment."[11] One important omission in Darnton's circuit is the book itself, an exclusion already remarked upon by Adams and Barker in their revised communication circuit.[12] As they point out, Darnton's model focuses too much on a social history of communication. The book itself in its material manifestations and its influence on the book historical discourse and hence on society and culture (instead of only the other way around) is not admitted as a form of agency, nor as

an agential relation in this model. The importance of including the book as a form of agency within a network of agents is similarly emphasized by book historian Paul Duguid, who argues that books are not simply passive "dead things" but should instead be seen as crucial agentic forces within the publishing value chain, a social system that books produce and at the same time are produced by.[13]

Applying these criticisms and expansions to the model in consideration, I want to use this updated communication chain to identify some of the main book historical topics or subfields.[14] First, there are studies that look at the book as an individual, material object. Here the focus lies predominantly on the technical analysis of the materiality of the book, on the importance or influence of format (i.e., bibliography or studies on paratexts), or on the kinds of uses a specific text or artifact triggers or demands. New Bibliographical studies that aim to establish authoritative texts and correct textual meaning would fall into this category, as would studies that take the book in a more abstracted form as their starting point by focusing on the agency of the book—and of print and print culture—and its influence on culture and society.[15]

Second, there is the research that focuses on the production of the book and the political economy surrounding the book value chain, which includes publishing, distribution, and sales. This subfield covers studies that analyze the whole system (as Darnton proposed) of material book production and culture and the various agents that play a role in it (also see the work of John Thompson in this respect); more materialist traditions, such as the Annales school or what has come to be known as the French histoire du livre; and, finally, D. F. McKenzie's extension and reorientation of (new) bibliography to include the sociology of texts by looking at the specific conditions under which books were produced.[16]

Third, there is the research that focuses on authorship. This includes studies that research authorial intention in an attempt to come closer to the "true" meaning of a text or that concentrate on the changing role of the author in the value chain—including the changing author function; but it also includes research that focuses on the development of (authorial) ownership or copyright of texts, for example.[17]

Finally, we can identify research that looks at readership, including the history of reading and the role of the reader, and at the historical uses and reception of books (i.e., reception history).[18]

Toward a Diffractive Genealogy of Book History

Alongside these general topics that can be seen to frame the debate on book history (and let me emphasize that this is not an all-inclusive list), it is important to outline and analyze some of the binary oppositions that have come to structure it, as they continue to influence and structure the discourse on book history in the present. A few of the most characteristic oppositions have been put forward by two of the field's key players, book historians Elizabeth Eisenstein and Adrian Johns, both in their separate works and in a highly polarized debate published in the *American Historical Review* in 2002.[19] This debate between Johns and Eisenstein is an interesting backdrop against which to describe and analyze the overall dichotomies within the book historical discourse, as the arguments both historians have brought forward for their specific position-taking provide a helpful illustration of the main oppositions that continue to structure it. Although the various position-takings on the history of the book overlap and interact, Eisenstein's work can be seen as representing the materialist-inspired Anglo-American stream of book studies, whereas Johns's work draws heavily on the history of the European continental tradition of social-economic and cultural-historical research in the wake of the Annales school.

Elizabeth Eisenstein is well-known for her seminal work, *The Printing Press as an Agent of Change* (1979). She was influenced by, while also critical of, the vision put forward by communication theorist Marshall McLuhan, who, in *The Gutenberg Galaxy* (1962), offered an interpretation that sees the technology of the printed book as having a direct influence on our consciousness and on society. Eisenstein argued for the importance of reevaluating what she calls the *unacknowledged revolution* that took place after the invention of print. She did so by exploring the consequences of the fifteenth-century shift in communications, focusing on how printing altered written communications within the *commonwealth of learning* (an early modern metaphor for what we now commonly conceive of as the public sphere). In this respect, Eisenstein didn't look at book history specifically but at the effects of *print culture* on modern society. In other words, she studied how changes affecting the transmission of records—altering the way data was collected, stored, and retrieved and how it restructured scholarly communication networks throughout Europe—might have influenced historical consciousness over an extended period of time. As such, in *The Printing Press as an Agent of Change*, Eisenstein is interested predominantly in exploring the

sociocultural impact of both print and publishing on the advancement of science and on the evolution of the thought of both humanist and reformation thinkers.

In contrast to Eisenstein, Adrian Johns—who has proved to be one of her biggest opponents—stressed that it was human, not medial, factors that were at the basis of the changes that led toward increased standardization and stability in the early modern period. As Johns states in *The Nature of the Book* (1998), what are often seen or regarded as essential elements and features of print are in fact more contingent, transitive entities. The self-evident environment created by print culture encourages us to ascribe certain characteristics to print and to a technological order of reality. However, the most common conviction, that of print being fixed, stable, identical, and reliable, is false, Johns argues, and stands in the way of a truly historical understanding of print. As Johns makes clear, the cultural and the social should be at the center of our attention.[20] Accordingly, he argues that both print and science are not universal and absolute but constructions that need to be maintained.

In their debate in the *American Historical Review*, Johns and Eisenstein further detailed their respective book historical visions.[21] As part of this debate, Eisenstein provides a comprehensive overview of their main theoretical differences, to which Johns subsequently responds. The first opposition or discursive struggle that deserves to be highlighted from this exchange is related to the *intrinsic properties of print*. According to Eisenstein, Johns denies that technology or the printing press has any intrinsic powers or agency, whereas for her the press affected significant historical developments. For example, where Eisenstein (along with Walter Ong and Marshall McLuhan) focuses on the establishment of fixity and standardization as effects of print technology, Johns states that they are the outcome of social constructions and practices. He points out that fixity is not an inherent property or quality of print but that it is transitive, acted upon and recognized by people, where Eisenstein argues that the circumstances that determined print culture can be attributed to print. For Johns, then, a book is the material embodiment of a consensus or of a collective consent, and therefore he argues that the development of a print culture was not as direct and straightforward as Eisenstein would have it, but was marked by uncertainty and a shaky integration. This disagreement illustrates a larger division visible in the book historical literature between technological determinism and cultural constructionism, or between gradations of both forms. Here the focus is on the

Toward a Diffractive Genealogy of Book History

attribution of historical agency: Does agency lie with impersonal processes (triggered by innovations in communication technology, i.e., media or book agency), or with personal agents and collective practices (i.e., human agency)? In other words, is print a result or a cause of culture?[22]

According to Eisenstein—writing in the 1970s—up to then there had been a paucity of studies looking at the consequences of the introduction of the print trade in Europe, and a lack of explicit theorization around what these consequences had been.[23] Eisenstein's moderate form of technological determinism can thus be seen as a revisionist strategy, wherein she argued that a lack of attention to the shift in communications and a continued focus on the prevailing schemes of *multivariable explanations* only skewed perspectives further in the future. According to Eisenstein, the focus should have been on exploring why "many variables, long present, began to interact in new ways."[24] Although accusations of technological determinism were indeed put forward by her critics and successors, Eisenstein has refuted any, as she states, "monocausal, reductionist and technological determinist reading" of her work, emphasizing that print was only one factor that was influential in bringing about change.[25] Acknowledging the importance of the human element, she believes impersonal transmission and communication processes must also be given due attention, as that is where print did have special effects. Although print did not *cause* the developments she described (it was merely *an* agent of change, not *the* agent of change), Eisenstein states that these developments were definitely reorientated by the communications shift.[26]

In *The Nature of the Book*, on the other hand, Johns clearly illustrates the constructivist nature of the book: how the very identity of print has been created and how print culture has been shaped historically.[27] According to Johns, it is not printing that possesses certain characteristics, but printing *put to use* in particular ways. He is thus interested in studying the genealogy of print culture in order to analyze how the bond to enforce fidelity, reliability, and truth in early modern printing was forged and to reappraise where our own concept of print culture has come from—but also to explore how print differed from place to place and how it changed over time when it took hold, as well as to investigate how books came to be made and used.

It is important to emphasize that in his reply to Eisenstein, Johns stresses that he does not see his view as being necessarily opposed to hers. He regards his position as a supplement in terms of approach, and primarily wants to

acknowledge the importance of print in a different way and therefore asks different questions: "Where Eisenstein asks what print culture itself is, I ask how printing's historic role came to be shaped. Where she ascribes power to a culture, I assign it to communities of people. Most generally, where she is interested in qualities, I want to know about processes."[28] In other words, Johns does not want to focus on a history of print culture but on a cultural history of print. As he points out, a cultural history of print should be broadly constructivist about its subject. He sees this as an essentially empiricist undertaking, arguing for the "inseparability of social reality and cultural understanding."[29] Johns is thus not saying that print determines history but that print is conditioned by history, as well as conditioning it. As he stresses, the effects or implications of technology are not monolithic or homogenic; they are both appropriated by users and imposed on them. The book is therefore the product of one complex set of social and technological processes and the starting point for another. For Johns, addressing the dichotomy sketched by Eisenstein directly, *The Nature of the Book* is not simply the negative component of a dialectic; it is not solely a critique of print culture and Eisenstein. Rather, it questions claims about print and examines how they came into being, and why we find them so appealing and plausible.[30]

The second opposition to highlight in this debate relates to the *perceived speed of the transition from manuscript to print*. Should we talk about a print evolution, or revolution? Should we stress the continuity of the manuscript book and written textual transmission, or the discontinuous revolutionary character of the introduction of print?[31] Eisenstein believes the establishment of printing shops inaugurated the communications revolution, whereas Johns—according to Eisenstein, at least—believes the "printing revolution" was a retrospective discursive construct that emerged in the eighteenth or nineteenth century.[32] Johns downplays the difference between script and print, Eisenstein argues, whereas she sees a big difference and a transition taking place between the two: the shift from manuscript to print involved a Europe-wide transition, one that occurred in a relatively short time span. The adoption of print was therefore not a slow revolution but a remarkably rapid and widespread development.[33] However, Eisenstein does not so much emphasize a revolutionary view as envision the transition as a line that was both continuous and broken, simultaneously consisting of continuity and radical change. Nonetheless, her emphasis within this

transition is on aspects of change, rather than on continuity. We shouldn't underestimate the large cluster of changes that took place, she claims, and the essential role print played in these. Eisenstein is therefore not interested in a simple *impact model*, as she calls it; changes brought about by printing are not easy to grasp and characterize more a change of phase, wherein the character of the links and relationships—the cluster itself—underwent change. It is about finding the balance, she argued, between saying that print changed everything and that it changed nothing.[34]

Johns, on the other hand, claims that Eisenstein sets printing outside of history in her definition of print culture: in her account, it becomes placeless and timeless and does not pay sufficient attention to how these essential properties of print and print culture as a whole emerged. His work, by contrast, is concerned with the relation between print and knowledge, and its focus is on the history of science. By exploring the history of the book and print in the making, we get a better understanding of the conditions of knowledge, Johns claims, and of the ways in which knowledge has been made and utilized. Print culture is based on practices and conventions, and Johns is interested in how these practices came to be shared, as well as in the people and the places that make print possible: the agents of the book trade. Part of the importance of *The Nature of the Book* therefore lies in Johns's reconstruction of how, in the seventeenth and eighteenth centuries, these agents decided and constructed what print was and ought to be by looking at its historical origins or by a reconstruction (in the way of a struggle) of the historical origins of the press.[35] As he argues, it is the appearance of print that has veiled real conflict in history. The principles that seem to us most essential to print have in fact been heavily disputed by the various stakeholders within the book trade for centuries. Johns thus shows that the uniformity exhibited by printed materials was as much a project of social actions and struggles as it was of the inherent properties of the press.[36]

Third, divergences in both historians' viewpoints are apparent with respect to what Eisenstein calls the *geography of the book*.[37] Within the book-historical discourse, some theorists concentrate mostly on the effects and practices surrounding technology as a local affair, versus research that focuses upon their supposedly international—though in most cases highly Western-centric—reach. The most obvious example of the former is that of the localist methodology followed in Johns's *The Nature of the Book*, which focuses on England. Johns argues that there exist a variety of different (local) print cultures as print

culture knows specific sites of cultural production, dynamic localities constituted by representations, practices, and skills.[38] Eisenstein's work, on the other hand, is more cosmopolitan in character, following a Europe-centered perspective. She would even argue that it was print that enabled such a cosmopolitan ethos and perspective in the first place.[39]

Moving beyond the debate between Johns and Eisenstein and the binaries around cultural and technological determinism, the (r)evolutionary character of print culture, and the geography of the book it has drawn attention to, there are two further oppositions to shortly highlight here that have similarly structured the book historical discourse. First of all, a further distinction can be made between what is called *cultural pessimism*, or dystopian thinking, and *technological utopianism*, or futurology, concerning the book and the rise of new technologies. Reflecting a general reaction to media change, this is clearly apparent in the current debate surrounding e-books, which has been classified by some theorists as a debate between bookservatists on the one hand and technofuturists on the other.[40] However, it illustrates a cultural feeling (from unease to euphoria) and a depiction of historical change that can already be discerned in the transition from manuscript to print, and even in the introduction of writing.[41]

Finally, the discourse around the book embodies both *teleological* and *antiteleological* strands. Topics here focus on whether technology (and human society as a whole) progresses, or whether there is such a thing as technological advancement or a driving force or prime agent behind it. Teleological strands can also be found in book historical debates that focus on the new (i.e., e-books or print books) and the old (i.e., print books or manuscripts) and those that make a clear division or cut between the present and the past and emphasize a progressive linear development, as opposed to describing histories as plural genealogies, nonlinear and cyclical, or as postdigital, for example.[42]

A Representationalist Discourse

If we look at the debate between Johns and Eisenstein in more detail, we can see that, although I have outlined and emphasized the main differences between the two thinkers, both are anxious not to be accused of any form of technicist or culturalist determinism or oppositional thinking. Eisenstein, for instance, is very careful to argue that print was only *an* agent of

Toward a Diffractive Genealogy of Book History

change, not *the* agent of change, and that the transition to print was not a revolutionary one, but a rapid, widespread development, both continuous and broken. Nonetheless, her emphasis is clearly on the "unacknowledged *revolution*," on change rather than on continuity, and on how print was incremental in bringing about this change. And, as I stated previously, Johns points out that his view is not opposed to that of Eisenstein but that he just asks different questions.[43] *The Nature of the Book* is not simply the negative component of a dialectic, he states; he is not opposed to print agency but wants to acknowledge print in a different way, as "print is conditioned by history as well as conditioning it."[44] Nonetheless, Johns does clearly emphasize the constructivist nature of the book and that it doesn't have inherent qualities but only transitive ones. To this end, Johns argues that the cultural and the social should be "at the center of our attention."[45]

Taking the debate between Johns and Eisenstein and the various positions they adopt as representative of the larger discourse on the history of the book, I want to make the claim that this discourse for the most part adheres to forms of *representationalism* in its depiction of the medium of the book. This becomes clear from, among other things, the technicist (Eisenstein, McLuhan, etc.) and culturalist (Darnton, Johns, etc.) assumptions that continue to underlie the debate. From a representationalist perspective, media describe or represent an objective reality from which they remain disconnected. As in Plato's cave metaphor, they stand apart from the real material world, of which they only offer mirror images. In a similar vein, science (or scholarly discourse or ideas) focuses on knowing and observing an objective material world "out there." Karen Barad defines *representationalism* as "the belief in the ontological distinction between representations and that which they purport to represent; in particular, that which is represented is held to be independent of all practices of representing."[46] In representationalism, separations (between words and things, discourse and matter) are thus foundational. On the level of history writing or historiography, this is manifested by how both Johns and Eisenstein, for example, do not take into account how *their own representations* might be (materially) influencing the things they represent—in other words, how their descriptions of the past of the book shape both that past and the current and future material becoming of the book. More importantly, they fail to acknowledge their own *becoming with* the book through their discursive practices and the exclusions they create through their specific

position-taking. In this respect, Eisenstein's technicist-inclined account is based on the presumption that books are real objects in the world—separate from ourselves, society, and culture—that can have certain effects on the world. As Kember and Zylinska make clear, however, from a *performative* viewpoint, "media cannot have *effects* on society if they are considered to be always already social."[47] In other words, books and society are always already entangled; they are not static and homogenous categories. There is an a priori connection between them. Books are already part of society and of the social, so logically, the one—books, conceived as (technologies of) representation—cannot have an *effect* on the other—the social or society, perceived as reality—as they do not stand in a position of externality to one another. Barad explains how in this respect, "neither can be explained in terms of the other. Neither has privileged status in determining the other."[48] Bolter emphasizes that "technologies . . . are not separate agents that can act on culture from the outside."[49] On the other hand, Johns argues from a more constructivist-inclined view that the book has been constructed or represented by the "agents of the book trade," outlining a position in which culture is inscribed on the book, making it into a more or less passive entity, limiting the possibilities for the material agency of the book. Where Eisenstein and Johns *do* give credit to cultural and machinic agency, respectively (as a form of limited constructivism or weak determinism), it is important to emphasize that they see both as complementary, as part of a set of influences (in which one set is always emphasized as being more influential). As a result, they maintain the ontological (and ethical) difference between discursive and media agency, instead of seeing them as coconstitutive and entangled relational and agentic phenomena, as I want to do.

In a nonrepresentationalist performative view, there is no simple causality between media on the one hand and culture/society on the other, as these are already interconnected from the start. In a dichotomy, the opposition is already implied in its negation, as Rick Dolphijn and Iris van der Tuin explicate in their book *New Materialism: Interviews & Cartographies*. This implies that both sides of a dialectic are in a relation, part of the same "intimate" framework of thought.[50] If we want to reframe the book historical discourse, we should thus focus on the relationship and coconstitution of these oppositions. Along with bringing forward this performative view of book history, I want to further examine how the specific representations that have been put forward by both Johns and Eisenstein, as well as by the

Toward a Diffractive Genealogy of Book History

larger debate on the history of the book, have come about. This involves taking a closer look at the context from which they derived: What kinds of cuts or dividing discursive practices have been promoted or excluded through these materializing representations? Cuts (such as the divisions created by our representations) have to be made, but it is in the acknowledgement of our own responsibility and contextual involvement herein that we can make a start with cutting differently, and perhaps more ethically. As Donna Haraway has argued, "worlds are built" from our articulations and from the distinctions we make as part of our entanglements.[51] Here it is our responsibility to enable transformative instead of merely iterative effects to come out of our performative processes. We have to insist on a "better account of the world."[52]

It must be granted, Johns does acknowledge that a reappraisal of a social history of print culture in the making is consequential and can contribute to our historical understanding of the present conditions of knowledge.[53] However, Johns does not seem to acknowledge *his own* involvement in print culture in the making in this respect—for instance, the specific cuts that he makes by abiding to the publication practices of scholarly publishing by presenting his ideas in a fixed, objectified, printed scholarly monograph, although he is from a historical viewpoint very attuned toward the construction of these specific forms of fixity. It was McLuhan who was actually more attentive to this issue, as he actively experimented with the form of his own representations, taking into account the entangled nature of his words and the medium in which they were represented.[54]

Both Eisenstein and Johns, as part of their representationalist accounts, are thus not able to evade oppositional thinking and can in fact even been seen to enforce it. Yet notwithstanding awareness of their limited validity, a continued use of binary oppositions remains common in scholarly analysis more in general too. Kember and Zylinska argue in this respect that "even where these false divisions have been identified as such—and of course many writers are aware of their limited currency—it has been difficult to avoid them." They point out that this is partly due to the "residual effects of disciplinarity" and its embracing of sets of essential key concepts, but also due to the predominance, in media studies in particular, of social sciences perspectives, bringing along with them what could be classified as an inherently positivist and humanist outlook.[55] To explore what might be behind the continued emphasis on (different forms of) oppositional binary

thinking in the debate on the book's history, I want to take a closer look at book history's disciplinary history and the specific developments literary studies and historiography went through during the rise of book history as a specific disciplinary niche.

New Historicist Genealogies and Feminist Critique

Book history has its roots in bibliographic and literary studies and in the study of history. In the 1970s and 1980s, there was an eagerness in these disciplines to get beyond earlier historiographic and literary traditions. What is important here is that these traditions (history and literary studies) started to merge increasingly during this period, a period that also saw the rise of book studies as initially an amalgam of the two. What we see in the development of book studies, for instance, is clear traces of *new historicist* thought, which emerged in the 1980s as a literary theory mostly reacting to the formalism of structuralism and certain strands of poststructuralism (mainly the forms of deconstructionism developed within the Yale school of literary criticism), as well as older forms of historicism.[56] New historicists argue that these theories focus mainly on the textual object for meaning extraction, whereas they state that we need to understand a text or work through its historical context too. In the famous words of literary theorist Louis Montrose, new historicism's concern is with "the historicity of texts and the textuality of history."[57] Especially in literary criticism, new historicism is therefore seen as a theory that focuses on the relationship between a text and its context.[58] New historicists critique the text/context divide that they claim had been upheld until then, as well as the focus on dominant readings of classical works. By contrast, they argue for a renewed emphasis on neglected readings and dissonant voices and for the study of a variety of historical documents, not just the canon.

In the 1970s and 1980s, new movements also emerged in historiography or the philosophy of history. These movements were mostly placed under the heading of *new cultural history* or *new historiography*.[59] They include new forms of cultural studies, such as the *histoire des mentalités* and the *nouvelle histoire* of the third generation of Annales scholars in France (e.g., Jacques Le Goff, Pierre Nora). These new cultural histories distinguished themselves from the earlier analytical philosophy of history by means of their focus on narrative, subjectivity, and a plurality of interpretations rather than on

Toward a Diffractive Genealogy of Book History

historical objectivity and facts. This meant doing away with positivist perspectives of objectivity and the possibility of truthfully representing the past in favor of poststructuralist theories of representation (e.g., De Certeau, Foucault) and the focus of historians on their own historicity (i.e., the way historians cannot exclude themselves from their investigation; instead, the present subject is seen as directly influencing the representation of the past).[60] Related to this, Attridge et al. have argued that poststructuralism can be seen as an attempt to reintroduce history into structuralism, but this naturally also poses questions about the concept of history as such. Under the influence of poststructuralism and, most importantly, Derridean deconstruction, history became *différance*, whereby the assumptions of *a history*, a single, objectified, final and absolute reading of history, came under attack.[61]

It is interesting to note that there are a lot of similarities and overlaps between the literary forms of new historicism and these new cultural histories; the former can be seen as wanting to put history back into literary studies and the latter as wanting to put literary studies into history.[62] It has even been argued that new historicism can "be taken to be the literary-critical variant of what Frank Ankersmit has termed the 'new historiography.'"[63]

We can clearly detect the influence of new historicism and new cultural histories on the rise of book history and the book historical debate; book history can even be conceived as an example of a new cultural history, especially in how it developed from within the Annales tradition. Furthermore, book history has been at the fore when it comes to arguing that it wants to collapse the text/context (or matter/culture) distinction, as well as the literary studies/history distinction. However, although new historicism and new cultural histories embraced poststructuralist perspectives—both with respect to doing literary studies and history, and related to their object(s) of study—they have not been able to embrace "difference" (insofar as it is possible to do so), nor to get beyond thinking in binary oppositions. Furthermore, as I will show in what follows, new historicism, especially within book historical studies, has been unable to fully take into account its own historical position.

One of the main issues faced by new historicism, its critics claim, is that it has a hard time getting beyond the text/context binary. Literary theorist Chung-Hsiung Lai argues in this respect that new historicism is faced with an insoluble predicament: How can it simultaneously deal with the perceived (post)structuralist focus on textuality and the historicist focus on

contextuality? This double claim (of both textuality and contextuality), and especially the claim of neutrality between the two, becomes impossible, resulting in a situation in which it ultimately remains focused more on textuality and in its intended neutrality remains more closely allied with formalism.[64] If we add to this the standpoint of feminist critique, Judith Newton argues that new historicism thus "produces readings of literature and history that are as marked by difference as by sameness."[65] Furthermore, this focus on neutrality leads to new historicism ultimately taking in an *apolitical posture*. This can partly be explained, as Lai and other feminist critics of new historicism such as Newton do, as due to new historicism's discursive focus on the early work of Foucault, as part of which history is seen as a system of power relations, structured by struggle. Yet power in this vision is seen as overdominant; there is no way to perform it differently (similar to forms of constructionist thinking). New historicism adopted a similar discourse focused on the universalization of power, lacking any meaningful politics of resistance and/or subversion. From this position of critique, attempts have been made to change this position by writing feminist scholarship and theory *into* the history of new historicism. For example, Lai suggests that in order to get beyond its textual focus, new historicism should focus more on plural sociohistorical dimensions and on dynamic forms of power that enable forms of subversive resistance. Lai uses an exploration of feminist genealogy to reconcile new historicism and feminism and to lift new historicism out of its textual formalism and early Foucauldian power theory. This includes a different reading of Foucault: Newton points out that "while feminists have drawn upon Foucault, they have also been insistent, for the most part, upon identifying those who have power and asserting the agency of those who have less."[66] As such, both Lai and Newton argue that new historicism needs to give up its apolitical condition and take material conditions seriously, to provide channels for the voices of the oppressed in order to really go beyond history as usual. Its focus should be on plurality, diversity, and difference so that new historicism can indeed become otherness-driven.[67]

Following a vision similar to feminist critics of new historicism, I propose a strategy that lifts the *discourse on book history* beyond an overtly simplified binary thinking, by reading it with, alongside, and through the discursive-materialist and performative practices put forward by theories of (feminist) new materialism—in specific, the work of theorists such as Karen

Toward a Diffractive Genealogy of Book History

Barad and Donna Haraway. And, similar to Lai, this strategy also includes looking at the later work of Foucault, including its emphasis on resistance and interventionism. As stated previously, I argue that we need to see discursive and media agency as entangled agential processes instead of a property that an entity (be it a machinic or human one) has. On the level of history writing, this means emphasizing that book historical studies (as well as new historicist ones) need to take their own historicity, as a form of performativity, into account more. Michel Callon qualifies a discourse that contributes to the construction of the reality that it analyses as *performative*. As such, he states that "scientific theories, models . . . are performative, that is, actively engaged in the constitution of the reality that they describe."[68] Yet although Johns, for example, narrates the way seventeenth-century publishers struggled over the construction of the origin of the book—and through that struggle partly came to define the future of the book—there is not enough acknowledgment, both within *The Nature of The Book* and in Johns's debate with Eisenstein, of how *his own history writing* and his position taking within the debate (indeed, even the debate itself) can be seen to influence and shape both the past and future of the book. Indeed, there is a lack of recognition here of how, as Bolter makes succinctly clear, discourses (be they utopian and dystopian) on the past and future of the book belong to and shape the materiality of our writing technologies: "The technology of modern writing includes not only the techniques of printing, but also the practices of modern science and bureaucracy and the economic and social consequences of print literacy. If personal computers and palmtops, browsers and word processors, are part of our contemporary technology of writing, so are the uses to which we put this hardware and software. So too is the rhetoric of revolution or disaster that enthusiasts and critics weave around the digital hardware and software."[69]

I want to propose here that book historians become more attentive toward their own discursive agency: there is currently a lack of awareness of how, through their own position-taking, they produce the object of their study and, with that, structure its future. This includes paying closer attention to how this object, the book, both in its materiality and as a metaphor, is and has been influencing their discursive practices. The debate on book history lacks in this respect a clear focus on its own publishing and scholarly communication practices as structuring entities, as well as a more feminist-oriented perspective that tries to go beyond simple binary thinking. To

what degree, then, are book historians taking responsibility for their own choices and focal points?[70] As with new historicism, although the discourse on book history is in many ways critical of and aware of the dichotomies described earlier, it can be argued to still uphold them. Furthermore, it runs the risk of, as Lai points out with respect to new historicism, taking in an apolitical position when its main focus is on describing and analyzing instead of critiquing, changing, or intervening in society. Book historians, I want to put forward, should therefore be more aware of the parts they play in the struggle for the future of the book. To start from this position, how can we get beyond this kind of oppositional thinking that, as I argue, still structures the debate? What can be the "beyond" of book studies in this respect?

An Alternative Vision: The Discursive Materiality of the Book

One of the more interesting media theories that has come to the fore recently, media archaeology, offers some valuable insights for book history and any attempt to move "beyond" its structuring oppositions. Media archaeologists construct, in the spirit of Foucault and Kittler, alternative histories to the present medial condition, counter histories of the suppressed and neglected, which challenge dominant teleological narratives.[71] Media archaeological approaches thus address "the rejection of history by modern media culture and theory alike by pointing out hitherto unnoticed continuities and ruptures."[72] As a theory, media *archaeology* should not be seen as being distinct from the genealogical method, however, in the sense that some thinkers emphasize the contrast between archaeology and genealogy as being a clear distinction in Foucault's thought, for example. Media theorist Wolfgang Ernst argues in this respect that as a method of analysis media archaeology is complementary with a genealogy of media: "Genealogy offers us a processual perspective on the web of discourse, in contrast to an archaeological approach which provides us with a snapshot, a slice through the discursive nexus."[73] Media archaeology can therefore be seen as an incorporation of both archaeological and genealogical methods.[74] Similar to book history, new historicism and new forms of cultural history were important influences on media archaeology, which further draws connections with the Annales school. From within this context, media

archaeology formed its own niche in 1990s media studies, bringing more of a historical perspective to new and digital media studies.[75]

What is interesting with respect to the approaches adopted by media archaeologists is that media archaeology is seen as a different way to theorize, to *think media archaeologically*. It investigates new media cultures by analyzing and drawing insights from forgotten or neglected past media and their specific practices and interventions.[76] In this respect, media archaeology is much more of a practice, a doing, an intervention than "regular" media histories and, as part of that, the book-historical debate. It is disruptive rather than representationalist.[77] From this perspective, media archaeological approaches could potentially be a valuable companion to book-historical studies, where they stress the multilayered entanglement of the present and the past and emphasize "dynamic, complex history cultures of media."[78]

However, as with new historicism, the question can be asked: To what extent, in its focus on histories of suppressed and neglected media, is media archaeology repeating and again emphasizing these exclusions? In what ways does media archaeology really "perform media history differently" through its (scholarly) practices, and in what sense is it really a "doing"?[79] In its creation of an entanglement of "alternative" and "neglected" media histories, how does it take responsibility for its own decisions and cuts?

It is here that an accompanying reading of the work of (feminist) new materialist thinkers—in specific, the work of thinkers such as Barad and Haraway—can be particularly valuable. Such a reading can emphasize this focus on ethical position-taking and on taking responsibility for our choices—or cuts, as Barad calls them—in media archaeological, new historicist, and book historical studies. Through a reading of feminist new materialist theories, I want to start exploring how we can write a book history that will perform a different vision of the book, one that is open to and responsible for change, difference, and exclusions and that accounts for our own ethical entanglements in the becoming of the book.

As part of this, and as outlined previously, I argue for a vision that seeks to move beyond (simplistic forms of) binary thinking with respect to both the book as an object and the discourse surrounding the history and future of the book. In a social constructionist or constructivist vision of media, technology is seen as embedded and understood predominantly by looking at the social context from which it emerges. Power structures—who controls,

defines, owns the media, and so on—are essential here. Technological determinism tends to stress that technology is an autonomous force, outside of forms of social control and context, and is seen as the prime agent in social change—except that technology is always shaped and constructed and is always political and gendered. The problem with constructionist theories, however, is that they tend to ignore material bodies as agential entities. Material bodies are not passive entities, just as technology is inseparable from politics: they are sites of bodily and material production.

Barad, in her theory of *agential realism*, focuses on the complex relationships that exist between the social and the nonsocial, moving beyond the distinction between reality and representation and replacing representationalism by a theory of posthumanist performativity. Barad's work triggers a variety of questions: How are nonhuman relationships related to the material, the bodily, the affective, the emotional, and the biological? How are discursive practices, representations, ideas, and discourses materially embodied? How are they sociopolitically and technoscientifically structured, and in what ways do they shape power relations, including the materiality of bodies and material objects? Bringing this back to a book-historical context, I am interested in exploring the following question: How is the book situated through and within material and discursive practices? From a new materialist perspective, discursive practices are fully implicated in the constitution and construction of matter. In this vision, materiality *is* discursive, just as discursive practices are always already material; that is, they (re)configure the world materially in an ongoing manner. As Barad argues in this respect:

> Discursive practices and material phenomena do not stand in a relationship of externality to one another; rather the material and the discursive are mutually implicated in the dynamics of intra-activity. But nor are they reducible to one another. The relationship between the material and the discursive is one of mutual entailment. Neither is articulated/articulable in the absence of the other; matter and meaning are mutually articulated. Neither discursive practices nor material phenomena are ontologically or epistemologically prior. Neither can be explained in terms of the other. Neither has privileged status in determining the other.[80]

The last two sentences in this passage are very important in the context of the study of the book: there is no prime mover or most essential element; neither social, discursive, or material practices nor the technology or object itself is solely *of itself* responsible for change, and they are each neither cause

Toward a Diffractive Genealogy of Book History

nor effect. Barad speaks of matter as *matter-in-the-process-of-becoming*. The same can be said of media or media formats such as books, which, as I propose, should be seen as dynamic, performative entities. By focusing on the nature of the relationship between discursive practices and material phenomena, by accounting for nonhuman as well as human forms of agency, Barad extends and reformulates the discursive elements of, for instance, Foucault's theory, with non- or posthuman object materiality.[81] Following this vision, agency becomes more than something reconfigured by human agents; it includes how media practices affect the human body, society, and power relations. In Barad's terminology, both the object and the human are constructed or emerge out of material-discursive intra-actions (which Barad calls *phenomena*), a vision that actively challenges the dichotomy presently upheld to a greater or lesser extent in most book-historical studies.

Following this approach, scholarly communication can be seen as a set of performative material and discursive practices (e.g., from the material act of book publishing to the discursive agency of book studies). The scholarly monograph itself can be analyzed as one of these practices and at the same time as a process, as a relationship between these practices and how they are constituted or embodied. Scholarly practices—such as publishing—cannot simply be reduced to material forms but necessarily also include discursive dimensions. Similarly, these practices do not only include the doings of human actors (such as authors or readers) but are constituted by, or encompass, the whole material configuration of the world (which includes both material objects and relationships). As Barad claims, following Butler, our practices are temporal and performative; they constitute our lifeworld as much as they are constituted by it. Related to this, Barad sees agency as being similarly performative and as something constituted *within* relationships; therefore, as a *relationship*—and not something that someone *has*—agency is a doing.[82]

We can find related views within the work of media theorist Katherine Hayles, who has argued that materiality is an emergent property, something that cannot be specified in advance and that, as such, is not a pre-given entity (and thus has no inherent or salient properties).[83] Materiality is and remains open to debate and interpretation. As Hayles points out in relationship to texts as embodied (relational) entities: "In this view of materiality, it is not merely an inert collection of physical properties but a dynamic quality that *emerges* from the interplay between the text as a

physical artifact, its conceptual content, and the interpretive activities of readers and writers. Materiality thus cannot be specified in advance; rather, it occupies a borderland—or better, performs as connective tissue—joining the physical and mental, the artifact and the user."[84] A variety of material agencies entwine to produce our media constructions: the natural and the cultural, the technological and the discursive are all interwoven.

This perspective, I propose, offers us a way to rewrite these modernist oppositions. It is not so much that we can speak of assemblages of human and nonhuman but that these assemblages are the *condition of possibility* of humans and nonhumans in their materiality. What is important in this vision is that specific practices of, in Barad's words, *mattering* (where matter is conceptualized not as an object but as an emergent process) have specific ethical consequences.[85] Things are intertwined, but the separations that people create (e.g., through their specific position-takings within book-historical debates) signify that they create inclusions and exclusions through their specific focus. This separation, or *agential cut*, as Barad calls it, enacts determinate boundaries, properties, and meanings. Where in reality differences are interwoven, agential cuts cleave things together and apart, creating subjects and objects. From this viewpoint, scholars have a responsibility toward and are accountable for the entanglements of self and other that they weave, as well as for the cuts and separations and the exclusions that they create and enact. As Barad phrases it, as scholars, we are responsible for "the lively relationalities of becoming of which we are a part."[86]

By envisioning the book either as a form of agency cut loose from its context, relations, and historicity or as a passive materiality on which forms of political and social agency enact, book historians make specific ethical choices or *cuts* for which they can be held accountable. *Living Books* explores why these incisions are made within the book historical discourse: What are the reasons, the politics and struggles, the value systems that lie behind these choices? At the same time, the book—and with it, scholarly communication—is repositioned as a material-discursive practice, as a process that gets cut into. *Living Books* aims to think through what this alternative vision of the book could signify for scholarship and academia. What does it mean, for instance, to enact a different vision of the book through our practices and actions?[87] How can we perform the book—and with it, ourselves as subjects—in such a way that we promote and enable the development of a more ethical publishing and communication system, one that

Toward a Diffractive Genealogy of Book History

encourages difference, complexity, and otherness, fluidity and change, but also responsibility and accountability for our choices and exclusions?

To explore this ethical dimension more in detail, I want to connect Barad's vision to the *minimal ethics* of Emmanuel Levinas; both stress that ethics is already part of our entanglements from the start.[88] As Barad states, "Science and justice, matter and meaning are not separate elements that intersect now and again. They are inextricably fused together."[89] Following Levinas, ethics is inevitable and foundational (it precedes ontology), where we are always already confronted by "the infinite alterity of the other."[90] This other makes me responsible and accountable, where *s/he/it* needs to be responded to as we are interconnected with them, with other beings and with matter more in general; *they/the other* are/is already part of *us*.[91] In this sense, ethics should be perceived as relational, as it stands in relation to and is responsive to alterity from the inside; that is, the self and other do not stand in a relationship of externality to one another either. As Derrida puts it, "Could it not be argued that, without exonerating myself in the least, decision and responsibility are always of the other? They always come back or come down to the other, from the other, even if it is the other in me?"[92] Following this vision, ethics is not outside or external (it doesn't involve the application of strong ethical injunctions or any predefined system of values); it is always already present in our practices and institutions and cannot be imposed from the exterior as it is performed *through* these practices and institutions. This is why taking in a position, why making incisions into "the fabric of the real" is an ethical decision, one that needs to be made responsibly, following an ethics that is not defined beforehand but always open and that is capable of responding to specific situations and singular events. Furthermore, this obligation to take responsibility for the differences we enact in the world through our actions should include an awareness of how we simultaneously come about *through* these incisions, as part of which we "become different from" the world. As Zylinska has argued in this respect "we humans have a singular responsibility to give an account of the differentiations of matter, of which we are part."[93]

Reading Book History Diffractively

As part of my own incision and intervention in the book-historical debate, I argue that debates on all three of the historical-discursive levels I described

in the introduction (i.e., on the levels of the sources, of history writing, and of historiography) determine our vision of the book as a medium on a material level, and the book as a material entity in turn influences and structures these debates. Matter (i.e., the book) and discourse (i.e., book studies) are both emerging from this continuous process. The book as a medium is thus never "done" and gets reconstituted and reimagined constantly: by technological developments; by the ongoing debate over its meaning, function, and value; by historical developments (i.e., reactions to other, "newer" media via remediation, appropriation, or remix); by the political economies and social institutions with their accompanying practices, within which the book functions; and by new uses, which include new material practices and the changing context of the production and consumption of books.[94]

Nonetheless, a few salient features, which remain very much debatable and in many cases have become central topics in the debate on book history, are increasingly seen as essential parts of the book in the common imagination, mostly in a reaction to the rise of digital media and the internet, to which the book is often compared and is similarly contrasted against in various ways.[95] These salient features include notions of stability and fixity; the integrity of a work (bound with a cover), as well as that of a clearly defined author with distinct author functions (responsibility, credibility, authority, ownership); and the selection and branding by a reputable press, which additionally vouches for a book's authority and quality. It is these features, however contested they might be, that have become the most well-known aspects used to define a *book* in common discourse. Furthermore, these perceptions are reproduced and fixed through our common daily practices, through which they eventually become the basis of our institutions. As a result, the salient features that have come to define the printed book look highly similar to the scholarly communication system that gets promoted within academia: one that is qualitative, stable, and trustworthy.

The problem with applying properties to media is that the process of doing so often relies on a historiographic fallacy: what historically came to be the characteristics of printing have been projected backward as its natural essential logic. However, it took a long time for these features to be established and perceived in the way they are now. They are the outcome of material processes of practice and dispute, and as concepts and practices they are changing constantly. What we perceive as fixity, standardization,

and authorship changes over time; their functions change; and the way these features and practices get produced and reproduced changes. For instance, now that we have started to experiment with preserving our collective heritage within sequences of DNA, the book might start to look like an incredibly unsteady and temporary storage medium.[96] It is interesting to see how these ideas connected to the printed book will now be reconfigured, reimagined, and challenged again by digital media, which serve as an added catalyst for the discussion on the future of the book. For example, as Kember and Zylinska point out, under the influence of the debate on new media, a distinction is upheld between *new media*, which are seen as interactive and converged, and *old media*, such as the book, which are seen as stable and fixed. However, arguably, if we take into consideration the work of Johns or the history of artists' books, books can be seen to be just as "hypertextual, immersive, and interactive as any computerized media."[97] As Kember and Zylinska emphasize, "the inherent instability of the book never disappeared, it just became obfuscated."[98]

There are additional reasons that it is important to keep on questioning, critiquing, and reconfiguring what are seen as essential print-based features. Print has come to shape and serve certain functions for scholarship. By continuously emphasizing and fixing what are in essence fluid and contestable features, we run the risk of making both print and the book, and with them eventually the scholarly communication system, into a conservative and conservationist entity. This can lead to an essentializing approach, wherein a medium's essences become fixed and differences are erased. Such an approach will limit our understanding of the book and its heterogeneous, multiple interactions.[99] However, when we start to recognize and emphasize that these so-called salient features are contested concepts that are reconfigured constantly when the book's materiality changes, readers change, the production methods change, and the discourse changes, we can begin to acknowledge that the book as a medium, concept, and material object keeps on changing too in relation to new contexts. Books are among beings and among agencies, interwoven with and implicated in them. As scholars, we are involved in the processes of becoming of the book, in our analyses and histories, as well as in our uses and performances of the book. In this sense, we have a responsibility when it comes to the creation of conditions for the emergence of media, where we emerge *with* these media; we "do" media, just as media are performative through their specific yet *relational*

affordances. When we start to acknowledge agential distribution, we can begin to look at the book as a processual, contextualized entity; the book becomes a means to critique our established practices and institutions, through its forms and the decisions we make to create these forms, through its discourses, and through the practices that accompany it.

A further important aspect of my critique of the perceived salient features of printed books focuses on the underlying humanist assumptions they perpetuate. We can see this in the way authorship is conceptualized and continuously reasserted following a liberal humanist notion of the author as an autonomous subject or agent. Indeed, this anthropocentrism, affirming the primacy of man in the creation of knowledge, remains strongly embedded in our publishing practices—instead of emphasizing the multiple intertwined agencies (human and nonhuman, technological and medial) that are involved in the production of research, for instance—from the printing press to desktop publishing software. Here, as Barad has argued, a humanist notion of agency as a property of individual entities is maintained. These kinds of essentialisms are further upheld when the book is talked about as an "original piece of work" and as a fixed and bound object or commodity, which can have certain material effects.

These humanist visions pertaining to the book, or to the scholarly monograph more specifically, are repeated within digital or postdigital spheres, together with essentializing practices such as copyright and DRM, which further objectify the book as a commodity. This situation is then sustained by a discourse on the (history of the) scholarly book that does not fundamentally critique or aim to rethink these humanisms, including those maintained through the political economy that surrounds the monograph. It is foremost our scholarly publishing institutions that have invested in the cultivation of this print-based situation and humanist discourse, and these institutions are eager to maintain their positions and defend their established interests. Although book historians are aware of how this humanist focus on the book has been constructed out of various power struggles, I again argue that they do not concentrate enough on their own publishing practices, nor do they formulate potential alternative visions of the book—based on open-endedness, for example.[100]

As a reminder, and as I mentioned in the introduction, when I mention *print-based features* or the *discourse of the (printed) book*, I am referring to the essentializing and humanist aspects that have been brought forward by this

discourse and by the institutions and iterative practices surrounding the book as object and commodity that are similarly maintaining them. In the following chapters, I analyze three aspects in particular that can be seen as some of the most fixating, essentialist, humanist, and print-based features of the book: *autonomous authorship*, the book as a *commodity*, and the *fixity* or *bound nature* of the book. Although each of the following chapters discusses one of these topics separately, they cannot be considered independently: as scholarly practices and institutions, they overlap and reinforce each other. Nonetheless, chapters 2–5 proceed by analyzing the institutions, practices, and discourses that have influenced and shaped these print-based features of the scholarly book in relation to the historical development of the book and book history as a discourse. At the same time, I discuss how these essentializing aspects are simultaneously maintained and critiqued in a digital context by analyzing various digital experiments with the book that have attempted to think beyond these fixtures and that have tried to challenge the stability, authority, and commodification of the book. This includes projects that have experimented with concepts and practices such as remix, fluidity or liquidity, and openness. However, as critical as they may be, I will show how many of these digital book experiments continue to adhere to humanist mechanisms, practices, and institutions.

The book historical discourse as discussed in this chapter plays an important role in each of the coming chapters, where it frames and introduces each of the three previously mentioned humanist and print-based features from a book-historical perspective—or, to be more specific, from how this perspective has been discursively positioned and produced. Yet instead of presenting these various book-historical position-takings in opposition to each other, each of the next chapters commences instead with a *diffractive (re)reading* of the discourse on book history related to that specific topic. It is thus not my aim to dialectically read the various positions in the debate on book history in opposition to each other, as I have done at the beginning of this chapter to expose the binary tendencies in the discourse and to illustrate the differences in position-taking between Johns and Eisenstein. Instead my aim is to read these book-historical insights together diffractively to acquire an overview of the debate from multiple positions, while being attentive to how diffractive readings, as Haraway explains, "record the history of interaction, interference, reinforcement, difference."[101] At the same time, I want to use this diffractive methodology to emphasize the genealogical aspects of

the debate (de-emphasizing linear origin stories); as Barad has noted, by reading insights through each other, we can explore where differences emerge and get constituted.[102] To explore where these differences emerge, I am reading the debate diffractively in relation to each specific theme that structures this book (authorship, the book as commodity, and the book as a fixed and stable object). The next chapter introduces such a diffractive reading in order to analyze the role humanist authorship plays within academia.

2 From Romantic to Posthumanist Authorship

I think that, as our society changes, at the very moment when it is in the process of changing, the author function will disappear, and in such a manner that fiction and its polysemous texts will once again function according to another mode, but still with a system of constraint—one that will no longer be the author but will have to be determined or, perhaps, experienced [expérimenter].
—Michel Foucault, "What Is an Author?"[1]

Authorship within academia has reached a cult status. Scholars, in the humanities at least, are increasingly assessed according to the weight of their individual, single authorial output in the form of published articles or books, and less according to the quality of their teaching, to take just one possible instance. The evaluation of a scholar's authorial contributions to a field is considered essential for hiring purposes and for further career and tenure development, for funding and grant allocations, and for interim institutional assessments, such as the REF in the United Kingdom. Authorial productivity and, connected to this, the originality of one's work are important factors in determining a scholar's standing within academic value networks. This fetishization of scholarly authorship is integral to an increasingly hegemonic academic discourse related to originality and authority, to impact and responsibility, and linked to a humanist and romantic notion of the individual author-genius. This specific discourse on authorship is directly connected to a certain essentialist idea of *the human*, which one could argue the humanities—and with it, scholarship as a whole—is based upon.[2] This is the idea of the universal human, the sovereign human individual, and of the self as unity—which can be translated, as Gary Hall has done, into the idea of "the indivisible, individual, liberal human(ist) author."[3] Although this

idea of human essence, of a unified self and an integral individual, has been interrogated by critical theorists for over a century now, the way knowledge is produced, consumed, and disseminated today remains very similar to the print-based authorship practices that were devised as part of the discourse on the humanist author. This discourse continues to shape our academic authorial practices, in conjunction with our publishing practices, even in an increasingly digital environment.

However, practices and discourses related to collaboration, networking, and the greater academic conversation have similarly fed into our notions of scholarship over the centuries, and for many scholars the internet and digital communication seem the perfect opportunity to promote these capacities further. Developments in the sciences, where multiauthorship has become common practice, also increasingly challenge ideas of individual scholarship in the humanities. Some even argue that networked science has the potential to fundamentally change the nature of scholarship and scientific discovery.[4]

In this chapter, I consider how we can explore and critique the role humanist authorship plays in academia (and more specifically in the humanities) by analyzing the way authorship currently functions within scholarly networks and how our authorial roles and practices are constructed and performed as part of these networks. I examine authorship from multiple angles, taking in historical and theoretical, as well as more concrete, perspectives (focusing on authorial *practices*) and the relationships between them. I do so in an effort to break down the discourse on the cult of individual authorship while also being critical of the in some instances almost utopian hope invested in scholarly practices of networked collaboration. By analyzing the history of authorship and the rise of a humanist authorial discourse, I show that single authorship is a very recent construct and that scholarship has in fact always been collaborative and distributed. At the same time, I explore the mostly theoretical critique of authorship provided by poststructuralist thinkers, as well as what can be seen as some of the recent concrete or practical embodiments of that critique. Although we have been proclaiming the "death of the author" for over half a century now, humanist authorship remains strongly embedded within our institutions and cultural practices. As such, I examine various practical experiments with authorship critique in different fields and contexts in what follows, including *hypertext*, which

From Romantic to Posthumanist Authorship

can be seen to focus mainly on replacing the authority and responsibility of the author with that of the reader. I also look at current practices within the digital humanities, which can be seen to foreground *collaborative* notions of authorship, challenging its presumed individualistic nature. Finally, I investigate *remix practices* within academia, which mainly complicate the idea of the proprietorial author creating original works.

Following my analysis of these practical authorship critiques, I outline how, although interesting and promising, many of these recent collaborative, networked, interactive, multimodal, hypertextual, and remixed forms of authorship proposed as alternatives to the previously described humanist authorship discourse nonetheless still resort to many of the same structures and practices. At the end of this chapter, I therefore put forward two examples of what can be seen as *antihumanist authorship critique*—namely, *plagiarism* and *anonymous authorship*. My analysis of both these examples will lead into an exploration of the potential for a *posthumanist* critique of authorship and, as an extension of this, possible forms of posthumanist authorship— part of what can be seen as a burgeoning *posthumanities*. As part of this, posthumanist authorship endeavors to continuously rethink, both in theory and in practice, the way authorship functions within academia, and in its critique of the humanist notions underlying authorship, it seeks to experiment with more distributed and multiagentic authorship practices.

Book History and the Perseverance of Liberal-Humanist Authorship

I would like to start by exploring how the figure of the liberal-humanist author developed: What is its relationship to the book (or the codex format) as a medium and object, and in what ways has authorship been narrated within the book historical discourse? What stands out here is that the relationship of book history and book historians with authorship, its historical development, and the author function has been changeable and complex. As Roger Chartier points out, book history developed within and alongside currents of literary criticism such as structuralism, analytic bibliography, and new criticism—especially dominant in Anglophone countries—which all saw the text, and thus books, as self-contained systems, objects without authors and readers. The history of the book was thus for a long time a history with neither readers nor authors.[5] In the French book-historical

tradition, following the influential Annales school, the situation initially was not much better, although it focused at least on the sociology of readers (but not on reading practices). In France, just as in the Anglo-Saxon bibliographic school, the author remained forgotten, even in the tradition of the social history and the material production of the book as produced by Febvre and Martin, among others. In France, Chartier claims, books thus had readers but no authors.[6] However, attention to the author returns in Bourdieu's sociology of cultural production, McKenzie's sociology of texts, reception history within literary criticism, and new historicism. Yet this time it is a *constrained author*—as opposed to a romantic one—that appears in these theoretical systems. The text and the book are reconnected with their author and her or his intentions, yet these intentions are no longer seen as fully determining the meaning of a text, nor its reception. In this vision, authorship is fragmented, dispersed, and plays a more contingent role. Chartier applauds this return of the author as a subject of investigation in book studies, especially and more precisely—in its constrained version—of the *author function* and its practice and techniques.[7]

One of the main debates around authorship and the author function as played out within the book-historical discourse relates to the dichotomy sketched in the previous chapter around the intrinsic agency of print: Is it print that established or enabled our modern notion of authorship, or does authorship predate print? For instance, scholars such as Mark Rose, but also Roger Chartier, focus on how in its connection with censorship, property, and ownership, authorship is fully inscribed within (the culture of) print. Following this argument, print extended the circulation of potentially transgressive books and established a market system in which proper roles were established (author, publisher, bookseller, etc.). At the same time, certain essential traits of authorship can be seen to predate print. Already in the manuscript age, authors such as Petrarch tried to establish control over the way their texts looked and were distributed, especially with respect to corruption through continual copying by copyists. According to Chartier, this shows an early emergence of "one of the major expressions of the author-function, the possibility of deciphering in the forms of a book the intention that lay behind the creation of the text."[8]

Walter Ong similarly locates the beginning of authorship before print, with the coming of written discourse. Where he argues that oral discourse can be seen to be performative—it produces community—written discourse

From Romantic to Posthumanist Authorship

on the other hand is detached from the performer; it developed into an autonomous practice, turning the writer into a subject distinct from the group. As such, as Ong puts it, "with writing, resentment at plagiarism begins to develop."[9] But initially, in manuscript culture, intertextuality remained strong, especially in its connections to the commonplace tradition of the oral world, creating and adapting texts out of other texts. Therefore, as Marshall McLuhan emphasizes, written text was still authoritative only in an oral way.[10] Both Ong and McLuhan thus contend that it was print that truly created a sense of the private ownership of words and a new feeling for authority, where it was print and its visual organization—representing the "final form" of an author's words and intentions, aesthetically reproducing them in multiple identical copies, and enclosing them as a result of print's formal consistency—that encouraged a different mindset. As McLuhan states in this respect, "Scribal culture could have neither authors nor publics such as were created by typography."[11] In printed form, a work becomes closed, cut off from other works, and thus unique. It was print culture that, according to Ong, finally enabled romantic notions such as originality and creativity to arise and that encouraged the development of our modern notion of authorship.[12]

How exactly then did authorship develop in a print environment according to this narrative? When it comes to early publishing, the modern division of labor was not yet very common. Printers were mostly printer-publishers, and many academics, such as Johannes Kepler, were themselves publishers or were very much involved in the printing process.[13] Early printers thus played an important role in forging definitions of property rights, shaping new concepts of authorship, and exploiting new markets. However, their labors would not have had much result in the manuscript age, Elizabeth Eisenstein argues, as it was only with the coming of print and with that of a fixed text that individual innovations and discoveries could become more explicitly recognized, and thus the distinction between copy and original could become clear.[14] After the advent of copyright especially, it became much easier for an author to make a profit by publicly releasing a text, as their invention rights were now firmly established in law and no longer only guaranteed by guild protection (in England, by the Stationers' Company—consisting of printers, booksellers, and binders—for instance). Only with the coming of print, Eisenstein contends, could personal authorship really become established, as writers wanted to see their work in print—fixed and unaltered. As

she puts it, "Until it became possible to distinguish between composing a poem and reciting one, or writing a book and copying one; until books could be classified by something other than incipits; how could modern games of books and authors be played?"[15] She points out that new forms of authorship and property rights started to undermine older forms of collective authority, which was exposed as error-prone. Where innovation came from was hard to determine before print, when, due to drifting texts and a lack of access to manuscripts, it was difficult to establish what was already known and who was the first to know it. In other words, Eisenstein argues, there was no systematic forward movement before the coming of print.[16] This can be illustrated by looking at the changing meaning of the term *original*, which started to change with the coming of print. Initially, *original* meant "close or back to the sources," yet the modern meaning of the term focuses on breaking with tradition instead. According to Eisenstein, it was print that started to change this meaning of *original*, as notions of recovery and discovery were reoriented after the coming of print technology.[17]

But the author was also very much a construct of printer-publishers, who started using authorship as a marketing product. New publicity techniques were explored, by printers and by authors, including marketing forms such as blurbs to publicly promote authors and sell their works. Yet again Eisenstein emphasizes that this kind of marketing could only take place successfully and promote and create new forms of authorship *after* the coming of print. Scribal culture, she points out, "could not sustain the patenting of inventions or the copyrighting of literary compositions. It worked against the concept of intellectual property rights."[18]

Book historians such as Adrian Johns, on the other hand, take a different approach with respect to the development of authorship, focusing mainly on the establishment of credentiality. How did readers ensure a work was authoritative? Within a print context, this remained far from straightforward, he stresses, especially because compositors, just like modern editors, played important authorial roles. Similarly, a copy of a manuscript could never be exactly reproduced in print—due to space constraints, for instance. Copies were often amended during the printing process, with typography used to enhance authorial meaning and changes made in anticipation of a certain readership. For Johns, the changing nature of the term *original* played a role here too. Original used to refer to a particular *performance* or *reading* of a work, which meant that written records were seen as simple, fallible

From Romantic to Posthumanist Authorship

transcriptions of a particular event. As Johns further points out, "Compositors could thus make the changes their cultural position demanded, not only because of the prized virtue of the master printer, but also because they held in their hands no sacrosanct text at risk of desecration."[19] Even more, copyright meant that a stationer had a right to *both* the manuscript and the text. Publishers thus protected their investment by turning (fallible) transcriptions into fully edited printed books.[20] In this way, stationers and booksellers controlled every aspect of their books' production.

The establishment of authorship as we know it today was very difficult in these conditions; hence both Johns and Chartier argue that we should speak of forms of *distributed* authorship at that time, where authorship was allocated to a number of individuals and groups. Chartier points to Foucault's focus on the penal background of authorship in this respect, arguing that ownership of a text has always been related to its penal appropriation. In Foucault's vision books only really came to have authors, instead of mythical figures, when authors became subject to punishment and could be held responsible for the diffusion of texts that were seen as scandalous or as guilty of heterodoxy.[21] Chartier focuses on how this responsibility was initially a distributed one:

> In the repression of suspect books, however, the responsibility of the author of a censured book does not seem to have been considered any greater than that of the printer who published it, the bookseller or the pedlar who sold it, or the reader who possessed it. All could be led to the stake if they were convicted of having proffered or diffused heretical opinions. What is more, the acts of conviction often mix accusations concerning the printing and sale of censured books and accusations concerning the opinions—published or unpublished—of the perpetrator.[22]

As part of the proprietary culture of the time, and based on their right to copy, stationers thus continued for a long time to hold the position of authors, Johns argues, specifically with respect to establishing crediality.[23] In forms of collaborative book production, however, this establishment of credentiality was much harder as no one publisher was responsible for the entire book. Nonetheless, for all intents and purposes, Johns stresses that the stationer was the proprietary author of the book, the one who was responsible for the content; authors had no right to their work once it was bought and published as then the copy was vested in the publisher.[24] As Johns makes clear, this responsibility was connected to the state's potential

to prosecute, which it was hoped would "eliminate unauthorized printing—the practice increasingly called 'piracy.'"[25]

What kinds of options did authors have in this situation? How could they control their authorship when the publishers' market-based conventions were so dominant? Did publishers control printed knowledge in this respect? As Johns argues, "Authorial civility was inextricably entangled with Stationers' civility. For the modern figure of the individualized author to be constructed, this had to change."[26] And the situation did change once authorship and copyright were embedded in law. With this, the notion of authorship started to change too. Johns points out that the Lockean idea of invention as the mark of property started to gain wider ground.[27] Martha Woodmansee stresses the role played by discourses of romantic aesthetics in this context, valorizing individuality with respect to notions of creativity, authorship, and ownership, which, together with the rise of a new class of authors (as writers making a livelihood from their profession), strongly influenced the construction of modern copyright and intellectual property protection.[28]

In opposition to Eisenstein and others, historians such as Johns and Chartier thus emphasize in their narratives that authorship and authority are foremost a matter of cultural practices and negotiation; they are conventions that could and can be challenged. We should see them as attributions to a book (by various groups and individuals, such as publishers, readers, etc.) instead of intrinsic attributes of a book, they argue.[29] As Johns claims, then, the author emerged out of the battle surrounding how and to whom a book should be attributed credit or ownership. For scholars, forms of appropriation were a natural part of publishing their book; to protect their reputation, they needed to negotiate potential hazards, such as piracy, translations, abridgements, commercial sustainability, and more, all matters that could deeply harm their intentions.[30] As the priority disputes in experimental philosophy, linked to publishing, grew increasingly complicated and urgent—since both the existence of a record and the identity of its contents mattered—a new proprietary culture was set up around authorship to deal with these problems, through which, Febvre and Martin point out, the profession of the author emerged.[31] Johns explains that fixity and authorship were thus set up together, as the establishment of a problem: "As the recognition of authorship blossomed, so, in a mutually reinforcing process, arguments demonstrating a resolved identity for printing began to win the upper

From Romantic to Posthumanist Authorship

hand, and the credit of its products became more widespread. By the end of the nineteenth century, print and fixity were as firmly conjoined by culture as ever could have been achieved by machinery."[32] Nonetheless, Chartier warns against pinpointing specific historical moments of construction or determining causes for the rise of authorship and the author function. In this respect, he stresses that book history needs to guard against a focus on univocal solutions or oversimplified causes. Book history can offer some insights into the authorship problem in all its variety—including the juridical, repressive, and material mechanisms Chartier himself focuses on—but it does not offer a definitive answer to what authorship was, is, and will be.[33]

What these book historical narratives do show, however, is that our modern notion of authorship is integrally linked on the one hand to the emergence of written communication and print, and on the other hand to developments in the commercial book trade, growing scholarly claims for priority and credit, and the expansion of ideas related to ownership, copyright, creativity, and originality. However, what I want to explore in this chapter is not where the agentic origin—or, as Chartier states, the specific historical moment of construction—of authorship (predominantly) lies; in other words, whether it was mainly established due to technological developments or due to changing discursive and societal practices. Instead I want to examine how these diverse agentic forces were aligned and aligned themselves around an intrinsically *humanist* authorship theory and practice, which should *itself* be seen as agentic and performative. By formulating and maintaining a discourse set up and structured around binary causations concerning the origins of authorship, the humanist characteristics that have shaped our authorial practices end up being further sustained. In the book-historical narratives described previously, authorship (or the humanist author-subject) is ultimately established as disconnected, as being separate from society, discourses, practices, and technologies, which are often too simplistically positioned as deterministic causes that enabled the emergence and rise of modern authorship. Yet authorship and/or the author-subject were materially established as hybrids through a process that incorporates multiple actors and agencies, including and as part of these position-takings, both now and in the past. In this sense, as I pointed out in the previous chapter, book history and book historians cannot take up a position that stands outside of authorship in their representations of it. Book historians materially shape the concept and practice of authorship

in specific ways through both their discursive position takings *and* their humanist authorial practices (e.g., when they sign their works as individual authoritative authors and when they write fixed, book-format commodities published by established presses).

Therefore, taking the view that authorship and the author-subject are not distinct autonomous entities, it remains important to highlight how authorship emerged together with the enlightenment and romantic ideals that structured its humanist focus. But authorship is simultaneously intricately bound up with the humanist characteristics now commonly attributed to the print-based book object (which proprietary authorship bound together tighter too, as we shall see in the next chapter). Fixed, essentialized, and bound as a book, romantic notions of authorship came to stand for a highly individualistic, authoritative, and original writer, who was to be connected to a permanent body of works. The commercial and capitalist nature of the book trade with its focus on propriety and ownership instilled the idea of copyright and property into the relationship between an author and her or his text. As such, the humanist aspects of authorship relate both to the book as object and to the social practices forged around it.

In this respect, it is useful to think further and in more detail here about how liberal humanism—through its notions of universalism and autonomy—has shaped the authorial debate, giving weight to the specific individual determinants of a text—be they its fixed form or its individual indivisible author as a specific "man of genius"—and thus determined the meaning attributed to it. Especially also in the context of academic publishing, wherein a specific mode of production has been installed, centered around individual authorship within academia, based on a unified author-subject and a fixed indivisible book object, both bound together by copyright. Yet at the same time, liberal humanism gained ground and became even more strongly established *through* mechanisms such as proprietorial (academic) authorship and the stable fixed book.

The first thing to point out here is that liberal humanism, as an ideology and practice characterized by specific social conventions, installed a universal definition of man into law, as part of which the figure of the individual proprietary author-owner of original book works was installed into copyright law. As such, humanism promoted an intrinsically normative and restrictive definition or convention of what it means to be human and, similarly, of what it means to be an author—a definition that of necessity

From Romantic to Posthumanist Authorship

excludes and discriminates. As Rosi Braidotti has argued in this respect, "The human is a historical construct that became a social convention about 'human nature,'" where the human as a standard was "posited as categorically and qualitatively distinct from the sexualized, racialized, naturalized others and also in opposition to the technological artefact."[34] Liberal humanism thus relies on binary distinctions to maintain and reassure the self as part of a process of exclusion, differentiation, and othering.

What kind of distinctions were then set up between the authorial self and its others within modern authorial practices? To determine this means examining how certain practices were regulated within authorship (restricting what counted and still counts as authorship) or excluded based on a specific normative mode set up around the individual humanist author—in which the author-subject was established as a rational, self-identical, proprietary individual. What has been excluded in this process—and thus established as a binary *other*—was characterized as *nonauthorship*, from plagiarism to piracy and anonymity. This process has seen diminishing roles for the various distributed (posthuman) agencies involved in knowledge production and consumption, from publishers and booksellers and editors to the book itself. This setting up in a dialectic relationship of radical alterity, practices that no longer abided to these now hegemonic and normative forms of individual proprietary authorship, functioned to reassure the humanist author-self and at the same time to control this alterity of "that which stands outside of authorship." The question I want to ask here is how we can then start to challenge and deconstruct this dictatorship of the human and its supposed "natural" or normative practices, in the name of an ethics and politics of alterity.

Although these humanist notions of authorship—including the connotations of reputation, individual creativity, ownership, authority, attribution, responsibility, and originality they came to carry—seem to be an integral part of the scholarly method, they are not "natural" or "normal"; even though they have been and are often critiqued, they remain normative and very hard to replace or overcome. As such, although many within academia have professed a need to challenge the universal validity of the stable author subject and the book object (as we are aware, they have none), we keep assigning meaning to the individual author in the way we produce and author books, in the way we measure impact, and in the way we assign responsibility to research.

Kathleen Fitzpatrick writes in her article "The Digital Future of Authorship: Rethinking Originality" about her personal struggle with traditional notions of authorship, a struggle not uncommon to other academic authors—including the author of this book.[35] As remarked upon at the beginning of this book, Fitzpatrick states that although we try to criticize the way authorship functions in academia and society at large, "our own authorship practices have remained subsumed within those institutional and ideological frameworks."[36] Connected as it is with our scholarly and publishing practices, one of the biggest challenges with respect to changing our notions of authorship will therefore be, as Fitzpatrick argues, that "changing one aspect of the way we work of necessity implies change across the entirety of the way we work."[37] For instance, if we want to move toward an authorship function that puts more emphasis on openness, sharing, experimentation, and collaboration, this means that we need to reconsider where scholarly authority, originality, and responsibility lie in a digital environment and whether or not we really need them (and, if so, at what specific points or moments in time). In this respect, as Derrida has pointed out, we "cannot tamper with it [the form of the book] without disturbing everything else."[38]

Notwithstanding its ubiquity and engrainedness, it is important to continue to challenge these humanist concepts, discourses, institutions, and practices as they relate to authorship within academia. Not the least because these essentialized notions of authorship do not do credit to the more collaborative and networked authorial practices as they exist currently and have existed in the past, in academia and beyond. As Johns and Chartier emphasize, agency is more complex and distributed than the highly individualist narratives accompanying romantic notions of authorship argue for. In this respect, there is an ongoing clash between what Robert Merton has identified as the values of originality and communism in scholarship.[39]

Yet another reason to challenge humanist concepts of authorship relates to the function currently fulfilled by authors in the political economy of academia. In an effort to gain reputation and authority in a scholarly attention economy, academics are increasingly depicted as being in constant competition with each other (for positions, impact, funding, etc.); scholars are still rewarded mostly on the basis of their publication track record and on their reputation as individual authors. Academic authors on the one hand are turned into commodities while on the other they increasingly need to act as entrepreneurs and marketeers of their own "brand."

From Romantic to Posthumanist Authorship

Not the least via social research-sharing websites such as Academia.edu and ResearchGate, which are not arranged around the research that is being shared, to provide just one example, but, again, according to author profiles created around publication lists. This objectification of authorship at a time when "unoriginal" thought, depicted as plagiarism, is heavily combated and frowned upon goes against some of the more distributive and collaborative notions, practices, and discourses of authorship described previously. Yet the latter can be seen to not only be just as prevalent in contemporary academia but in many ways to be a more realistic depiction of scholarly authorial practices—although they are not the ones that necessarily push one's academic career forward.

The strength of the humanist discourse of authorship in academia can also be seen to inhibit experimentation with different models and functions of authorship—and forms of what can be called *posthumanist authorship*, which I more fully explore at the end of this chapter—and the potential of digital media to help rethink what authorship is and can be. This does not mean that digital forms of authorship are always a critique of the humanist notions underlying more traditional and print-based forms of writing. However, I want to emphasize that, no matter how problematic they still might be, we should still experiment with digital media technologies to explore how they might help us rethink and reperform authorship and envision more ethical and inclusive forms of authorship within academia.

To analyze some of the main theoretical and practical criticisms that have been brought to the table with respect to romantic and humanist notions of authorship, it is essential to explore the authorship theories put forward by poststructuralist thinkers in the 1960s and 1970s. The by now classic antihumanist critiques coined by Roland Barthes and Michel Foucault examined and questioned romantic and humanist forms of authorship by analyzing the specific subject position and agency of the author and the relationship of authorship to text, writing, and the work. In his essay "The Death of the Author" (1967), Barthes describes how authorship kills the text by stabilizing it. It is authorship in this sense that tries to affix a definite meaning and that has been used over the centuries as a strategy to read meaning into texts. This process reaches its culmination, as we have previously established, in capitalist society, where work and author are united in a commercial product. However, in his anti-intentionalist critique of authorship, Barthes states that we cannot affix a stable meaning to a text via the authorship function

as it does not (fully) control it. He focuses instead on the multiplicity of meanings (heteroglossia) and threads that are available in language, in the relationships between texts (intertextuality), and in the act of writing, and which are extracted through the person of the reader. In Barthes's vision, then, text, and its multiple meanings, comes into existence in the act of reading, not when the author is creating it. In this respect, Barthes's critique initiated a move away from the integral connection between an author and her or his work, focusing more on the performative character of text and language and the meaning attribution by readers instead.[40]

Foucault has drawn further on Barthes's critique in his seminal paper "What Is an Author?" (1969). Foucault here directly relates the notion of the author to the humanist framework I described earlier—that is, to a moment of individualization in history, connected to ideas of attribution and authenticity. A move away from authorship such as that proposed by Barthes will not be enough, Foucault claims, as this has to involve a similar departure from the idea of the single, stable, and often bounded work that is still integrally connected to our notion of the author, even if we abandon authorial meaning attribution. In this respect, Foucault makes the pointed argument that a critique of authorship necessarily implies a critique of the work and, in this specific context, of the scholarly book. Where does a work end when it becomes no more than a trace of writing, disconnected from a specific author? What this implies is that both the notion of the work and of the author are problematic, and replacing the latter's authority with the former will not be very helpful. As such, Foucault stresses that we need to analyze the *functions* authorship fulfills in a society, such as the way authorship operates within a certain discursive setting to bind together a group of texts and establish a relationship among them. We need to critically reassess these functions as being the representation of certain discourses within a society, discourses focusing on ownership of research (appropriation) and related to (penal) responsibility. In Foucault's vision, authorship is thus a function of discourse. This shows the inherent material nature of discourse, where through authorship discursive structures turn from acts into things, goods, and property. And as Foucault states, criticizing Barthes in this respect, authorship is only one of the discursive practices that need to be analyzed.[41]

Following Foucault, I want to explore here how authorship and knowledge get to be produced in our knowledge economies and whether we need to reassess or change these discourses. In what ways do we construct an

From Romantic to Posthumanist Authorship

author and how do we determine the origin of a work? How can we rethink knowledge products, authority, truth claims, and originality? In what sense is an author function introduced to regulate meaning? By questioning the author, Foucault states, we are not simply freeing the text; we are interrogating the work at the same time, the latter being the extension of certain discursive practices within a society.[42]

Barthes and Foucault's writings on the death of the author, the author function, and the role the author plays in capitalist knowledge production have proved to be tremendously important for literary theory and authorship studies. In particular, next to decentralizing the author as the main and only locator of meaning in a text, they have played a significant role in focusing attention away from the humanist idea of what an author *is* and instead on what an author *does*.[43] At the same time, they have also helped to place more attention on the discursive historicity of both authorship and the work. Nonetheless, it can be argued that both Foucault and Barthes didn't in practice do much to critique their own authorship position, status, and practices and were themselves often writing in a very authorial and traditional way, focusing on the authority and originality of their mostly individually authored and published texts. In this respect, their work at times lacked a practical or practice-based performative dimension.[44] However, the examples of authorship critique that I want to discuss next *can* be seen to offer a more practical critique of authorship, experimenting with and taking into consideration the potential of the digital medium while targeting specific aspects structuring the romantic, humanist authorship discourse in academia.

Reperforming Authorship: Hypertext, Networked Collaboration, and Remix Practices

The three examples discussed in this section can all in different ways be seen as a practical extension of the poststructuralists' critique. These more embodied expositions target different aspects of the discourse of the liberal humanist author, from the author's authority and individuality to its originality and proprietorship. First, the specific position taken by theorists and practitioners of hypertext is analyzed with respect to networked authorship, challenging the authority of the author by focusing on the power of the reader and on the author as a node in a distributed network of meaning production and consumption. After that, some of the authorial practices that

have been developed in the sciences and increasingly in the digital humanities are explored, such as hyperauthorship, and networked and collaborative research work. These practices are challenging the individualistic nature of authorship and are promoting increasingly open-ended research and alternative (digital) views concerning creativity and invention. This section ends with an exploration of academic remix practices, which mainly critique how so-perceived original ideas are attributed to authors as their (intellectual) property; as an alternative, the trope of the remixer or curator seems to be increasingly making inroads in current scholarship on digital authorship (and the narrative of the latter seems to be replacing the former).

Hypertext

Hypertext, defined aptly by the Electronic Labyrinth project as "the presentation of information as a linked network of nodes which readers are free to navigate in a non-linear fashion," has been classified as a practical application of Barthes's and Foucault's criticism of authorship, at least to the extent that in hypertext debates the focus returns to a critique of authorship exactly from this perspective of a new (literary) practice.[45] For example, as literary scholar George Landow points out, hypertext can be seen as the "electronic embodiment of poststructuralist conceptions of textuality" and it thus "reconceive[s] the figure and function of authorship."[46] Hypertext scholarship is among other things interested in bridging the gap between the author and the reader, where the reader increasingly becomes the author of the hypertextual work that is being consumed and interacted with, challenging and blurring the authorial role.[47] Here the argument is that in hypertext theory, the figures and functions of author and reader become more deeply entangled, with authorial power redirected to the reader. According to Landow, this is possible due to the read/write capabilities of the net and hypertext, for example. This offers the reader interactivity and the possibility to choose their own way through a work, via hyperlinks to other textual nodes and locations, and thus to create their own meaning based on that path. In a networked hypertext environment, the reader then becomes the *performer* of a text, with each text a unique enactment. As such, hypertext suggests a changed relationship between the reader and the text. The multiple meanings of a work and a text, as theorized by Barthes and Foucault, are thus arguably more practically embodied and visualized in the production and consumption of hypertexts. As such,

From Romantic to Posthumanist Authorship

radical changes in textuality or in the material object, such as with hypertext, will cause radical changes in authorship; hypertext's lack of textual autonomy, its unboundedness, disperses ideas of authorship too.[48] Instead of the author-subject and the bounded text-object, we now have the network, in which both are decentered. Hypertext can thus be seen to embody a decentered textuality, open and interactive, where, due to its capacity to transform on a continuous basis, it is simultaneously dispersed, performative, and processual.[49]

Notwithstanding the potential of hypertext theory to decenter the author's authority, it keeps many of the other juridical and economical authorship functions in check. We see this if we look at an early practical installment of hypertext, *hypertext fiction* or *hyperliterature*, a specific hypertext-based genre of electronic literature (although hypertext fiction is not solely digital), which was seen to embody many of the possibilities the argument outlined previously focused on. Yet although hypertext fiction introduced a practical multiplicitous conception of authorship or of the prosumer (the reader as author), for example, it did not fundamentally deconstruct the various other functions that are part of the romantic, humanist notion of authorship and the way it has been embodied in our institutions and practices. For instance, hypertext fiction works continued to be mainly published as complete and finished works or commodities. In their early distribution mechanisms, using CD-ROMs or particular forms of software and/or platforms such as Storyspace and Intermedia—which were utilized by well-known hypertext authors such as Shelley Jackson and Michael Joyce—hypertext fiction also remained "bound" together (albeit in a different way than books), both in a medial sense and bound together by their authors. For hypertext fiction still very much came with a recognizable author, including a copyright disclaimer. Not only do hypertextual works thus remain recognizable by a distinct author, they also continue to function in terms of a reputation economy with clear attribution and responsibility, and in this respect the originality of the work is also still attributed to the author.

We can clearly see this at work in the Electronic Literature Directory (ELD), an influential collection of e-lit works, descriptions, and keywords/ tags, which includes many works of early hypertext fiction.[50] The ELD, maintained by the Electronic Literature Organization, is organized around individual works and their authors, and not, for example, around specific readings of a work. Although the ELD focuses on "irreproducable reading

experiences" and on "the interventionary actions of an active reader,"[51] it has not organized its directory around these experiences—although it does recognize its entry authors and their specific reading experiences, and it allows you to search for their additional entries in the ELD. But these reviewers/readers/authors are not listed as a specific category in the main menu, which could have given them more authority, for example. As such, these entry authors and their reading experiences are not on par with the works of hypertext fiction and their authors when it comes to the directory's organization.

In the dynamic between author and reader within hypertext, the author also continues to stand out as the designer of the hypertext, where the specific paths or linearities created remain prescriptive in many ways. In what sense is this authorial predescription then not already fixing possible meaning association for readers? As it is still the author who defines relationships within a hypertext, it can be argued that readers remain second-grade authors: it is an ad hoc relationship. Partly due to the complexity of many hypertext fictions, when it comes to the interactivity promised by early hypertext works, on reflection this can also be judged to have been rather low. The different paths and structures within hypertext can seem problematic and do not always create a coherent narrative for readers; on a design level, many of the interfaces were also hard to navigate.[52]

Instead of seeing hypertext as a radical discontinuity, which is how many of hypertext's proponents have presented it—perceiving hypertext, as Jay David Bolter has argued, as a revolutionary break with the past, similar to the rhetoric of modernist artists and writers—such a dichotomous schism between the old and the new, and between networked or hypertext authors and print authors can be seen as overstated, as many print texts and works (from fiction to scholarly works) already functioned according to hypertext structures.[53] Was print reading not always already collaborative and performative too in this respect? And does the author function really undergo a practical critique in a setting where artistic creativity and ownership and the authorial acknowledgement of works still remains an important aspect of the networked environment?

Collaborative Authorship
Initially, hypertext structures were mostly experimented with in a specialized literary-academic context, but increasingly aspects of hypertextual structures

(especially its hyperlinking capacity) have become more common in digital academic communication, and many of the elements of hypertext practice and theory are being experimented with in both formal and informal digital publishing. In this respect, developments in digital tools and media, from blogs to wikis to online collaborative writing, annotation, and commenting systems, have made readerly interaction with and prosumption of academic texts easier and more convenient. Indeed, experiments currently taking place within the field of digital humanities—which has been defined as "not a unified field but an array of convergent practices"—can be seen to try to move beyond some of the issues with readerly interaction that hypertext faced.[54] As Fitzpatrick has argued in this respect, experiments in hypertext "may have pointed in the general direction of a digital publishing future, but were finally hampered by difficulties in readerly engagement, as well as . . . by having awakened in readers a desire for fuller participation that hypertext could not itself satisfy."[55] Within academia, however, a practical authorship critique of its own had started to develop, one which has been mainly based upon two developments: the rise of digital tools, media, platforms, and networked environments in scholarly research, which has led to new forms of networked collaboration; and the growth, especially in a scientific context, of massively collaborative projects, following the principles of networked science.[56] These developments have led to an enhanced questioning of the romantic humanist discourse of single authorship, especially within those fields in the sciences and the humanities in which the adoption of digital tools has been the most apparent.

One example of a discipline in which the humanist discourse on authorship as it normally functions within academia has become a serious problem is high-energy physics (HEP). As we have seen, from the seventeenth century onward, the appropriation of credit and the allocation of accountability developed as simultaneous processes, based on the idea of a work written by an individual author.[57] Jeremy Birnholtz argues, however, that even though authorship is the accepted method in science to assess contributions of researchers to their specific discipline—playing an important role in the reputation economy and as a measurement of symbolic capital—it can be difficult to recognize an individual's contributions to a research article, something that becomes increasingly problematic on highly collaborative projects. For example, in HEP, the authorship model has not been functioning very well in the traditional sense as the number of people working on a collaborative

project can run into the hundreds. It is therefore not uncommon that every article authored by a research team member lists *all* the participating physicists on that particular project, a phenomenon known as *hyperauthorship*.[58] In 2015, a physics paper by the team at the Large Hadron Collider at CERN with 5,154 authors broke the record for the largest number of contributors to a single research article. Published in *Physical Review Letters*, twenty-four pages of the thirty-three-page article are taken up by a list of the authors and their institutions.[59] The problem within such a regime of hyperauthorship is that it leads to *diffusion of responsibility* as it becomes impossible to determine where ultimately authority, credit, and accountability reside. Authorship without responsibility becomes literally meaningless, Blaise Cronin points out, as responsibility, in the form of affixing authority, credit, and accountability, is an essential part of the standard "rights and responsibilities" model of authorship in the current scholarly communication model. For instance, I have the right to claim credit and symbolic capital for my authorship but also the responsibility to defend and stand behind my claims and take the blame if they are flawed.[60]

This has led to a situation where, in HEP, the reputation economy no longer works on the basis of authorship or formal records of contribution, but increasingly runs via informal means of assessment and evaluation.[61] This informal system of recognition relies on word-of-mouth recommendations and the ability to get noticed within large group collaborations. Credit here does not come from publications but from establishing a reputation within the work group. Although traditional authorship has therefore become problematic within this environment, and the idea of individual responsibility seems to be bestowed upon the group and on collaborative notions of authorship within HEP publishing practices, the rights and recognition part of the standard model of authorship continues to run via individual recognition. In addition to this, to address the issue of (the lack of) responsibility within group authorship, there have been experiments with appointing guarantors to articles (accepting full responsibility for the work) and, with digital badges, denoting a contributor's specific individual research contribution on a project.[62]

Although hyperauthorship is not particularly common in the humanities and social sciences to date, where the single author still dominates most fields, the example of HEP does raise some problems that can be related to accepted notions of authorship in these contexts too. First, it shows that

From Romantic to Posthumanist Authorship

different research cultures have different approaches to authorship and to issues of social trust, as well as various ways of awarding responsibility and recognition for research findings. This emphasizes that there exists no standard concept or definition of authorship that traverses the various research communities. There are different definitions of authorship, and these tend to change too within fields, making them contingent. These examples all seem to underscore that authorship is a social construct, not a natural fact, and that these constructs, and the way authorship "functions," differs between epistemic communities, both within the life sciences and in contrast to the humanities and social sciences.[63] Second, the examples from HEP show that what we perceive as the standard romantic discourse of authorship has a problem when it comes to distinguishing different kinds of research contributions and collaborations. It only works within certain limits, limits that HEP and biomedicine seem to be exceeding and that are also increasingly being challenged in the humanities and social sciences.

Collaboration and coauthorship practices, combined with a discourse that encourages collaboration, have been on the rise in the humanities and social sciences too, especially in the digital humanities and adjacent fields, in which digital tools and increasingly also scientific methods for conducting research are being applied to humanities research.[64] Collaboration is seen as an essential aspect of the research culture here.[65] As digital humanist Lisa Spiro puts it, "Work in many areas of the digital humanities seems to both depend upon collaboration and aim to support it."[66] Simeone et al. explain this in more detail with the example of data mining: "With computational tools, digital archives can reveal more than they obscure by providing organizational frameworks and tools for analysis. However, these tools—in the guise of metadata organization, indexing, searching, and analytics—are not self-generated. They require the combined work of humanists with their interdisciplinary questions and computer scientists with their disciplinary approaches to partner with one another to produce viable research methodologies and pedagogies."[67]

Digital humanities research needs collaboration but also depends on reliable infrastructures and platforms to make collaborations possible. In this context, digital humanities research tends to situate itself in laboratories or "labs" and is often organized around "projects" to emphasize its collaborative nature.[68] Collaboration is visible in the valuable support received from, among others, librarians, IT departments, and computer scientists, which

are only slowly being acknowledged as full-fledged contributors to digital humanities projects.[69] There is thus a continued call within this environment to give credit to the various alternative academic (alt-ac) collaborators in digital projects, following nonstandard academic careers such as the ones mentioned earlier, in which efforts are made to "establish computing practitioners and non-technical scholars as equals in research," for example.[70]

Collaboration is also visible in the "nondigital" humanities—if only by taking part in the "great conversation" of scholarship. In the process of preparing a publication, we rely on others in multiple ways, both online and offline—for instance, via comments at conferences, in blogs, and on social media, via peer reviews, and via support from editors, proofreaders, copy editors, book designers, printers, and so forth.[71] There is also a growing amount of interest, in both the "traditional" and the digital humanities, in environments and platforms for online collaborative work—in the case of international or cross-institutional research projects involving multiple project members, for instance. This has led to the rise of informal collaboration online (e.g., with the aid of software such as Google Docs and Dropbox, document annotation on platforms such as Academia.edu, Medium, and PubPub, and via a wide variety of online project-management tools) and more formal collaboration through what have been termed *collaboratories*, *virtual research environments* (VREs), digital research infrastructures (such as DARIAH in the EU), and other instantiations of collaborative teams and technologies within the humanities.[72] As Simeone et al. show in their discussion of one of these collaborative projects, with the rise of large-scale, multiparticipant collaborative research projects, the authorship of articles, papers, and books written by project team members becomes problematic as it is hard to establish individual and collective contributions—similar to the situation in HEP.[73] The romanticizing of the sole author in science and scholarship leads to a notion of science as a stream of *geniuses* and inventors, intrinsically connected to a cultural and historical context that privileges individual creativity.[74] This narrative stands in strong contrast to the community aspect of networked scholarship that can similarly be perceived to be at the basis of our scholarly practices and seems to be increasingly so—especially if we take into consideration the importance assigned to it within digital humanities discourses.

However, within the digital humanities, further reasons have been developed that we need to be critical of our standard notions of authorship, as some have argued that they are becoming increasingly hard to sustain in a

From Romantic to Posthumanist Authorship 93

digital environment that can be seen as privileging *process* over product. As Fitzpatrick explains, online texts, such as blogs, tend to work via a logic of commenting, linking, and versioning, stimulating the open-ended nature of networked writing and producing texts that "are no longer discrete or static, but that live and develop as part of a network of other such texts, among which ideas flow."[75] Research in blogs especially—which, among social media use, are becoming more common in academic scholarship—but also in other forms of online publications, from wikis to e-books, can be updated and changed—not only by the author(s), but increasingly by the community at large too.[76]

Various publishing projects, platforms, and software within the (digital) humanities have over the last years started to explore processual and collaborative forms of publishing and reviewing, from Open Humanities Press's Living Books series (mentioned in the introduction and explored in more depth in chapter 5), which were published in wikis open for others to edit after publication, to the processual books recently initiated by the University of Minnesota Press on its Manifold platform, which enable readers to follow and comment on research as it evolves online. But we also see this in platforms and technologies such as MediaCommons Press, CommentPress, PubPub, and Hypothesis, which all enable online commenting on and annotation of research documents, often both before and after they have been (in)formally published.[77]

This challenges the notion of a fixed text and with it the author's authority based on that fixed text, which, as Cronin has argued, is an essential aspect of the traditional rights and responsibilities model of authorship. As Susan Brown et al. state with regard to the open-endedness of digital humanities research: "Scholars will increasingly be able to build on existing electronic texts, restructuring or adding to them, or recombining them with new content to produce new texts. In a radical extension of earlier forms of textuality, the possibility that an electronic text will continue to morph, be reproduced, and live on in ways quite unforeseen by its producers makes 'done' to an extent always provisional."[78] In this respect, traditional authorship, similar to what we discussed previously with respect to hypertext, is judged as having a hard time accommodating rival claims of authority from a reader or community perspective.

In practice, however, ideas based on the processual and unbound potential of digital works are still facing difficulty. Discourses building on print-based

authorship, with its notions of individual ownership and authority, have functioned within academia as solidifying processes, where scholarship is from its inception already being created to function as a product to exchange on the reputation market. This process is institutionalized and enforced within the professional publishing system. David Sewell, editor at the University of Virginia Press, explains how under economic external constraints, the open-ended or processual character of both digital and traditional publications can be sacrificed once they become part of the formal publishing process:

> But completely extrinsic factors such as the desire to include the book in a particular season's list will often lead a press to veto an author's wish to continue tinkering with a manuscript. Similarly, an author may not consider a monograph on Chinese art formally complete without the inclusion of several dozen full-page color reproductions on glossy inserts, but a publisher may omit them for the wholly extrinsic reason that the profit-and-loss sheet doesn't budget for them. Once a book is in print, decisions about its subsequent "done-ness" (i.e., whether to reprint, revise, issue in paperback, etc.) are based almost entirely on economic factors. In the case of digital publications, I will suggest, extrinsic factors become important at an earlier stage and are proportionately more important at every stage of composition and publication.[79]

But this insistence on creating a finished marketable object, favoring product over process, cannot only be blamed on publishers. Fitzpatrick emphasizes the "distinctly Fordist functionalist mode of working" of scholars as writers, where in the reputation economy surrounding academia, the ultimate goal of research projects is final completion, the moment when a new item can be added to one's CV as evidence of scholarly productivity.[80] We can similarly see how this reputational pressure plays out in authorship practices within the digital humanities, where, contrary to its celebration of collaboration and group work, scholars continue to mainly publish single-authored articles. Research by Nyhan and Duke-Williams shows that, notwithstanding efforts within the digital humanities community to enable and promote collaborative authorship through statements such as the Collaborators' Bill of Rights, single authorship remains predominant in the sample that Nyhan and Duke-Williams took from some of the core journals within the digital humanities.[81] As they state, this does not necessarily indicate an absence of collaboration on the research that has contributed to these single-authored articles—but it does exemplify the continued conformity

with publishing according to established print-based authorship practices, even within the digital humanities.[82]

The narratives and institutional customs mentioned thus far all in different ways argue for a revision of our discourses on, and practices of, individual authorship. Rethinking and reperforming authorship might aid in promoting the discourse of collaboration that similarly accompanies authorship, as well as the newly developing digital research practices and their potential underlying values of scholarly openness, experimentation, and sharing. However, in these narratives, collaborative authorship still seems to focus mainly on *extending* (e.g., to include alt-ac contributors) forms of individual authorship to a larger group, instead of critiquing fundamentally the notions that individual humanist authorship is based upon. We can find an example of this in Fitzpatrick's book *Planned Obsolescence*, in which she makes a passionate plea for the need for community and collaboration in (digital) humanist and experimental research and publishing projects. Yet when Fitzpatrick talks about forms of collaborative authorship in *Planned Obsolescence*, her focus seems to be primarily on stimulating interaction and conversation and on getting the collaborative aspects of scholarship acknowledged more widely. Fitzpatrick's can be seen as a reformist stance in this respect, rather than a disruptive one: her critique of authorship focuses mostly on fostering individual authors' sense of community in order to stimulate their writing practices and to find more pleasure (as opposed to anxiety) in their writing process.[83] As she states, her aim is "less to disrupt all our conventional notions of authorship than to demonstrate why thinking about authorship from a different perspective—one that's always been embedded, if dormant, in many of our authorship practices—could result in a more productive, and hopefully less anxious, relationship to our work."[84] As Gary Hall has pointed out in this respect, Fitzpatrick "does not really offer a profound challenge to ideas of the human, subjectivity, or the associated concept of the author at all," nor is she "radically questioning the notion of the human that underpins [quoting Stanley Fish] 'the "myth" of the stand-alone, masterful author.'"[85] Her notion of collaborative authorship thus seems to be mainly based on the idea of a group of "'unique,' stable, centered authors . . . now involved in a 'social' conversation 'composed of individuals.'"[86]

From this perspective, one can question whether the collaborative authorship practices promoted in networked science and the digital humanities are

really an embodiment of the antihumanist critique put forward by thinkers such as Barthes and Foucault. Especially when, to provide yet another example, in the instrumentalist rhetoric of Michael Nielsen, networked science is foremost focused on aiding discovery, more than it is on challenging the problems individual authorship has created for the way our institutions, practices, and political economies of research production currently operate.[87]

Nonetheless, following Foucault's plea to rethink the way authorship *functions*—in this context within academia—experimenting practically with new forms of collaborative authorship might be seen as a way of beginning to reperform and recut authorship in a more ethical way. However, in this process, as scholars we have to remain wary of simply replicating our liberal humanist authorship discourses and practices as part of our notions of collaborative authorship, which means that we should remain critical toward these alternative forms of authorship in a continued fashion too. For example, replacing individual authorship with forms of community knowledge production can still promote liberal hegemonic forms of control and, as I have written elsewhere, runs the risk of creating "problems of conformity, groupthink and bias in online communal knowledge production."[88] How can we in this respect continue to critique the potentially "oppressive aspects of the consensus model of community," as Fitzpatrick calls it?[89]

Remix Practices

Questioning the individual notions of authorship that we have adopted within academia and exploring how different forms of agency are involved in our authoring practices also leads us to explore how our writing is always a cowriting, how it always builds on the writing of others. In many ways, remix can be seen as an essential notion underlying our academic writing practices, where our research is embedded within a larger conversation that we draw upon, cite, analyze, synthesize, and juxtapose in various ways: from reworking arguments and citations into a new work to drafting and redrafting scholarship from and out of notebooks and reconfigured index cards. We also version and reuse content for different types of publications (where it occurs in different guises in anything from blog posts and reports to abstracts, papers, announcements, funding applications, etc.). What I want to explore here is how remix practices within academia—from combining different media in innovative ways to collaboratively (re)mixing fragments of texts in new contexts—not only offer an alternative vision of

From Romantic to Posthumanist Authorship

collaborative authorship but also challenge one of the other main aspects of romantic, humanist authorship: its discourse of originality and, related to that, of ownership of original works.

Yet at the same time, remix practices have also been critiqued in a variety of ways from a scholarly perspective. For instance, they have been attacked from a viewpoint declaring that in a digital environment, these practices take on a "wide democratic approach," in which everyone is able to update, reuse, and remix online content. Critics such as Andrew Keen and Sven Birkerts see this as a threat to expert knowledge and as diluting the distinction between amateur and professional content.[90] Others have criticized Wikipedia, which is based on the online collaborative editing and re-editing of encyclopedic or topical entries, for its perceived failure as a reliable source due to the lack of credentials of its editors.[91] Remix practices also have the potential to challenge the idea of a stable scholarly work and pose a problem for the idea of the integrity of the scholarly object. They thus question the idea that fixed scholarly objects exist and should even be preserved as discrete entities.[92] Remix practices are therefore seen as posing a challenge to our traditional conception of authorship while presenting a problem for responsibility and attribution in the scholarly reputation economy.

However, many contemporary scholarly remix practices are in essence much less radical and less of a threat than they are sometimes perceived to be to the practices, institutions, and discourses that surround the fixed-print regime that continues to structure academia. I am thinking, for example, of remix practices such as the use of Creative Commons licenses for scholarly publications, which in many cases (such as the CC BY attribution license) allow for the reuse of material, or those practices associated with Wikipedia. But I am also thinking of strands within remix theory, including arguments put forward by theorists such as Lev Manovich, Eduardo Navas, and Lawrence Lessig, that focus mainly on finding a place for humanist and essentialist notions of attribution and authorship *within* remix practice and scholarship. As I outline in the next section, although remix practices in academia, including the notion of the selector or curator, wikis as a research method, and Creative Commons licenses, have the potential to shake up the authorship function, until now they have not managed to dethrone the traditional academic author-god—and in some cases, they even end up reinforcing her or him.

The Selector or Curator

One of the proposals offered in discussions on remix to grapple with the problem of authorship in an increasingly online networked setting is to shift the focus from the author to the selector, the moderator, or the curator. This is one of the suggested solutions explored by remix theorist Eduardo Navas, especially in the realm of music. In music, authorship, as Navas states, is increasingly being replaced by sampling, and "sampling . . . allows for the death of the author," where it is hard to trace the origin of a tiny fragment of a musical composition.[93] This makes authorship and writing into something distinct from an original work; it becomes an act of resampling, selecting, and reinterpreting previous material. As Navas points out, with the death of the author as the one who creates a new and original work, the author function in the Foucauldian sense of selectivity takes over. Navas argues in this respect that s/he who selects the sources to be remixed takes on the critical position or the needed distance to the material used in remix, and with that takes on a new author function.[94]

One of the problems with replacing the idea of authorship with the idea of the selector, however, is that this move only shifts the locus of authority from the author to the selector. Selection, although incorporating a broader appreciation for other forms of authorship or for an extension of the author function, can all too easily be just another form of humanist and individualistic *agency*, and so does not necessarily offer a fundamental challenge to the idea of authorship or authorial intention. Along with not inherently confronting the idea of authorial authority and intentionality, the selector also cannot be seen as automatically critiquing or rethinking *authority*, as authority is frequently just shifted from the author onto s/he who selects or curates, who still carries responsibility for the selections s/he makes. What happens when the author function is further decentered and agency is distributed within the system? And what do we do with forms of nonhuman authorship? It becomes increasingly hard to establish authority in an environment where the contributions of a single author are hard to trace back or where content is created by anonymous users or avatars, for example. Or, indeed, in situations in which there is no human author and the content is machine-generated based on certain tags, algorithms, or protocols, such as is the case with data feeds, where users receive updated data from a large variety of sources in a single feed. As such, the role of the selector as an

From Romantic to Posthumanist Authorship

authoritative figure is diminished when selections can be made redundant and choices can be altered and undone by mass-collaborative, multiuser remixes and mash-ups. At what point then does it become necessary to let go of our established notions of responsibility and authority as they become impossible to uphold? What alternative cuts can we make that start to move in directions beyond individualistic forms of authority and toward distributed and posthumanist forms of authorship?

Another difficulty associated with replacing the author with s/he who selects is that this doesn't really offer a critique of the profit- and object-based aspects of the system of individual authorship and therefore doesn't form a challenge to the traditional idea of *ownership* as it is connected to authorship.[95] As Bill Herman shows in his excellent article on the DJ as an author, the DJ is *made* an author, not by what they do, but by the representation of their practices in a capitalist system. As Herman points out, the DJ was instilled with authorship by the music industry by marketing them as a brand name and promoting the sale of commodities related to the DJ. In this sense, the DJ is a tool; the author as selector becomes an object from which commodities can be derived. Herman argues that initially in remix culture we could see the disappearance of traditional forms of authorship. As he explains: "The authorship that was traditionally invested in the performers of songs was deteriorated as the songs' individuality disappeared into the mix."[96] The DJ started out playing a background role, foregrounding the artists and numbers that were being remixed; they themselves were just another member of the party. This situation didn't last long, however. Following the logic of profit and capitalism, authorship was soon reestablished on an even stronger basis. The DJ became a superstar to fill a commercial void, eventually leading to the DJ being instilled by music producers as another Barthesian author-god.

Herman makes a compelling argument for seeing the commodification of music via the DJ figure as a crucial part of the author function in the music industry.[97] Furthermore, he offers additional weight to the idea that the author function is a sociological construct, instilled upon the author—for instance, by cultural businesspersons within the music industry. The author is created as an integral part of a larger set of social relations, a system of exchange that is governed by the logic of capital. As Herman states: "The DJ's authorship becomes the discursive solution to an economic problem."[98]

Wikis

Where the selector or curator in many ways can be seen to further instill liberal humanist forms of authorship, taking on the authority and ownership functions connected to the idea of the individual author-owner, forms of communal writing might further disturb this connection to individuality. For example, wikis, web applications that allow users to directly edit and modify content online in a collaborative manner, can be seen as an important experiment in cultivating new understandings of what it means to be an author based on ideas of collective authorship.[99] By being open to anyone while maintaining the relative anonymity of their authors, wikis have the potential to break down the authority of the specialist and replace it with forms of crowd-sourced authority. Wikipedia is the most famous example here; its peer-production potential was seen to compete with traditional sources of expert knowledge such as the *Encyclopedia Britannica*.[100] Whereas in early hypertexts the potential for user interaction was still arguably low, with the implementation of hypertextual elements into a wiki environment, the distinction between readers and authors in practice seems to almost disappear.

However, wikis are envisaged and structured in such a way that authorship and clear attribution—and therefore responsibility, as well as version control—remain an essential part of their functioning. The structure behind most wikis is still based on an identifiable author—or at least an identifiable IP address—and on a version history that lets you check all changes and modifications if needed. Wikipedia, the largest public wiki and one of the most well-known examples of a wiki functioning via the structure described previously, also encourages authors to sign their articles. As it states on Wikipedia's Etiquette page: "Unless you have an excellent reason not to do so, sign and date your posts to talk pages (not articles)."[101] Wikipedia is also increasingly moderated, and some of its moderators have more power than others, thus in a way becoming not unlike curators.[102] In reality, the authority of the author is therefore not fundamentally challenged in Wikipedia; nor does its authority really come to terms with the element of continual updating that wikis evoke. In this way, Wikipedia can be seen to struggle between traditional notions of authorship and credibility and the more communal crowd-surfed ideologies of openness it is said to support; the prevalence of print-based authorship notions still seems to be strong here. Juridical researcher Ayelet Oz argues that there is "a conflict between

the aspirational and organizational goals" within Wikipedia. As she points out: "The enforcement mechanisms on Wikipedia enact an internal conflict between Wikipedia's open, inclusive ethos and its organizational reliance on power, hierarchy and punishment."[103]

Yet even though wikis are still largely structured according to print-based notions of authorship and version control, the relative anonymity they offer to authors might explain why their uptake hasn't been really significant within academia. It might also explain why collaborative work on documents within the humanities predominantly seems to take the form of comments in the margins of a source or draft text. This becomes clear from the uptake of popular collaboration and annotation software and platforms such as Google Docs,[104] shared Dropbox files, Hypothesis, and Comment-Press. This specific form of collaborative text editing and commenting in the margins has also been incorporated in large platforms such as Academia .edu and Medium (and it forms a core aspect of the University of Minnesota Press's Manifold platform for processual monographs, for example), all of which are regularly used by academics in the humanities for research purposes and collaborative work. This preference for commenting or suggesting, instead of direct editing, might be related to a reluctance among authors to directly edit a text that is seen as the original work of another author or group of authors.[105] Hence margin comments can be considered as less disruptive to both the integrity of a text and the authority of an author. Yet in addition to this, comments in the margins, as we have discussed with the example of Fitzpatrick's *Planned Obsolescence,* also offer a mechanism to clearly distinguish author(s) from commenter(s), and in this process establish the authority and individuality of the commenter as a separate named contributor to a text (albeit on a different level than the authority instilled in the author)—a relationship that would be much more obscured within wiki authorship. This clearly plays into specific author functions within academia focused on promoting one's standing and reputation (and one's brand) as a commenter or reviewer within a community. Now that it is increasingly possible to link to and reference specific comments made, these functions might become more important, potentially leading to a system of assessment and recognition that recognizes the contributions made by reviewers, annotators, commenters, and other contributors to a document. As such, even though wikis offer the opportunity to identify authorial contributions, the fact that they still obscure them might

explain why other "reputation-enhancing" forms of collaborative authorship have seen more uptake within academia.

Creative Commons

The remix practices related to the selector or curator, and the wiki editor, rely on the texts or sources that are remixed being openly available to edit and reuse. Creative Commons licenses are a type of copyright license that have become the default in an open access environment to promote the free distribution of research by granting permission to others to share it and/or reuse it. Within academia, it is not only books and articles but also blogs and wikis that stimulate such academic reuse by using the CC BY license, or any other of its seven license variants that allows free reuse. Lawrence Lessig, one of the founders of the Creative Commons organization, explains part of the reasoning behind these licenses in his book *Remix*. Taking a pragmatic position, Lessig's specific kind of copyright reform focuses on ending the "copyright wars" while at the same time promising artists and authors the necessary copyright protection—which Lessig claims authors need as an incentive to create.[106] The argument Lessig makes pro remix culture and against the current severe copyright law focuses on the latter's restriction of creative freedom, evolution, and development. He emphasizes that the law should not be too rigid and as such should not criminalize an entire generation of downloaders and remixers by designating them as illegal pirates. However, at no point does Lessig go so far as to dispute copyright altogether, as this would go against "creative evolution," following his argument that authors and producers need an incentive to create. This incentive, in Lessig's vision, is at the very minimum *attribution*, which ensures the reputation economy still functions. Here, Lessig can be seen to still abide by liberal humanist notions of individual ownership and responsibility, based on privatized capital and individuated resources.[107] In its initial form, Creative Commons and its licenses, set up to stimulate creativity and promote remix practices, thus strongly holds on to the authorship function: CC BY still requires attribution, for example, despite being one of its most liberal licenses. Even with more recent licenses, such as CC0, which releases a work directly into the public domain, copyright still needs to be granted (or waived) *by the author*.[108] It could therefore be said that Creative Commons makes copyright less rigid and more open while also placing an extra burden on the authorship function. The author becomes more

From Romantic to Posthumanist Authorship

103

powerful in determining under which exact conditions their work can be shared and distributed. Instead of seeing cultural works and information as something people are always allowed to share, we are still operating here with a system in which sharing (of individuated creative objects) needs to be authorized and in which any work created by an author is automatically their property upon creation.

Law professor Niva Elkin-Koren offers a compelling argument in her supportive but at the same time critical review of Creative Commons. She regrets that the strategy of Creative Commons is not aimed at creating a public domain in the legal sense, free of exclusive proprietary rights. Those behind Creative Commons believe free culture will arise by a different exercise of copyright on the part of owners, where contracts are used to liberate creative works and make them more accessible.[109] As Elkin-Koren argues, however, "in the absence of commitment to a single (even if minimal) standard of *freedom in information*, Creative Commons' strategy is left with the single unifying principle which empowers authors to govern their own work."[110] The focus point of Elkin-Koren's critique is that by maintaining the idea of copyright, Creative Commons keeps on seeing cultural goods as consumable products; it treats creative works as commodities. This only strengthens the proprietary regime in information and culture and with that the practice and discourse of proprietorial authorship within academia.

Antiauthorship Critique: Plagiarism and Anonymity

In the previous section, I examined some of the more recent practical strategies to reperform authorship as developed within hypertext theory, the digital humanities, and as part of various remix practices. What I want to conclude based on this analysis is that although these fields, theories, and practices try to rethink specific aspects of the romantic, liberal humanist authorship discourse in academia (such as authority, individuality, originality, ownership), these notions continue to be strongly ingrained. Furthermore, targeting one of these aspects (such as authority) often only strengthens the others. As such, these examples of authorship critique all in some way or another continue to adhere to humanist authorship discourses and practices. What kinds of strategies and analyses of authorship and the way it currently functions can we then devise to try and rethink the various aspects of the romantic and humanist notion of authorship in

a perhaps more comprehensive, critical, and consistent fashion? Could one strategy involve paying more attention to the institutions and structures in which our authorship practices are embedded, as well as to the hegemonic discourse of the liberal autonomous author that continues to structure and inform these practices? Would this perhaps also involve exploring what a *posthumanist critique of authorship* could look like in this respect?

In this section, I want to do exactly that, to offer some suggestions as to what such a posthumanist critique and practice of authorship might encompass. I first look at two practices, *plagiarism* and *anonymous authorship*, that can be identified as forms of antiauthorship critique. I have chosen to examine plagiarism and anonymous authorship in particular due to the fact that, as practices, they are potentially less focused on accommodating new forms of authorship in a digital environment or on making authorship more inclusive. In other words, these practices are less focused on extending individual authorship to include new liberal and autonomous subjects (such as many of the practices I have previously discussed ended up doing) and are aimed more at directly undermining our current humanist notions of authorship, along with the political economy that surrounds them.

Plagiarism

Even if scholarly research is shared without having to pay to access it, as is the case with certain open access publications using a CC BY or similar license, these publications remain objects within a reputation economy that will be exchanged to create more value in the form of citations, for example. In this sense, it can be argued that it is *plagiarism* (understood here as not citing someone) that becomes the biggest taboo in the academic exchange economy—next to threatening core academic values. Yet following Lessig's reasoning, as plagiarism is perceived to be increasingly prevalent in academic culture today, is it worth "criminalizing" a whole generation?[111] Could plagiarism even be seen as a strategy to stimulate creativity and promote the creative freedom and development of students? We could think of examples in which borrowing the words of others can be used as a method to learn to write, for example. As such, could plagiarism be the next battle after copyright reform to be fought and addressed in order to stimulate (new) forms of creativity that are less focused on the main elements of humanist authorship: ownership, originality, and authority?

Plagiarism as a term evokes mostly negative connotations, especially within academia. It is most often defined here as taking someone else's work and presenting it as one's own original work. Following this definition to the letter, plagiarism doesn't really critique or question authorship in any way, as the plagiarist's intent is to elevate her or his own authorship standing and status. In addition, the plagiarist in this account still seeks to claim something as an original work of authorship within the academic reputation economy—it's just that they are doing so falsely. However, there is a more interesting aspect to using someone else's work and representing it as one's own. For within a different discourse or framework, including, as I will argue, a discourse of authorship critique, this is perceived as appropriation. *Appropriation* is used here instead of plagiarism; as a term, it is more commonly used and accepted as a creative strategy within the artistic realm, albeit one in which the source is acknowledged in an implicit way as a form of cultural citation.[112] Here the difference is one of *intent*—but also, as I will show, one of cultural difference, such as the difference between art and academia—and this becomes interesting when we discuss the work of conceptual poet Kenneth Goldsmith, for instance.

Rebecca Moore Howard argues that *patchwriting*, a form of copying and collating different sources without any fundamental alterations, can be a part of a pedagogy of writing as appropriation and indeed a fundamental aspect of language learning and use.[113] Goldsmith has a similar vision, pointing out that appropriation is creative and that he uses it as a pedagogical method in his Uncreative Writing classes (he defines *uncreative writing* as "the art of managing information and representing it as writing") at the University of Pennsylvania.[114] As Goldsmith suggests, following his method, the author won't die, but we might start viewing authorship in a more conceptual way, stating that "perhaps the best authors of the future will be ones who can write the best programs with which to manipulate, parse, and distribute language-based practices."[115] His argument in support of appropriation criticizes the idea of originality as it is traditionally connected to authorship. However, in making his plea for uncreative writing, Goldsmith does not fundamentally critique authorship (nor what it means to be creative); he again just elevates the role of the copier or remixer to that of the author, saying that: "the simple act of retyping a text is enough to constitute a work of literature, thereby raising the craft of the copyist to the same

level as the author."[116] Although his is an interesting attempt to challenge the continued emphasis on originality and creativity in writing, if we look closer at what Goldsmith argues, it seems that he is mainly interested in broadening the categories of what counts as original and creative, as well as writing, instead of fundamentally troubling them, for example. For him, the digital environment actually adds more functions to authorship, helping to produce a situation in which, besides originality and creativity, skills such as manipulation and management will become increasingly important.

Nonetheless, in his practical work as a conceptual poet, Goldsmith does try to push the appropriation discourse further by deliberately juxtaposing it against and playing with the blurred lines that exist between this discourse and plagiarism. In the works of Goldsmith and in those of fellow conceptual poets, including Vanessa Place and Kent Johnson, this flirtation with the boundaries between appropriation and plagiarism clearly functions as a way to undermine discourses of liberal authorship.[117] For example, in *Day*, Goldsmith has retyped word by word a whole daily issue of the *New York Times* and published it as his own work.[118] Goldsmith doesn't label this as plagiarism but as a practice of uncreativity (challenging originality) and of constrained writing. A few years later, conceptual poet Kent Johnson republished *Day*, keeping the book entirely intact, while just replacing his own name on the dust cover.[119] In this sense Johnson was extending Goldsmith's uncreativity discourse even further.

In her Factory series, conceptual poet Vanessa Place targets both the originality and the authority that reside in our discourses on authorship. Inspired by Andy Warhol's "factory model" of creative production, she commissioned ten writers and artists, or *art-workers*, to make chapbooks for her, which she subsequently published under her own name, taking on the author function. As Place explains: "I, being the one they call 'Vanessa Place,' am the (immaterial) public author function."[120] By appropriating/ plagiarizing other artists as well as her own work in an ongoing fashion, Place thus seeks to challenge the authority that underlies the "referent" or "signature" of the author: "I authorize works not authored by me or by those I authorize to author my work—copies of copies of absent authority. Like citation, the referent betrays a fundamental lack of authority on the part of the citing author. Unlike citation, there is no authoritative source. It's a rank imitation of 'Vanessa Place' as 'Vanessa Place' is rank imitation."[121]

From Romantic to Posthumanist Authorship

These practices of extending what would previously perhaps be seen as plagiarism into an appropriation discourse, of challenging the boundaries between the two, goes beyond what is commonly seen as appropriation or remix practices. They clearly intend to actively disturb or undermine the system of authorship and the notions of originality and authority that come with it by "hollowing" out or putting to the test those notions. In this respect, we can see the preceding examples as an illustration of how practices and concepts of appropriation and plagiarism exist on a spectrum, where appropriation practices in an art context might be judged as plagiarism practices within an academic publishing context. This might have to do with the fact that the boundaries between plagiarism and appropriation aren't always clear. When is "cultural citation" sufficiently acknowledged, for example? Therefore, appropriation that takes place within an academic publishing context that does not adhere to a citation or referencing context runs the risk of being condemned. In this respect, Goldsmith's strategy can be seen as more subversive when he argues for extending forms of appropriation that are accepted within the artistic field—but are still predominantly perceived as plagiarism within a literary or academic context—into scholarship or academic knowledge production.

As such, a focus on different forms and notions of creativity and originality might already be a significant change for those within academia who still adhere more to the print-based discourse of authorship. As Howard notes in this respect, patchwriting does not sit well with our common notions of authorship (and ideas of originality most of all). Although patchwriting was a normal part of writing and scholarship in the Middle Ages, authorship as we now practice it, including ideas of literary individualism and ownership, is a modern invention. These humanist notions are currently seen as natural facts in relation to authorship even though, as Howard rightly argues, our views of what authorship entails keeps shifting. She states that "their historical emergence demonstrates them to be cultural arbitraries, textual corollaries to the technological and economic conditions of the society that instated them."[122] Although new digital practices like hypertext and wikis, as well as remix and collaborative writing endeavors, make it increasingly hard to uphold a stable category of authorship, and in the process make it difficult to establish what merits plagiarism, academia nevertheless needs authorship and its plagiarizing counterpart as a taboo to sustain traditional

forms of authority. As Howard puts it, "The prosecution of plagiarism . . . is the last line of defense for academic standards."[123]

Nonetheless, although the forms of strategic plagiarism or appropriation discussed here constitute an interesting critique of authorship, by definition plagiarism and appropriation also involve reinstating certain aspects of the liberal authorship function—albeit a different, uncreative, or unoriginal one. In addition, the way this specific form of authorship critique is "read" risks installing the authorship function even further. As Bill Freind shows, the latter has partly to do with the lack of "meaning" in conceptual projects like the ones I discussed earlier, in which the deconstruction of the work object often leads to the fetishization of the author instead: "The assault on the fetishized status of the artwork in (for example), Dada, language writing, or uncreative writing has not led to a similar interrogation of the status of the author. If anything, the questioning of the artwork has often led to a re-inscription of the author function, as readers look for a locus of meaning in texts that resist traditional explication."[124]

Similarly, Place has pointed out that when there is no meaning to be found within the text, the author, or thinker, again becomes more important: "There is nothing to be mined from these texts, no points of constellation or dilation, no subject within which to squat. The text object simply is. The reader is, but is irrelevant. But the thinker becomes quite important."[125]

At this point, then, I would like to look at a further antiauthorship critique and practice (and to also return more squarely to the academic realm) in order to discuss examples of anonymous authorship in academic writing.

Anonymous Authorship

Anonymous authorship has a long history in academic writing, most famously as a strategy to avoid censorship or for authors to shield themselves from political or religious prosecution. This is related to what Foucault has called *penal appropriation*, in which "texts, books, and discourses really began to have authors (other than mythical, 'sacralised' and 'sacralising' figures) to the extent that authors became subject to punishment, that is, to the extent that discourses could be transgressive."[126] Anonymous authorship can therefore be seen to function in a tradition of *escaping responsibility*, but it is also triggered by a critique of the individual ownership of a work. For example, anonymous authorship was quite normal in medieval and early modern times, whereas with the coming of print a new model came

into prominence based on proclaiming individual authorship, as now the author was in a position to profit from these works.[127]

Anonymous authorship's long history extends into current scholarly and literary practices. In 2013, Duke University Press published *Speculate This!* (see figure 2.1), a manifesto in book form to promote "affirmative speculation." This manifesto has been written collaboratively by an anonymous collective, going by the name *uncertain commons*, in line with a more contemporary tradition of anonymous writing—exemplified by initiatives in the literary field such as Luther Blissett and Wu Ming, and by the collective pseudonym Nicolas Bourbaki that was used by a group of mathematicians in the twentieth century. The uncertain commons collective define themselves as "an open and non-finite group," their main reasons for choosing anonymous authorship being to "challenge the current norms of evaluating, commodifying, and institutionalizing intellectual labor."[128] As such, they specifically refer to academic labor and to a situation of growing corporatization of academia, which increasingly demands "quantifiable outcomes for merit and promotion." Their protest is thus focused on the "proprietary enclosure of knowledge, imagination, and communication." The collective point out that they "do not claim authorship" nor control

Figure 2.1
Speculate This! on the Pressbooks platform

over *Speculate This!*, which they characterize not as an object but as an "emergence." However, they do not see their actions as a "true resistance" or as standing outside the system, but more as "playfully inhabiting" the various forms of discourse that are already available, which include the exploration of collective intellectual labor and the potentialities of the common.[129] This focus on resistance from within might explain why they chose to publish *Speculate This!* as a coherent and bound book-object with an established university press, although their manifesto is also available for free online. Here the question arises in what sense the publisher ends up taking on some of the authorship functions that the collective tries to dispute and how, in its final published form, this book can then still count as an emergence.

In this specific case, as with the case of other writing collectives such as Wu Ming, it could be argued that the name and brand of the collective can come to stand in for the author due to the lack of other signifiers. This is why critics such as Scott Drake argue that from a proprietary perspective, not much changes: "While [it] may seem obvious given the fact that the name refers to a collective rather than an individual, on its own this does not prevent the name from being taken up into the economic-juridical order as a single name that protects the work as a literary property."[130] Furthermore, as I made clear previously with respect to collaborative authorship practices in the digital humanities, a celebration of collaborative authorship can also lead to new hegemonic discourses. That said, uncertain commons do try to evade this narrative when they write that they "do not intend to romanticize this form of communal authorship," which is also apparent in various commercial writing practices and genres and in the example of the *team* as a specific postindustrial form of collaborative labor. From their perspective, collaborative writing practices don't rely on consensus but on "collaborative modes that instead embrace dissensus."[131]

It is interesting to go back to the idea of *intent* here, in relationship to what Drake has called *self-reflexive anonymous authorship*, where the intent to question authorship, as he puts it, "acts as a dissident form of cultural production in the economic-juridical order of neoliberalism."[132] The problem here lies in the idea of self-reflexivity, where, as in the case of Creative Commons licenses discussed earlier, it needs to be the direct intent of the author to publish work anonymously, as authorship is otherwise granted automatically. It is the author who instills the command not to read any

From Romantic to Posthumanist Authorship

meanings into the work related to the authorship function, thus already shaping it from the outset. This act of renunciation is nevertheless interesting, notwithstanding the paradoxical nature of this situation. To actively renounce itself, authorship needs to be self-reflexive first.

Still, the notion of intent in anonymous authorship can also be directed to create more open-ended meanings in (scholarly) works. This is exactly why anonymous authorship can be a potent alternative to the current neoliberal system of cultural reproduction and literary property. For example, Drake points out—referring to the literary collective Wu Ming—that by using an open name, it is the intent of this collective to conceptualize their work as "material for further expansion." This openness creates possibilities for seeing anonymous work as functioning within and reproducing an open public domain, or a commons, instead of promoting individual property.[133] Nick Thoburn argues similarly when he writes about the use of a multiple name (where anyone is free to take up this moniker to author their texts). Thoburn states that these communal works and forms of writing, although in a way extending the author function, also fragment it, expanding its openness:

> Luther Blissett was an "open reputation" that conferred a certain authority and capacity to speak—the authority of the author, no less—on an open multiplicity of unnamed writers, activists, and cultural workers, whose work in turn contributed to and extended the open reputation. In this sense, the author-function is magnified and writ large. But it is such in breach of the structures that generate a concentrated and unified point of rarity and authority, because the author becomes a potential available to anyone, and each manifestation of the name is as original as any other. In this fashion, a different kind of individuation emerges, the individuation of the multiple single: Luther Blissett is at once collective, a "co-dividual" shared by many, and singular or fragmented, a "dividual," an infinitely divisible entity composed of multiple situations and personalities simultaneously.[134]

In what sense can we then speak of, as Thoburn does, a "desubjectifying politics of anonymity?" Can anonymity function as a communist or collective alternative to the cult of personality and individual genius, where this discourse, Thoburn points out, is both misguided and also seen as perpetuating "an essentially capitalist structure of identity?"[135] How can the politics of collaborative writing offer a critique of capitalism and help to shape an alternative in this respect? As no one *owns* the collaborative name of Luther Blissett, Wu Ming, or uncertain commons, for example, nor of the "anonymous author," the commodity form of the work is indeed being

challenged in these anonymous practices, Thoburn argues: the *author name* is not connected to the ownership of the product. However, the *publication* of a novel or of a scholarly book or manifesto, as in the case of the uncertain commons collective, complicates this, as *Speculate This!*, in its printed format, for sale through the usual academic publication channels, functions as a clear commodity, of course. Nonetheless, in its published form, *Speculate This!* is also available for free online. Thoburn therefore argues with respect to openly available anonymous works that "in their published form, these books at the least indicate and allow for circuits of distribution not constrained by commercial exchange."[136] Yet one wonders whether this applies to the context of scholarly publishing, where increasingly a certain kind of open access model is being adopted, as part of which (commercial) publishers charge article and book processing charges upfront to authors, their institutions, or their funders, to pay for their publication's open availability (or to cover their commercial losses). In addition, libraries, the main purchasers of academic books, do not always have (automatic) mechanisms in place to accommodate free or open access publications and tend to follow a strategy, in particular for books, where they obtain both an online/ electronic *and* a printed version in order to fulfill users' continued demand for printed books.[137]

As we have seen from these examples, the role played by publishers in the way anonymous works are published and distributed remains very important. In many ways, they can be seen to take over some authorship functions (authority, responsibility, etc.). How, then, can we start to truly acknowledge the multiple agencies involved in knowledge production, while at the same time questioning and breaking down our ongoing reliance on liberal humanist notions of authorship and, with that, our inherited ways of being and acting as academic authors?

The Emergence of Posthumanist Forms of Authorship

Now that we have examined two practices, plagiarism and anonymous authorship, that can be identified as forms of antiauthorship critique, I would like to explore how these relate to the form of authorship critique I want to investigate and promote in this chapter—namely, a posthumanist one. What could a posthumanist critique and practice of authorship potentially look like? Especially in a context in which a questioning of

From Romantic to Posthumanist Authorship

authorship's humanist legacy does not necessarily need to be a *distancing* of humanism as such. For authorship's humanist history already provides the seed for a radical self-critique, where an inherent *post*humanist authorship has, as can be argued, always already been a part of its proclaimed otherness. The question is then how we can aid in a practical posthumanist critique of authorship's humanist notions, if we see posthumanism as "humanism's ongoing deconstruction."[138] In this sense, posthumanist authorship is not a form of antihumanism (as, in setting up an absolute opposition between humanism and its other, antihumanism remains humanist); it similarly does not go *beyond* humanism, but intends to deconstruct its assertions in a continuous manner.

One possible starting point from which to answer this question—What would a posthumanist authorship look like?—and from which to rethink the humanist notions underlying individualist liberal authorship, including ideas such as originality, ownership, authority, and responsibility—would be to focus on challenging the *integrity of the subject* and the *priority of the human* that continues to underlie knowledge production in the humanities. The posthuman subject—or author, I would argue—can then be seen, in the words of Hayles, "as an amalgam, a collection of heterogeneous components, a material-informational entity whose boundaries undergo continuous construction and reconstruction."[139] This means that a critique of the essentialisms underlying authorship would need to be continuous and would, as Mark Fisher argues with respect to the "dismissal of the self-present, conscious subject," need to be focused on a reformulation of agency.[140] Breaking down the barriers between human and nonhuman agency and acknowledging the agency of nonhumans, of material objects—among others, in scientific practices—while also refusing to take this human/nonhuman division for granted, would be a valuable starting point. This issue has been explored in depth in feminist new materialist and actor network theories, which both tend to emphasize nonhuman and distributed forms of agency.

For example, as part of her posthumanist performative practice, Karen Barad actively explores, via a Foucauldian genealogical analysis, how these kinds of distinctions (between human and nonhuman, self and object) are created.[141] What are the practices that stabilize the categories of human and nonhuman—but also, I would add, of the author, the work, and the reader? As shown in the previous chapter (and I will continue to develop

this in chapter 5), specific book-objects and author-subjects have emerged and solidified out of the cuts into the book as apparatus that we have created and that are created for us as part of our scholarly practices, discourses, and institutions. How can we reconsider these boundaries while at the same time acknowledging the various distributed and interwoven agencies involved in the creation of scholarly works—from the material we work with, the media and technology we use, to the various material forms and practices (paper, editors, print on demand, peer reviewers, software, ink) that accompany a scholarly work's production? But how can we also reconsider, as Hanna Kuusela has shown, our sociocultural practices, consisting of "hybrid networks of both human and non-human actors, technologies and texts" that shape how a work is subsequently received and consumed?[142]

As part of the process of continuously questioning these humanist incisions and boundaries, would a posthumanist (critique of) authorship not also have to include both a theoretical *and* a practical critique? As Gary Hall and I have previously argued in this respect, a digital posthumanities, which entails a radical critique of the humanist notions underlying our idea of the university and of the humanities, should involve a critical theoretical investment from scholars; but it should just as much be part of our scholarly publishing and authoring practices (especially because theory, as a form of discourse, is also materially enacted: it is a form of practice and vice versa).[143]

Hall has provided several examples in his research related to the uptake among critical theorists of the posthuman, of their ideas and politics as part of their own research practices. His critique focuses among others on thinkers such as Rosi Braidotti, Bernard Stiegler, and Cary Wolfe (and in a self-reflexive move, he does not exclude himself from this critique). For example, Braidotti, in her book *The Posthuman* (2013), specifically calls for an affirmative, practical, and situated critique of the humanism that underpins much of our scholarship in the humanities.[144] But Hall shows that in her own writing and research practices (and thus in the way she *acts* as a theorist), Braidotti continues to adhere to liberal humanist authorship functions, to such an extent that "*The Posthuman* also helps sustain the not unrelated sense of Braidotti as an identifiable, self-contained, individual human, whose subjectivity is static and stable enough for her to be able to sign a contract giving her the legal right to assert her identity as the 'Author of the Work (. . .) in accordance with the UK Copyright, Designs

From Romantic to Posthumanist Authorship 115

and Patents Act 1988,' and to claim this original, fixed and final version of the text as her isolable intellectual property—not least via an 'all rights reserved' copyright notice."[145]

Besides providing a practical, alternative, and affirmative authorship critique, a posthumanist critique of authorship, as part its criticism of essentialisms, would also have to target the relationship between the individual author and the book as a commodity. Related to what we saw Drake and Thoburn argue in the previous section, a posthumanist critique of authorship would need to continuously challenge the idea of the *ownership* of a scholarly work, especially as our scholarly authorship practices continue to function within an object-based neoliberal capitalist system—a system that is fed and sustained by the idea of autonomous ownership of a work, copyright, and a reputation economy based on individualized authors. In this respect, an exploration of more distributed and collaborative notions of authorship, as well as of forms of (practical) antiauthorship critique, might help us take attention away from the scholarly work as a fixed and bound product and the book as an academic commodity. This could further stimulate reuse and more processual forms of research, for example. Similarly, a move toward envisioning the production of research as an ongoing and fluid process might promote our awareness of the variety of actants and relations that play a role in the production, dissemination, and consumption of that research, complicating any simplistic notions of ownership.

This entangled relationship between the author-subject and the book-object reflects the need for a wider reconsideration within forms of posthumanist authorship of the relationship between authorship and the *technologies* involved in authoring and communicating scholarly content. Informed by actor-network theory (ANT) and posthumanism, Lesley Gourlay has explored this relationship in depth in her research on textual practices, which, being complex and distributed, take place across a multitude of domains, networked devices, and technologies of inscription.[146] Gourlay argues, building on Latour's assertion that objects are not normally perceived as part of "the social" (which tends to be seen as exclusively human), that similarly within literacy studies, objects are perceived simply and instrumentally as tools, set up in a binary relationship with authorship. Instead she argues for the need to recognize their agentive role in how we make meaning around texts; that is, they are not *intermediaries*, but agentive *mediators*.[147] As such, her research outlines how "material objects play

a central role in meaning-making practice, co-constituting texts and authorial subjectivities."[148]

But even in an environment where we start to acknowledge these multiple human and nonhuman, material and discursive agencies, there remains a need to question notions of control and oppression, which continue to exist in more collaborative authorship practices. Within the digital humanities, a growing critical awareness of our *becoming with* technologies (from material objects to infrastructures) has started to develop, especially in the works of authors such as Johanna Drucker, Federica Frabetti, Alan Liu, and Tara McPherson. Julia Flanders has started to address this issue head-on, starting from digital humanities' ongoing infatuation with collaboration. In relation to what we previously discussed with respect to the potentially "oppressive aspects of the consensus model of community," as Fitzpatrick calls it, this is also reflected in, and can become normative and performative through, technical standards and infrastructures.[149] Flanders is acutely aware of this and sets out how an acknowledgement of the agency of these diverse material-discursive entities within knowledge production has to involve an assessment of the ways in which they impose uniformity and become dogmatic through their creation of standards—especially as many digital humanists perceive uniformity and technical standards as essential to collaboration and interoperability (and, as Flanders argues, abiding by them is framed as good citizenship within this community). Flanders outlines how digital humanities projects take place in an digital environment "constrained by a set of technical norms" (i.e., XML documents, the TEI [Text Encoding Initiative] guidelines, markup languages) and material objects, which both mediate and "govern the informational and operational behavior" of that environment and which can be quite exacting and uncompromising.[150] The digital humanities has been instrumental in showing how these technical and disciplinary standards are, as Flanders argues, "tightly interwoven and mutually consequential."[151] Yet these software tools and data standards are integrally entangled with disciplinary norms, methods, and practices, which tend to be similarly based on some form of consensus or agreement.

How then can we enable dissent and alterity within our collaborative ecologies? Flanders argues in this respect that it is essential that we think closely about "mechanisms for negotiating dissent," especially to enable "longitudinal collaboration" with future posthumanist collaborators and

From Romantic to Posthumanist Authorship

for our standards and tools to "be founded on debate rather than on straightforward agreement." This is especially important in a context of processual and living publications, in which we will not know who (or what) our future collaborators will be or through which media and technologies our differential publications will be mediated. As such, as Flanders argues, "to collaborate effectively under these circumstances is thus a matter not of enforcing an artificial uniformity through which vital distinctions are elided but rather of supporting the real and accurate exchange of the data in which we have a strong stake."[152] Related to this, I want to examine how we can enable different and agonistic practices to emerge within and through collaborative, multidistributed posthumanist authorial practices, both now and in the future. Any form of posthumanist communal authorship should in this respect remain aware of how it enables the diversity of authorial agencies to be distributed within collaborative ecologies, as a certain amount of antagonism is what "makes both the common and community possible," as Hall has argued.[153] Following the practice of the uncertain commons collective, posthumanist authorship would thus involve "collaborative modes that instead embrace dissensus."[154]

Finally, as part of its practical critique of liberal humanist authorship, *experimenting* with alternative forms of authorship or knowledge production, or with discourses of originality and ownership, should also be an important aspect of any kind of posthumanist authorship. As an ongoing, emerging, and multiplicitous critique and practice of rethinking authorship in an experimental way, posthumanist authorship questions the boundaries of authorship, the authorship function, and antiauthorship critique for our current medial and cultural-economic condition. What is important in this experimental exploration of authorship is again a continuous engagement with expanded concepts of *agency*, such as those brought forward by posthumanist and feminist new materialist theories, as well as by the practices (collaboration, remix, and hypertext) described previously. These experiments enable us to examine closely the interactions that take place among authors, readers, texts, institutions, and technologies in the production of knowledge and the creation of meaning. Here the focus should be on questioning and reperforming the distinctions that are made between the author-subject and the work-object and the other agencies at play, and the ways these incisions are enacted and by whom. What kind of power relations are at stake in these demarcations, and how can we potentially

disturb these? Can we, as part of our publishing practices, experiment with more distributed forms of authorship? For example, in the specific context of academic book publishing, and as I have started to do here to some extent, it might be useful to explore the authorial function of publishers in contemporary scholarly publishing: What is their role in establishing authorship, and in marketing and branding it, in taking responsibility for a work and for turning it into a publishable object? In which ways do they acknowledge and enable more diverse and distributed agencies involved in academic knowledge production? (I will discuss in depth the experiments done by Mattering Press in this context in chapter 4.)

Furthermore, how are we to devise our authorial practices in a world in which the stable objects they supposedly belong to are constantly changing? This emphasizes again that neither authorship nor the authorial I is or has ever been a stable category itself.[155] How do we revise and rethink our authorship practices to take this into account? What would a *processual and emergent*—rather than an object-based—authorship look like in this respect? Finally, how do we relate to the role played by these fluid media objects when increasingly they are writing themselves? For example, as Christian Bök stated while referring to RACTER, an automated algorithm written in the 1980s that randomly generated poems: "Why hire a poet to write a poem when the poem can in fact write itself?"[156] A lot of our authorship is automated these days, or machinic, seemingly without any intent. In this respect, it would be interesting, as part of a posthumanist critique of authorship, to focus on forms of what Bök has called *robopoetics*,[157] defined by Goldsmith as a "condition whereby machines write literature meant to be read by other machines, bypassing a human readership entirely."[158] What do we do with machine-generated content, gathered in feeds, collected through tags and hashtags, sourced from a variety of locations? What about the authorial actions that are being made by computers and software? How do we assess or respond to the authorship related to automatically generated prose, Flarf poetry, Google poetics, or the Postmodernism Generator?[159]

A posthumanist critique of authorship, as an emergent and continuous practice and theory, can of course potentially consist of a variety of strategies to reperform the humanist notions underlying our current scholarly authoring practices. However, as part of these strategies, it will be essential to continue to actively explore the consequences of the alternative incisions we make as part of our performances. For instance, and as discussed

From Romantic to Posthumanist Authorship

previously in this chapter, in what sense might we, while critiquing certain aspects of the authorship function (such as individuality), reproduce or reinstall other functions of authorship again (such as originality)? In what ways do anonymous authorship practices run the risk of installing more authority in the publisher's author function, for example? One way we might try to overcome this problem is by analyzing closely how humanist discourses and practices of authorship continue to function within academia so that our posthumanist critique might at least try to address these forms of authorship in their ongoing complexity.

When we start to look closely at authorship, and at texts and books (as we, I would like to think, have always been doing), at how their fluidity or open-endedness has been marginalized in favor of a print-based discourse and practice that privileges a more stable identity, this might mean making more rigorous choices toward what constitutes authority in our scholarly practices—but also toward, as Hall states, the "meaning, importance, value and quality" of texts, something we need to be involved in as authors, as readers, and as communities of scholars.[160] This would entail taking more responsibility for the entanglements of which we are a part and for how agency is distributed and authors and works are mediated throughout our academic system. However, experimenting with remix, collaboration, openness, and wikis as such is not enough, not if we invariably end up replicating many of the features associated with print—for reasons of stability, quality, and so on—we want to reexamine. Therefore, we should see these experiments as critical practices, as a way of challenging humanist notions of authorship by intervening practically in and with them on a *continuous* basis.

3 The Commodification of the Book and Its Discursive Formation

The frontiers of a book are never clear-cut.
—Michel Foucault, *The Archaeology of Knowledge*[1]

The book as a perceived object of material and discursive unity comes about partly through unitary notions such as the work and the oeuvre, both of which emerge out of the close bond between the book and the author.[2] In the previous chapter, I explored the discourse surrounding authorship: how it developed within book history and was taken up in theories of poststructuralism and in practices ranging from hypertext to the digital humanities and remix studies. As I showed there, this discourse has been shaped and sustained by essentialist and liberal-humanist notions such as (possessive) individualism, authority, and originality. These notions are, as became clear, hard to critique or recut in a sustained way (both theoretically and practically). This has to do partly with the close intra-action between the author-subject and the book-object. In their essentialist humanist uptake and performance, both can be seen to provide bindings and fixtures for scholarly communication (connected through notions such as the work and the ownership of a work). On the other hand, both the author-subject and the book-object can potentially be performed differently: through forms of antiauthorship and posthumanist authorship (critique) in the case of the author, for example, but also, as I will show in both this and the next chapter, through forms of open, experimental, and relational publishing in the case of the book-object. But due to their entangled state, this means that each alternative performance has consequences for both the book *and* the author.

Although authorship has played an important role in the formation of the book as an object, the commodification of the monograph has developed

alongside a more complex and interwoven system of scholarly communication and publishing. Over the centuries, the system of material production that has surrounded the scholarly book—which includes its production, distribution, and consumption and involves a variety of actors and practices—has played an essential role in the creation of the book-object and in how the monograph as a specific form of scholarly communication has developed and how it has been perceived and used. It is this book-object that has again performed a range of roles in the system of material production from which it coemerged. Not only has it functioned as a specific medium or a technological format through which research is communicated, but it has also served as a marketable commodity (i.e., for the publishing industry) and as an object of symbolic value exchange (i.e., for tenure and promotion in the context of the academic profession).

The history of print can be seen to privilege a vision of the book as a fixed object of communication; a discrete medial entity that, when well preserved, can have certain cultural effects. Here, in what can be seen as a naturalizing tendency in media history writing, print is often opposed to the presumed fluidity of orality and the mutability of handwritten texts.[3] This dualist discourse surrounding the physical materiality of the book and its inherent fixity, stability, and authority, as opposed to more fluid and liquid perceptions, will be explored and critiqued in depth in chapter 5. In this and the next chapter, on the other hand, I will investigate how an aggregate of technological, economical, and institutional factors and structures, and the tensions among them, stimulated the development of the book into both a product and a value-laden object of knowledge exchange within academia. At the same time, I will show how the material features of the book-object, in intra-action with these factors and structures, were involved in bringing about our modern system of scholarly communication.

This chapter focuses in particular on the historical development of the scholarly book as a commodity and as an object of symbolic value exchange within publishing and academia. It explores—and at specific points intervenes in and reframes—the specific ways in which *the discourse* on book history has narrated and shaped this history, which has culminated in a communication system and a book-object that is no longer seen as sustainable and which runs the risk of becoming obsolete before long, if it has not done so already.[4] Chapter 4 then outlines how we can critique and potentially start to change these cultures and systems of material and technological production

The Commodification of the Book and Its Discursive Formation

surrounding scholarly communication in such a way that it allows for alternative, critical, more relational and experimental forms of research.

Rethinking and deconstructing the object-formation and commodification of the book and of scholarship, both in academia and as part of our publishing system, will be a useful first step to start imagining alternative forms of research. Nonetheless, we can't ignore the fact that the book is and needs to be a scholarly object at some point in time and thus cannot only be processual and never ending, for a number of reasons. One of the reasons it will therefore be useful to rethink this object-formation is that doing so will enable us to emphasize what *other incisions and cuts* are possible that might critique certain excessive forms of the ongoing commercialization and capitalization of scholarship, such as the increasing need for measurement and audit criteria and for marketable and innovative research. Although the scholarly book functions within an integrally connected scholarly, technological, and economic context, this does not mean that we do not have a hand in constructing these realms differently, to intervene in the cultures of knowledge production in both publishing *and* academia. This is what I want to begin to do here by means of a *threefold, interdependent strategy* of rethinking and re-envisioning (1) the discourse surrounding the commodification of the scholarly book (which is the focus of this chapter); (2) the modes and relations of academic knowledge production; and (3) our own performances of, and material-discursive practices relating to, the book as a marketable object (both of which will be discussed in chapter 4).

The Discursive Formation of the Book as a Knowledge Object

With the coming of print (or even earlier, with the coming of writing), one can claim that the book turned into an object, a standardized product that can be duplicated over and over again to securely communicate and preserve thoughts. Even more, it can be argued that with the coming of the printing press, and especially with the advent of industrial mechanization and printing processes in the nineteenth century, the book turned into a mass-market commodity. Due to declining production costs, the book could be produced and sold to an ever-growing audience of potential consumers. New forms of material production thus accompanied this book-object, part of which became the blossoming (early) capitalist enterprise of the international book trade.

Similarly, and simultaneously, a system of scholarly communication and publishing arose as part of these new forms of print communication in Europe, with specific roles and power structures. It was a system that from the beginning was integrally connected with, and almost indistinguishable from, the developments and interests of the commercial book trade. This system for the production, distribution, and consumption of scholarly research (which can be seen as continuously in progress) consisted of practices and tactics of standardization, attribution, reviewing, selection, and quality establishment, as well as trust and reputation building.[5] Eventually this developed into what we presently perceive as the "modern" system of formal scholarly communication.[6] This gradually developing system can be said to have been partly responsible for turning the book, both materially and conceptually, into a *knowledge object* playing specific roles and functions within the scholarly communication and publishing systems and influencing future scholarly journal and book forms.

An analysis of the book historical discourse will help explain how this development in which publications turned into integral, trustworthy, authorized documents, unlikely to change, has been narrated and how, in a related manner, a set of functions and roles developed involving academics, publishers, and librarians, among others, all with a great stake in the system of securing the book as a stable and solid knowledge object and a commodity. At the same time, the specific materiality of the printed book is seen to have helped shape our scholarly communication system; some have even said that "historically, the school and the university have been the institutional expressions of the book"[7]

This chapter looks at some of the particular position-takings that were formulated within the book historical discourse in relation to the *commodification of the book* within publishing and academia.[8] It outlines how these specific position-takings can actually be seen to have contributed to the emergence of the idea of the book as object and commodity. At the same time, it examines how an intervening in and a *reframing* of this discourse at certain specific points could potentially start to disturb simplified notions of the book as object and the binaries that have structured its discursive formation.

To provide an example, in battling the increasing commercialization of scholarship and publishing, it will not do much good to see scholarship as solely or most of all a cultural endeavor, in a conservative and reactive

The Commodification of the Book and Its Discursive Formation 125

stance against market forces.[9] And all the more so because, as Bill Readings has argued, to uphold the idea of culture and the university's cultural value as a kind of antidote against commercialism has in many ways become useless, due to the way culture has now become dereferentialized (without a specific set of referents—i.e., things or ideas to refer to).[10] In this respect, Stefan Collini has pointed out that we are still defining our cultural values concerning the ideal of university education based on an ahistorical context, one that was always already contingent and differential from the start.[11] It will therefore likewise not be particularly useful, in this specific context, to blame commercial publishers and their profit-driven interests for the impoverishment of formal scholarly publishing, while at the same time seeing scholarship and research as an endeavor that is, or has been, led solely by cultural values and motives.[12] Making a distinction between publishing as a commercial undertaking and scholarship as a purely cultural endeavor (which John Thompson is close to doing, as I show in this chapter) does not do justice to the fact that scholarly research and communication has always been a commercial enterprise, too, and has been intrinsically connected with and heavily involved in trade publishing from its inception. These kinds of simplified, black-and-white analyses are counterproductive when it comes to developing a sustained critique of some of the excesses and problems underlying the current highly interconnected publishing and scholarly systems and the way they function. Building on this position, I want to make the argument that academia and publishing are not characterized by separate, conflicting field logics; instead, a publishing function (or any other alternative system of material production surrounding scholarly communication) should be seen as an integral aspect of scholarship and of knowledge formation.[13] What is more, change in scholarly communication, publishing, or even the university and, with that, our scholarly practices can only come about if we take into consideration the entangled nature of scholarship and the diverse concerns that continue to shape it.

For this reason, this chapter focuses on the genealogy of the material production of the book as a struggled over disciplining regime, involving both knowledge and bodies of knowledge across a plurality of frontiers of object formation, including technological, economical, and cultural-institutional aspects, and taking into consideration the book as both object and discourse. This chapter reframes this discourse at specific points by highlighting (some of) the binary oppositions underlying it (between technology

and culture, scholarship and publishing, commerce and the public good, openness and closedness) and proposes this as a first step in both targeting this object formation and formulating alternative conceptualizations.[14]

The following sections outline the development of our modern system of scholarly communication. The first section starts by exploring the initial stages of book objectification as narrated within the discourse on book history. It shows how historically, *historiography*, or specific narratives and representations related to print's origins and essential properties, has been used extensively as part of power and priority struggles—for example, between the stationers and the Royal Society in the UK—over who was to regulate the book-object through the material regime of trust that was being established around it. Here the history of the book was framed in such a way to better fulfill the various stakeholders' goals. This included the creation of binary representations; for example, print was seen as serving democratic scholarly ideals and the public good on the one hand, and market-based values, property rights, and political interests on the other. However, this was not a simple struggle between publishers and scholarly institutions or economic interests and scholarship; instead, politics, trust, propriety, and print were integrally connected within a print-disciplining regime and as part of property relations. These binary representations were highly performative, entwined as they were with power plays and politics, creating the future of print while setting up its modes of material production at the same time. In a similar vein, the genealogy of peer review points out that this was not simply a system devised and controlled by scholars to determine the quality of publications, but that it developed as a system of control and censorship, supporting economic interests and prestige. It was these struggles between stakeholders and the historical constructions that have arisen out of them (e.g., peer review) that enabled the rise of our modern system of scholarly communication.

The ensuing section then focuses on the rise of the university press as an institution that epitomizes the entanglement of university extension work and the forces of the publishing economy, pushing it to increasingly develop into a break-even operation. It examines how the mission of the press has been narrated within the discourse on book history before showing how a *repositioning* of this discourse can be beneficial with regard to battling the ongoing commodification of the book. As such, I offer a different frame for how to analyze the relationship between publishing and

The Commodification of the Book and Its Discursive Formation 127

academia, or the press and the university. Through an engagement with the work of John Thompson, the argument is made here that it can be highly problematic to perceive academia and publishing as different fields, the one operating via a cultural logic and the other via a commercial logic; instead, this section highlights how they both operate according to a similar neoliberal market-driven logic rather than via opposed field logics. In doing so, it emphasizes the direct connection between the university's marketization and the crisis in publishing brought on by ongoing commodification, metrification, and managerialization.

The final section of this chapter looks at the development of open access publishing, which has been narrated as both a strategy against the commodification and objectification of scholarship and the book-object and as one strengthening it, being increasingly co-opted by commercial players, neoliberal rhetoric, and funder-driven mandates and models. It engages with the work of Nate Tkacz, who argues that the neoliberal tendencies within openness can be traced back and connected to its genealogy in the works of Hayek and Popper and an open-closed dichotomy. Instead, I propose an alternative genealogy for openness here—based on how it is integrally connected with practices of secrecy—which is put forward as a way to envision openness as a potential critique of the marketization of knowledge. I argue that openness has the potential to question these established closures as it inherently developed as part of an antagonistic system.

The Development of a Modern System of Scholarly Communication

When starting to analyze a history or genealogy of the cultural and material production of the monograph, the lack of a general historical overview is immediately apparent. Where the rise and development of the scholarly journal as a specific format has been reasonably well documented, resources on the development of scholarly book publishing are rather scattered, tending to be divided over individual press and publishing house histories that focus on regional or national developments (mostly concentrating on the UK and the US) or on a specific historical period.[15] Scholarly book histories are often discussed and mixed up with general book publishing histories and with studies on the history of print or print culture.[16] Either that or they are mentioned alongside textbook, trade publishing, and journal publishing, often without any focus being placed on their specific characteristics and

development.[17] And in those cases in which a regional or periodic history is available, it is mostly historical facts that are provided, not a thorough analysis of the system and relations of material production surrounding the book.[18] Based on a selection of the secondary resources that are available, I have sketched the following short history of the discursive formation of our material system of knowledge production and how it developed in dynamic relationship with the monograph.

Print Technology

Within book historical narratives, a lot of emphasis has been placed on the influence of print technology upon both the rise of the modern scholarly communication system and the rise of the book as a scholarly object and a mass commodity. But was it print that started this development? Ong, for example, states that it was the objectifying movement of writing that turned words into signs and time into fragments.[19] Nonetheless, he argues at the same time that it was print that truly objectified words as things, to the extent that words were now made out of preexisting mechanical units (types). Print "embedded the word itself deeply in the manufacturing process and made it into a kind of commodity."[20] It was with print that we entered what McLuhan called the "first great consumer age," while Febvre and Martin declared the introduction of printing "a stage on the road to our present society of mass consumption and of standardisation."[21] Eisenstein also emphasizes that it was the advent of print that enabled the mechanical reproduction of books and transformed the conditions under which texts were produced, disseminated, and consumed. Initially, she states, it was not the product that changed (in the age of incunabula); it was that this product was reproduced in larger quantities than was ever possible before.[22] The organization of printed book production also introduced new roles and functions, she points out, and with that the whole system around book production took on a different scale. By the same token, however, one could argue that the medieval production of manuscripts by scribes in scriptoria was already a highly commercial business. The market value of hand-copied books also remained high for a long time after the invention of the printing press.[23] Nonetheless, as Ong stresses, manuscript production was producer-oriented, while print was highly consumer-oriented.[24] The use of abbreviations in manuscripts, for instance, was designed to help the producer of the work, not to improve the ease of reading. Texts were

The Commodification of the Book and Its Discursive Formation 129

also often bound in one book cover in the Middle Ages, making it hard to ascertain the number of texts included in one manuscript. Eisenstein points out therefore that it was print that influenced the coming of the book as an object containing a single work.[25]

Eisenstein further outlines how the printing press was incremental in promoting one of the main values of science: that of making knowledge public.[26] Print enabled feedback and secured old and new records. Once research observations could be duplicated in printed books, they became available to readers who could check them and feed corrections back with new observations that could then be incorporated into new editions again.[27] Print, Eisenstein states, was a publicizing machine: it stimulated the circulation of what was previously private information as a public good, promoting the move away from a system of guild secrecy and toward one of publication, which in turn led to more cooperative science. Print, she stresses, thus served both the motives of altruism and self-advancement that came to be so important in modern science.[28]

The Commercial Book Trade

In addition to paying attention to the role played by technology and the materiality of the printed book, book historians have also focused on the influence the commercial book trade had on the development of our modern system of scholarly communication. As Eisenstein emphasizes, for example, one of the effects of the modernization and rationalization of the new commercial book trade was that it influenced the rise of an *esprit de système* in academia.[29] The newly established international book trade promoted an ethos that became associated with the community of men of letters, she states: "tolerant yet not secular, genuinely pious yet opposed to fanaticism."[30] Besides being commercial enterprises, print shops were also cultural centers, serving as the focal point of scientific development. Eisenstein thus argues that the rise of the republic of letters must be seen to have gone hand in hand with the development of the printed book trade.[31] Febvre and Martin similarly point out that from its earliest days printing existed as an industry, in which the scholarly book was a piece of merchandise from which to make a profit and earn a living, even for scholars.[32] For example, as part of the growing market economy around books, printers used new publicizing techniques such as blurbs to sell their books. Individual achievement was heightened in these processes, based on a market mechanism that followed

the practical need to advertise products and bring trade to shops. Likewise, Eisenstein argues that it was "the industry which encouraged publishers to advertise authors and authors to advertise themselves."[33] The rise of scholarly authorship and the growing prestige of the inventor are also connected to new forms of intellectual property rights that were introduced in the book trade to prevent piracy.

The system of material production set up around print and scholarship is thus seen as having played an important role in shaping the emerging scientific communication system. Johns, building on Steven Shapin's identification of trust as a key element in the making of knowledge, focuses specifically on how this system of material production established notions of credibility and trust.[34] He argues that it was not fixity as brought about by print technology but trust in a textual work that was able to turn a book into both a commercial trade and scholarly object. This included constructing trust in the book's integrity, quality, and authority. Johns is therefore mainly interested in how the system of book production, distribution, and consumption was constructed and how it functioned, as well as in the shifting roles that were played by printers/publishers (stationers), booksellers, scholars, and the government or monarch, together with the various institutions that grew out of these groups, such as the Stationers' Company and the Royal Society in England.

Chartier similarly emphasizes the importance of studying material practices with respect to book production and consumption, but, unlike Johns, he directly connects this back to the book as a specific technological affordance. For Chartier, then, a text is integrally connected to its physical support, where meaning gets constructed through the form in which a text reaches its readers. Publishing decisions and the constraints of print production are constituted within this form, he argues.[35] Chartier is thus interested in the controls that were exercised over printed matter as part of its production process, from exterior moral or religious censorship or forms of patronage to constraining interior mechanisms within the book itself. Print established a market, which came, Chartier shows, with certain rules and conventions for those players that made a monetary gain from this new commercial system.[36] What kind of struggles over the construction of the scholarly book and its history took place between these various constituencies? What was the influence of these discursive struggles on the establishment of trust and the creation of the modern system of scholarly communication?

The Commodification of the Book and Its Discursive Formation 131

As I made clear previously, Johns points out that it was first and foremost the stationers or publishers, and to a lesser extent booksellers, who were responsible for constructing a trustworthy realm of knowledge, by articulating conventions related to propriety.[37] Through the publishers' agency, following their interests and practices, printed materials and the knowledge embodied within them came into being. The social character of the printing house hereby influenced its products: who had access to the printing house, what were they allowed to do, and under what conditions. What kinds of books were printed and who got to decide what could be printed? Not unlike the present situation of academic book publishing, Johns points out that these decisions were often based on economics, where the priorities of the book trade came first, a state of affairs that did not always benefit academic authors nor the emerging system of scientific scholarship. Many scholarly works were expensive to produce (often requiring special typefaces in the cases of mathematics and astronomy, for instance, as well as elaborate graphs and images), and they suffered from a small market plagued by piracy.[38] This made learned titles unsustainable to produce in situations in which stationers were reluctant to publish them unless they could be guaranteed to sell. Capital was needed to print a title, Febvre and Martin explain, and thus only those books that satisfied a demand were actually produced at a competitive price.[39] Powerful patronage from public authorities such as bishops or the state was often needed in these situations, as well as capital injections through loans, to provide just one example. As such, in the early days of the press, the main factor in its rapid development was the interest influential men and institutions had in making texts accessible.[40] Nevertheless, marketable products still came first, Johns explains. Work on scholarly books was often delayed while printers concentrated on more immediately profitable material, such as pamphlets and ephemera, which were produced in the same space as folio volumes. These were what printers relied on for their economic sustenance, meaning that, as Johns explains, profitable pamphlets came before scientific books.[41]

Printers, Johns explains, were seen to personally vouch for the propriety of their products through their character, which was determined among other things by their respect of copy (meaning no piracy). Attempts to regulate the book trade against piracy and impropriety thus stressed the model of a stable, domestic household. This household image of propriety, comparable with today's emphasis on branding, played an important

role in reading strategies too. According to Johns, a reader judged a book based on practices and pragmatics, which included looking at the name of the stationer or publisher on a book's title page to determine reliable content.[42] The craft community (including booksellers) worked to sustain good character for the book trade as a whole.[43] In this process, Johns argues, politics, propriety, and print were integrally connected: trust could become possible because of a print-disciplining regime. In England, the Stationers' Company established a propriety culture, as Johns calls it, which was essential in the establishment of the book as a trade and scholarly object. The connection between the market and the emerging scholarly communication system becomes even clearer if we take into account that property and propriety used to mean the same. As Johns states: "offenses against the property enshrined by convention in the register were seen simultaneously as offenses against proper conduct."[44] The Stationers' Company established a registry system for published books to counter piracy and to strengthen the representation of its business as a respectable and moral art.[45] In reality, this meant it had a monopoly over the publishing industry for setting and enforcing regulations. Where concerns of the state mattered heavily when it came to the book trade, in the representation of the stationer, licensing and propriety were both seen as integral not only to the concerns of the stationers, but to those of the state. In this sense, the company, Johns claims, "constituted the conditions of existence for printed knowledge itself."[46]

The Academies and the Journal System

What role did the emerging scholarly societies play in this development? How can they be connected to the systems of material production that were set up around scholarly books? In the sixteenth and seventeenth centuries, new ideas were initially communicated by means of written correspondences.[47] Gradually, with the aid of official scientific academies, the increase in correspondences led to their standardization in journals or periodicals, which, as Kronick points out, enabled these conversations to take place in a more open setting. At the same time, the increase in the number of scholarly books being published led to the creation of book reviews. These developments mark the start of the first journals, such as *Philosophical Transactions*, which dealt with new ideas, and the *Journal des Sçavans*, which primarily served as a medium for book reviewing.[48]

The Commodification of the Book and Its Discursive Formation 133

In England, as Johns has extensively recounted, it was the Royal Society, chartered in 1662 as a learned society of scholars, that tried to set up an order for the communication of scholarly research that was tailored more to the needs of academia. It did this by, among other actions, aggressive intervention in the realm of print.[49] The society has become famous for its publishing enterprises, which include—as mentioned earlier—the first scientific journal, the *Philosophical Transactions*, along with Newton's *Philosophiae Naturalis Principia Mathematica*. As Johns points out, however, these were the outcome of long processes of establishing conventions based on experiments within the society. As with the stationers, new concepts of authorship, publication, and reading were enacted in conditions of civil trust, ensuring that productions would not be reprinted, translated, or pirated without consent.[50] The Royal Society thus, Johns explains, attempted to "contain, and even redefine, the powers of print" in direct opposition to the order set up by the Stationers' Company.[51] Experimental natural philosophers, in cooperation with the society, created new forms of sociability and new genres of writing, such as the experimental paper, the journal, the book review, the editor, and the experimental author. Within these confines, an openness and readiness to communicate was essential to promote the common good, Johns states. Virtual forms of witnessing were developed through detailed forms of scientific reporting. This civil domain of print was based on the society's own system of internal registration (or licensing) and external publication.[52] Together, the protocols established around these systems are seen to constitute the emerging communication system in the experimental community.

Henry Oldenburg, secretary of the Royal Society, first developed an extensive system of external publication by setting up a network of correspondents across Europe, connecting the society to the broader world of learned men. It was this network that formed the basis of the *Philosophical Transactions*.[53] The latter extended the society's register into the "public" realm of print as a new strategy to secure authorship within the scholarly community of natural philosophers, creating forms of international propriety, Johns explains.[54] Johns also narrates how the society proposed a radical solution to the problem of discredit, making it an expressly *political* problem by suggesting direct royal intervention in the civility of printing: the Stationers' Company, together with the "print-disciplining regime" it had set up, should be replaced by a system of crown-appointed patentees,

with printers to be employed as servants to the society and the crown. The Stationers' Company regulated property via its register, which, seen as a threat to the power of the king, was ultimately challenged by this new royal patenting system that promised to replace the stationers' power with that of the monarch. In this new system, property and the right to copy came to be embedded in law, Johns explains. In this way, powerful intertwined representations of printing and politics (and power and knowledge) were constructed, representing, as Johns emphasizes, a revolutionary reconstruction of the cultural politics of print.[55]

This reconstruction also had a historiographical element: in order to determine what the future of print should be (i.e., if it should be based on a registration or on a patenting system), a battle was fought over the historical origins of print, via a reconstruction of the historical origins of the press itself. The licensers from the Royal Society argued that print should return to its pure status as an "Art" that it had enjoyed before being incorporated, owned and regulated by the mercenary interests of the stationers as a "Mechanick Trade."[56] They claimed that the printing craft was the personal property of the monarch, whereas the stationers pointed out that it had always been a "common" trade. This example shows how the essential properties of print were disputed and how participants in the debate actually created print itself. As Johns states, "Practitioners of the press . . . made creative use of their own histories to delineate cultural proprieties for themselves and their craft."[57]

In the end, printing would become part of court service and would rest on the civility of this system. The register mechanism became the defining element of experimental propriety within the society and the *Philosophical Transactions* its symbol abroad.[58] It is important to emphasize, however, as both Johns and Jean-Claude Guédon have done, that the emergence of this scholarly journal system had little to do with democratic scholarly ideas (in the tradition of Merton—something that is also visible in Kronick, for instance) and the public good, but with issues of copyright, with priority claims, and with royal hierarchies. As Guédon remarks in this respect: "The design of a scientific periodical, far from primarily aiming at disseminating knowledge, really seeks to reinforce property rights over ideas; intellectual property and authors were not legal concepts designed to protect writers—they were invented for the printers' or Stationers' benefits."[59] The limitation of the stationers' property rights in favor of the Royal Society as

The Commodification of the Book and Its Discursive Formation

a scholarly institution should thus not be seen as a form of promoting the public good and scholarship *in opposition* against economic interests. It was most of all a political conflict between the crown and the stationers, where the crown wanted to reassert its authority via the institution of the Royal Society and the law. In this respect, developments such as copyright should be seen, as Guédon has argued, as specific historical constructions that arise out of a moment of equilibrium between conflicting interests and parties. And just like the system of scholarly communication, this equilibrium is not stable or solid, but keeps on evolving.

To provide another example, the peer-review system did not initially appear as an integral part of science and scholarship. As Mario Biagioli has emphasized, peer review, or *refereeing*, was a specific seventeenth-century development tied to the emergence of the new institutions of the academies. These state-sponsored institutions were granted the privilege to publish their own works. Up until then, censorship systems had been controlled by religious authorities and licensing by the printers/stationers. The genealogy of peer review thus suggests that it developed within the logic of royal censorship, not as something protecting the interests of the broader scholarly community. Peer review was about establishing unacceptable claims (censorship), not about establishing good claims (quality), Biagioli points out.[60] As he puts it: "So while peer review is now cast as a sign of the hard-won independence of science from socio-political interests, it actually developed as the result of royal privileges attributed to very few academies to become part and parcel of the book licensing and censorship systems."[61] The academies needed to control print in order to sustain themselves and their protection by the royal patron. There were also strong economic interests involved. In addition to controlling publications, the academies needed to promote them in order to build their prestige and recognition to foster continued state support. This was the beginning of a cultural market, Biagioli remarks, where "publications . . . became a credit-carrying object, and these 'academic banknotes' needed to be printed, not only censored."[62] So although it started as an early modern disciplinary technique akin to book censorship, as Biagioli shows, peer review developed in the eighteenth century into an in-house disciplinary technique, and then it began to function as a producer of academic value. In the end, it no longer depended on a center of authority but was internalized, changing from external disciplining (state censors) to internal review (academic reviewers). It thus

functioned as a Foucauldian disciplining technique, repressing and producing knowledge at the same time.[63]

Seeing the academies as promoting and enabling cultural and scholarly values and the public good in opposition to the economic and political interests of the state and the stationers can thus be considered a misrepresentation. This view ignores the priority struggles the academies, the state, and the stationers were involved in as part of the entanglement of political, economic, and technological factors, which enabled the rise of the modern system of scholarly communication. As Guédon rightly claims: "In short, a good deal of irony presides over the emergence of scholarly publishing: all the democratic justifications that generally accompany our contemporary discussions of copyright seem to have been the result of reasons best forgotten, almost unmentionable. The history of scientific publishing either displays Hegel's cunning of history at its best, or it reveals how good institutions are at covering their own tracks with lofty pronouncements!"[64]

University Press Publishing

In addition to the development of the academies, universities increasingly started to set up presses of their own to communicate their scholarly findings.[65] In Europe, Oxford University Press (1478) and Cambridge University Press (1521) were both founded shortly after the coming of print. Their early development was anything but stable, however, as it was only in the sixteenth century that some form of continuous publishing production was established for both presses. They were integral parts of their universities but also depended on commercial activities, such as bible publishing, to survive. This monopoly on bible publishing, which was disputed in its early days by the Stationers' Company, supplied sufficient funding to support publishing in other, less profitable areas. American university presses were established in the late 1800s, as part of the rise of the American university itself, modeled on the German research universities. With the rise of the first universities, the need for a university press to accompany the university mission was strongly felt. In the case of Johns Hopkins Press (1878), for instance, it was the university president who strongly believed in the need for a press. As Thompson notes: "The American university presses were set up with the aim of advancing and disseminating knowledge by publishing high quality scholarly work; they were generally seen as an integral part of

The Commodification of the Book and Its Discursive Formation 137

the function of the university."[66] After Hopkins, 1891 saw the coming of the University of Chicago Press and 1869 of Cornell University Press, followed by the presses of the University of California and Columbia University in 1893.[67] The University of California's press grew out of the interest of the institution's librarian in creating series of scholarly monographs to exchange with similar series issued from other universities. These presses arrived at a time when higher education in the US was still in its early stages, operating on a very small scale. From the rise of the university presses onward, this gradually started to change at a steadily faster pace.[68]

In the US, commercial publishing was already well developed by the time university presses came about. The main mission of the presses was to publish the kind of research that could not find a commercial outlet: specialized scholarly research. Again, Hawes states the importance here of university support, where "the American presses have depended essentially on funds from university appropriations and from varieties of benefactors, rather than from religious publishing, to help support the dissemination of scholarly research." This includes their tax-exempt status in the US.[69] It took the first presses some time to establish themselves (in a process that comprised a lot of failing and reviving) before a new wave arrived in 1905, with the formation of Princeton University Press. Alumni also played an important role in this movement by providing monetary funds in support of the presses.[70] Eleven more universities founded presses by the end of the 1920s, and another twelve did so in the 1930s.[71] Hawes emphasizes the individual, organic development of these presses, as related to the specific university and people that ran the press. Eventually, in 1946 the Association of American University Presses (AAUP) was founded—a trade organization for scholarly publishers—stipulating membership qualifications in 1949.[72]

What this short overview of the development of the university press focused especially on the US shows is how the publishing function was seen as directly related to the university's mission, which resulted in a relationship in which university funding to support the press was essential to the functioning of the institution. As Hawes argued: "Just as relatively high costs and narrow markets typify the publishing economics of scholarly books, subsidy support plays a fundamental role in the publishing economics of a university press."[73]

The Monograph Crisis

As Hawes and others have pointed out, the ability to publish specialized, experimental work is not a sustainable enterprise. University presses were brought into life exactly for this reason, as nonprofit institutions publishing the kinds of works that were not commercially viable. The objective of university press publishing could therefore be seen as a form of university extension work.[74] This means they depend on forms of outside support and subsidies that lend them an advantage over commercial publishers, enabling university presses to support books that are not viable by their nature because they have a small potential market.[75] Nevertheless, after the gradual if moderate development of academic publishing in the United States up to the first half of the twentieth century, the 1950s and 1960s saw an extended growth as a direct result of the expansion of universities worldwide following the Second World War. Other factors involved in this expansion were the baby boom, the GI bill, the influx of women in academia, economic advancement, and educational investments as part of the Cold War. This rise in student numbers and universities led to increased funds and investments in libraries, which in turn created a demand for more content. By 1967, there were sixty university presses affiliated with universities in the US and Canada, and by 1970 there were thirty smaller presses active outside the AAUP. In the UK, seven university presses were active in 1970: Cambridge, Oxford, Liverpool, Manchester, Edinburgh, Leicester, and Athlone Press of the University of London.[76]

This growth-boom ended rather abruptly at the beginning of the 1970s, followed by the economic recession of the 1980s, which marked the beginning of what we now know as the *serials* and *monograph crises*.[77] Greco has analyzed a large collection of sources, based mainly on research papers from the 1960s to the 1990s from the *Journal of Scholarly Publishing*, that first talk about a crisis in scholarly communication at the beginning of the 1970s, extending into the present. He narrates how the rise of commercial scholarly publishing at that time was luring commercially interesting scholars away from university presses, making it even harder for the latter to sustain themselves.[78] In their description of the start of the crisis, Harvey et al. note that universities were facing severe budget cuts at these times, which mostly meant their presses were the first areas of their activity to be cut, in the form of declining university subsidies. Library budgets were also cut, while publishing (warehousing, distribution, etc.) costs went up. This led

The Commodification of the Book and Its Discursive Formation 139

to a situation in which presses were—and still are—forced to change the books they publish, to the detriment of specialized scholarly monographs in the humanities.[79]

The serials and monograph crises only became more pronounced in the 1980s and 1990s. In this period, the focus of the debate on the crisis in academic publishing shifted to the impact it was having on the tenure review process and on the future of early career scholars. This period also saw the growing penetration of commercial market forces into university press practices. Academic publishing was increasingly forced to adhere to a business ideology.[80] According to Thompson, a "new climate of financial accountability" arose for university presses around this time, which strengthened their uncertainty toward the nature and purpose of a university press. To a growing degree, they were expected to break even and to reduce their dependence on their institutions.[81] In a sense, the perceived mission of the university press was breached in this situation. One of the results of this development was a greater throughput model, where publishers had to publish more and more titles in order to attain the same level of revenue. The growth in titles over the years did not necessarily mean the presses were doing well, however: they may have been publishing more titles, but they were making less profit per title.[82] Besides, as Hall has argued, the increase in titles didn't necessarily mean more new research was being published, as many scholarly books were "merely repeating and repackaging old ideas and material," with publishers focusing on more marketable overview publications, such as readers and introductions targeted at students.[83]

As noted earlier, this decline of university press publishing was at the same time affected by the immense growth of commercial scholarly publishing. Since the 1970s, the book publishing industry as a whole has been the focus of intensive merger and acquisitions activity, leading to a situation in which international conglomerates now rule the business. Thompson saw these developments coming about most clearly in the growth of title output (also in book publishing, where, as part of the commodification of the sector, both paperbacks and hardbacks were increasingly published); the concentration of corporate power; the transformation of the retail sectors; the globalization of markets and publishing firms; and the influence of new technologies.[84] This progressively corporate concentration of scholarly publishing can, as Larivière et al. note, be illustrated most clearly if we look

at journals. As they show, based on forty-five million documents indexed in the Web of Science over the period from 1973 to 2013, more than 50 percent of all papers published in 2013 were published by just five publishers. In the social sciences and humanities in particular, there has been a dramatic increase in concentration since 1973:

> Between 1973 and 1990, the five most prolific publishers combined accounted for less than 10% of the published output of the domain, with their share slightly increasing over the period. By the mid-1990s, their share grew to collectively account for 15% of papers. However, since then, this share has increased to more than 51%, meaning that, in 2013, the majority of SSH papers are published by journals that belong to five commercial publishers. Specifically, in 2013, Elsevier accounts for 16.4% of all SSH papers (4.4 fold increase since 1990), Taylor & Francis for 12.4% (16 fold increase), Wiley-Blackwell for 12.1% (3.8 fold increase), Springer for 7.1% (21.3 fold increase), and Sage Publications for 6.4% (4 fold increase).[85]

As John Willinsky argues, mergers with smaller publishers also led to a growth in subscription prices.[86] The excessive use of commercial branding, developed as a technique to cope with information overload, created a form of core science (i.e., citation index hierarchy), as well as core journals and reputable publishers. This creation of hierarchy out of branding has again made it easier to make a profit out of publishing, by creating an inelastic market; it has also made it easier to distinguish so-perceived excellent from mediocre scholars and researchers.[87]

Journal publishing thus turned into a very lucrative business, affecting the system of scholarly communication directly. As Thompson points out, this "rise of powerful corporate players in the fields of STM publishing and journal publishing has squeezed the budgets of university libraries with dire consequences for academic publishers."[88] Furthermore, university presses have increasingly been forced into commercial trade and textbook publishing to survive, while they are faced with strong competition from the conglomerates. This development led to the establishment of new publishing strategies for university presses, including more paperbacks, more textbooks, and a bigger focus on disciplines and subjects that sell: strategies that were seen as being inevitable if they wanted to survive. This again emphasizes how the logic of the market has increasingly become entangled with the perceived mission of presses to do university extension work. But beyond the commercialization and consolidation of the scholarly

The Commodification of the Book and Its Discursive Formation 141

publishing market, universities have played an important role in this development, too, as the next section outlines.

The Neoliberal University and the Marketization of Academia

The serials and subsequent monograph crises continued to be a topic of hot debate from the 1990s on, particularly where it concerned the function and future of the university press and its relationship to the university, something that would have direct consequences for the further development of monograph publishing. Critics such as Lindsay Waters have continuously pointed out the risks that come with the continued commercialization of university presses: "Academic books are not a sustainable or profitable business. The idea then that university presses should turn into profit centers and strengthen the university's budget is ludicrous."[89] Waters emphasizes the role played by the market in this development, pointing out that there is a direct connection between the university's marketization and the crisis in publishing. Where the universities were increasingly focused on growth in productivity—that is, more publications—this meant, in Waters words, "the draining of all publications of any significance other than as a number." As with journal articles, this meant books increasingly turned into "objects to quantify."[90] Here there are larger problems that need to be addressed, connected to issues of accountability in university systems, the managerial/bureaucratic revolution, and forms of what Waters calls *cognitive rationality*.[91] This turn toward an increasingly economic rationality in both academia and publishing took place after WWII, a period when "the university was made over on the model of the American corporation."[92] We can see here similarities with Reading's argument on how the natural cultural mission that determined the university logic in the past has been declining and has been replaced by the idea of the "University of Excellence."[93] From a connection to the nation state, producing and sustaining an idea of national culture, the university has become a transnational bureaucratic company following the logic of the discourse of excellence and accountability: a "relatively autonomous consumer-oriented corporation."[94] Consumerism replaces nationalism here, where increasingly culture no longer seems to matter as a foundational *idea* for the institution.[95] The emerging issue of the demand for publications was one of the factors, in addition to a more widespread social shift generated by neoliberalism's

reliance on managerial and consultancy techniques, that has led to the emergence of an audit culture within universities. Here quality is no longer assessed, but credentialing happens by counting up publications (what Waters refers to as *Fordist production*), with the effect that decisions about tenure or promotion have been increasingly outsourced to the presses.[96] The corporatization of the university, as well as the administrative revolution and the search for excellence, thus all play an important role in the commercialization of publishing, as well as in the development of the serials and monograph crises.[97]

It is important to emphasize the role the corporatization of the university played in this development, as this lays some of the responsibility for these developments on a shift in academia as a whole to marketization, as well as on our own institutions embracing this market logic, and ultimately on ourselves as scholars within these institutions. Should we as scholars reassess our own role in this development? Are there ways in which we can create an alternative to the University of Excellence? Would this not involve, notwithstanding the abstract and often ungraspable nature of these market forces, that we start to change our own scholarly practices in response to and in reaction to them? I will come back to say more about this in the next chapter, but here I want to argue—as I already made clear in my introduction to this chapter—that it can be highly problematic to perceive academia and publishing as different fields, the one operating via a cultural logic and the other via an economic logic. Here the publishing function is perceived as a separate entity, something outside the university that is outsourced and othered, instead of envisioning it as a function that could and should be (and has been!) an integral part of the development of the university. The commercialization of scholarly publishing is deeply entangled with the waning of the humanities, and the increasing lack of subsidies for these fields is hitting both its disciplines and not-for-profit, book-focused university presses hard. The developments in scholarly publishing are directly connected to both the commercialization and globalization of the book publishing business, but what is equally significant is that they are integrally related to the neoliberal marketization and managerialization of the university.[98]

Nonetheless, there are other views. Sociologist John Thompson, for instance, based on his specific adaptation of Bourdieu's field theory, makes a clear distinction between different publishing fields and the so-called social

The Commodification of the Book and Its Discursive Formation 143

fields to which they are related, such as that of higher education (which in Thompson's vision includes the world of university libraries).[99] Although he emphasizes that these fields are connected and have developed together, in his application of field theory, Thompson has a tendency to cleave the publishing function from the social field of the university. According to him, they are shaped by different interests and logics: "These fields are not the same, they have different social and institutional characteristics, but they are locked together through multiple forms of interdependency."[100] For Thompson, then, there is a distinction between higher education or the university, which is preoccupied with cultural capital and scholarly esteem, and the publishing field, which deals with commerce and the market— and these conflicting field logics give rise to tension, misunderstanding, and conflict.[101] What he tends to undervalue is the fact that this tension is already part of the university system and has been from its inception. Likewise, this tension has been part of a publishing system in which cultural values and struggles have always played an important role—as illustrated earlier by the power play between the stationers and the Royal Society, for example.[102] Here I would like to argue that the publishing field and the social field of the university—as Thompson distinguishes them—are not so much governed by separate (cultural and commercial) logics. Indeed, it is the logic of commerce, or the growing monopoly that economic values have in our neoliberal institutions, that is turning both the university and the university press more and more into commercial businesses. Academia as a whole, in which I include the publishing function, is structured by connected and clashing economic, cultural, technological, and political logics, rather than by logics subdivided into publishing and social fields that are then seen as conflicting with each other. Publishing, or the publishing function, is not to be solely blamed in this respect for the increasing commercialization. The root cause of this problem should be located in the larger struggle for the future of the university, where at the moment it seems commercial interests are winning.

In what ways are these functions then entangled? How do developments in (book) publishing relate to developments within universities? In addition to the examples already mentioned previously, another connection can be found in the hyperspecialization in scholarship—increasingly countered now by the need for inter- and transdisciplinary studies. This urge to specialize within academia is connected to the demand to produce ever

more research to increase one's *research impact* (which, as Collini points out, chiefly refers to economic, medical, and policy impact), based on research that at the same time needs to be original and new.[103] This kind of highly specialized scholarship is, however, increasingly hard to market by university presses that are supposed to break even or make a profit on their endeavors.[104] Another related problem is the creation of ever more PhD students, as well as academics on zero hours and temporary contracts, who are to a growing degree working as cheap labor and replacing contracted, full-time staff.[105] PhD students interested in an academic career are also, following the accountability logic of the university, expected to publish their dissertations, which are again supposed to contain highly original and new research, in order to apply for increasingly fewer full-time positions. All this while "at the same time . . . the market for the scholarly book has collapsed," making it harder for these early career researchers to attain tenure positions in their fields.[106]

Thompson argues that it has been the clash between different logics that has created a situation in which the "field of academic publishing and the field of the academy are being propelled in opposite directions."[107] Instead, I think it is more accurate to see this as a result of the internal contradictions structuring neoliberal marketization, where both the publishers' need to be more selective when deciding what to publish according to market needs and the demand on scholars to publish more for research impact are based on principles of market competition. Credential inflation means that there are increasingly fewer positions available for scholars, which leads to a stronger selection based on more and better publications, just as more publications and less market demand means more selection and increased competition for publishers.

Openness Contested

Due to the rise of economic ideologies and market forces in both academia and scholarly book publishing over the last few decades, the monograph as a specific publishing and communication format has thus increasingly developed according to market demands. Many scholars feel that access to specialized research, especially in the humanities, has diminished due to shrinking library budgets on the one hand and more trade-focused scholarly presses and publishers on the other. In the struggle for the future of the

The Commodification of the Book and Its Discursive Formation 145

book and the university, access to scholarship has thus become an increasingly important issue, one that is standing at the base of various new digital knowledge practices. Open access publishing can be seen as one of the most important recent developments in digital scholarly publishing, one that targets this issue directly. David Prosser, the director of Research Libraries UK (RLUK), even goes so far as to call it "the next information revolution," and globally governments and research funders are increasingly making headway with mandating open access for publicly funded research.[108] Open access has also been important for book publishing and, more specifically, for the struggle over the future of the book. In this final section, I therefore want to take a closer look at the relationship between open access and scholarly book publishing, and the motives behind the latter's interest in and uptake of open access. As part of this, I will examine in the next chapter some of the forms a politics of the book based on openness might take.

To examine such a politics of the book, I want to first look at some of the critiques that have been put forward with respect to the concept of openness, and open politics more specifically. Where initially the open access and open source movements were heralded by progressive thinkers as part of a critique of the commodification of knowledge, openness is seen increasingly as a concept and practice that connects well with neoliberal needs and rhetoric, and that can be related to ideas of transparency and efficiency promoted by business and government.[109] From an initially subversive idea, one can argue that open access, partly related to its growing accessibility and wider general uptake, is increasingly co-opted by capitalist ideology (of which the Finch report, which I will discuss in the next chapter, is ample evidence) and as a result is turning, in some respects at least, into yet another business model for commercial publishers to reap a profit from.[110]

What, then, were the main reasons behind the uptake of open access, especially in scholarly book publishing? How was it envisioned as a potential strategy against excessive forms of commercial publishing and academic capitalism? Open access literature has been defined as "digital, online, free of charge, and free of most copyright and licensing restrictions."[111] The open access movement grew out of an initiative established by academic researchers, librarians, managers, and administrators, who argued that the established publishing system was no longer able or willing to fulfill their communication needs, even though opportunities were now increasingly

offered by new digital distribution formats and mechanisms to make research more widely accessible.[112] The movement can be seen as a direct reaction against the ongoing commercialization of research and of the publishing industry, coupled to a felt need to make research more widely accessible in a faster and more efficient way. From the early 1990s on, open access was initiated and developed within the science, technology, engineering, and mathematics (STEM) fields, where it focused mainly on the author self-archiving research works in central, subject- or institution-based repositories (green open access). These can be works that have been submitted for peer review (preprints) or that are final peer-reviewed versions (postprints). The other main and complementary route to open access focused on the publishing of research works in open access journals, books, or other types of literature (gold open access).[113] In the humanities and social sciences (HSS), the fields in which books have tended to be the preferred communication medium, open access caught on later than in the STEM fields. This was due, among other reasons, to the slow rise of book digitization and of e-book uptake by scholars; the focus on green open access within the STEM fields, targeting the high costs of subscriptions to journals in these fields (journals in HSS are generally cheaper); the specific difficulty with copyright and licensing agreements for books; and the expenses involved in publishing books in comparison with articles (i.e., they have different publishing and business models).[114]

Open access also filled another void in the HSS, where it was perceived as the answer to the monograph crisis. As described previously, scholarly monograph publishing is seen to be facing a crisis, in which its already feeble sustainability is being endangered by declining book sales.[115] Partly in response to this perceived monograph crisis, these developments have seen the rise of a number of scholarly, library, and/or university press initiatives that are experimenting more directly with making monographs available on an open access basis. These initiatives include scholar-led presses such as Open Humanities Press, Éditions science et bien commun (ÉSBC), African Minds, and punctum books, plus new university presses, such as ANU Press (originally ANU E Press), UCL Press, Goldsmiths Press, and Firenze University Press.[116] They also include presses established by or working with libraries, such as Athabasca University's AU Press and Göttingen University Press; cooperatives of university presses, such as (in its original instantiation) the OAPEN project and Open Edition in Europe and Lever Press in

The Commodification of the Book and Its Discursive Formation 147

the US; commercial presses such as Bloomsbury Academic and Ubiquity Press in the UK; and crowdfunding platforms and consortial library partnerships such as Unglue.it, Knowledge Unlatched, and (more recently) COPIM (Community-led Open Publication Infrastructures for Monographs).[117] As Sigi Jöttkandt and Gary Hall argue with respect to the decision to set up Open Humanities Press in relation to the monograph crisis:

> Such a situation not only affects the careers and, potentially, the choice of research areas of individuals. It also impacts the humanities itself—both because a lot of excellent work is unable to find appropriate publication outlets and also because decisions concerning the production, publication, dissemination and promotion of humanities research are being made less and less by universities and academics on intellectual grounds, and more and more by scholarly and commercial presses on economic grounds. When ground-breaking research that develops new insights is rejected in favor of more marketable introductions and readers, it is clear that academia as a whole becomes "intellectually impoverished."[118]

However, as is already indicated by the variety of initiatives listed previously and the diversity of their backgrounds, the motivations behind the development of open access archiving and publishing are extremely diverse. They include the desire to increase accessibility to specialized humanities research by making it online and openly available (to enable increased readership and to promote the impact of scholarly research, next to enabling heightened accessibility to research to those who can't access subscription content); to publish or disseminate research in an open way in order to take social responsibility and to enhance a democratic public sphere as a means of stimulating a liberal democracy that thrives on an informed public; to argue for the importance of sharing research results in a more immediate and direct way; and to offer an alternative to, and to stand up against, the large, established, profit-led, commercial publishing houses that have come to dominate the field in order to liberate ideas and thinkers from market constraints and to be able to publish specialist scholarship that lacks a clear commercial market.

However, these liberal-democratic motives for open access exist side by side, not just with more radical and critical motives, but also with the neoliberal rhetoric of the knowledge economy. In the latter, open access is seen as supporting a competitive economy by making the flow of information more flexible, efficient, transparent, and cost-effective and by making research more accessible to more people. This will stimulate industry to capitalize on academic knowledge, encouraging global competition.[119]

As Hall has argued in *Digitize This Book!*, in which he gives a very detailed and comprehensive overview of the differing but often also overlapping motivations that exist concerning open access and openness, there is nothing intrinsically political or democratic about open access. Motives that focus on democratic principles often go hand in hand with neoliberal arguments concerning the benefits of open access for the knowledge economy.[120] A politics of the book in relation to open access publishing is thus not predefined, nor is it my intention to argue that it should be. Openness in many ways can be seen as what Laclau calls a *floating signifier*, a concept without a fixed meaning and one that is easily adopted by different political ideologies.[121] As I will point out, it is this very *openness* and lack of fixity of the concept that gives it its power, but it also brings with it a risk of uncertainty about its (future) adoption. However, for some scholars it is exactly this openness of open access or of the concept of openness that is problematic.

To present another context to this debate and to open up and argue for an alternative future for the already diverse and contingent idea of openness, I want to critically engage here with the work of media scholar Nathaniel Tkacz. In his work, Tkacz pinpoints what he considers to be some of the inconsistencies in the concept of openness and open politics and how from its very inception it can be connected to neoliberal thought. He achieves this both by going back to the "father of open thought," Karl Popper, and by analyzing the influence of open software cultures on current open movements. Tkacz's analysis can be seen as an illustrative example of the kind of thinking that criticizes the liberatory tendencies and idealism present in many openness advocacies and that sees openness as related to neoliberalism—a way of thinking that is no less fueled by the recent uptake of open access by certain governments, research funders, and commercial publishers.

Tkacz's assessment of openness is based on what he sees as "a critical flaw in how openness functions in relation to politics."[122] To explore how openness has come to proliferate as a political concept, becoming "a master category of political thought," Tkacz provides a detailed reading of the work of Popper on openness and the open society, while further tracing its recent genealogy through the politics and political economy of software and network cultures.[123] His critique focuses mainly on how openness and open politics, both in Popper and in contemporary incarnations of open

The Commodification of the Book and Its Discursive Formation

149

politics, serves as an inscrutable political ideal, merely opposed to its empty binary, the closed society, or closed politics, which is a politics based on centralized governance (critiqued by neoliberalists such as Friedrich Hayek) and/or unchallengeable truths (such as Popper argues one can find in the politics of fascism and communism). Yet this binary open-closed cannot be upheld in Popper's thought, Tkacz argues, because closure is inherent in his notion of openness. Based on the philosophy of Popper, *open* as a concept is reactionary (where it merely states what it is *not*—i.e., *not closed*); it has no (true or positive) meaning—which would close it off—and cannot "build a lasting affirmative dimension."[124] Tkacz further argues that if there are positive qualities to openness, they exist at the level of reality (of real practices) and are therefore subject to continual transformation, which he sees as paradoxical: How can something that is already open then become more open, when this means that it thus must have not been open before? For Tkacz, then, clearly, "openness . . . implies antagonism, or what the language of openness would describe as closures."[125]

The issue, Tkacz states, is that these closures get obscured in current incarnations of open politics, which, he argues, have been highly influenced by the thinking of both Popper and Hayek. How then has this concept and the "empty ideal" of openness reemerged in politics, and how has it has been repoliticized based on its connections with software cultures? Tkacz describes the recent proliferation of openness in open movements "largely as a reaction to a set of undesirable developments, beginning with the realm of closed systems and intellectual property and its 'closed source.'"[126] He shows how openness has been translated into new domains, such as open access, in entities such as Wikipedia and Google, and in a variety of government initiatives, as a practical application of open-source politics. His examination leads Tkacz to conclude that "the same rhetoric [of openness] is deployed by what are otherwise very different groups or organizations."[127] Openness shows certain consistencies throughout these cultures, such as in "its couplings with transparency, collaboration, competition and participation, and its close ties with various enactments of liberalism," which can also be seen to underpin our current neoliberal governmentality.[128] This mobilization of openness in the politics of both "activist and marginal network cultures," as well as in more mainstream organizations, urges Tkacz to coin a critique of the open, arguing that there are some crucial problems with the concept and that it has a poverty that "makes it

unsuitable for political description."[129] For example, the way openness is used in a forward-looking and almost prophetic way in many open movements (toward "more openness") has made simultaneous closures invisible, Tkacz argues, which mainly has to do with the lack of critique of the open in these movements. There has been little reflection on the concept of openness, he states, especially with respect to this situation of "how seemingly radically different groups can all claim it as their own." From this, Tkacz concludes that "openness, it seems, is beyond disagreement and beyond scrutiny," and, elsewhere, that its "meaning is so overwhelmingly positive it seems impossible to question, let alone critique."[130]

In response to Tkacz's analysis that openness is "beyond disagreement" and "impossible to question," I would like to argue that an extensive critique of openness does exist (including his own work on the topic) and has been formulated, also from within open movements.[131] In addition to that, I would like to offer an alternative to Tkacz's genealogy of openness—and of open access and open politics—one that is closely connected to the history of the book and of scholarly knowledge production, as discussed previously. I want to do so to offer a supplement to his genealogy of openness based on the thought of Popper and the politics of software and network cultures, but also in an attempt to offer a genealogy that does not rely so strongly on the open-closed binary. For the genealogy of openness that Tkacz traces is a very specific one; one that relates to what Hall has called "the liberal, democratizing approach" to openness.[132] An alternative genealogy that tries to reassess the open-closed binary and that can be traced back to the early developments of scholarly publishing, influencing current incarnations of open access, might therefore be beneficial here. It might be so not only with regard to rethinking some of the problems Tkacz describes relating to the concept of openness, but also for casting a more favorable, affirmative light on the potential of openness.

Tkacz's problem with the concept of openness relates mostly to how openness has been developed and used by Popper, I would claim (notwithstanding the influence this has had on the political reincarnation of openness). It isn't the concept itself, in all its uses—as Tkacz describes it—that has crucial problems, but the specific concept of openness developed and used by Popper. It is this concept that is based on a binary between open and closed; and that has been further developed through the thought of Hayek and network and software cultures, following a forward-looking

The Commodification of the Book and Its Discursive Formation 151

(neo)liberal/democratic approach to openness. In this respect, Tkacz has traced the genealogy of a *specific approach* to openness, one that makes it easy to connect openness to neoliberalism and capitalist democracies, as well as to a teleological conception of openness as a form of looking forward, focused on being more open (in the sense of being less closed).[133]

However, I would like to draw attention to other forms and cultures of openness that do not abide so strictly to this binary, but rather envision openness and closure as enmeshed, similarly to the argument Tkacz makes when he states that openness inevitably includes closures. Tkacz regards these closures in openness as something inherent in openness, but then—following the binary conception of openness in the thought of Popper—decides to see this as problematic and paradoxical for the concept of openness, instead of developing this further and envisioning it as a potential core strength of ideas of the open and open politics, as I want to do here. As he states: "Closure remains an inherent part of the open; it is what openness must continually respond to and work against—a continual threat amongst the ranks."[134] However, building further on what Tkacz states about openness implying antagonisms, I would argue that these antagonisms, these closures, are exactly what we need (and have always had) *as part of* an open politics, and what give it its strength.

I would thus like to propose a genealogy of openness in which openness is integrally connected to and entangled with a different "antagonist"— namely, secrecy. Interestingly, in this genealogy, openness as a concept is directly related to the historical development of systems and discourses of knowledge production and communication. Scholarly research on openness in scientific communication can be seen to be far more ambivalent and contextual in its coverage of the concept of openness than Popper is, for instance.[135] The emphasis I am placing here on the sheer variety that makes up the schools of thought on openness and open access also serves to counter the vision that open access is intrinsically connected to neoliberalist discourses and practices, and enables me to argue instead that it can, at least potentially, be used as a powerful critique of these systems. By offering both a contrasting and a supplementary genealogy of openness, I would like to shed a more positive light on the potential of openness, both as a concept and as a practice and politics, to critique the ongoing marketization of knowledge. This alternative and complimentary genealogy of openness also forges a stronger connection between the development

of scholarly communication and the specific, contextual politics of open access and open access publishing, where it sees openness and secrecy/closure not as binaries but as integrally enmeshed.

A Genealogy of Openness and Secrecy

In her book *Openness, Secrecy, Authorship* (2001), historian Pamela Long provides a genealogy of openness that is closely connected to the development of specific *cultures of knowledge* and the way these have categorized and conceptualized knowledge. Long shows how openness advanced in connection to ideas and practices of secrecy, authorship, and property rights, and alongside the establishment of print and the printed scholarly book in the West (although her exploration of openness, secrecy, authorship, and the technical arts stretches back to developments in antiquity). She also looks at the influence and development of craft and practice-based or mechanical knowledge, alongside traditions of theoretical knowledge, and their mutual influence and interaction with respect to the construction of the discourse surrounding knowledge over the centuries, including its relationship to openness and secrecy. For example, where initially in antiquity Aristotelian science made strict divisions between *têchne* (material and technical production), *praxis* (action), and *episteme* (theoretical knowledge), Long argues that it was the direct links and closer interaction between the *mechanical arts* (craft knowledge), *political power*, and *learned traditions* (theoretical knowledge) that led to the development of empirical and experimental scientific methodologies in the seventeenth century, including an expansion of scientific authorship into practices of "openly purveyed treatises."[136]

As Long explains, it was the new alliance between praxis and têchne—that is, between those in power and in the technical or mechanical arts—that enabled authorship in these fields to expand in an effort to legitimate and promote those in political power. New city-based rulers wanted to emphasize their legitimacy, and did so through, among other things, grand urban redesigns and other construction projects. Following on from this, books on the mechanical arts became a worthy subject from the fifteenth and sixteenth centuries on, when many of these volumes emerged from a patronage system, produced to enhance the status of the patron. At the same time, however, they also served to enhance the status of mechanical and craft knowledge, for one important aspect of openness as it developed

The Commodification of the Book and Its Discursive Formation

in relation to knowledge production was, as Long states, the accurate or proper crediting of authorship. In the mechanical arts, this led to the validation of practice in an environment in which priority and novelty became of growing value.[137] Therefore, as Long makes clear, "open display of technological practices and of practitioners-authors developed in tandem with the growing value of novelty and priority," as forms of open authorship were used to establish priority.[138] These practices led to, as Long explains, "the development of an arena of discursive practice in which the productive value of certain technical arts (inherent in their ability to produce fabricated and constructed objects) was augmented by their status as knowledge-based disciplines."[139] It was this improved cultural status for the mechanical fields and for new forms of open authorship that significantly influenced the culture of knowledge. Long claims that it was these forms of open authorship that developed in the technical and mechanical arts that were highly influential when it came to "seventeenth-century struggles to validate new experimental methodologies"—of which open authorship was one—in the scientific fields and realms of theoretical knowledge.[140]

However, and this is where her argument becomes particularly important in this context, Long also argues that these new, open traditions of authorship developed *at the same time* that neoplatonic secrecy and magic and esoteric knowledge saw a rise in popularity.[141] Part of the complexity of early modern science was exactly the coexistence of "diverse values of transmission, including both openness and secrecy, as well as evolving attitudes of ownership and priority."[142] Long clearly complicates the opposition between openness and secrecy here, as well as the identification of science with openness. As she states: "Until recently openness was taken to be characteristic of science, and there was very little reflection concerning whether scientific practices were actually open and, if they were, what that openness meant."[143] We can locate this association of science with openness in scholars such as Robert Merton and Derek de Solla Price, who argue that *science* is intrinsically open (to communicate findings, the scientific norm of communism is seen as essential), whereas *technology* is regarded as intrinsically secret (to sell material, trademarked objects).[144] But as Long argues, recent historical research into the development of early modern natural philosophy shows a far more complex and contextual picture, where Vermeir and Margócsy write that "the opposition between secretive technology and open science has been qualified, nuanced and contextualized."[145]

Openness is thus intricate and (historically) enmeshed with secrecy, and integrally connected to issues of priority and patronage, where it functions in a complicated network of alliances, mixed up with authorship in relationships of power and secrecy. This is something supported by historian Paul David, who argues that a functionalist search for the origin of open science can know a historicist bias, in which we take our current conception of open science for granted. A more contextualized historical search for origins shows a very different and messier picture, one caught up in systems of power and rival political patronage.[146]

Long gives neither a positive nor a negative definition of openness, but she connects it to secrecy directly when she argues that openness is relative and contingent upon the degree of freedom given to information when we disseminate it, as it also involves assumptions on the nature and extent of the audience for whom that information is intended.[147] Historian Koen Vermeir has similarly pointed out that "openness and secrecy are often interlocked, impossible to take apart" and that they "might even reinforce each other." As such, he argues, "they should be understood as positive (instead of privative) categories that do not necessarily stand in opposition to each other."[148] Similar to Long, Vermeir thus make a plea to pay more attention to the specific genealogies and contexts in which the values and the practices of openness and secrecy have operated. Whereas normally they are seen as negations of each other, it might be more useful to see them as gradational categories that need to be judged according to their specific historicity; openness now means something different than it did in the seventeenth century, for instance. We might also consider positive notions of openness and secrecy (as in the positive notion of freedom) by looking at the intentionality behind openness: How or in what way is the circulation or dissemination of scholarship positively promoted? For example, Vermeir emphasizes that something can be open but at the same time undiscoverable in a sea of information overload, which can make for new forms of secrecy.[149] Openness and secrecy also don't always exclude each other—in the publication of a coded text, for instance. Furthermore, whether we see something as open or secret also depends on the perceiver's viewpoint.

What this short overview of an alternative genealogy of openness shows is that as part of the history of our cultures of knowledge and scholarly authorship and the development of our modern systems of scholarly communication and publishing (including its technological advances),

openness as a concept and practice has always been integrally interwoven with notions of secrecy. At the same time, following Vermeir and Long, I want to put forward that it is essential to take this genealogy into account if we want to study and understand the development of the open access movement—particularly as a specific incarnation of open politics and of the commodification of knowledge. The particular context in which the open access movement arose, related to developments in (digital) technology, the existing cultures of knowledge, and unfavorable economic and material conditions, requires us to acknowledge the influence this long-standing tradition of open scholarship has had on its values and underlying motivations. At the same time, it is important to study this ideal of open science and the assumption that knowledge needs to be shared by efficient forms of dissemination and consumption as part of a historical development in which, in practice, openness and secrecy codeveloped in changing conditions of power, patronage, economic interest, and technological development.[150]

4 Publishing as a Relational Practice: Radical Open Access and Experimentation

> What is on the other side of the agential cut is not separate from us—agential separability is not individuation. Ethics is therefore not about right response to a radically exterior/ized other, but about responsibility and accountability for the lively relationalities of becoming of which we are a part.
>
> —Karen Barad, *Meeting the Universe Halfway*[1]

In the previous chapter, I shortly outlined how the system of material production that historically developed around the scholarly book—encompassing its production, distribution, and consumption—and that helped establish a contingent configuration of powerful stakeholders has played an essential role in the creation of the book as a stable object and a commodity. This book-object, as a technology with specific material and aesthetic features, has in intra-action with these structures and relations again shaped our modern scholarly communication system, influencing future journal and book forms. Yet what I predominantly focused on in chapter 3 is how the various discourses that were formulated around the history of the book played an active role in this development—in particular, how discursive power struggles between different stakeholders were—and are—often set up around binary oppositions (i.e., culture-market, technology-society, scholarship-publishing, open-closed) and differing value systems around propriety, property, and the public good. What is clear is that the outcomes of these struggles, around the origin of the book and peer review, for example, have had a material influence on the format and role of the book. In particular, there is a need to acknowledge here how the often single-sided positions taken in by book (and media) historians have materially shaped the book's becoming.

I have therefore proposed a reframing of this discourse at certain important points, showing how alternative book-historical genealogies highlight that it was technological, economical, and institutional factors and structures combined, and the struggles among them, that stimulated the development of the book into both a product and a value-laden object of knowledge exchange within academia. At the same time, I have tried to show how a reframing of specific narratives (around the press and publishing and around openness, for example), while being aware of and emphasizing the performativity of our discursive practices, can be beneficial to battle the ongoing commodification of the book. Chapter 3 thus highlighted how creating alternative material-discursive incisions in our scholarship, in the way it is historicized, might help develop a more constructive critique of some of the excessive forms of scholarship's ongoing marketization—such as the increasing need for measurement and audit criteria and for commercially viable and innovative forms of research.

This chapter explores various recently developed alternatives to our academic publishing system as it is presently set up, focusing on those that not only intend to change the way we publish but also have the potential to change academia as a whole. To provide an example, these alternatives include publishing initiatives that not only want to increase equitable access to books in order to battle the object formation and increasing commodification of the book, but also intend to ask important questions on the material nature of books, authorship, copyright, originality, responsibility, and fixity, too—issues that lie at the basis of our modern (humanist) system of scholarly communication and its relations of production. This chapter therefore focuses on the two remaining aspects of the strategy I proposed toward recutting the book as commodity in the previous chapter. There I explored the first step of this strategy by intervening in and reframing the discourse that surrounds the past and future of the book. Here I examine two further steps—namely, reimagining the institutions and modes of material production surrounding the book and, related to that, reperforming our own entangled scholarly research, communication, and publishing practices. I explore how these strategies offer opportunities to intervene in the current cultures of knowledge production in both publishing *and* academia.

To investigate potential alternatives, this chapter begins by focusing on some of the people and projects that are exploring more radical forms of *open scholarship* and *open access*. Related to that, it examines some of the

forms a politics of the book based on openness might take, where a politics of the book is concerned with exploring how we can criticize and potentially start to change the cultures of material and technological production that surround scholarly communication in such a way as to allow for alternative, more ethical, critical, and responsible forms of research to emerge. One way to do this is by rethinking and deconstructing the object formation of scholarship, both as part of academia's impact and audit culture and as part of the publishing market's focus on commercially profitable book commodities. This can be achieved not by ignoring the fact that the book is and needs to be cut at some point in time (and thus cannot only be a processual and never-ending project) but by focusing on what *other boundaries* we might emphasize and take responsibility for. For example, we could cut down research at alternative points in its development or emphasize other forms of relationality that do not (solely) revolve around the book-object or the humanist author-subject. How might these aid us in critiquing the ongoing capitalization of research?

The second part of this chapter concentrates on research and publishing efforts that are investigating *experimentation* as a specific discourse and practice of critique, in particular as a counterpoint to narratives of *innovation*. The latter focus on how perpetual innovation can strengthen the knowledge economy, encouraging the intensification of relationships between higher education and industry to support economic growth and outcomes that enable that growth. This business rhetoric of innovation accompanies the university of excellence and more neoliberal visions of openness in publishing, where it limits the value of "disruption" to increasing the marketability and further object formation of scholarship. I instead explore a number of publishing initiatives here for which experimenting with the book and the way we perform our scholarly practices has been an essential aspect of their publishing endeavors. For these projects, experimenting is very much an *affirmative* speculative practice, a means to reperform our existing scholarly institutions and practices in potentially more ethical and responsible ways; opening up spaces for otherness and differentiation beyond our hegemonic conceptual knowledge frameworks; and exploring more inclusive forms of knowledge, open to ambivalence and failure. As such, I outline how in order to sustain affirmative critiques of the object formation of the scholarly monograph (and scholarly research more in general), we need radical forms of open access that include experimentation.

Based on theories related to mattering, relationality, and an ethics of care, and a reading of works on feminist poetics of responsibility, the concluding section of this chapter explores how various scholar-led publishing initiatives, often as part of their publishing experiments, are currently moving away from a predominant focus on the outcomes of publishing. Rather than concentrating on scholarly products and objects, these initiatives want to instead draw attention to the *relationalities of publishing*, taking into consideration issues such as the amount of free and hidden labor involved in publishing, the lack of transparency and diversity in peer-review and citation practices, and the roles various human and nonhuman actors play in the production and circulation of books. This recognition of the diversity of relations at work in publishing and scholarly communication presents a potential alternative to the hegemony of specific forms of relationality in contemporary publishing—that is, ones in which the logic of the commodity tends to be imposed on all social relations.

Radical Open Access

The alternative genealogy of openness I outlined in the previous chapter focuses on the complex interaction between openness and secrecy, as a form of closure, and on the intricate relationship between the concept and practice of openness and the development of our modern system of scholarly communication. Extending from this, I want to offer a short account here of the different ways in which openness and open access have recently been theorized and practiced. What this shows is that openness—which, as I made clear earlier, functions as a floating signifier—and especially open access have indeed increasingly been taken up in neoliberal rhetoric and politics. However, contrary to Tkacz and those critics of open access that relate it or its roots to neoliberalism or see its current uptake as part of profit-focused, author-pays models as exemplary, I explore how the understanding of open access, openness, and open science has been heavily contested and how separate discourses on the concept of openness have been developed within the scholarly communication realm.[2] Extending from that, and in response to Tkacz's prompt to explore open projects more closely, I take a more contextualized look at some specific open access projects in the next section.[3] If we analyze specific instances of how openness is practiced and theorized, it becomes clear that open access is not one thing, that its

Publishing as a Relational Practice

161

meaning is highly disputed, that it is (or can be) implemented in different ways, and that this leads to different and often contrasting politics. For neither the same rhetoric nor the same underlying motivations for openness are shared by the different groups of people involved in open access practices; openness, as Leslie Chan has argued, "is not a binary condition, but is highly situational, contingent, and dependent on context" and different groups theorize openness according to different underlying value systems.[4] It is important to emphasize this because if the implementation of open access in the UK, for instance, continues to proceed along the lines of the government's adaptation of the recommendations outlined in the Finch report—which I discuss ahead—then there is a risk that this policy-driven version of open access will become the dominant or hegemonic narrative, subsuming the variety of discourses (and practices) that currently exist on open access, as well as its multifaceted history.[5]

The emphasis I am placing here on the sheer variety that makes up the schools of thought on openness and open access also serves to counter the vision that open access is intrinsically connected to neoliberalist discourses and practices, and it enables me to argue instead that it can, at least potentially, be used as a powerful critique of these systems. For example, practices and theories of *radical open access* are critical of openness in its neoliberal guises, but still try to engage with the open in an affirmative way too.[6] These projects don't necessarily adhere to a teleological vision of openness (toward the goal of more openness, whatever that would be), but argue instead that openness is not about being *more open*, for instance, but is rather about *being open* to change and experimentation—depending on the contingent circumstances, the political and ethical decisions and cuts that need to be made, and so on. This is a process of continual critique, without necessarily being forward-looking in a teleological sense. In our ongoing affirmative politics and practices of the open, we have to make decisions and thus close down the open; however, we can start to think more responsibly and ethically about the closures we enact and enable in our communication practices and through our systems of knowledge production: for instance, by focusing on creating difference as part of the decisions (which are also *in*cisions or enactments of closure) we make, and by promoting otherness, variety, and processual becoming. Therefore, instead of shying away from these closures, these boundaries that are already implied in openness, might a more interesting approach not be to explore how

162 Chapter 4

these decisions are made, by whom, and how we can recut them in different ways? And might it not be more interesting to do so especially with respect to how we currently publish our scholarly books? It is for this reason that I want to both reclaim and put forward an alternative version of open access, one that targets calculative business-oriented approaches directly and instead positions open access as an ongoing critical project. Focused on experimentation and the exploration of new institutions, relationalities, and practices, this approach toward openness, examining new formats and stimulating sharing and reuse of content as part of a knowledge commons, can be seen as a radical alternative to, and critique of, the business ethics underlying innovations in the knowledge economy. It also offers a potential way to break through the object formation and commodification of the scholarly book—something that, as this chapter shows, prevails in the neoliberal vision of open access, which sees the book as a product—and the exploitation of scholarly communications as capital, as objects to sustain and innovate the knowledge economy.

To illustrate this diversity of uptake, the neoliberal vision of open access publishing as envisioned in the Finch report will be contrasted with forms of radical open access publishing, drawing on some recent experiments that try to challenge and rethink the book as commodity, as well as the political economy surrounding it, by cutting the book *together and apart* differently.[7] To do this, I compare the motives that the Finch report identifies as being fundamental to open access with the values and relationalities underlying these radical open access publishing experiments. This discussion of open access concludes with an exploration of what an open politics of the book could potentially be, the latter being a politics that has its base in forms of open-ended experimentation but that at the same time remains aware of, and takes responsibility for, the boundaries that still need to be enacted.

The Neoliberal Discourse on Open Access

Neoliberalism, which broadly defined focuses on the reshaping of culture and society according to the demands and needs of the market, has infiltrated higher education on different levels. Neoliberalism has turned capitalism from a mode of production into a cultural logic, where economic freedom is seen as the necessary precondition for political freedom. David Harvey, in his history of neoliberalism, describes it as "a theory of political economic practices that proposes that human well-being can best be

Publishing as a Relational Practice

advanced by liberating individual entrepreneurial freedoms and skills within an institutional framework characterized by strong private property rights, free markets and free trade."[8] Yet in many ways it goes beyond this; theorists such as Wendy Brown (extending from Foucault) conceptualize neoliberalism as a political rationality that extends market values and economic rationality beyond the economy *into all dimensions of human life*, including our educational institutions, where they become part of our social actions. Neoliberalism should thus be seen as a form of governmentality that "produces subjects, forms of citizenship and behavior, and a new organization of the social."[9]

Within this mode of thinking, not only are universities forced to act more and more like profit-making enterprises instead of public institutions—in a process that also involves the ongoing privatization of higher education in the UK, for example—but the focus of the knowledge economy is also placed to an ever-higher degree on the extensive standardization and economic exploitation of knowledge as a form of capital produced within these universities.[10] This leads to a situation wherein researchers within the knowledge economy are asked to produce research that feeds directly into and sustains the neoliberal economy.[11] As part of this, procedures and measures have been put in place to quantify and measure research *outputs* in specific, as part of a neoliberal knowledge regime structured around market-based performance indicators, feeding an impact agenda that increasingly determines public funding of research. This regime revolves around and further reinforces the vision that knowledge functions as a form of capital, turning research into commodities and intellectual property, knowledge into a product to be owned, and interactions around it to data to be mined. Here the value of research is in danger of being narrowly measured in economic terms, instead of, to provide just one example, perceiving knowledge and scholarly research in terms of a commons of shared knowledge, something to value as a public good or as part of a gift economy, as a process and relationship, rather than as a product.[12]

Increasingly, open access publishing is featuring in neoliberal discourses in higher education and government as a system to promote innovation and transparency of research (fitting in well with the aforementioned audit culture).[13] Open access supports the knowledge economy by making access to information more efficient and cost-effective, which includes making it easier for knowledge, as a form of capital, to be taken up by businesses

for commercial reuse, stimulating economic competition and innovation. Following this discourse, open access also means knowledge objects and their dissemination and impact can be more efficiently and continuously monitored and hence can be better made accountable as measurable outputs as part of audit cultures: think of experiments with bibliometrics, for example, or other calculative practices and performance indicators used as tools to rank and index scholars and their universities, and to stimulate greater accountability and transparency of research. In conclusion, according to this neoliberal rhetoric, society—or, better said, the individual taxpayer—gets improved value for its money or return on investment with open access, while making it ever more convenient for business and industry to capitalize on academic knowledge.[14]

The *openness* of the discourse around open access has made it easy to incorporate in a neoliberal context. For example, Martin Eve, although critical of an equation of open access with neoliberalism, argues that open access is easily connected to measures related to the REF, the system used to assess research quality in the UK, with its impact agenda and call for transparency and the privatization of knowledge.[15] This connection can be used to explain to some extent the current resistance of certain (groups of) scholars to open access, again related to its potential for promoting audit cultures—which are severely refashioning the working environment and affecting the subjectivities of academics—and state or institutional control.[16] This opposition focuses on, among other issues, how in the open access system promoted by the UK government (together with funding agencies and research councils—including the seven UK Research Councils and Research England, under the umbrella UK Research and Innovation [UKRI] organization), universities—more specifically, university management—will have more widespread control over their academics' ability to publish. These scholars argue against the article processing charge (APC) model, a specific implementation of gold open access, in which in order to publish in an open access journal, a fee needs to be paid beforehand (e.g., by one's institution). They argue that this model, favored in the Finch report, is an attack on the academic freedom of researchers to choose where they will publish and will most likely be aligned with the REF's impact agenda.[17] In this view, these academics are not necessarily against increasing access to scholarly publications, but they are afraid that the policy recommendations of transparency and openness will be used as an instrumentalist justification for

the imposition of a certain version of open access: one that has the potential to promote a further expansion of neoliberalism and that, as sociologist John Holmwood has argued, will function to "open all activities to the market and reduce public accountability of its operation."[18]

To explore this neoliberal rhetoric surrounding open access in more depth, I want to take a closer look at the report of the Working Group on Expanding Access to Published Research Findings, entitled *Accessibility, Sustainability, Excellence: How to Expand Access to Research Publications*—or the Finch report, as it is more commonly known, after its chair, Dame Janet Finch. This is an independent study commissioned by then UK government science minister David Willetts, released in June 2012 and drawing on the advice and support of a group of representatives of the research, library, and publishing communities. It proved to be a seminal document that set the trend toward recommending the implementation of a certain kind of open access in the UK.[19] The study set out to produce a series of recommendations for making a transition toward and developing an open access publishing system in the UK. The report recommends the further implementation of author-side fees for the open access publishing of journals, in which, as previously outlined, an APC will be needed to cover the publishing costs. This fee, paid for by authors or in most cases by their institutions, will enable the article to be opened up to the wider public under a CC BY license (as recommended by the Finch report). This is a strategy that can be seen to maintain and favor the system of communication (or *ecology*, as the Finch report calls it) as it is currently set up.[20] In this gold APC-based system, publishers' profits will be sustained; in green open access, on the other hand, depositing of articles in repositories will not require an APC, for example.

All the recommendations that came out of the Finch report were subsequently accepted by the UK government, to be implemented by the four UK higher education funding bodies and the research councils. Yet growing critique of the Finch report and the government's open access policy led to a House of Lords inquiry and to a report from the House of Commons' select committee of members of parliament (MPs) that oversees the work of the Department of Business, Innovation and Skills (BIS), which was released after the committee conducted an inquiry into this policy. This report called on the government and RCUK to reconsider their preference for gold open access given widespread evidence of the importance of repositories

and green open access in the move toward an open access publishing system. The full focus on APCs as the main route to open access as laid out in the Finch report (and taken on by government) and the downplaying of the importance of the green option is here seen as a mistake. This preference for APC-based models, against better judgment, makes clear how Willets and Finch's priorities from the outset lay with protecting the UK publishing industry. As Philip Sykes, a librarian on the Finch panel, has said, "It's not in the interests of UK scholarship to make recommendations which undermine the sustainability of the publishing industry."[21] This has provoked Stevan Harnad to conclude that "the Finch Report is a successful case of lobbying by publishers to protect the interests of publishing at the expense of the interests of research and the public that funds research."[22] The Finch report made an active recommendation to adopt a system that simply redistributes costs from libraries to researchers and their institutions, without challenging the commercial premises that underlie this system and without any real mechanism to exert downward price pressure on APCs for scholars and their universities wanting to publish research in open access. Instead of research itself, what are being sustained here are the exorbitant profit margins of publishing industries.

The Finch report also offers recommendations to ensure sustainable and efficient models for future scholarly communication, defining, among other things, the criteria for success with regard to how to reach this goal. In the following quote related to APCs, the report accurately illustrates the neoliberal vision of promoting market mechanisms in higher education and of universities acting as businesses or "purchasers" within an APC realm: "The measures we recommend will bring greater competition on price as well as the status of the journals in which researchers wish to publish. We therefore expect market competition to intensify, and that universities and funders should be able to use their power as purchasers to bear down on the costs to them both of APCs and of subscriptions."[23]

Here a neoliberal vision of market rationality is clearly upheld. As Lawson et al. explain, "By introducing a transparent market for individual transactions within the academic publishing system, we can see that the UK coalition government's support of APC-funded open access is congruent with their neoliberal agenda. The journal article is construed as a commodified unit of exchange, and market competition will determine the economic value of that unit."[24] However, as Eve also argues, our academic "goods for sale" are

unique, noncomparable, and nonsubstitutable (i.e., a journal article cannot be simply substituted for another); this works against competitive market price pressure.[25] As Eve makes clear, without a price point, then, "rates will be based on what the market will bear, rather than what it actually costs, which will continue the ongoing hyperinflationary serials crisis."[26]

But this neoliberal vision toward open access comes to the fore even more directly when we look at the motivations underlying the wider dissemination of research that the Finch report identifies and supports. According to the report, improving the flows of information and knowledge will promote the following:

- enhanced transparency, openness and accountability, and public engagement with research;
- closer linkages between research and innovation, with benefits for public policy and services, and for economic growth;
- improved efficiency in the research process itself, through increases in the amount of information that is readily accessible, reductions in the time spent in finding it, and greater use of the latest tools and services to organize, manipulate and analyze it; increased returns on the investments made in research, especially the investments from public funds.[27]

In short, according to the vision of the Finch report, "these are the motivations behind the growth of the world-wide open access movement": promoting greater transparency, accountability, innovation, economic growth, efficiency, and return on investment.[28] The report thus locates the values underlying open access for the most part in the effect it will have on the knowledge economy and on how it will be a valuable return on investment. Here, again, the focus is not on improving access or rethinking the profit model; it is about promoting the knowledge economy and about publishing economics, about valuing publishers' business models.

Not-for-Profit and Scholar-Led Alternatives

Motivations for experimenting with forms of open academic publishing are not only focused on serving the knowledge economy, however, as implied previously. Many open access advocates, for instance, perceive open access as a movement and a practice that actually has the potential to critique and provide alternatives to the increasing marketization of higher education and scholarly publishing. Yet the schools of thought involved in open access publishing and research can be said to be more wide-reaching, more

complex and enmeshed, even than that. It will therefore not be fruitful to create yet another dichotomy, distinguishing neoliberal motives for open access publishing from anti-neoliberal ones, as John Holmwood implies, for instance.[29]

What I want to explore at this point are examples of experiments with openness in digital publishing as part of which organizations or individuals offer affirmative, practical dimensions through their uptake, critique, and experimenting with openness; as such, they work with their own, alternative value systems that cannot easily be classified as the negative side of a dialectic. Instead, these initiatives can be seen to endorse another set of principles, based on a different underlying system of ethics, distinct from the motivations for open access as defined by the Finch report. Mostly scholar-led and centered, they experiment with making research available on an open access basis using new formats such as liquid monographs, wiki publications, and remixed books; they abide by a not-for-profit ethos, working collaboratively to build a noncompetitive publishing ecosystem (including open, community-governed infrastructures) and to support a progressive knowledge commons based on mutual reliance and cooperation; bottom-up, pluralistic, and community-led, they aim to stimulate a diverse system of scholarly communications as part of their publishing experiments.[30] In addition, through the establishment of new, alternative institutions, practices, and infrastructures, they try to challenge and reconceptualize scholarly communication while simultaneously experimenting with and rethinking openness itself. This approach toward openness can be seen as a potentially radical alternative to, and a critique of, the business ethics underlying innovations in the knowledge economy. At the same time, it is an approach focused on creating strong alternatives that try to break down the commercial object formation that has encompassed the scholarly book, by envisioning open access as an ongoing critical and collective project.

What I am calling *radical open access*, as shorthand, is not one thing, nor is it an overarching plan. It consists of various groups, peoples, institutions, and projects with their own affordances.[31] Moreover, radical open access is also a contingent and contextual approach that cannot easily be pinned down as, again, it is an ongoing critical project, one that endeavors to embrace its own inconsistencies and struggles with its own conceptions of openness. Nonetheless, I want to highlight some points of similarity that radical open access projects seem to share—not least as a way of contrasting

Publishing as a Relational Practice

them to the vision of open access put forward in the Finch report. These points of similarity are illustrated by looking at three examples in particular of what can be seen by now as classic radical open access initiatives that have tried to experiment with progressive, counterinstitutional alternatives: Open Humanities Press, Ted Striphas's Differences & Repetitions wiki, and Kathleen Fitzpatrick's experiments with open peer review for her book *Planned Obsolescence*.[32]

Open Humanities Press (OHP) is an international open access publishing collective in critical and cultural theory, founded in 2006 as an independent volunteer initiative by "open access journal editors, librarians and IT professionals," experimenting with open access journal and book publishing.[33] As an international collective, OHP involves multiple self-governing scholarly communities, operating as a radically heterogeneous collective. OHP focuses on countering negative perceptions that still exist concerning open access and online publishing by creating a trustworthy, reliable, high-quality system for those scholars skeptical about online modes of distribution and dissemination. Battling these negative perceptions serves two goals, OHP argues: first, it makes experimentation with new business models possible and can therefore work to help solve the current publishing crisis in the arts and humanities; second, it paves the way for further experiments in scholarly communication—with new forms of writing and publishing and with open content and open editing, for instance—something that stands at the basis of OHP's projects.[34]

The Differences & Repetitions wiki is a site for open source writing (along the lines of libre/read-write open access), which was set up by cultural theorist Ted Striphas. It contains fully editable wiki projects and working papers (which are not openly editable) and was built by Striphas using free open source software. As a personal (though at the same time collaborative) archive of writings, Striphas explores here what it means to publish scholarly findings in a different way and to experiment with new, digital, collaborative writing practices that try not to give in to the compulsion to repeat established habits.

Media theorist Kathleen Fitzpatrick coestablished MediaCommons, a scholarly publishing community, to build networks and collaborations among media scholars. She used MediaCommons Press, a digital text platform and publishing experiment from MediaCommons, to openly review the manuscript of her book *Planned Obsolescence*. Adopting CommentPress

software—a WordPress plug-in that allows comments to be made next to specific paragraphs of text—the draft was made available online in 2009 to potential reviewers and commentators (alongside a traditional peer review process by NYU Press).

When examining these projects more closely, it first of all becomes clear that they all offer a practical, affirmative engagement with open access: making research openly available lies at the basis of their publishing practices and is integral to it. Openness enables them to *collaborate* on publishing projects more directly, to create scholarly communities around research. This communal aspect is clearly visible in the Differences & Repetitions wiki, for example, where the collaborative open source aspect of the project enables discursive communities to be created around documents. This has made Striphas reconsider "his sense of propriety" over the works and made him question how we can "curate academic research so as to encourage more broad-ranging engagement with it."[35] Similarly, MediaCommons Press publishes longer-form digital writing in an open way to create communities of collaboration around it. It does so mainly via the open community reviewing of texts, building upon the MediaCommons network of scholars, students, and practitioners in media studies, which is at its root community-driven. Kathleen Fitzpatrick makes this connection between openness and community creation all the more clear when she reflects on the motivations behind MediaCommons: "The more we thought about the purposes behind electronic scholarly publishing, the more we became focused on the need not simply to provide better access to discrete scholarly texts but rather to reinvigorate intellectual discourse, and thus connections, amongst peers (and, not incidentally, discourse between the academy and the wider intellectual public)."[36]

However, next to establishing practical community-driven and scholar-led alternatives to the present scholarly publishing system, these initiatives also serve to question the system of (commercial) academic publishing as it is currently set up—a system that, as I outlined in the previous chapter, functions increasingly according to market needs. These projects thus also aim to critique the commodification and commercialization of research in and through academic publishing. For example, Fitzpatrick highlights the importance of establishing open access presses in order to save certain forms of specialized research, such as the monograph, from obsolescence in the current "fiscally impossible" system of scholarly publishing. This as

Publishing as a Relational Practice

part of an effort to rethink our publishing practices and to "revitalize the academy."[37] Gary Hall, cofounder of OHP, similarly notes that the current profit-driven publishing system does not allow space for works that are specialized, advanced, difficult, or avant-garde, but favors instead more marketable products, making academia as a whole, as he states, "intellectually impoverished."[38] These publishing initiatives therefore highlight, in a shared critique, how our current publishing system increasingly serves marketization instead of our communication needs as academics; as Striphas points out, "The system is functioning *only too well* these days—just not for the scholars it is intended to serve."[39]

What's more, we can see how experiments in radical open access not only aim to stimulate access and reuse of scholarly content by critiquing the economics and excessive commercialization of the current scholarly publishing system and by setting up their own alternative publishing institutions. For these initiatives, open access also forms the starting point for a further interrogation of our (humanist) institutions, practices, notions of academic authorship, the book, content creation, copyright, and publication, among other things. Here the focus is on exploring the kinds of ethical and responsible questions that, according to Hall, "we really should have been asking all along."[40] This questioning of institutions also focuses on the hegemonic print-on-paper paradigm that, as Hall and Jöttkandt from OHP argue, still structures our current (digital) scholarly practices, including our standards for reviewing and certifying academic work.[41] We also need to keep in mind, as Striphas notes, the specific historical context in which our currently dominant structures were forged, according to circumstances that might not apply anymore today.[42] In this respect, there seems to be a combined aim to, as Fitzpatrick argues, ensure our interrogations explore not only our scholarly institutions but also our own scholarly practices of doing research, writing, and reviewing in a digital context.[43] As Hall and Jöttkandt ask, might this involve exploring "a new knowledge, a new grammar, a new language and literacy, a new visual/aural/linguistic code of the digital that is capable of responding to the singularity and inventiveness of such [digital] texts with an answering singularity and inventiveness?"[44]

The practical aspects of these interrogations of our scholarly forms of communication come to the fore in some of these radical open access projects too. For instance, Fitzpatrick's experiment with peer-to-peer review very much focused on re-envisioning peer review and quality control in

a digital context, pushing it toward a more community-oriented system. Furthermore, her experiment aimed to change the way we think about academic publishing and peer review, moving away from "a system focused on the production and dissemination of individual *products* to imagining it as a system focused more broadly on facilitating the *processes* of scholarly work."[45] Striphas similarly argues that we need to engage with peer review—as a specific fixture of scholarly communication—more creatively in order to explore its future. His wiki, functioning as a form of prepublication review, is a good example of that, as well as comprising an investigation into more communal forms of writing, questioning, as noted before, the individual author and his or her propriety.[46] Hall and his colleagues explored this rethinking of the book, authorship, and authority in OHP's Liquid and Living Books series, which are books published using wikis that are available on a read/write basis. With this open, collaborative, and distributed way of publishing, OHP endeavors to raise "all sorts of interesting questions for ideas of academic authorship, fair use, quality control, accreditation, peer-review, copyright, Intellectual Property, and content creation."[47]

But radical open access also involves the critique of openness as a concept and the practices of openness themselves. This is something that Tkacz, as I mentioned at the beginning of this chapter, sees as missing in open projects. He feels there has been too little reflection on the concept of openness and on its specific projects. What radical open access projects share, however, is a common aim to emphasize that there are ways for open access not to be simply a neoliberal or even an *economic* issue. Instead, as I have shown, they explore open access as a concept and practice based on experimentation, sharing, and community, among other things. We can see this in Fitzpatrick's aim to shift the discourse on the way we perceive open access away from a focus on costs and toward a focus on values, asking, "What might happen if outreach, generosity, giving it away were our primary values?"[48] But we can also see this in Striphas's ongoing critical exploration of the drawbacks and benefits of his own open research projects, where he sees his Differences & Repetitions wiki not as "a model" but as a "thing to think with."[49]

I would like to contend that the engagement these radical open access projects exhibit with respect to openness evidences a specific vision of politics, a vision in which politics is seen as something that can and needs to be rethought in an ongoing manner, adapting to new contexts and conditions. For example, according to political philosopher Étienne Balibar, a

more interesting and radical notion of politics involves focusing on the *process* of the democratization of democracy itself, thus turning democracy into a form of continuous struggle or critical self-reflection. Balibar argues that the problem with much of the discourse surrounding democracy is that it sees democracy as model that can be implemented in different contexts. If we conceptualize democracy in such a way, however, there is a danger of it becoming a *homogenizing force,* masking differences and inequalities, as well as becoming a *dominating force*—yet another political regime that takes control and power. However, democracy is not an established reality, nor is it a mere ideal; it is rather a permanent struggle for democratization.[50] And in this respect, open access can and should be understood in similar terms: not as a homogeneous project striving to become a dominating model or force; not as a thing, an object, or a model with predescribed meaning or ideology; but as a project with an unknown outcome, as an ongoing series of critical struggles. And this is exactly why we cannot pin down open (nor radical open access) as a concept, but instead need to leave it *open*: open to otherness and difference, and open to adapt to different circumstances.

To explore this idea of an open politics more in depth, in particular with respect to open access and the politics of the book and knowledge production, it will be helpful to look at the work of the media theorists Mark Poster and Gary Hall and of literary theorist Bill Reading; Hall in particular has written extensively on the subject of politics in relation to open access.

Open Politics

Mark Poster's influential essay "Cyberdemocracy: Internet and the Public Sphere," published in 1997, explores the relationship between the internet (or new media) and democracy and examines whether the internet has stimulated the emergence of a new politics and new configurations (or relationalities) of communicative power. As part of his argument, Poster criticizes modernist, enlightenment-based conceptions of politics based on fixed, autonomous, and sovereign individuals, while emphasizing that there doesn't exist an adequate *postmodern* conception of politics either that doesn't appear to function as merely an extension of our modern political institutions. As such, Poster explores how the internet reconfigures our modern conceptions of politics and hence represents a potential challenge to our conventional understanding of it, based as it is on rational communication of fixed humanist subjects within a public sphere. Most

importantly, as part of this critique of modern political forms, Poster also focuses on how the internet challenges our understanding of politics in the form of *democracy*, next to the humanist and determinist assumption that "the relation between the technology and human beings is external."[51] Poster's call for a cyberdemocracy thus entails an openness to rethinking politics beyond two of our most ingrained modernist conventions: democracy and the rational humanist subject.

Hall, in his always already contingent conception of politics, further extends the work of Poster to think through what such an open vision of politics might entail, which he formulates in the context of this theoretical exchange as a *hypercyberdemocracy*. Similar to Balibar, Hall's conception of openness and politics is not one that should be conceptualized as a project or a model. He warns, for instance, that when it comes to politics on the internet, we should be cautious about forms of predetermined politics in which "politics would be reduced to just the rolling out of a political plan, project, or program that is already known and decided upon in advance." This would close down what politics is and what it means to be political, without giving space to the potential of the new and the experimental. In such a scenario, "there would be no responsible or ethical opening to the future, the unknown, uncertain, unseen, and unexpected."[52] For Hall, cyberdemocracy then emerges as a potential space for new, "unthought" forms of democracy, in which, following Poster's prompt, "in order to understand the politics of the Internet we need to remain open to the possibility of a form of politics that is 'something other than democracy' as we can currently conceive it."[53] Hall therefore argues for the development of new, specific, and singular theories of politics—especially concerning the politics of digital media; theories in which politics is responsive to the particular contingent contexts and developments it encounters and is invented in relation to specific practices (such as those described in Poster's account of cyberdemocracy), as these have the potential to alter both our politics and our understanding and analysis of digital culture.[54] Hall points out that in Poster's essay this contextual connection comes to the fore in, among other things, his argument for the intrinsic connection between humans and technology. Hall extends this argumentation; as he states, "Technology is not just part of what makes us 'a cyborg in cyberspace,' as Poster has it; it is part of what makes us *human* per se"—referring to Stiegler's idea of *originary technology* and Derrida's concept of the *technological condition*,

Publishing as a Relational Practice

explaining that political subjects are continuously constituted by the political networks in which they interact and vice versa. Because "the human is always already constituted in and by a relation with technology," this means we are already cyborgs *before* we interact with internet politics.[55]

Such an open conception of politics runs into a number of challenges: for many, embracing such a position or way of thinking and practicing might be to risk too much, not least because it has the potential ultimately to place in question what we have come to understand as democracy. This is why, as both Hall and Poster claim, many critics hold on to conventional conceptions of (internet) politics and democracy, including related ideas around technological determinism, the public sphere (in a Habermasian sense), and citizenship. In this sense, Hall and Poster also go further than Balibar. For Balibar, rethinking politics as a process is still seen as a democratization of democracy, in which we can be caught up in a framework of change that necessarily needs to be more democratic, instead of thinking out of the democratic box to explore if there is, potentially, another political form that might be more appropriate for our digital condition. Hall eventually argues, beyond but at the same time with Poster (while simultaneously pointing to the modernistic aspects that remain part of Poster's politics), that we need to be open to both politics *and* hyperpolitics, which are not easily disconnected. As such, following in the tradition of thinkers such as Levinas and Derrida, *hyperpolitics* "names a refusal to consider the question of politics as closed or decided in advance, and a concomitant willingness to open up an unconditional space for thinking about politics and the political 'beyond' the way in which they have been conventionally conceived—a thinking of politics which is more than politics, while still being political."[56]

Applying this argumentation to the specific politics of open access publishing and archiving, Hall states that it is too easy to see open access as merely an extension of neoliberalism, which it necessarily is or can be, when it can also be conceived as a progressive cyberutopian democratic concept. However, Hall is not interested in exploring open access along either of these lines as the two sides of the digital debate—which, as I argued before, are not so easily distinguished in the form of a dialectic. He is concerned not so much with attaching preexisting political labels to open access publishing, as in the potential of open access and of internet politics "to resist and reconfigure the very nature of politics as we currently understand it, its basis in notions of citizenship, the public sphere, democracy, and so on."[57]

Following Derrida and Laclau and Mouffe, this focus on a politics of undecidability doesn't mean that we do not need to make decisions, or don't need to cut, in Barad's terminology.[58] By the same token, though Hall does not offer a fully fledged *politics*, he nonetheless insists, following Mouffe, that we need to be *political*, as we still need to make affirmative, practical, and ethical political decisions.[59] And through these decisions, we need to imagine, invent, and experiment with new forms of politics, by asking questions and remaining open toward our notions of politics, scholarship, authorship, and, in this context specifically, the book.

Hall is not the only one exploring such ideas of openness and experimentation in relation to the political in an academic context. In his influential book *The University in Ruins*, Readings formulated a similarly forceful argument focused on openness (though not specifically on open access) and experimentation in his exploration of the ideal type of the *University of Thought*, which he envisions as an alternative to the University of Excellence. Readings argues that the original cultural mission that determined the logic of the university in the past has been declining, producing a situation in which, from a connection to the nation state (producing and sustaining an idea of national culture), it has become a transnational bureaucratic company following the discourse of excellence and accountability.[60] From this position, Readings points out that we should let go of the idea that the university has a social mission connected to cultural identity, when "the notion of culture ceases to mean anything vital for the University as a whole" and "culture no longer matters as an *idea* for the institution."[61] As he states, introducing new referents won't do the university any good; rather, it is important that the university provides a context in which judgment of cultural value and of the value and meaning of the university *itself* is left open. In this dereferentialized, open, and flexible space that the university then becomes, Readings suggests we can start to think of notions of community and communication differently and thus begin to envision them as places for radical dissensus.[62] We need a community without a common identity, which consists of singularities, not of subjects, and therefore we can't refer to an idea outside of ourselves and the university for a community's justification. Instead, Readings argues, we need to take responsibility for our immediate actions *here*, in relation to our present contextualized practices. Readings thus reiterates that we need to keep the question of evaluation open.

Publishing as a Relational Practice

However, just as in the thinking of Hall and Barad, this does not absolve us from the responsibility of making cuts, a necessity Readings formulates as the need to make judgments about issues of values. These judgments should not be seen as final, though, as they themselves are part of an ongoing critique and discussion, as "value is a question of judgment, a question whose answers must continually be discussed."[63] Knowledge for Readings then becomes a permanent question, as "thought does not function as an answer but as a *question*."[64] He is thus interested in conditions of openness and decidedness in higher education that enable agonism and heteronomous communities of dissent. From this it follows that disciplinary structures should be rethought and reconfigured periodically; they should remain open to ensure disciplinarity remains a permanent question.[65] In Readings's vision, these communities of dissent are also nonhumanist in their basic outlook, where they profess an obligation to nonhuman otherness. As he states: "To speak of obligation is to engage with an ethics in which the human subject is no longer a unique point of reference. The obligation is not to other humans but to the condition of things, *ta pragmata*."[66]

What these readings of openness in an academic context by Poster, Hall, and Readings highlight is the importance of remaining open to, and affirmatively exploring new forms of, *open* politics, while still taking responsibility for the decisions and value judgments we need to make as part of our experiments. In this sense, I want to put forward that the politics and ethics of open access publishing and archiving are not predetermined, do not simply come prepackaged; they need to be creatively performed, produced, and invented by their users in an ongoing manner in response to changing technologies, practices, and conditions. And these practices of open access publishing at the same time offer an opportunity to formulate new forms of politics. As Hall states, "Digitization and open access represent an opportunity, a chance, a risk, for the (re)politicization—or, better, hyperpoliticization—of cultural studies; a reactivization of the antagonistic dimension that is precisely what cultural studies' politics is."[67]

Experimentation

In the previous passages, I have explored how open access, and specifically forms of radical open access book publishing, can be envisioned and performed as part of affirmative, continuous strategies directed toward

rethinking our market-based publishing institutions, as well as the object formation that takes part through forms of academic capitalism. Although open access, in its neoliberal guise, also has the potential to contribute to this object formation, I have made a plea for reclaiming open access by focusing on its potential to critically reperform our print-based institutions and practices and on its capability to experiment with new ideas of politics, scholarly communication, the university, and the book. Now is precisely the time to focus on a different discourse of openness—in addition to reframing the historical discourse on the book as an object, as discussed in the previous chapter—to emphasize these other aspects of openness and the potential for change it also inhibits, and to encourage a diversity of experiments with open access books.

As I want to outline in this section, experimentation is essential here, not only as an integral aspect of forms of radical open access, but also as a strategy on its own to break through the material structures and practices surrounding the object formation of the book. As Sarah Kember has written, "Experimenting with academic writing and publishing is a form of political intervention, a direct engagement with the underlying issues of privatization and marketization in academia."[68] To explore this concept of experimenting in more depth, however, I want to distinguish it from neoliberal notions of *innovation*. I want to do so because, as with open access, the motives, values, and goals that lie behind these two concepts differ fundamentally. I want to differentiate the business rhetoric of *innovation* that accompanies the University of Excellence and more neoliberal visions of openness from the vision of experimentation as promoted from within cultural studies, among other fields. The latter vision will be illustrated by a selection of research and publishing efforts that specifically explore experimentation as a discourse and practice of critique, especially with respect to the current system of scholarly object formation.

The Business of Innovation

The neoliberal rhetoric increasingly accompanying the open access discourse in large part pertains to the knowledge economy and its need for continual *innovation*. Following this demand for innovation and the transparency that it relates to, making research results available online is seen to aid the search for new sustainable business models, to help the creation of competitive advantage, and to maintain the successive testing of new

Publishing as a Relational Practice

products to satisfy consumer demand. Within this context, experiments with digital, open publishing increasingly take place with a specific outcome already in place: to ensure that a new publishing or business model is viable and that it is effective, in order for it to become a model that can be monetized, with the ultimate goal of increasing return on investment. Besides that, making publicly created research information and data available in this way allows the private sector in general to thrive and to help drive further innovation and creativity for all kinds of business opportunities, enabling our economy at large to be more profitable and competitive.

Joseph Schumpeter's theories of economic development have heavily influenced the current discourse around the concept and practice of innovation within knowledge economies and creative industries, and it is here that we can locate innovation's inherent connection to economic growth and development. In Schumpeter's theorization, innovation is seen as the essential driving force of changes within an economy and of capitalist production and growth, where he defines innovation as (1) the introduction of a new good, (2) the introduction of a new method of production, (3) the opening of a new market, (4) the conquest of a new source or supply of raw materials or half-manufactured goods, and (5) the implementation of a new form of organization.[69] The aim of technological innovation here is to establish temporary monopolies as part of the dynamic cycle of business innovation, which result in higher profits and economic growth.[70]

Consequentially, such a focus on innovation driving economic growth creates situations in which our ideas of experimentation, or even of critique as open intellectual enquiry, are challenged by what is in essence a corporate rhetoric. Researchers are increasingly asked to experiment with new ideas, methods, or practices not just for experiment's sake or to encourage critical thought, but in the name of innovation, leading to results that are deemed to be an improvement over the previous situation in the sense that they serve dynamic economic growth. If we adhere to a neoliberal logic, then we need continual innovation to stimulate the competitive mechanisms that encourage this dynamic growth. Critical thought, Giroux argues, has given way to market-driven values and corporate interests here. Knowledge becomes a product, a commodity, just another form of capital.[71] As Giroux states: "In its dubious appeals to universal laws, neutrality, and selective scientific research, neoliberalism eliminates the very possibility of critical thinking, without which democratic debate becomes impossible."[72] And Fitzpatrick similarly

argues that "having marketability as our only indicator of the value of scholarship or a scholar's work represents a neoliberal corruption of the critical project in which we as scholars are ostensibly engaged."[73]

We can see a situation arise in which the elements of unpredictability and potential failure that accompany experimental scholarly methods are filtered out in favor of robust risk assessments and contingency plans (risk aversion), where the notion of critique, of pushing boundaries, of rethinking systems, is replaced by demands for increased efficiency and transparency. The goal is to make experimentation predictable, where experiments are designed to achieve the goals they were set out to achieve, creating outcomes that are measurable and demonstrable, mirroring a situation in which innovation is often closely linked to specific objectives—namely, those that encourage economic growth.

Pellizzoni and Ylönen point out that perpetual innovation as part of the knowledge economy is seen as one of the guiding principles of the neoliberal era.[74] Within the knowledge economy, innovation is then conceptualized as a collective endeavor, as a coalition between education and industry. The OECD report *The Knowledge-Based Economy* (1996), quoted in Roberts and Peters, states that "innovation is driven by the interaction of producers and users in the exchange of both codified and tacit knowledge," and it pertains to a model of knowledge flows and relationships among industry, government, and academia in the development of science and technology.[75] Based on her analysis of the perceptions of Canadian health scientists, Wendy McGuire argues that this reorientation of knowledge production toward a collaboration of research and industry is promoting a new vision of what constitutes legitimate science, one based on innovation policies: "Innovation policy is both an ideological discourse that promotes a new vision of legitimate science, emphasizing social and economic relevance, and a neoliberal strategy to change the organization of knowledge production through the intensification of relationships between university scientists, industry and government."[76]

To develop a critique of this notion of perpetual innovation that is increasingly structuring our knowledge domains, experimentation is explored as an alternative discourse. In particular, I want to turn to a selection of alternative conceptualizations of experimentation, to examine how these are practically implemented in radical forms of open, online publishing. The openness of the politics of these projects lies with their will to experiment, wherein

experimentation is understood as a heterogeneous, unpredictable, singular, and uncontained process or *experience*. In this respect, these projects argue for a more inclusive vision of experimentation, one that is open for ambivalence, and for failure. This vision is all the more important in the context of monograph publishing, where I contend that issues of access and experimentation are crucial to the future of the scholarly book, if the critical potentiality of the book as a medium is to remain open to new political, economic, and intellectual contingencies. I want to explore this idea of experimentation in more depth from a specific cultural studies perspective, as cultural studies has a special relationship with experimentation. Because of this, it is in an excellent position to put forward an alternative vision with respect to experimenting in open digital publishing, a vision that differs significantly from the neoliberal focus on experimentation as a force to drive innovation, capital accumulation, and further object formation.

Cultural Studies and Experimentation

In her book *The Ethics of Cultural Studies* (2005), Joanna Zylinska refers to the specific engagement of cultural studies with experimentation, which marks the "open-ended nature of the cultural studies project," as she calls it. This means that, as a project, cultural studies is constantly being repositioned, without an assured or fixed outcome. For Zylinska, this openness to the unknown, to forms of knowledge and politics that cannot be described easily in more "established disciplinary discourses," is what makes cultural studies intrinsically ethical.[77] Cultural studies, as a field, has also been interested in exploring more inclusive forms of knowledge that acknowledge otherness and differentiation and that are more affective and experiential. This exploration by cultural theorists of different forms of knowledge was initiated, among other means, by restoring the separation between the concepts of *experience* and *experiment*. Raymond Williams, under the heading of "Empiricism" in his *Keywords* volume, explores the etymology of *experiment* and how it came to mean something different from *experience*, with which, until the eighteenth century, it was interchangeable. Where *experience* started to mean subjective or internal knowledge, *experiment* came to be aligned with the scientific method of an arranged methodical observation of an event, a theoretical knowledge directed toward the external world. For Williams, however, *experience* is crucial to tackle and grasp change, flux, flow—all that escapes our fixed efforts at signification and at knowing.

Experience is thus directed toward process and emergence. The splitting of experience and experiment, then, led to distinctions between practical and theoretical, between subjective and objective knowledge, and between experience past and present. Williams wanted wholeness again with respect to this concept, with experience now based upon a set of exclusions (of theory, of creativity, of the present and future) and upon a subjectively centered model of consciousness.[78]

This search for a more inclusive knowledge—one that includes both experience *and* experiment—which we can find in Williams work, has been identified by cultural theorist Gregory Seigworth in the projects of a variety of other thinkers, too—most notably, Deleuze, Benjamin, and Bergson.[79] The influence and popularity of these thinkers within cultural studies as a result of the boom in Deleuzian cultural studies might also explain the current renewed attention to empiricism as a resurgent culturalist *experiential* paradigm, Seigworth argues. This is an empiricism in which *experience* and *experiment*—or practice and theory in more general terms—are still one and the same and are not split up. Within this paradigm, the concept of *experience* operates beyond the interpretative powers of a being's knowing sensibility. Experience does not belong to the subject, nor is it mediating between subject and object. It is, as Seigworth states, referring to Williams and his concept of *structures of feeling*, something that needs a form of autonomy; experience needs to become an active potential, freed from the fixed and the personal it has come to be associated with in daily life.

Seigworth goes on to show how Benjamin, Deleuze, and Bergson all explored ways to establish this wholeness between experience and experiment again. Benjamin's notion of speculative knowledge, the knowledge derived from experience, focuses on the incorporeal and the ephemeral, for example. Unlike a model of knowledge based on representation and resemblance, and similar to Barad's theory of posthumanist performativity, speculative knowledge for Benjamin is nonrepresentational; it belongs to neither subject nor object and is neither inside nor outside. For Deleuze, *experience* refers to open intensities and sensations (affect), which are not subsumed necessarily by faculties of knowing and interpretation. Experience is open-ended and emergent here, not yet articulated. For Bergson, experience and experiment are linked in intuition, which exceeds or overflows the intellect. Intuition is a lived immediacy, it is mobile, processual; it connects past,

Publishing as a Relational Practice

present, and future; experience can then be seen as memory, duration, and experiment. This relates to William's idea of the pre-emergent, the not yet articulated, in which a practical consciousness functions as a creative process. Williams tried to find space for creative intuition, for an experimental openness to the world beyond our fixing, interpretive consciousness and preexistent conceptual frameworks—an openness toward multiplicities. In this respect, Williams wanted to analyze the flows between process and structure, between a thing's singularity and its contexts of relations, to explore where something new emerges.[80]

In keeping with the viewpoint I expressed earlier when presenting my alternative genealogy of openness, just as it is not useful to maintain the binary between open and closed, so it is likewise not beneficial to emphasize the rupture between experience and experiment. Instead, we need to enable a form of knowledge, a critique that remains open to question but that can at the same time be reconfigured, that can be cut and (temporally) fixed at some points to establish meaning and signify knowing. It is a knowing that in this case goes beyond an internal subjectivity and includes the external lifeworld. Williams's aim to explore experimentation as a way of opening up space for difference and otherness beyond our hegemonic conceptual knowledge frameworks could be extended to our knowledge institutions and practices more widely too. In this particular context, philosopher Samuel Weber has used experimentation to deconstruct one of our most established knowledge fixtures: the university. In the context of experimenting with and rethinking scholarly institutions and practices, his work is therefore essential. Weber connects the search for a different concept and meaning for experimentation directly to the need to break down the modern (or humanist) conception of the university. This conception depends, he argues, on a bias toward universally valid interpretative knowledge, or on a notion of knowledge and a vision of the human as unifying, holistic, and totalizing. Weber notices the integral connection between this perception of knowledge and neoliberalism: "What lurks behind its ostensible universalism is the message that there are no longer any alternatives to the dominant neoliberal political-economic system."[81] For Weber, however, hope lies in the experimental method derived from the modern sciences, which is focused on creating replicable sequences and repetition and which has an orientation toward the future and the world as open, consisting of a plurality of possibilities.

Yet the scientific method still subsumes the particular under a general conceptual framework. Weber therefore explores alternative conceptualizations of experimentation that are open to ambivalence. To this end, he adopts Kierkegaard's notion of *experimenting* as a transitive verb, using the present participle form of the verb (ending in *ing*), instead of the substantive *experiment*, therewith bringing the noun into motion. The former emphasizes experimentation as a notion, wherein the singular gets articulated without letting its particularities dissolve into the universal. This opens up room for that what is different in repetition, for the exception, and for transformation in repetition.[82] Using Kierkegaard's notion, Weber finds a way to introduce uncertainty, unpredictability, and ambivalence into our modern conception of experimentation, one that seems to go directly against the neoliberal rhetoric of planned outcomes, risk analysis, and contingency plans, all of which are designed to filter out the uncertain and the unpredictable.

Following on from this, we can see how a reconceptualization of experimentation within the discourse of cultural studies toward iterability and difference in repetition opens up possibilities to imagine cultural studies *itself* as a space of experimentation. In addition to the relationship Zylinska sketches between the role played by experimentation in cultural studies and the latter's open-ended nature, we can also connect experimentation directly to cultural studies' *performative* dimension. For example, in his Deleuzian posthumanist reading of cultural studies as experimentation, Simon O'Sullivan breaks with a focus on the interpretation and *representation* of culture, and he opposes the idea of an object of study (culture) that gets interpreted by a human subject. This idea, O'Sullivan argues, works as a mechanism to fix and define culture, as well as fixing both the subject and knowledge, however fragmented they both are. Moving away from this move to fix knowledge, O'Sullivan instead proposes cultural studies be understood as a pragmatic *experimental* program, affirming cultural studies as a critical process, as a *doing*. Using the Deleuzian metaphor of *the rhizome*, he envisions cultural studies as a dynamic, fluid, open, and interdisciplinary system, capable of creating the world differently. This enables multiplicities and the thinking of virtual potentialities, he argues. O'Sullivan notices in this respect how cultural studies, through its actual institutionalizing mechanisms, stabilizes and, through experimentation, creates new lines of flight. Cultural studies is thus both programmatic *and* diagrammatic.[83] It is this performative dimension—more than a representational one—and the way

Publishing as a Relational Practice

it is apparent in and being practiced in cultural studies as part of its engagement with experimenting that I am most interested in here.

This in-depth look at the ways in which Zylinska, Williams, Seigworth, Weber, and O'Sullivan have reconceptualized the concept of experimentation from within the discourse of cultural studies forms the basis from which to next explore experimentation from a wider perspective—namely, that of humanities knowledge production, wherein various research and publishing projects are using experimentation in a manner that is distinct from the business logic underlying neoliberal forms of experimentation as innovation. To recap, according to the thinkers discussed thus far, experimenting means to welcome the possibility of new thinking, to explore the conditions whereby ideas and phenomena that escape the formulations of previous conceptual paradigms emerge. To create and think new forms of knowledge, experimentation is reconciled with experience to include speculative forms of knowledge and difference in repetition, thus providing room for ambivalence, for the ephemeral, and for failure, for that which does not fit. Experimentation here has the potential to become part of knowledge production in general, where it can be used to critique the essentializing object formation of our scholarly institutions (including the book) and to actively explore in an affirmative manner what new forms scholarship will take, how it will continue to transform itself, ourselves, and our understanding of the world we live in.

In this respect, it is important to emphasize—and this is where I want to connect back to the work of Barad—that we as scholars are always already a part of the intra-action of the experiment. Based on her reading of Bohr, Barad argues that our experimenting, intertwined with our theorizing, is a material practice. Both theory and experiment are complexly entangled dynamic practices of material engagement with the world. They are both material-discursive enactments that we as scholars perform through our scholarly practices. We therefore produce matter and meaning through our experimenting. And this is in turn a material engaging with the world, in which our experimenting is not an intervening from the outside, but an intra-acting from within, wherein we as scholars are part of the experimental apparatus.[84]

Experiments in Open Publishing

Ted Striphas has noted that experiments in cultural studies publishing (including experiments in open access publishing) have mainly taken place

at the fringes of the field, where these kinds of explorations have mostly been ignored and undervalued as a subject of exploration.[85] This can be partly explained by the way in which our socially constructed habits and honored ways of doing things lead us to engage with repetitive practices in the way we read, write, do research, publish, and assess our research findings. Experimentation, as described earlier, also serves to question the fixtures in scholarly (book) publishing that we have grown accustomed too, especially those established as part of our modern system of scholarly communication and the mostly print-based media ecologies of the twentieth century. We therefore need to think more creatively and expansively, Striphas argues, about these fixtures in scholarly communication and how they might work otherwise—like peer review and authorship, for instance. As stated previously, Striphas uses his Differences & Repetitions wiki to explore this: to experiment with new, digital, and collaborative writing practices that challenge the accustomed tradition of single authorship and the idea of ownership of works and ideas, trying to not give in to the compulsion to repeat and merely produce more of the same. For Striphas, the open wiki experiment is not meant to function as a new type of institution, but as a thing to think with, ongoing, changing, uncertain. As he points out, this experiment has taught him, and can teach us, "a great deal about the types of questions we might ask about our performances of scholarly communication in general, and of academic journal publishing in particular."[86]

Tara McPherson likewise frames some of the publishing projects she has been involved in—such as *Vectors*, an openly available multimedia journal and platform that investigates the intersections of technology and culture, and Scalar, a multimedia scholarly publishing and authoring platform—specifically within a framework of experimentation. The aim of both of these projects is to use experimentation to explore new publishing practices that try to make better use of the potentialities and affordances that the internet has to offer, from multimodal scholarship to networked forms of communication. As McPherson puts it, in this respect, "Vectors has functioned largely as an experimental space, publishing work that is formally challenging and that explores the boundaries of what might count as scholarly argument."[87] For these specific projects, this has meant examining the boundaries between creative expression and scholarship, exploring so-called emergent genres that "better take advantage of the affordances of computation." This includes investigating "bold new forms of experimentation and

bookishness" to push scholarly publishing in the humanities further.[88] For McPherson, experimentation and open access are aligned projects here; for her, this framework of experimentation also stretches to the ownership and distribution of scholarly content. Although she promotes broad experimentation, McPherson is also aware of the fact that it might not be sustainable in the long run. Although we need to continue to experiment, we should also, as she puts it, "evolve more 'standardized' structures and interfaces that will allow us to delineate more stable genres and to scale multimodal scholarship."[89] Nonetheless, this process should not stand in the way of exploring new modes of scholarship and publishing, where McPherson emphasizes the ongoing need for forms of bold experimentation.

A similar sense of open experimentation stood at the basis of one of the earliest online cultural studies archives, the CSeARCH e-archive and publishing project (see figure 4.1), founded in 2006.[90] Based on the model of the physics preprint archive arXiv.org, CSeARCH was a free, open access archive for cultural studies research literature and related materials and was provided as a further supplement to the online open access journal *Culture Machine*. This archive formed an experiment with making digital, open texts available online and was one of the first projects to explore some of the possibilities these online works have beyond merely replicating print in the online world.[91] Here it was felt that with their lack of fixity and permanence, with their undermining of traditional intermediaries and roles (i.e., publishers and libraries), and their use of and incorporation of different

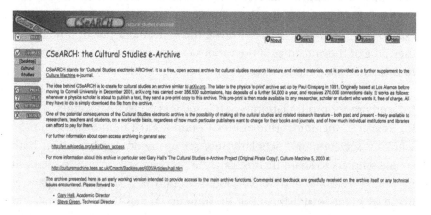

Figure 4.1
About page of the CSeARCH e-archive

media, these works have the potential to fundamentally transform the content they transmit and, with that, to change our relationship to knowledge.

The clear intention of Hall (one of the founders of CSeARCH) was to experiment with these latter, more uncomfortable issues and the kind of impact open publishing has on these.[92] He argues that setting up CSeARCH was motivated by a need to creatively experiment with the invention of new institutional forms, to think the university differently, and to help us conceive a different future for it.[93] Hall and his colleagues, as mentioned before, also experiment with how to reimagine our institutions via Open Humanities Press, especially in its experiments with publishing work in nontraditional formats, such as liquid, living, wiki books that reuse and repackage existing material and that are open for collaborative editing.[94] These books are questioning our notions of authorship, legitimacy, and quality assessment and are exploring the idea of research as a more processual event. These kinds of institutions, Hall argues, are structurally open. As a form or experiment, this makes it easier for them to be incorporated into a neoliberal discourse—as I have tried to show with the example of the Finch report and open access publishing. But it also gives them their force as forms and sites of resistance. In particular, it gives them ethical and political power to create something different, an alternative, a critique of and a resistance to the neoliberal discourse and its hegemonic project.[95] Echoing Bergson, Hall argues that these kinds of experimental archives and institutions can be seen as, as he calls it, "singular, different, alternative instances" of a kind of "experimental, creative militantism" from the side of cultural studies.[96] These institutions, like Weberian experiments, are never finished, nor do they know the answers to the theoretical and practical questions they pose or the outcomes of the various experiments they are conducting. In this sense, they can be seen as always emerging institutions.[97]

More recently, we have seen the emergence of several new open, scholar-led, and not-for-profit platforms in HSS focused on archiving and networking research, including Humanities Commons (HCommons), set up by scholarly societies, and ScholarlyHub, set up by academics, which both enable scholars to share their research in an open setting and to establish networks, relations, and conversations around it.[98] Kathleen Fitzpatrick, involved in the establishment of HCommons, argues that it fills a need in specific by enabling "forms of scholarly communication that exceed the conventionally understood affordances of publishing." At the same time,

Publishing as a Relational Practice

for Fitzpatrick, experiments with these kinds of new open platforms enable scholarship as a whole to continuously evolve, based on values of collective action and collaboration. As she states:

> Looking at the scholarly communication landscape today, one can see a lot of experimentation taking place, including many Mellon- and NEH-funded projects exploring new open access business models, new multimodal publishing platforms, new digital-first workflows, and the like. Not all of these experiments will result in lasting changes to the scholarly communication landscape, but they all promise to teach us some important things about the ways that scholars work today and the ways that they might be encouraged to work tomorrow. And the platforms and workflows that result from these experiments, if shared, might be built upon by others in ways that will allow scholarly communication to continue evolving.[99]

Experimentation can thus be seen as a critical process that allows for the emergence of multiplicities, opening up spaces for difference and otherness beyond our fixating and totalizing conceptual and knowledge frameworks. We can see the importance of the preceding articulation of experimentation for the concept of openness—and open access in particular—which is further reflected in forms of what I have called radical open access publishing. Here, as we can see from the examples mentioned previously, experimenting in many ways takes central stage, in contrast with more mainstream forms of publishing that tend either to focus on maintaining the status quo or to invest in innovation with the aim to disrupt or monopolize the existing market to grow their profit margins (which is how most commercial publishers tend to operate). Within forms of radical open access, on the other hand, experimentation serves as a means to reperform our existing institutions and scholarly practices in a more ethical and responsible way. Experimentation here stands at the base of a rethinking of scholarly communication and the university in general and can even potentially be seen as a means to rethink politics itself. For instance, and as outlined previously, by experimenting in an open way with the idea and the concept of the book, but also with the materiality and the system of material production surrounding it—which includes our ideas of the material and materiality—we can ask important questions concerning authorship, the fixity of the text, quality, authority, and responsibility—issues that lie at the base of what scholarship is and what, ultimately, the functions of the university should be. Radical open access, as an affirmative *experimental* practice,

can therefore be seen as an effort toward the deconstruction of the object formation and commodification of the book, which is maintained by the print-based institutions of material production and by our own repetitive and consolidating scholarly communication practices. It can be seen as a political and ethical effort to reperform these stabilizations.[100]

Yet openness itself can also be part of these stabilizing and fixating moves.[101] Radical open access can therefore, to some extent, be seen to function as a critique of the wider open access movement at the same time. In the latter, strategies of providing access to information and of making open, online scholarship more qualitatively esteemed are rather disconnected from strategies focused on experimentation.[102] In this respect, radical open access also constitutes an integral critique of openness, both of the strategic openness of the wider open access movement and of the more neoliberal incarnations of open access that favor a business logic and that promote the existing hegemonic power structures and vested interests of the scholarly publishing system. Both are in their own way very anxious about questioning or disturbing the object formation of the book.

Relational Publishing and an Ethics of Care

Next to an ongoing exploration of the forms our scholarly research can potentially take and the new kinds of institutions we can build to support them, experimentation in this context also involves a creative reimagining of the practices and relationalities that make up publishing. Several radical open access initiatives and organizations are currently, as part of their ongoing experiments with academic publishing and scholarly communication, trying to do exactly that: reconfigure what research is and how we can produce, disseminate, and consume it differently. As part of their theoretical and practical interventions, these initiatives are exploring alternative forms of relational and distributed publishing. This includes envisioning their publishing outlook and relationship with the research community within and as part of an *ethics of care*.[103] For example, one of the presses that has been very outspoken on these matters is Mattering Press, a scholar-led open access book publishing initiative founded in 2012 and launched in 2016, which publishes in the field of science and technology studies (STS) and employs a production model based on cooperation and shared scholarship. Mattering Press works with two interrelated feminist (new materialist) and STS concepts to structure and perform their ethos: mattering

and care. With respect to *mattering*, Mattering Press is conscious of how its experiments in knowledge production, being inherently situated, put new relationships and configurations into the world. What therefore *matters* for Mattering Press are not so much the author or the outcome (the object), but the process and the relationships that make up publishing: "The way academic texts are produced *matters*—both analytically and politically. Dominant publishing practices work with assumptions about the conditions of academic knowledge production that rarely reflect what goes on in laboratories, field sites, university offices, libraries, and various workshops and conferences. They tend to deal with almost complete manuscripts and a small number of authors, who are greatly dependent on the politics of the publishing industry."[104]

As part of its publishing ethos, politics, and ideology, Mattering Press is therefore keen to include and acknowledge the various agencies involved in the production of scholarship, including "authors, reviewers, editors, copy editors, proof readers, typesetters, distributers, designers, web developers and readers."[105] For Mattering Press, then, *care* is something that extends not only to authors but also to the many other actants involved in knowledge production, who often provide free volunteer labor within a gift economy context. Sharing time freely and gifting labor is something that underscores many radical open access projects, but volunteer labor also lies at the base of commercial publishing endeavors, where it is often exploited to gain higher profits. Many scholar-led and not-for-profit projects therefore try to redirect this volunteer labor where possible toward more progressive forms of publishing—for example, by shifting it away from commercial, profit-driven publishers and gifting it to developing, not-for-profit, open access projects instead, as Mattering Press is doing.

As Mattering Press emphasizes, the ethics of care "mark vital relations and practices whose value cannot be calculated and thus often goes unacknowledged where logics of calculation are dominant."[106] For Mattering Press, then, care can help offset and engage with the calculative logic and metrics-based regimes that permeate academic publishing infrastructures and increasingly determine how we relate to one another: "The concept of care can help to engage with calculative logics, such as those of costs, without granting them dominance. How do we calculate so that calculations do not dominate our considerations? What would it be to care for rather than to calculate the cost of a book? This is but one and arguably a relatively

conservative strategy for allowing other logics than those of calculation to take centre stage in publishing."[107]

This logic of care refers, among other things, to making visible the "unseen others," as Joe Deville (one of Mattering Press's editors) calls them, those who exemplify the plethora of hidden labor that goes unnoticed within this object- and author-focused (academic) publishing model.[108] As Endre Danyi, another Mattering Press editor, remarks, quoting Susan Leigh Star: "This is, in the end, a profoundly political process, since so many forms of social control rely on the erasure or silencing of various workers, on deleting their work from representations of the work."[109]

Yet care also extends to the published object itself and how relationships and communities are established around it. Tahani Nadim, a long-time friend of Mattering Press, is interested in this respect in how an ethics of care extends through the realm of the personal and is further established through the crafting of affective bonds, constructed and modulated through the publishing process and most importantly through books as affiliative objects. Books are central here as objects within the publishing process that "mediate and modulate relationships" and which, "for example in the form of gifts, can strengthen and diversify existing bonds and even create new ones."[110] Nadim emphasizes the role relations of friendship play within scholarly production and how they lie at the heart of Mattering Press. She argues that we can develop new ethical positions drawn from interpersonal relations of friendship, just as Mattering Press is doing. Nadim therefore feels that it is "through the realm of the personal that we can articulate and enact a different kind of politics."[111]

Mattering Press is not alone in exploring an ethics of care in the context of the underlying relations of academic publishing. Mercedes Bunz, one of the editors of meson press (a cooperative press focusing on media theory and digital culture), argues that a sociology of the invisible would have to incorporate *infrastructure work*, the work of accounting for and crediting everyone who is involved in producing a book.[112] As she explains, "A book isn't just a product that starts a dialogue between author and reader. It is accompanied by lots of other academic conversations—peer review, co-authors, copy editors—and these conversations deserve to be taken more serious."[113] And Sarah Kember, director of Goldsmiths Press, is also adamant about making the underlying processes of publishing (i.e., peer review, citation practices) more transparent and accountable, to determine

Publishing as a Relational Practice

where exclusions and hierarchies are created as part of our relations of publishing: "We need to look at the infrastructure and the many mechanisms that reproduce inequality, precarity, anxiety, and ill health off the page and 'below the line,' as Carol Stabile puts it."[114] Open Humanities Press can also be seen as an experiment in how to reimagine our publishing institutions, by operating according to a gift economy while functioning as a networked, cooperative, and multiuser collective, in which authors and editors both internal and external to OHP support one another and share knowledge and skills. In this sense, OHP very much works horizontally in a noncompetitive fashion, freely sharing its knowledge, expertise, and even publications, copublishing with other open access presses such as Open Book Publishers and meson press. As a peer publishing initiative, OHP is fully volunteer-led, which means that hundreds of academics are directly involved in OHP's publishing activities as part of multiple, self-governing scholarly communities, which include academics, librarians, publishers, technologists, journal editors, and more, all operating as a radically heterogeneous collective.

In this context, the question of agency, of who and what produces knowledge and according to what (power) relations, differentials, and hierarchies, takes central stage. When we understand publishing as a complex, multiagential, relational practice, the focus should be on how to better foreground the various agencies involved in knowledge production—for example, by experimenting with what a potential posthumanities could look like. This includes an acknowledgement of the role played by nonhuman agencies in the production of books (from paper to screens, ink, printers, trees, and Amazon warehouses) and by the book itself as a specific material form (be it printed or digital) in the relations it interweaves as part of its processual becoming: materially, geopolitically, environmentally. It is about recognizing the hierarchies and inequalities at play here and about highlighting the role played by these multiple others—that is, the materials and forms, the practices and processes that constitute and perform, mediate, and read the becoming book, codetermining its temporary stabilizations: "all those distributed, heterogeneous humans, nonhumans, objects, nonobjects, and nonanthropomorphic elements that collectively contribute to the emergence and history of an ink-on-paper-and-card book."[115] Yet next to (starting to) acknowledging the role these play in the production of the book, there needs to be a recognition of how, entangled with this, they

are shaping us as authors—but also as humans, disrupting what it means to be human as we adapt to new technological possibilities and affordances, from books to screens to encoded DNA.

What further ties radical open access projects together, then, is exactly a desire to attend more closely to, and reorient, how we work and interact together to create possibilities for more just forms of knowledge production. What is needed to enable this is first and foremost a reimagining of what academic collectivity, community, and commonality is and could be in a digital publishing environment. By developing an ethics of care, supporting the collective advancement of scholarship, and building digital knowledge commons, these projects try to reimagine the relations within the publishing system. "Commoning," as Samuel Moore points out, can therefore be seen as a prime example of a (publishing) practice grounded in care, a relational process "positioned towards a shared, common(s) horizon":

> We can thus reconceive of radical open access publishing as a commons not because of the resources that radical open access publishers make available, nor even because they are governed according to any particular rules or not-for-profit philosophy, but because the presses are involved in various forms of commoning–which is to say informal practices of care, resilience and shared enterprise within and across various institutional arrangements positioned towards a shared horizon of reclaiming the common. Care in this sense is relational rather than end-directed: it is a situated practice.[116]

Taking care to foster community-driven publishing models and relationships of mutual cooperation, bringing to light forms of work and relationality often neglected, absented, or silenced in contemporary discourses on technology, opens up new aspects of the rich, multifaceted relations between humans and things, including those in which the book is no longer perceived as (merely) a commodity or an object of value exchange fueling both publishing and university markets, but becomes an ever-evolving node in a network of relations of commoning, which it both fosters and is fostered by.

Toward a Scholarly Poethics

In what way then should a commitment to a kind of publishing that recognizes the multiple relationalities, forms, and agencies involved in the distribution and circulation of research materials (and that aims to reconfigure and care for them) not also have to include—and perhaps even start

with—an exploration of our own scholarly research practices? Following on from what I have argued in chapter 3, in order to combat the ongoing commercialization and object formation of the book and scholarship, strategies to intervene in the current cultures of knowledge production will need to do so in both publishing *and* academia. Next to the previously described radical open access publishing projects (many of which are scholar-led), which are experimenting with and reimagining the forms and relationships of scholarly publishing, I would argue that it is our practices as scholars that need to be open to experimenting more too. This might involve paying more attention to the way we do our scholarship and the way we perform or communicate it—that is, attention to the formats through which we publish our research and make it available to the wider public. Next to forms of radical open access publishing, a focus on a specific scholarly *poethics* might therefore prove crucial to transform the ongoing object formation of scholarship.

Discussions about the contents of our scholarship, about the different methodologies, theories, and politics that we use to give meaning and structure to our research, abound. Yet should we not have similar deliberations about the way we *do* research? About the way we craft of our own aesthetics and poetics as scholars? Should this then have to include a more in-depth focus on the medial forms, the formats, and the graphic spaces in and through which we communicate and perform scholarship (and the discourses that surround these), next to the structures and institutions that shape and determine our scholarly practices—instead of, as Ted Striphas has remarked upon, simply repeating the established forms, formats, and habits we are familiar with? This contextual discussion, focusing on the materiality of our (textual) scholarship and its material modes of production, is not and should not in any way be separate from a discussion on the contents of our work. Should we then start to more closely explore how the way we *do* scholarship (e.g., by publishing it in fixed, closed access, printed books) informs the kinds of methodologies, theories, and politics we choose and how these again shape the way we perform our scholarship—and with that its outcomes, what scholarship looks like as part of this development (and what is excluded in this process)?

Poetics is commonly perceived as the theory of ready-made textual and literary forms; it presumes structure and fixed literary objects. However, literary theorist Terry Threadgold, in her formulation of a *feminist poetics*, juxtaposes this theory of poetics with the more dynamic concept of *poiesis*, the

act of making or performing in language, which, she argues, better reflects and accommodates cultural and semiotic processes and the writing process itself.[117] For Threadgold, feminist writings in particular have examined this concept of poiesis, rather than poetics, of textuality by focusing on the process of text creation and the multiple identities and positions from which meaning is derived. This is especially visible in forms of feminist rewriting—for example, rewriting of patriarchal knowledges, theories, and narratives, which "reveal their gaps and fissures and the binary logic which structures them."[118] Moving beyond any opposition of poetics and poiesis, the poet, essayist, and scholar Joan Retallack brings them together in her concept of *poethics* (with an added *h*), which captures the responsibility that comes with the formulating and performing of a poetics. This, Retallack points out, always involves a wager, a staking of something that matters on an uncertain outcome—what Mouffe and Laclau have described as making a decision in an undecidable terrain.[119] Following Retallack, a focus on what I would then like to call a *scholarly poethics* might be useful in bridging the previously described context/content divide. I perceive a scholarly poethics to be a form of *doing* scholarship that pays specific attention to the relation between context and content, ethics and aesthetics in our research; between the methods and theories informing our scholarship and the media formats and graphic spaces we communicate through. A scholarly poethics thus tries to connect the doing of scholarship with its political, ethical, and aesthetical elements. It involves scholars taking responsibility for the practices and systems they are part of and often uncritically repeat, but also for the potential they have to perform them differently; to take risks, to wager on exploring other communication forms and practices or on a thinking that breaks through formalizations of thought—if these better reflect and perform (potentially) the complexities of the world and our contemporary society as part of our intra-action with it.

A scholarly poethics, conceptualized as such, would include forms of openness that do not either simply repeat established forms (such as the closed print-based book, single authorship, linear thought, copyright, exploitative publishing relationships) or succumb to the closures that its own implementation (e.g., through commercial adaptations) and institutionalization (e.g., as part of top-down policy mandates) of necessity also implies and brings with it. It involves an awareness that publishing in an open way directly impacts what research is, what authorship is, and, with that, what publishing

Publishing as a Relational Practice

is. It asks us to take responsibility for how we engage with open access, to take a position toward it and publishing more broadly, and toward the goals we want it to serve (which I here and others elsewhere have done through the concept and project of radical open access, for example). As I envision it, a scholarly poethics is not a specific prescriptive methodology or way of doing scholarship; it is a plural and evolving process in which content and context codevelop. Scholarly poethics thus focuses on the abundant and continuously changing material-discursive attitudes toward scholarly practices, research, communication media (text/film/audio), institutions, and infrastructures.

Chapters 3 and 4 have explored the discourses, institutions, relations, and practices that have surrounded the material production of the academic book-object. As part of this exploration, I have examined what specific roles the book as a commodity has come to play in the current scholarly communication constellation (both in publishing and academia), what struggles it has encountered along its way, and what potential opportunities for intervention this might offer. In this chapter, I have tried to supplement the material-discursive genealogy of the monograph's object formation, which I discussed in chapter 3, with alternative visions and practices related to both its past and future, to show how a politics of the book can extend beyond dichotomies such as openness and closure/secrecy, experimentation and experience, and object and process.

Our scholarly publishing and communication practices continue to function within an object-based neoliberal capitalist system: a system that is fed and sustained by the idea of autonomous ownership of a work, copyright (mostly going to publishers), and a reputation economy based on individualized authors. In other words, text and works are mostly perceived here as fixed and stable objects and commodities instead of material and creative processes and entangled relationalities. The earlier described more relational notions of publishing—visible in radical open access experiments, including a wider appreciation of the various (posthuman) agencies involved in academic publishing and communication, based on an ethics of care—challenge the vision of this neoliberal calculative regime and discourse, which originated in and is very much still based on physical book-objects and on a print-based situation.

In this respect, the book, and the practices and discourses surrounding the production, distribution, and consumption of its material incarnations,

offers an important starting point to envision and shape our scholarly communication system differently. Through its open-ended nature (again, both conceptually and materially), the book offers opportunities to make alternative, critical (political) incisions, enabling practices of ongoing experimentation.[120] Affirmatively engaging with its affordances can thus enable us to explore more ethical, alternative, and responsible forms of doing research. Experimenting through our discourses and practices and through the material form of the book and the various (posthuman) relationalities that make up publishing will potentially give us the opportunity to deconstruct and recut what we still see as the fixed and naturalized features of how we communicate as scholars. Critiquing these structures, however, means at the same time taking responsibility for the new boundaries that we enact, with respect to authorship, copyright, originality, and authority. Nevertheless, through our alternative incisions, we can start to imagine a potentially new politics of the book, one that is open-ended but responds to its environment. This critique of our forms, narratives, and performances of publishing and research needs to be ongoing, however, given that it involves a series of continuous critical struggles concerning both the past and the future of the book, materiality, the university, and what it means to be political.

5 On Liquid Books and Fluid Humanities

Books traditionally have edges: some are rough-cut, some are smooth-cut, and a few, at least at my extravagant publishing house, are even top-stained. In the electronic anthill, where are the edges? The book revolution, which, from the Renaissance on, taught men and women to cherish and cultivate their individuality, threatens to end in a sparkling cloud of snippets. So, booksellers, defend your lonely forts. Keep your edges dry. Your edges are our edges. For some of us, books are intrinsic to our sense of personal identity.

—John Updike, "The End of Authorship"[1]

Fixity, or the idea of a stable, standardized, and reliable text, ready to endure the ages, is a quality that often gets attributed to printed codex books—so much so that it has come to signify one of the essential defining elements of what we perceive a book to be today: a collection of bound pages. *Fixity* here relates to the bound nature of the printed codex book in a spatial sense, but it also refers to the book's stability, continuity, and durability as a means of communication over time. This is because the combination of bound and easily duplicated printed editions of texts has offered an excellent preservation strategy.[2] Fixity, however, not only emerged in connection to the medial, technological, and material affordances of the printed book, exemplified by developments in design and by typographic elements—look, for instance, at cover pages, titles, chapters, standardized fonts, indices, and concordances, all of which were incremental in turning the book into a fixed object that is easy to navigate. Fixity also advanced as part of the practices, institutions, and discourses that surround the printed book, as I briefly touched upon in the previous chapters. Here, concepts and practices such as authorship, the ownership of a work, and copyright, were incremental in

fixing, legally and morally, the contents of a book.[3] Moreover, and as discussed in chapters 3 and 4, books have also been sold and disseminated as finalized and bound commodities by (scholarly) publishers, as well as being preserved and indexed by our libraries and archives as permanent, stable, and solid artifacts.

The concept of *gathering* plays an important role in creating fixity, as emphasized in commentaries on Mallarmé's *Un Coup de Dés* by both Blanchot and Derrida.[4] Binding takes place here in the sense of "gathering together from dispersion," something that, as Derrida has argued, is essential to the idea of the library too. Readers also bind and gather a book together through their reading practices, both conceptually—cutting it down in their interpretation or meaning giving—and practically. For instance, when it comes to hypertexts, it is specific readings that serve to bind disparate routes and texts together. In an online environment, readers as writers cut, paste, and gather dispersed networked nodes together in fluid digital scrapbooks and book collections. However, alongside these practices and institutions, there have also been strong cultural discourses that have stimulated the bound nature of the book, promoting its perception as a finished and completed object, the culmination of a writer's work. This discourse is strongly embedded in academia, in which the published book is most often perceived as the endpoint of the research process, in certain areas of the humanities especially. Similarly, it is common practice in many humanities disciplines for an academic only to become an author or a researcher in the true sense, viable for employment, tenure, promotion, and so forth, once their first book has been published. Here the book fixes or determines the author in a similar way too.

This chapter analyzes the discursive-material practices that have promoted the idea and use of the academic book as a fixed object of communication. The printed codex book has come to exemplify durability, authority, and responsibility, as opposed to the more fluid, flowing visions of information transmission that are commonly attached to oral cultures and exchanges and, more recently, to digital forms of communication. This alternative fluid or liquid vision of communication carries important consequences with it for scholarly research, which, one could argue, has based its modern existence on the reliable transmission of research results. Under the influence of digital technology, what is seen as the essential fixed and bound nature of the book has, however, increasingly given way to visions

On Liquid Books and Fluid Humanities

of the rhizomatic, the fluid, the wikified, the networked, and the liquid book—as well as to other, similar entities that explore the book's potential unbinding. What do these more fluent forms entail for the idea of the limits or the edges of the book? Can a collection of texts, pages, or websites still be called a book without some form of enduring stability? What would a potential unbinding entail for academic research? Especially when bound and stable texts have been of fundamental importance to our ideas of science and scholarship: to ensure that experiments can be repeated according to the same conditions in which they were originally conducted; as a preservation mechanism to make sure academics have access to the research materials needed; but also as a means to assure that authors can take responsibility for certain fixed and relatively unchangeable sequences of text, guaranteeing a work's integrity. Will we be able to imagine new forms of scholarship and preservation of research that no longer rely so strongly on the idea of a fixed and stable text? Will we be able to allow for more fluidity in our age of virtually unlimited digital dissemination and storage capabilities?

When considering these questions, it might be beneficial to look at them from a different angle. For it can also be argued that books have never been fixed, stable, and linear, and that print as a medium and technology is not and has never been able to guarantee fixity—not the least because fixity is for a large part embedded in social structures.[5] Similarly, the way in which digital media have been taken up in academic publishing—their potential for unbinding the book notwithstanding—mostly mirrors the practices of fixing and stabilizing that were introduced and further developed through print media. It can even be argued that, with its potential for unlimited storage, the digital is much better suited to create forms of fixity than print ever was. This becomes obvious if we look at Wikipedia. Its MediaWiki software has made it much easier to preserve changes to a text and therefore to detect and track these changes. All alterations to, and revisions of, a text can now conceivably be saved.[6] Therefore, the preservation capacities of the net have the possibility to offer texts far more durability—and in that sense, stability—than print could potentially ever have.[7]

In this respect, it might be more useful to start thinking beyond dialectical oppositions such as bound/unbound and fixed/fluid, and to explore the idea of research being *processual*—although it also necessarily needs to be bound and cut at some point for us to make sense of it. If we then conceive

the book as a potential form of binding or gathering this processual research together, we may be able to start to shift our focus toward questions of *why* it is that we cut and bind.

It is these questions that are explored in this chapter, through an analysis of the demarcations or boundaries that we as academics enact. This includes an examination of the bindings that are made *for us* by the book's changing materiality and the institutions, discourses, and power struggles that have grown up around it. The question then becomes: How can we rethink the way we cut and paste our processual research together? Especially in a context in which these boundaries that are enacted (including forms of print fixity) are actually unstable, as we iteratively produce research and books through our incisions and boundary-making practices. How can we start to rework these forms of binding? And what role can the book continue to play in these processes of gathering and collecting? It is important to emphasize here that books are not determinate objects in themselves that are bound or unbound or that have inherent properties and boundaries. Books emerge from specific intra-actions or *phenomena*, which, in Barad's words, "do not merely mark the epistemological inseparability of observer and observed, or the results of measurements; rather, phenomena are the ontological inseparability/entanglement of intra-acting 'agencies.'"[8] In this sense, and as I have argued previously, it is through our book binding and unbinding practices, cutting our research together and apart, that both the book as we know it *and* we ourselves as scholars arise.

Rethinking how we bind research therefore includes asking questions about who and what binds and about the ways in which we currently gather our research together. What are the media-specific factors in the book's material becoming that force forms of binding on us in their intra-actions with our institutions and practices? In which specific ways do these material structures currently tie our research and our books together, and what new forms of (digital) gathering do they propose?

This chapter starts with a section that outlines how certain authoritative scholars within the book historical field have helped further construct, historiographically, an image of the book as fixed and bound and how they have done so by focusing on how, historically, the printed book, in its materiality and through our institutions and practices, developed the forms of book fixity and trust that we are accustomed to today. The following section then analyzes several recent digital experiments that have explored the

unbinding of scholarly research, most notably in the form of fluid, remixed, and modular (scholarly) books and projects that are focused on remixed authorship and digital archives. I argue that these unbound book alternatives are not so much examples of unbinding as proposals for alternative ways of gathering research together. This section focuses on some of the critiques these experiments have formulated concerning the ways we bind and are being bound, while analyzing some of the different forms of cutting and pasting that are currently being put forward. The fact that these alternative projects and practices do not so much unbind as propose new forms of gathering—forms that still seem to mirror in the main our codex-based forms of closure (e.g., via authorship, copyright, design, and interface)— shows how difficult it is to let go of the methods of binding developed as part of the print paradigm.

Nonetheless, it is important to challenge, critique, and rethink some of the major practices and institutions of gathering and fixity we currently adhere to, from copyright to authorship to the book as a published object and commodity. It is important to do so not only to challenge the humanist focus on essentialized notions such as the unity of the work and the individual author, but also to counter the problems created by the book-bound commodity fetish within academic publishing, which I discussed in chapters 3 and 4. This includes investigating the power structures and interests that are invested in maintaining stable texts and that determine when a text is fixed and finalized, and for what reasons. For instance, commercial interests promote the creation of heavily copyrighted or DRM-controlled academic works, which, it can be argued, are standing in the way of the more widespread sharing and dissemination of scholarly research online. The current communication model is based on codex-shaped journals and books with stable and static content, a situation that protects the integrity of the liberal author's work.

In this context, experiments with alternative hypertextual and multimodal forms of publishing, or with reuse, updating, and versioning, are hard to sustain. And this is the case even though these experiments with the form and shape of publications could offer us ways to rethink and reperform scholarly communication in a different and potentially more ethical way, along with offering us the possibility to explore what Tara McPherson has referred to as *emergent genres* for multimodal scholarship.[9] This could include exploring the capacity of new technologies to produce scholarship

at various scales—for example, audiovisual and sensory ones—but also reappreciating humanities scholarship from the perspective of aesthetics or, as McPherson argues, "how multimodal expression might allow for different relationships of form to content." This includes the potential of the digital to better accommodate movement and change. But it also allows, or even demands, a further questioning of how computation, which, as McPherson remarks, has "long been deeply intertwined with visuality, aesthetics, and the sensory," intersects with both the humanities and with the human.[10]

What could be the potential in alternative unbound book projects to reenvision the way we perceive the book and do research, to explore different forms of cutting and binding, and to promote forms of processual research? Are there other ways of binding that do not necessarily close down research and the book (and even ourselves as scholars) by means of strict forms of authorship and copyright, for example? And what does it mean for the political potential of the book as a medium through which we can reimagine alternative futures for scholarly communication, if we uncritically foreclose its open-endedness?

Here it is again worth emphasizing—and this is something scholars of bibliography and critical editing are already intensely familiar with—that print has always been an unstable medium and only offers, as Johanna Drucker has rightly noted, "the illusion of fixity."[11] As she continues: "A book is a snapshot of a continuous stream of intellectual activity. Texts are fluid. They change from edition to edition, from copy to copy, and only temporarily fix the state of a conversation among many individuals and works across time. . . . A book is a temporary intervention in that living field."[12] The second half of this chapter explores this idea of texts and books as forms of temporary intervention and fixing in more depth by looking at the concept of *the cut* as theorized in new materialism, continental philosophy, and remix studies. Again, this analysis is not an attempt on my part to explore the problem of the fixity and stability of the book from a perspective of bound or unbound—where both print and digital media have the potential to bind and unbind—but rather from that of cutting and iterative boundary-making. I want to focus on how books can be shaped and bound in a way that doesn't foreclose or demarcate them. In this respect, this chapter asks: If we see research as an ongoing process that needs to be gathered together at some point, that needs to be cut, how can we do it differently and potentially better? Here the focus is not on the book-object

unbinding, but on the processes of research and how we can imagine different cuts to stabilize it. That is, How can we give meaning to its fluidity by making the right incisions?

From Orality to Fixity?

One of the main points of contention concerning the development of fixity as a material condition and concept remains the question whether a book can ever be defined as a stable text, and, if so, whether this quality of stability and fixity is an intrinsic element of print—or to a lesser extent of manuscripts—or whether it is something that has been imposed on the printed object by historical actors. How did a selection of influential scholars, who have played a key role in shaping and forming the book-historical discourse, frame questions around the book's permanence and durability along the lines of this binary analysis, with that playing an important part in the discursive construction of the book as bound and gathered?

On the one hand, book historians have identified standardization and uniformity as properties integral to the development of print technology. In *The Printing Press as an Agent of Change*, Eisenstein analyzes how print influenced many aspects of scholarship and science. As she argues, print influenced the dissemination, standardization, and organization of research results, but it also impacted upon data collection and the preservation, amplification, and reinforcement of science.[13] Books became much cheaper, and a more varied selection of books was available, to the benefit of scholars. This encouraged the transition from the wandering to the sedentary scholar and stimulated the cross-referencing of books. Increasingly, printers also began standardizing the design of books. They started by experimenting with the readability and classification of data in books, introducing title pages, indexes, running heads, footnotes, and cross-references.[14] Yet as Eisenstein, but also McLuhan and Ong, have emphasized, scholars benefitted most from the standardization of printed images, maps, charts, and diagrams, which had previously proven very difficult to multiply identically by hand. This was essential for the development of modern science, they maintain.[15]

Yet others, including Ong, contend that fixity was already enabled by preceding technologies. For Ong, it is writing and literacy that are inherently connected to fixity and stability; he argues that scientific thinking should be seen as a result of writing, for instance. In opposition to Eisenstein, who

emphasizes the fixity brought about by printing in comparison to the scribal culture that preceded it, Ong focuses more on the relationship between orality and literacy—specifically, on the differences in mentality between oral and writing cultures. The shift from orality to writing, he argues, is essentially a shift from sound to visual space, where print mostly had effects on the use of the latter. Writing, he states, locks words into a visual field—as opposed to orality, in which language is much more flexible.[16]

Eisenstein, however, emphasizes that fixity could only really come about with the development of print. She sees standardization and uniformity as properties of print culture, properties that were usually absent in a predominantly scribal environment.[17] No manuscript at that time could be preserved without undergoing corruption by copyists, she argues.[18] Long-term preservation of these unique objects also left a lot to be desired, as the use of manuscripts led to wear and tear, while moisture, vermin, theft, and fire all meant that "their ultimate dispersal and loss was inevitable."[19] Although printing required the use of paper, which is much less durable than either parchment or vellum, the preservative powers of print, Eisenstein emphasizes, lay mainly in its strategy of conservation by duplication and making public: printing a lot of books and spreading them widely proved a viable preservation strategy.

Eisenstein similarly points out that printing, through its powers of precise reproduction, helped spread a number of cultural revolutions (i.e., the Renaissance, the Reformation, and the scientific revolution)—revolutions that were, as she claims, essential in the shaping of the modern mind.[20] Febvre and Martin also explored the influence of the book on the Renaissance and the Reformation, analyzing print's causes and effects as part of a socioeconomic history of book production and consumption over a long period of time. Being slightly more cautious, they wonder how successful the book has been as an agent for the propagation of new ideas.[21] They see preservation through duplication and (typographic) fixity as basic prerequisites for the advancement of learning, agreeing that *it was* print that gave the book a permanent and unchanging text.[22] However, for them printing is just part of a *set* of innovations. The printing press is only one of a number of actors in the general social and political history they try to reconstruct.

Although Eisenstein acknowledges this plurality of actors, in her view print was the main agent of change impacting the revolutionary developments detailed previously. She argues that it builds on previous achievements

but emphasizes that the preservative powers of print were more permanent than previous movements: print revolutionized these previous systems. Where scribal copying ultimately led to more mistakes and corruption of the text, successive print editions allowed for corrections and improvements to be made. With fixity, Eisenstein explains, came "cumulative cognitive advance."[23] Even if the printing press also multiplied and accelerated errors and variants—and many errata had to be issued—the fact was that errata could now be issued. Therefore, she states, print made corruption more visible at the same time.[24] In Eisenstein's vision, this print-enabled fixity was essential for the development of modern science. Texts, she states, were now sufficiently alike for scholars in different regions to correspond with each other about what was, to all intents and purposes, a uniform text. Networks of correspondents were created, which in turn led to new forms of feedback that had not been possible in the age of scribes. This again was an influence on the scientific method and on the modern idea of scientific cooperation.

Print, however, went further than just encouraging popularization and propaganda and the mere spreading of new ideas.[25] It was the availability and access to diverse materials that was really revolutionary, Eisenstein argues. Permanence was also able to bring out progressive change, she states, where "the preservation of the old . . . launched a tradition of the new."[26] From valuing the ancients, the emphasis increasingly came to be placed on admiring the new. According to Eisenstein, the communications revolution created a "fixed distance in time," influencing the development of a modern historical consciousness. McLuhan similarly claims that with print, a "fixed point of view" became possible; print fosters the separation of functions and a specialist outlook.[27] Eisenstein confesses that it is hard to establish how exactly printed materials affected human behavior; nonetheless, enhanced access to a greater abundance of records and a standardization brought about by printing did influence the literate elite, she argues.[28] For example, printing standardized vernacular languages and led to the nationalization of politics (increasingly, political documents were written in the vernacular) and the fragmentation of Latin. Drawing on McLuhan, Eisenstein also shows how the thoughts of readers are guided by the way the contents of books are arranged and presented. Basic changes in book format led to changes in thought patterns; for example, standardization helped to develop a new *esprit de système* (including systematic cataloging and indexing).[29] She also makes a clear claim for the importance of

print on the development of the Reformation: the press was the ultimate propaganda machine. However, Eisenstein points out that print not only diffused Reformation views but also shaped them: print stabilized the bible (and scholars were being provided with Greek and Hebrew texts), and its availability in vernacular languages changed who read the bible and how they read it.[30]

In contrast to Eisenstein's arguments toward the agency of print in establishing fixity, Adrian Johns, and others with him, emphasizes that it is not printing per se that possesses preservative power, but the way printing is put to use in particular ways. If we reassess the way print has been constructed, Johns argues, we can contribute to our historical understanding of the conditions of knowledge itself, how it emerged and came to depend on stability. Printed books themselves do not contain attributes of credibility and fixity—which are features that take much work to maintain—and as such printed records were not necessarily authorized or faithful, Johns remarks. According to Johns, it was the social system then in place, not the technology, that needed to change first in order for the printing revolution or print culture to gain ground.[31]

Johns brings the cultural and the social to the center of our attention through his interest in the roles of historical figures (i.e., readers, authors, and publishers) in bringing about fixity. He argues that Eisenstein neglects the labors through which fixity was achieved, to the extent that she describes what Johns sees as being the results of those labors, as powers or agency intrinsic to texts instead. For Johns, then, fixity is not an inherent quality but a transitive one; fixity exists only inasmuch as it is recognized and acted upon by people—and not otherwise. In this sense, fixity, he states, is the result of manifold representations, practices, and, most importantly, conflicts and struggles that arise out of the establishment of different print cultures.[32]

Roger Chartier similarly argues against the direct influence of print on readers' consciousness. He is interested in how books as material forms do not impose but command uses and appropriations. In his vision, works have no stable, universal, or fixed meaning as they are "invested with plural and mobile significations that are constructed in the encounter between a proposal and a reception"; in other words, Chartier's route map to a history of reading is based on the paradox of the freedom of the reader versus

On Liquid Books and Fluid Humanities

the order of the book: How is the order of the book constructed, and how is it subverted through reading?[33] As part of his work as a historian, he reconstructs the variations in what he calls the *espaces lisibles*, the texts in their discursive and material forms, and the variations that govern their effectuation.[34]

Although Johns acknowledges that print to some extent led to the stabilization of texts, he questions "the character of the link between the two."[35] For him, printed texts were not intrinsically trustworthy, nor were they seen as self-evidently creditable in early modern times, when piracy and plagiarism and other forms of "impropriety" were widespread. This meant that the focus was not so much on "assumptions of fixity," as Johns calls it, but on "questions of credit" and on the importance of trust in the making of knowledge.[36] Print culture came about through changes in the conventions of civility and in the practice of investing credit in materials (i.e., by the historical labors of publishers, authors, and readers) as much as through changes in technology, he argues.[37] Johns is therefore interested in how knowledge was made (where knowledge is seen as contingent). How did readers decide what to believe?

Reading practices were very important to cope with the appraisal of books, Johns points out; especially with respect to the issue of piracy, the credibility of print became a significant issue, one with both economic and epistemic implications.[38] As discussed in previous chapters, the character of a printer or stationer was very influential in the establishment of trust or credit. This trust, Johns explains, was related to a respect of the principle of *copy*, meaning the recognition of another (printer's) prior claim to the printing of a work, based on a repudiation of piracy. As Johns shows, the stationer's name on a book's title page could tell prospective readers as much about its contents as could the author's name.[39] The character of booksellers mattered, too, he notes, as they determined what appeared in print and what could be bought, sold, borrowed, and read. Readers thus assessed printed books according to the places, personnel, and practices of their production and distribution. To contemporaries, Johns argues, the link between print and stable or fixed knowledge seemed far less secure, not least because a certain amount of creativity (i.e., textual adaptation) was essential to the stationer's craft, where piracy was also not unfamiliar: in fact, it was far more common than was certainty and uniform editions.

Furthermore, pirates were not a distinguishable social group, existing as they did at all ranks of the stationers' community, and at times they were among its most prominent and "proper" members, Johns explains.[40] It is important in this respect to realize that piracy was not attached to an *object*; it was used as a category or a label to cope with print, as a tactic to construct and maintain truth claims.

The reliability of printed books thus depended in large part on *representations* of the larger stationers' community as proper and well-ordered, Johns emphasizes.[41] This clashed, he states, with the characteristic feature of the stationers' commonwealth—namely, *uncertainty*. Print culture was characterized by endemic distrust, conspiracies, and counterfeits. The concept of piracy was used as a representation of these cultural conditions and practices as they were prevailing in the domain of print, Johns explains. With this uncertainty, it became clear that the achievement of print-based knowledge and authorship was transient.

Yet readers did come to trust and use print, Johns points out, as books were of course produced, sold, read, and put to use, meaning that the epistemological problems of reading them were, in practice, overcome.[42] Trust could become possible, Johns argues, because of a disciplining regime—including elaborate mechanisms to deal with all the problems of piracy—brought about by publishers, booksellers, authors, and the wider realm of institutions and governments, exemplified for Johns by the Stationers' Company. Licensing, patenting, and copyright were similarly machineries for producing credit, Johns points out, where the register set up by the Royal Society, together with the *Philosophical Transactions*—which became their trademark symbols of credibility and propriety—were also achievements that required strenuous efforts to discipline the processes of printing and reading.[43] With this regime in place, Johns claims that trust in printed books could become a routine possibility.[44] As he explains, however, power struggles arose regarding who gets to decide on or govern these social mechanisms for generating and protecting credit in printed books, displaying the complex interactions of piracy, propriety, political power, and knowledge. Conflicts arose over the implementation of patents and/or copyright and about the different consequences a print culture governed by a specific entity (stationers or the crown, for Johns) would face. These conflicts held, according to Johns, "the potential for a fundamental reconsideration of the nature, order, and consequences of printing in early modern society."[45]

On Liquid Books and Fluid Humanities

211

The debate outlined thus far between those who can be perceived as some of the most influential book historical theorists shows how fixity has been narrated predominantly in a binary manner, with a focus on the effects of either technology or societal structures on the standardization and fixity print enabled. Yet what I want to put forward here is that these historical narratives further strengthen a perception of the book (either as technology or as societal construct) *as* stable, fixed, and permanent—notwithstanding the ambivalence that thinkers such as Johns and Chartier also introduce. As part of the historiographical dispute around the agency of print and its institutions in the development of fixity, a—perhaps unintended—outcome of this debate has been a continued focus on the more or less linear development of fixity and standardization as integral aspects (whether intrinsic or transitive) of printing and the book and of science and scholarship more in general. Instead of focusing on the inherent fluidity, mutability, or malleability of the book, for example, or the open and flexible nature of scholarly publications, this narrative remains dominant. The next section explores examples of theorists and publishing projects that have tried to examine this preconception of or even fixation on print and fixity, questioning the inherent connection between stability and the book that continues to be reinstilled by both sides of the book historical debate.

Before I turn to this next section, I want to highlight how more recently a new generation of book historians have started to question this preconception, focusing on the malleability of texts instead. Leslie Howsam, for example, has argued that "no consequential history of books and the cultures they inhabit will be possible until historians take mutability, not fixity, as their starting point."[46] Yet even here, with this gradual shift in the book-historical discourse, there remains a danger of the debate falling back into binary distinctions between stability and malleability again (i.e., in the sense of a turn from a focus on the one, fixity, to the other, malleability). Instead of focusing on whether texts are fixed or fluid, I want to explore here why there is, and has been, a tendency within the book-historical discourse to focus on *either* of these characterizations. What I want to argue for instead is more reflection on how this shift in the debate—in which the perception of print as stable and fixed starts to be complicated—has a direct material influence on the object under study, the book itself, paying more attention, in other words, on how *the discourse itself is performative.* Following this thread, then, the fact that the discourse itself is changing can be

understood as a response to and a reflection on the changing materiality of the book, because the digital is in many ways, as I have argued previously, making us rethink the perceived stability of the book, both online and in print. Therefore, as Bolter has argued, "it is important to remember . . . that the values of stability, monumentality and authority, are themselves not entirely stable: they have always been interpreted in terms of the contemporary technology of handwriting or printing."[47] These kinds of *historiographical cuts*, choices that are made by us as scholars in intra-action with the materiality of the book and in response to discursive fields, therefore once again show the complexity and multiplicity of agencies involved in the creation of fixity.

Fluid Publishing

If we contend that—until more recently, at least—book-historical narratives have contributed to the vision of the book as fixed, durable, and bound, then they should be perceived as part of the disciplining regime Johns talks about, which has privileged certain cuts in intra-action with the book's material becoming. While the growing use and importance of the digital medium in scholarship is affecting the materiality of the book, it is in the interplay with the established disciplining regime (which again includes the historiography of the book) that its development is being structured. An increasing interest in the communication and publishing of humanities research in what can be seen as a less fixed and more open way is nonetheless challenging the integrity of the book, something that the systems surrounding it have tried so hard to develop and maintain. Technological change has in this respect triggered a questioning of many taken-for-granted stabilizations.

Why is this disciplining regime, and the specific print-based stabilizations it promotes, being interrogated at this particular point in time? First, and as the genealogies provided previously testify, this regime has seen a continuing power struggle over its upkeep and constituency and as such has always been disputed. Nonetheless, changes in technology, and in particular the development of digital media, have acted as a disruptive force, especially because much of the discourse surrounding digital media, culture, and technology tends to promote a narrative of openness, fluidity, and change. In this respect, this specific moment of disruption and

On Liquid Books and Fluid Humanities 213

remediation brings with it an increased awareness of how the semblances of fixity that were created and upheld in, and by, the printed medium are indeed a construct, upheld to maintain certain established institutional, economic, and political (and even historiographical) structures.[48] This has led to a growing awareness of the fact that these structures are formations we can rethink and perform otherwise. All of which may explain why there is currently a heightened interest in how we can intra-act with the digital medium in such a way as to explore potential alternative forms of fixity and fluidity, from blogs to multimodal and versioned publications, to wikis and networked books.

The construction of what we perceive as stable knowledge objects serves certain goals, mostly to do with the establishment of authority, preservation (archiving), reputation building (stability as threshold), and commercialization (the stable object as a reproducible product). In *Writing Space: Computers, Hypertext, and the Remediation of Print* (2001), Bolter conceptualizes stability (as well as authority) as a value under negotiation, as well as the product of a certain writing technology. This acknowledgment of the relative and constructed nature of stability and of the way we presently cut with and through media encourages us to conduct a closer analysis of the structures underlying our knowledge and communication system and how they are set up at present: Who is involved in creating a consensus on fixity and stability? Similarly, what forms of fluidity are allowed, and what is valued—and what is not—in this process?

It could therefore be argued that it is the specific cuts or forms of fixing and binding of scholarship that are being questioned at the moment, while the potential of more processual research is being explored at the same time: for example, via the publication of work in progress on blogs or personal websites. The ease with which continual updates can be made has brought into question not only the stability of documents but also the need for such stable objects. Wikipedia is one of the most frequently cited examples of how the speed of improving factual errors and the efficiency of real-time updating in a collaborative setting can win out over the perceived benefits of stable material knowledge objects. There has perhaps been a shift away in this respect from the need for fixity in scholarly research and communication toward the importance of other values, such as collaboration, quality, speed, and efficiency, combined with a desire for more autonomous forms of publishing. Scholars are using digital media to explore the

possibilities for publishing research in more direct ways, often cutting out the traditional middlemen (e.g., publishers and libraries) that have become part of the print disciplining regime they often aim to critique. Accordingly, they are raising the question: Do these middlemen still serve the needs of their users, of scholars as authors and readers? For example, the desire for flexibility, speed, autonomy, and so on has caused new genres of formal and informal scholarly communication to arise; a focus on openness and fluidity is seen as having the potential to expand academic scholarship to new audiences; digital forms of publishing have the potential to include informal and multimodal scholarship that hasn't been communicated particularly extensively before; and new experimental publishing practices are assisting scholars in sharing research results and forms of publication that cannot exist in print because of their scale, their multimodality, or even their genre. In what way, then, could making the processual aspect of scholarship more visible—which includes the way we collaborate, informally communicate, review, and publish our research—and highlighting not only the successes but also the failures that come with that potentially aid in demystifying the way scholarship is produced?

From social media to blogging software, mailing lists, institutional repositories, and academic social research sharing networks (e.g., commercial services such as Academia.edu and ResearchGate or the not-for-profit Humanities Commons), scholars are increasingly moving to digital media and the internet to publish both their informal and formal research in what they perceive as a more straightforward, direct, and open way. This includes the mechanisms developed for the more formal publication of research discussed in the previous chapter, via either green (archiving) or gold (directly via a press or journal) open access publishing. Nonetheless, the question remains whether these specific open forms of publishing have really produced a fundamental shift away from fixity and its disciplinary regime and discourse. The next section therefore draws attention to a specific feature of openness, a feature that can in many ways be seen as one of its most contested aspects—namely, the possibility to reuse, adapt, modify, and remix material.[49] Although remix and reuse has an extensive predigital history, the digital environment has further stimulated and facilitated remix practices, both within and outside of an academic context.[50] It is this part of the ethos or definition of openness (libre more than gratis) that can be said to most actively challenge the concepts of stability, fixity, trust, and authority that have accompanied the rhetoric

On Liquid Books and Fluid Humanities

215

of printed publications for so long.[51] Where more stripped-down versions of openness focus primarily on achieving greater access, and do so in such a way that the stability of a text or product need not be affected (indeed, as remarked before, the open and online distribution of books might even promote its fixity and durability due to the enlarged availability of digital copies in multiple places), *libre* openness directly challenges the integrity of a work by enabling different versions of a work to exist simultaneously (by allowing reuse rights that include derivatives). At the same time, libre forms of openness also problematize such integrity by offering readers the opportunity to remix and reuse (parts of) the content in different settings and contexts, from publications and learning materials to translations, visualizations, and data mining. Within academia, this creates not only practical problems (which version to cite and preserve, who is the original author, who is responsible for the text) but also theoretical problems (what is an author, in what ways are texts ever stable, where does the authority of a text lie). The founding act of a work—that specific function of authorship described by Foucault in his seminal article "What Is an Author?"—becomes less important for both the interpretation and the development of a work once it goes through the processes of adaptation and reinterpretation, and the meaning given as part of the author function becomes dispersed—and with that the authorial force of binding is weakened.[52]

Fitzpatrick discusses the repurposing of academic content in this regard, which remains problematic within a print paradigm: "What digital publishing facilitates, however, is a kind of repurposing of published material that extends beyond mere reprinting. The ability of an author to return to previously published work, to rework it, to think through it anew, is one of the gifts of digital text's malleability—but our ability to accept and make good use of such a gift will require us to shake many of the preconceptions that we carry over from print."[53]

The ability to expand and build upon, to make modifications and create derivative works, to appropriate, change, and update content within a digital environment, also has the potential to shift the focus in scholarly communication away from the publication as a fixed, final, and definitive research output and on to the process of researching.[54] It is a shift that, as discussed previously, may have the ability to make us more aware of the contingency of our research and the cuts and boundaries we enact and that are enacted for us when we communicate and disseminate our findings.

It is this shift away from models of print stability and toward process and fluidity (including the necessary stabilizations) that the following sections focus on in order to explore some of the ways in which both the practical and theoretical problems that are posed within this development are being dealt with at this moment in time and whether these should or can be approached differently.

I want to focus on three alternatives in particular here that have been put forward by or have derived from within this context of reworking and remaking, which include suggestions for alternative concepts and performative practices to explore or deal with questions of fixity, stable authorship, and (print-based forms of) authority, within more open, fluid, or networked environments—alternatives that, I argue, can potentially have important consequences for knowledge production in the humanities. As such, I briefly discuss the concept of modularity, as discussed in the work of Lev Manovich, before proceeding to the concept of the fluid text, as put forward by textual critic John Bryant. I end with an exploration of the role played by the (networked) archive in a digital environment, by looking at the work of remix theorist Eduardo Navas.

As part of my analysis of these concepts and practices, I outline how they still mostly end up adhering to fixtures and boundaries—such as liberal humanist authorship and authority—that have been created within the print paradigm and how they often end up uncritically maintaining or repeating established institutions and practices. My aim in offering such a critique is to push forward our thinking on the different kinds of cuts and stabilizations that are possible within humanities research, its institutions, and practices; to explore interruptions that are perhaps both more ethical and open to difference and critical of both the print paradigm *and* of the promises of the digital.[55] How might these alternative and affirmative cuts enable us to conceive a concept of the book built upon openness and, with that, a concept of the humanities built upon fluidity?

Modularity

Within his research on remix and software culture, media theorist Lev Manovich discusses the concept of *modularity* (of digital media) extensively, among others, as one of his five principles of new media.[56] He describes how with the coming of software, a shift in the nature of what constitutes a

On Liquid Books and Fluid Humanities

217

cultural object has taken place; in his vision, cultural content no longer has finite boundaries. Similar to the modular character of code and software, Manovich argues that new media consist of various independent elements (images, text, code, sound) or modules that, (re)combined together, form a new digital media object. Furthermore, he explains that the shift away from stable environments in a digital online environment means there are no longer senders and receivers of information in a classical sense; there are only temporary reception points in information's path through remix. The role of the user is thus expanded in this vision, as content is no longer simply *received* by the user but is traversed, constructed, and managed. Thus, culture becomes a product that is constructed by both the maker *and* the consumer. What is more, according to Manovich, culture is actively being modularized by users to make it more adaptive; in other words, in his vision culture *is* not modular, but is (increasingly) *made* modular in digital environments.[57] However, as Manovich explains, the real remix revolution lies in the possibility this generates to exchange information between media—what in *Software Takes Command* he calls the concept of *deep remixability*—describing a situation in which modularity is increasingly being extended to media themselves. In a common software-based environment, the remixing of various media has now become possible, along with a remixing of the methodologies of these media, offering the possibility of mash-ups of text with audio and visual content, expanding the range of cultural and scholarly communication.[58]

Manovich sketches a rather utopian future here (one that does not take into account present copyright regimes, for instance), in which cultural forms will be deliberately made from Lego-like modular building blocks, designed to be easily copied and pasted into new objects and projects. For Manovich, this involves forms of standardization, which function as a strategy to make culture freer and more shareable, with the aim of creating an ecology in which remix and modularity become a reality. In this respect, for Manovich, "helping cultural bits move around more easily" is a method to devise a new way with which we can perform cultural analysis.[59] Similarly, the concept of modularity and of recombinable datasets offers him a way of looking beyond static knowledge objects, presenting an alternative view of how we structure and control culture and data, as well as how we can analyze our ever-expanding information flows. With the help of these

software-based concepts, Manovich thus examines how remix can be an active stance by which people will be able to deliberately shape culture in the future and deal with knowledge objects in a digital context.

Within scholarly communication, the concept of modularity has similarly proved popular when it comes to making research more efficient and to cope with information overload: from triplets and nanopublications to other forms of modular publishing, these kinds of software-inspired concepts have mostly found their way into scientific publishing.[60] Within this context, Joost Kircz, for instance, argues that instead of structuring scholarly research according to linear articles, we should have a coherent set of "well-defined, cognitive, textual modules."[61] Similarly, Jan Velterop and Barend Mons suggest moving toward a model of nanopublications in order to deal with information overload, which can be seen as a move in the direction of both more modularity and the standardization of research outcomes.[62]

There are, however, problems with applying this kind of modular database logic to cultural objects. Of course, in those cases in which culture or cultural objects are already structured and modular, reuse and repurposing are much easier. However, cultural objects tend to differ, and it is not necessarily always possible or even appropriate to modularize or cut up a scholarly or fictional work; not all cultural objects are translatable into digital media objects either. Hence, too strict a focus on modularity might be detrimental to our ideas of *cultural difference*. Media theorist Tara McPherson formulates an important critique of modularity to this end. She is mostly interested in how the digital, privileging as it does a logic of modularity and seriality, became such a dominant paradigm in contemporary culture: How did these discourses from software and coding cultures translate into the wider social world?[63] In other words, what is the specific relationship between context and code in this historical context? How have code and culture become so intermingled? As McPherson argues, in the mid-twentieth century, modular thinking took hold in a period that also saw the rise of identity politics and racial formations in the US, hyperspecialization and niched production of knowledge in the university, and forms of Fordist capitalism in economic systems: all of which represent a move toward modular knowledges. However, modular thinking, McPherson points out, tends to obscure the political, cultural, and social context from which this thinking emerged. She emphasizes the importance here of understanding the discourses and peculiar histories that have created these forms of the digital and of digital

On Liquid Books and Fluid Humanities

culture, which encourage forms of partitioning. This includes being more aware of how cultural and computational operating systems mutually infect one another. In this respect, McPherson wonders, "how has computation pushed modularity in new directions, directions in dialogue with other cultural shifts and ruptures? Why does modularity emerge in our systems with such a vengeance across the 1960s?"[64] She argues that these forms of modular thinking, which function via a lenticular logic, offer "a logic of the fragment or the chunk, a way of seeing the world as discrete modules or nodes, a mode that suppresses relation and context. As such, the lenticular also manages and controls complexity."[65] We therefore need to be wary of this bracketing of identity in computational culture, McPherson warns, where it holds back complexity and difference. She favors the application of Barad's concept of the agential cut in these contexts, using this to replace bracketing strategies (which bring modularity back); for McPherson, then, as a methodological paradigm, the cut is more fluid and mobile.[66]

The concept of modularity, as described by Manovich (where culture is *made* modular), does not seem able to guarantee these more fluid and contingent movements of culture and knowledge. The kind of modularity he is suggesting does not so much offer a challenge to object and commodity thinking as apply the same logic of stability and standardized cultural objects or works, only on another scale. Indeed, Manovich defines his modular Lego blocks as "any well-defined part of any finished cultural object."[67] There is thus still the idea of a finished and bound entity (the module) at work here, but it is smaller, compartmentalized.

Fluid Texts and Liquid Publications

Where Manovich's concept of modularity mostly focuses on criticizing stability and fixity from a spatial perspective (dividing objects into smaller recombinable blocks), within a web environment, forms of temporal instability—over time, cultural objects change, adapt, get added to, re-envisioned, enhanced, and so on—are also being increasingly introduced. In this respect, experiments with liquid texts and with fluid books not only stress the benefits and potential of processual, iterative, and versioned scholarship, of capturing research developments over time and so forth, but also challenge the essentialist notions that underlie the perceived stability of scholarly works.

Textual scholar John Bryant theorizes the concept of fluidity extensively in his book *The Fluid Text: A Theory of Revision and Editing for Book and Screen*

(2002). Bryant's main argument revolves around the myth of stability, insofar as he argues that all works are fluid texts. As he explains, this is because fluidity is an inherent phenomenon of writing itself; we keep on revising our words to approach our thoughts more closely, with our thoughts changing again in this process of revision. In *The Fluid Text*, Bryant displays (and puts into practice) a way of editing and doing textual scholarship that is based not on a final authoritative text, but on revisions. He argues that for many readers, critics, and scholars, the idea of textual scholarship is designed to do away with the otherness that surrounds a work and to establish an authoritative or definitive text. This urge for stability is part of a desire for what Bryant calls "authenticity, authority, exactitude, singularity, fixity in the midst of the inherent indeterminacy of language."[68] By contrast, Bryant calls for the recognition of a multiplicity of texts, or rather the *fluid text*. Texts are fluid in his view because the versions flow from one to another. For this, he uses the metaphor of a work as *energy* that flows from version to version.

In Bryant's vision, this idea of a multiplicity of texts extends from different material manifestations (drafts, proofs, editions) of a certain work to an extension of the social text (translations and adaptations). Logically, this also leads to a vision of multiple authorship, wherein Bryant wants to give a place to what he calls the *collaborators* of or on a text, to include those readers who also materially alter texts. For Bryant, with his emphasis on the revisions of a text and the differences between versions, it is essential to focus on the different *intentionalities* of both authors and collaborators. The digital medium offers the perfect possibility to achieve this, he argues, and to create a fluid text edition. Bryant established such an edition—both in a print and an online edition—for Melville's *Typee*, showing how a combination of book format and screen can be used to effectively present a fluid textual work.[69]

For Bryant, this specific choice of a textual presentation focusing on revision is at the same time a moral choice. This is because, for him, understanding the fluidity of language enables us to better understand social change. Furthermore, constructionist intentions to pin a text down fail to acknowledge that, as Bryant puts it, "the past, too, is a fluid text that we revise as we desire."[70] Finally, he argues that the idea of a fluid text encourages a new kind of critical thinking, one that is based on difference, otherness, variation, and change. This is where, in his vision, the fixation on the

On Liquid Books and Fluid Humanities

idea of having a stable text to achieve easy retrieval and unified reading experiences loses out to a discourse that focuses on the energies that drive text from version to version. In Bryant's words, "by masking the energies of revision, it reduces our ability to historicize our reading, and, in turn, disempowers the citizen reader from gaining a fuller experience of the necessary elements of change that drive a democratic culture."[71]

Bryant's fluid text edition of Melville's *Typee* is a prime example of a practical experiment focusing upon the benefits of fluidity for scholarly communication. Within academic publishing, however, fluid books have mostly been experimented with within the open educational resources (OER) movement, in the form of open textbooks. Open textbooks are published with licenses that allow users to adapt them and recombine them with other texts or resources. The European Liquid Publications (or Liquid-Pub) project was an important early experiment in open (text)book publishing.[72] As described by Casati et al., this was a project that tried to bring into practice the idea of modularity as described previously.[73] Focusing mainly on textbooks in the sciences, the aim of this project was to enable teachers to compose a customized and evolving book out of modular precomposed content. This book would then be a multiauthor collection of materials on a given topic that can include different types of documents.

The LiquidPub project tried to cope with questions of authority and authorship in a liquid environment by making a distinction between versions and editions. *Editions* are solidifications of the liquid book, with stable and fixed content, which can be referred to, preserved, and made commercially available. The project also created different roles for authors—from editors to collaborators—which were accompanied by an elaborate rights structure, with the possibility for authors to give away certain rights to their modular pieces while holding on to others. As a result, the LiquidPub project was a very pragmatic project, catering to the needs and demands of authors (mainly for the recognition of their moral rights), while at the same time trying to benefit from, and create efficiencies and modularity within, a fluid environment. The project offered authors a choice of different ways to distribute content, from completely open and reuseable books, to partially open and completely closed books.

Introducing graduations of authorship such as editors and collaborators, as proposed in both the work of Bryant and in the LiquidPub project, is one way to deal with plural authorship or authorship in collaborative research

or writing environments. However, as I showed in chapter 2, it does not fundamentally resolve some of the main questions it intends to address around authority—namely, how to establish authority in an environment (e.g., a wiki) where the contributions of a single author are difficult to source and content is created by anonymous users or machine-generated by algorithms, bots, and AIs. Furthermore, what becomes of the proposed role of editor or collaborator as an authoritative figure when selections can be made redundant and choices altered and undone by mass-collaborative, multiuser remixes and mash-ups? The projects mentioned earlier are therefore not so much posing a challenge to liberal humanist notions of authorship—or, more specifically, are not really questioning the authorship function as it is currently established as a *force of binding*. They are merely applying this established author function to smaller compartments of text and are dividing publications, and the responsibilities that come with them, up accordingly.

In addition to that, the concept of fluidity as described by Bryant, together with the notion of liquidity as used in the LiquidPub project, does not necessarily problematize or disturb the idea of object-like thinking or fixity within scholarly communication either. For Bryant, for example, a fluid book edition is still made up of separate, different versions, while in the LiquidPub Project, which focuses mostly on an ethos of speed and efficiency, a liquid book is a customized combination of different recombinable documents. In this sense, both projects adhere quite closely to the concept of modularity as described by Manovich (where culture is *made* modular), and the question remains whether they can thus be seen as fluid or liquid—that is, if one is to perceive fluidity or liquidity as a condition in which the stability and fixity of a text is fundamentally reconsidered in a continual or processual manner or as part of which cuts are made without simply demarcating the text anew. The idea of the object or the module still plays an essential role; however, it is smaller, compartmentalized: witness the way both these projects still hinge on the idea of extracted objects, of editions and versions, in their liquid projects. For example, Bryant's analysis is focused not so much on creating fluidity or a fluid text—however impossible this might be—but on creating a network between more or less stable versions while showcasing their revision history. He thus still makes a distinction between *works* and *versions*, neither seeing these versions as part of one extended work nor giving them the status of separate works. In this way, he keeps a hierarchical and linear thinking alive: "A version can

On Liquid Books and Fluid Humanities

223

never be revised into a different work because by its nature, revision begins with an original to which it cannot be unlinked unless through some form of amnesia we forget the continuities that link it to its parent. Put another way, a descendant is always a descendant, and no amount of material erasure can remove the chromosomal link."[74] Texts here are not fluid, at least not in the sense of being (able to be) continually updated; they are networked at the most. McKenzie Wark's terminology for her book *Gamer Theory*—which Wark distinctively calls a *networked book*—might therefore be more fitting and applicable in such cases. A networked book, at least in its wording, positions itself as being located more in between the ideal types of stability and fluidity.[75]

A final remark concerning the way in which these two projects theorize and bring into practice the fluid or liquid book: in both projects, texts are actively *made* modular or fluid by outside agents, by authors and editors. There is not a lot of consideration here of the inherent fluidity or liquidity that exists as part of a text or book's emergent materiality, in intra-action with the elements of what theorists such as Jerome McGann and D. F. McKenzie have called the *social text*—which, in an extended version, is what underlies Bryant's concept of the fluid text. In the social text, human agents create fluidity through the creation of various instantiations of a text post production. As McKenzie has put it: "A book is never simply a remarkable object. Like every other technology, it is invariably the product of human agency in complex and highly volatile contexts."[76] McKenzie, in his exploration of the social text, sought to highlight the importance of a wide variety of actors in a text's emergence and meaning giving, from printers to typesetters. He does so in order to argue against a narrow focus on a text's materiality or an author's intention. However, there is a lack of acknowledgement here of how the processual nature of the book comes about out of an interplay of agential processes of both a human and non-human nature.

Something similar can be seen in the work of Bryant, in that for him a fluid text is foremost fluid because it consists of various versions. Bryant wants to showcase material revision here, by authors, editors, or readers, among others. But this is a very specific—and humanist—understanding of the fluid text. For revision is, arguably, only one major source of textual variation or fluidity. In this sense, to provide some alternative examples, it is not the inherent emergent discursive-materiality of a text, nor the plurality

of material (human or machinic) reading paths through a text, that make a text always already unstable for Bryant. What does make a text fluid for him is the existence of multiple versions brought into play by human and authorial agents of some sort. This is related to his insistence on a hermeneutic context in which fluid texts are representations of extended and distributed forms of *intentionality*. As I will ask ahead, would it not be more interesting to perceive of fluidity or the fluid text rather as a process that comes about out of the entanglement and performance of a plurality of agentic processes: material, discursive, technological, medial, human and nonhuman, intentional and nonintentional? From this position, a focus on how incisions, interruptions, and boundaries are being enacted within processual texts and books, in an inherently emergent and ongoing manner, might offer a more inclusive strategy to deal with the complexity of a book's fluidity. This idea is explored in more depth toward the end of this chapter, when I return to theories of textual criticism to take a closer look at Jerome McGann's work.

The Archive

As discussed in chapter 2, remix as a practice has the potential to raise questions for the idea of authorship, as well as for related concepts of authority and legitimacy. For example, do moral and ownership rights of an author extend to derivative works? And who can be held responsible for the creation of a work when authorship is increasingly difficult to establish in music mash-ups or in data feeds, through which users receive updated information from a large variety of sources? As touched upon previously, one of the suggestions made in discussions of remix to cope with the question of authorship in a digital context has involved shifting the focus from the author to the *selector*, *moderator*, or *curator*. Yet in addition to that, in cases in which authorship is hard to establish or even absent, the *archive* has been put forward as a means to potentially establish authority in fluid environments retrospectively.

Eduardo Navas has examined both notions as potential alternatives to (established) forms of authority within knowledge environments that rely on continual updates and in which process is preferred to product. Navas emphasizes, however, that to establish authority and to make knowledge possible, keeping a critical distance from a text or work is necessary. As authorship has been replaced by sampling—and "sampling allows for the

On Liquid Books and Fluid Humanities 225

death of the author," according to Navas, as the origin of a tiny fragment of a musical composition becomes hard to trace—he argues that this critical position in remix is taken in by s/he who selects the sources to be remixed. Yet in mash-ups, this critical distance increasingly becomes difficult to uphold. As Navas puts it, "This shift is beyond anyone's control, because the flow of information demands that individuals embed themselves within the actual space of critique, and use constant updating as a critical tool."[77]

To deal with the constantly changing present, Navas therefore turns to history as a source of authority: to give legitimacy to fluidity retrospectively by means of the archive (e.g., see the data collected in digital environments by search engines and social media platforms or by public institutions and nonprofits such as the Internet Archive and the Library of Congress). The ability to search the archive establishes the remix's reliability and its market value (i.e., by mining the archive's database), Navas points out. By recording information, it becomes metainformation, information that is static, available when needed, and always in the same form, he argues. Retroactively, this recorded state, this staticity of information, is what makes theory and philosophical thinking possible. As Navas claims, "The archive, then, legitimates constant updates allegorically. The database becomes a delivery device of authority in potentia: when needed, call upon it to verify the reliability of accessed material; but until that time, all that is needed is to know that such archives exist."[78] Yet Navas is at the same time ambivalent about the archive as a search engine. He argues that in many ways it is a truly egalitarian space—able to answer all queries possible—but it is a space that is easily commercialized too and hence keeps changing, in part due to market interests. What does it mean when Google or Facebook harvest the data we collect and contribute, and our databases and archives are predominantly built upon commercial social media sites? In this respect, Navas states, we are also witnessing an increasing rise of information flow control and lock in.[79]

The importance of Navas's theorizing in this context lies in the possibilities his thinking offers for the book and the knowledge system we have created around it. First of all, as discussed previously, he proposes the role of s/he who selects, curates, or moderates as an alternative to that of the author; he also explores the archive as a way of both stabilizing flow and of creating a form of authority out of fluidity and the continual updating of information. In a way, this alternative model of agency is already quite

akin to the one found in scholarly communication, wherein selection of resources and referring to other sources, next to collection building, is part of the research and writing process of most academics. Yet although these are interesting steps to think beyond the status quo of the book as fixed and self-contained—challenging scholarly thinking to experiment with notions of process and sharing and to question idealized ideas of authorship—nonetheless, as Navas also already highlights, the archive as a tool poses some serious problems with respect to legitimating fluidity retrospectively and providing the necessary critical distance, as Navas positions it.[80] For the archive as such does not provide any legitimation but is built upon the authority and the commands that constitute it: what Derrida calls "the politics of the archive."[81] What is kept and preserved within archives is connected to power structures, to the interests of those who decide what to collect (and on what grounds) and the capacity to interpret the archive and its content when called upon for legitimation claims later on. The question of authority does not so much lie with the archive, then, but with who has access to the archive and with who gets to constitute it. At the same time, although it has no real power of its own to legitimize fluidity, the archive is used as an objectified extension of these power structures that constitute and control it; as Derrida argues, archiving is an act of externalization.[82]

A still further critique of the archive states that, rather than functioning as a legitimizing device, its focus is first and foremost on objectification, commercialization, and consummation. In the archive, knowledge streams are turned into knowledge objects when we order our research into consumable bits of data. Witness the way in which publishing companies such as Reed Elsevier (or RELX, as it has renamed itself) increasingly brand themselves as data and information analytics companies, highlighting that for them the published object becomes valuable once we are able to create, collect, and extract (and ultimately sell) the data around it. As Navas has shown, the search engine, based on the growing digital archive we are collectively building online, is Google's bread and butter. By initiating large projects like Google Books, for instance, Google aims to make the world's archive digitally available or to digitize the "world's knowledge"—or at least, that part of it that Google finds appropriate to digitize (i.e., mostly works in American and British libraries, and thus mostly English-language works). In Google's terms, this means making the information it deems most relevant—based on the specific programming of its algorithms—freely

On Liquid Books and Fluid Humanities

searchable, and Google partners with many libraries worldwide to make this service available. However, most of the time only snippets of poorly digitized information are freely available; for full-text functionality, or more contextualized information, books must be acquired via Google Play Books (formerly Google eBooks and Google Editions) on the Google Play store, for instance. This makes it clear how search is fully embedded within a commercial framework in this environment.

The interpretation of the archive is therefore a fluctuating one, and the stability it seems to offer is, arguably, relatively selective and limited. As Derrida points out in *Archive Fever*, using the example of email, the digital offers new and different ways of archiving and thus also provides a different vision of what it constitutes and archives (both from a producer and a consumer perspective).[83] Furthermore, the archiving possibilities also determine the structure of the content that will be archived as it is becoming. The archive thus *produces* just as much as it *records* the event. In this respect, the archive is highly performative: it produces information, creates knowledge, and decides how we determine what knowledge will be. And the way the archive is constructed is very much a consideration under institutional and practical constraints. For example, what made the Library of Congress decide in 2010 to preserve and archive all public Twitter feeds starting from its inception in 2006? And why only Twitter and not other similar social media platforms?[84] The relationship of the archive to scholarship in this respect is a mutual one, as they determine one another: a new scholarly paradigm asks for and creates a new vision of the archive. This is why the archive does not stabilize or guarantee any concept. As Derrida aptly states, "The archive is never closed. It opens out of the future."[85]

Foucault acknowledges this fluidity of the archive, where he sees it as a general system of both the formation *and* transformation of statements. However, the archive also structures our way of perceiving the world as we operate and see the world from within the archive. As Foucault states, "It is from within these rules that we speak."[86] The archive can thus be seen as governing us, and this again directly opposes the idea of critical distance that Navas has explored through the concept of the archive, as we can never be outside of it (nor can the archive be outside of the event it memorializes). Matthew Kirschenbaum argues along similar lines when he discusses the preservation of digital objects, pointing out that their preservation is *"logically inseparable* from the act of their creation."[87] He explains

this as follows: "The lag between creation and preservation collapses completely, since a digital object may only ever be said to be preserved *if* it is accessible, and each individual access creates the object anew. One can, in a very literal sense, *never* access the 'same' electronic file twice, since each and every access constitutes a distinct instance of the file that will be addressed and stored in a unique location in computer memory."[88]

This means that every time we access a digital object, we duplicate it, we copy it. And this is exactly why, in our strategies of conservation, every time we access a file we also (re)create these objects anew over and over again. Critical distance here is impossible when we are actively involved in the archive's functioning. Kirschenbaum quotes Abby Smith, who states that "the act of retrieval precipitates the temporary reassembling of 0's and 1's into a meaningful sequence that can be decoded by software and hardware."[89] Here the agency of the archive, of the software and hardware, also becomes apparent. Kirschenbaum refers to Wolfgang Ernst's notion of *archaeography*, which denotes forms of machinic or medial writing—or, as Ernst puts it, "expressions of the machines themselves, functions of their very mediatic logic."[90] At this point, archives become "active 'archaeologists' of knowledge"—or, as Kirschenbaum puts it, "the archive writes itself."[91]

Let me reiterate that this critique is not focused on doing away with either the archive or the creation of (open access) archives: archives play an essential role in making scholarly research accessible, preserving it, adding metadata, and making it harvestable. Yet a critical awareness of the structures at play behind the archive, while putting question marks on both its perceived stability and its (objective) authority and legitimacy, should remain an important aspect of the scholarly method.

The Limits of Fluidity and Stability

These experiments with modular, fluid, and liquid publications, with new forms of authorship and retrospective archival legitimation, provide valuable insights into the possibilities the digital medium offers to organize knowledge production differently to accommodate more fluid environments. However, as I have shown, most of the "solutions" presented earlier when it comes to engaging with or accommodating fluidity in online environments continue to rely on preestablished print-based conventions and demarcations. Although these experiments all explore alternative ways of

On Liquid Books and Fluid Humanities

establishing authority and authorship in increasingly fluid environments, these alternatives still very much rely on print-based forms and concepts of stability and fixity (structured around the liberal humanist author and the work as a bound and defined object) and the knowledge and power systems built around them. In many ways, these experiments thus remain bound to the essentialisms established as part of this object-oriented scholarly communication system: for example, when they propose smaller or more compartmentalized modular objects, a strategy that favors the fixed and the standard over the more diverse, complex, and relational; or when they explore linear, networked versions of original works, which remain connected to intentional and humanist authorial agencies; or are legitimized by archives that cannot uphold an objectified external function, as they are embedded in the objects and events they performatively (re)produce. As such, these experiments also do not fundamentally challenge our established notions and conventional understandings of the autonomous human subject, the author, the text, and fixity in relation to the printed book, authorship, authority, and stability in a digital context.

However, my critique of these notions is not intended as a condemnation of their experimental potential. On the contrary, I support these explorations of fluidity strongly, for all the reasons outlined here. Yet instead of intentionally or unintentionally reproducing humanist and print-based forms of fixity and stability in a digital context, as the concepts and projects mentioned previously still end up doing, I want to examine these *practices of stabilizing* themselves and the value systems on which they are based. Books are an emergent property; instead of trying to cope with the fluidity offered by the digital medium by using the same disciplinary regime we are used to from a print context to fix and cut down the digital medium, I want to argue that we should direct our attention more toward the cuts we make in, and as part of, our research, and the reasons *why* we make these cuts (both in a print and digital context) as part of our intra-active becoming with the book.

As I made clear earlier, instead of emphasizing the dualities of fixity/fluidity, closed/open, bound/unbound, and print/digital, I want to shift attention to the issue of the cut; to the performative processes of the demarcation of scholarly knowledge, of the fixing we need to do at specific points during its communication. How can we, by cutting, take responsibility for the boundaries we enact and that are being enacted? How can we do this while

simultaneously enabling responsiveness by promoting forms and practices of cutting that allow the book to remain emergent and processual (i.e., that do not tie it down or bind it to fixed and predetermined meanings, practices, and institutions) and that also examine and disturb the humanist and print-based notions that continue to accompany the book?

Rather than seeing the book as either a stable or a processual entity, a focus on the agential processes that bring about book-objects, on the constructions and value systems we adhere to as part of our daily scholarly practices, might be key in understanding the performative nature of the book as an ongoing effect of these agential incisions. The next section therefore returns to remix theory, this time exploring it from the perspective of the cut. I want to analyze the potential of remix here as part of a discourse of critical resistance against essentialism to question humanist notions such as fixity and authorship/authority; notions that continue to structure humanities scholarship and on which a great deal of the print-based academic institution continues to rest. As I argue, within a posthumanist performative framework, remix, as a form of differential cutting, can be a means to intervene in and rethink humanities knowledge production, specifically with respect to the political-economy of book publishing and the commodification of scholarship into knowledge objects.

Remix and the Cut

Cutting can be understood as an essential aspect of the way reality at large is structured and provided with meaning. However, within remix studies there has been a tendency to theorize the cut and the practice of cutting from a *representationalist* framework. Instead, my analysis here will be juxtaposed and entangled with a diffractive reading of a selection of critical theory, feminist new materialist, and media studies texts that specifically focus on the act of cutting from a *performative* perspective, to explore what forms a posthumanist vision of remix and the cut might take.[92] I then explore how the potential of the cut and, relating to that, how the politics inherent in the act of making an incision can be applied to scholarly book publishing in an affirmative way. How can we account for our own ethical entanglements as scholars in the becoming of the book?[93] Based on Foucault's concept of the apparatus, as well as on Barad's posthumanist expansion of this concept, I argue that the scholarly book currently functions as an

apparatus that cuts the processes of scholarly creation and becoming into authors, scholarly objects, and an observed world separate from these and us.[94] Drawing attention to the processual and unstable nature of the book instead, I focus on the book's critical and political potential to question these cuts and to disturb these existing scholarly practices and institutions.

After analyzing how the book functions as an apparatus, a material-discursive formation or assemblage that enacts incisions, I explore two book publishing projects—Open Humanities Press's Living Books About Life series and Mark Amerika's *remixthebook*—that have tried to rethink and reperform this apparatus by specifically taking responsibility for the cuts they make in an effort to cut well.[95] In what way do these projects create spaces for alternative, more inclusive posthumanities' methods and practices to perform scholarship, accommodating a plurality of human and nonhuman agencies and subjectivities? How have they established an alternative politics and ethics of the cut that is open to change, and what have been some of their potential shortcomings?

The Material-Discursive Cut within a Performative Framework

As discussed previously, media theorist Eduardo Navas has written extensively about cut/copy and paste as a practice and concept within remixed music and art. For Navas, remix, as a process, is deeply embedded in a cultural and linguistic framework, where he sees it as a form of discourse at play across culture.[96] This focus on remix as a *cultural variable* or as a form of cultural *representation* seems to be one of the dominant modes of analysis within remix studies as a field.[97] Based on his discursive framework of remix as representation and repetition (following Jacques Attali), Navas makes a distinction between copying and cutting. He sees *cutting* (into something physical) as materially altering the world, while *copying*, as a specific form of cutting, keeps the integrity of the original intact. Navas explores in his work how the concept of sampling was altered under the influence of changes in mechanical reproduction, where *sampling* as a term started to take on the meaning of copying as the act of taking, not from the world, but from an archive of representations of the world. Sampling thus came to be understood culturally as a meta-activity.[98] In this sense, Navas distinguishes between material sampling from the world (which is disturbing) and sampling from representations (which is a form of meta-representation that keeps the original intact). The latter is a form of cultural

citation—where one cites in terms of discourse—and this citation is strictly conceptual.[99]

What I want to do here instead is extend remix beyond a *cultural* logic operating at the level of *representations*, by seeing it as an always already *material* practice that disturbs and intervenes in the world. It will be beneficial here to apply the insights of new materialist theorists, to explore what a material-discursive and performative vision of cutting and the cut is able to contribute to the idea of remix as a critical affirmative *doing*. Following Barad, "The move toward performative alternatives to representationalism shifts the focus from questions of correspondence between descriptions and reality (e.g. do they mirror nature or culture?) to matters of practices/ doings/actions."[100] Here remixes as representations are not just mirrors or allegories *of* the world, but direct interventions *in* the world. Therefore, both copying and cutting are performative, in the sense that they change the world; they alter and disturb it.[101] Following this reasoning, copying is not ontologically distinct from cutting, as there is no distinction between discourse and the real world: language and matter are entangled, where matter is always already discursive and vice versa.[102]

As I explored in more depth in the introduction and in chapter 1, Barad's material-discursive vision of the cut focuses on the complex relationship between the social and the nonsocial, moving beyond the binary distinction between reality and representation by replacing *representationalism* with a theory of *posthumanist performativity*. Her form of realism is not about representing an independent reality outside of us, but about performatively intervening, intra-acting with and as part of the world.[103] For Barad, intentions are attributable to complex networks of agencies, both human and nonhuman, functioning within a certain context of material conditions.[104] Where in reality agencies and differences are interwoven phenomena, what Barad calls *agential cuts* cleave things together and apart, creating subjects and objects by enacting determinate boundaries, properties, and meanings. These separations that we create also enact specific inclusions and exclusions, insides and outsides. Here it is important to take responsibility for the incisions that we make, where being accountable for the complex relationalities of self and other that we weave also means we need to take responsibility for the exclusions we create.[105] Although not enacted directly by us, but rather by the larger material arrangement of which we are a part (cuts are made from the inside), we are still accountable to the cuts we help

On Liquid Books and Fluid Humanities

to enact: there are new possibilities and ethical obligations to act (cut) at every moment.[106] In this sense, "cuts do violence but also open up and rework the agential conditions of possibility."[107] It matters which incisions are enacted, where different cuts enact different materialized becomings. As Barad states: "It's all a matter of where we place the cut. . . . What is at stake is accountability to marks on bodies in their specificity by attending to how different cuts produce differences that matter."[108]

Related to this, media theorists Sarah Kember and Joanna Zylinska explore the notion of the cut as an inevitable conceptual and material interruption in the process of mediation, focusing specifically on *where* to cut insofar as it relates to *how to cut well*. As they point out, the cut is both a technique and an ethical imperative; cutting is an act that is necessary to create meaning, to be able to say something about things.[109] Here they see a similarity with Derrida's notion of *différance*, a term that functions as an incision, where it stabilizes the flow of mediation (which is also a process of *differentiation*) into things, objects, and subjects.[110] Through the act of cutting, we shape our temporally stabilized selves (we become individuated), as well as actively form the world we are part of and the matter surrounding us. On a more ontological level, therefore, "cutting is fundamental to our emergence in the world, as well as our differentiation from it."[111] Cutting thus enacts both separation and relationality (it cleaves) where an incision becomes an ethical imperative, a decision, one however that is not made by a *humanist, liberal subject* but by *agentic processes*. In this more performative vision, cutting becomes a technique, not of rendering or representing the world, but of managing it, of ordering and creating it, of giving it meaning.

Kember and Zylinska are specifically interested in the ethics of the cut. If we inevitably have to intervene in the process of becoming (to shape it and give it meaning), how is it that we can cut well? How can we engage with a process of *differential cutting*, as they call it, enabling space for the vitality of becoming? To enable a productive engagement with the cut, Kember and Zylinska explore performative and affirmative acts of cutting, using the example of photography to examine "this imperative [that] entails a call to make cuts where necessary, while not forgoing the duration of things." Cutting well for them thus involves leaving space for *duration*, where cutting does not close down creativity or "foreclose on the creative possibility of life."[112]

The Affirmative Cut in Remix Studies

To explore further the imperative to cut well, I want to return to remix theory and practice, in which the potential of the cut and of remix as subversion and affirmative logic, and of appropriation as a political tool and a form of critical production, has been explored extensively. In particular, I want to examine what forms a more performative vision of remix might take to again examine how this might help us in reconstructing an alternative politics of the book, one which, instead of focusing on either achieving states of stability or fluidity, instead enacts cuts while leaving space for duration—in other words, while not foreclosing on the duration of things (or, following Kember and Zylinska, on the creative possibility of life). In what sense do remix theory and practice also function, in the words of Barad, as "specific agential practices/intra-actions/performances through which specific exclusionary boundaries are enacted?"[113] Navas, for instance, conceptualizes remix as a vitalism: as a formless force, capable of taking on any form and medium. In this vitalism lies the power of remix to create something new out of something already existing, by reconfiguring it. In this sense, as Navas states, "to remix is to compose."

Through these reconfiguring and juxtaposing gestures, remix also has the potential to question and critique, becoming an act that interrogates "authorship, creativity, originality, and the economics that supported the discourse behind these terms as stable cultural forms."[114] However, Navas warns of the potential of remix to be both what he calls *regressive* and *reflexive*, where the openness of its politics means that it can also be easily co-opted, where "sampling and principles of Remix . . . have been turned into the preferred tools for consumer culture."[115] A *regressive remix*, then, is a recombination of something that is already familiar and has proved to be successful for the commercial market. A *reflexive remix*, on the other hand, is regenerative, as it allows for constant change.[116] Here we can find the potential seeds of resistance in remix, where, as a type of intervention, Navas states it has the potential to question conventions, "to rupture the norm in order to open spaces of expression for marginalized communities," and, if implemented well, to become a tool of autonomy.[117]

One of the realms of remix practice in which an affirmative position of critique and politics has been explored in depth, while taking clear responsibility for the interventions it enacts, is in feminist remix culture—most specifically in vidding and political remix video. Francesca Coppa defines

On Liquid Books and Fluid Humanities 235

vidding as "a grassroots art form in which fans re-edit television or film into music videos called 'vids' or 'fanvids.'"[118] By cutting and selecting certain bits of videos and juxtaposing them with others, the practice of vidding, beyond or as part of a celebratory fan work, has the potential to become a critical textual engagement, as well as a recutting and recomposing (cutting together) of the world differently. As fandom scholars Kristina Busse and Alexis Lothian state, vidding practically takes apart "the ideological frameworks of film and TV by unmaking those frameworks technologically."[119] Coppa sees vidding as an act of both bringing together and taking apart ("what a vidder cuts out can be just as important as what she chooses to include"); the act of cutting is empowering to vidders in Coppa's vision, insofar as "she who cuts" is better than "she who is cut into pieces."[120]

Video artist Elisa Kreisinger, who makes queer video remixes of TV series such as *Sex and the City* and *Mad Men*, states that political remix videos harvest more of an element of critique in order to correct certain elements (such as gender norms) in media works, without necessarily having to be fan works. As Kreisinger argues, "I see remixing as the rebuilding and reclaiming of once-oppressive images into a positive vision of just society."[121] Africana studies scholar Renee Slajda is interested in this respect in how Kreisinger's remix videos can be seen as part of a feminist move beyond criticism, as part of which remix artists turn critical consciousness into a creative practice aiming to "reshape the media—and the world—as they would like to see it."[122] For Kreisinger, too, political remix video is not only about creating "more diverse and affirming narratives of representation"; it also has the potential to effect actual change (although, like Navas, she is aware that remix is also often co-opted by corporations to reinforce stereotypes). Remix challenges dominant notions of ownership and copyright, as well as the author/reader and owner/user binaries that support these notions. Kreisinger explains how by challenging these notions and binaries, remix videos also challenge the production and political economy of media.[123] As video artist Martin Leduc argues in this respect, "We may find that remix can offer a means not only of responding to the commercial media industry, but of replacing it."[124]

The Agentic Cut in Remix Studies

Alongside providing valuable affirmative contributions to the imperative to cut well and its critical potential to reconfigure boundaries, remix has

also been important with regard to rethinking and reperforming agency and authorship in art and academia. In this context, it critiques the liberal humanist subject that underpins most academic performances of the author, while exploring more posthumanist and entangled notions of agency in the form of agentic processes in which agency is more distributed. For example, Paul Miller writes about flows and cuts in his artist's book *Rhythm Science*. For Miller, sampling is a doing, a creating with found objects, yet this involves taking responsibility for its genealogy, for "who speaks through you."[125] Miller's practical and critical engagement with remix and the cut is especially interesting therefore when it comes to his conceptualizing of identity, where—as in the new materialist thinking of Barad—he does not presuppose a pregiven identity or self, but states that our identity comes about *through* our incisions, the act of cutting, shaping, and creating our selves: "The collage becomes my identity," he states.[126] For Miller, agency is thus not related to our identity as creators or artists, but to the flow or becoming, which always comes first. We are so immersed in and defined by the data that surrounds us on a daily basis that "we are entering an era of multiplex consciousness," he argues.[127]

Where Miller talks about creating different personas as *shareware*, Mark Amerika is interested in the concept of performing theory and critiquing individuality and the self through notions such as "flux personae," establishing the self as an "artist-medium" and a "post-production medium."[128] Amerika sees performing theory as a creative process, in which pluralities of conceptual personae are created that explore their becoming. Through these various personae, Amerika wants to challenge the "unity of the self."[129] In this vision, the artist becomes a medium through which language, in the form of prior inhabited data, flows. When artists write their words, they don't feel like their *own* words but like a "compilation of sampled artefacts" from the artist's cocreators and collaborators. By becoming an artist-medium, Amerika thus argues that "the self per se disappears in a sea of source material."[130] By exploring this idea of the networked author concept or of the writer as an artist-medium, Amerika contemplates what could be a new (posthuman) author function for the digital age, with the artist as a postproduction medium, even "becoming instrument" and "becoming electronics."[131]

Cutting Scholarship Together-Apart

What can we take away from this transversal reading of feminist new materialism, media theory, and remix studies with respect to cutting as an affirmative, material-discursive practice—especially where this reading concerns how remix and the cut can performatively critique established humanist notions such as authorship, authority, and fixity, which continue to underlie scholarly book publishing? How can this reading trigger alternatives to the political economy of book publishing, especially the latter's persistent focus on ownership and copyright and the book as an object and commodity? Could this (re)reading even pose potential problems for our ideas of critique and ethics themselves when notions of stability, objectivity, and distance tend to disappear? Taking the previously discussed works into consideration, the question then is: How can we make ethical, critical cuts in our scholarship while at the same time promoting a politics of the book that is open and responsible to change, difference, and the inevitable exclusions that result?

To explore this further, I want to analyze the way the book functions and has functioned as an apparatus. The concept of *dispositive* or *apparatus* originates from Foucault's later work. As a concept, it expands beyond the idea of discursive formation to more closely connect discourse with non-discursive elements, with material practices. The apparatus, then, Foucault argues, is the system of relations that can be established between these disparate elements.[132] However, an apparatus for Foucault is not a stable and solid "thing" but a shifting set of relations inscribed in a play of power, one that is strategic and responds to an "urgent need," a need to control.[133] In comparison, Deleuze's more fluid outlook sees the apparatus as an assemblage capable of escaping attempts at subversion and control. Deleuze is specifically interested in the variable creativity that arises out of dispositifs (in their actuality), or in the ability of the apparatus to transform itself; as he explains, we as human beings belong to dispositifs and act within them.[134] Barad, meanwhile, connects the notion of the cut to her posthumanist Bohrian concept of the apparatus. As part of our intra-actions, apparatuses, in the form of certain material arrangements or practices, effect an agential cut between subject and object, which are not separate but come into being through these intra-actions.[135] Apparatuses, for Barad, are thus

open-ended and dynamic material-discursive practices, practices that articulate concepts and things.[136]

Applying this more directly, in what way has *the apparatus of the book*—consisting of an entanglement of relationships between, among other things, authors, books, the outside world, readers, the material production and political economy of book publishing, and the discursive formation of scholarship—executed its power relations through cutting in a certain way? In the present scholarly book publishing constellation, it has mostly operated via a logic of incision: one that favors neat separations between books, authors (as human creators), and readers; that cuts out fixed scholarly book-objects of an established quality and originality; and that simultaneously pastes this system together via a system of strict ownership and copyright rules. The manner in which the apparatus of the book enacts these delineations at the present moment does not take into full consideration the processual aspects of the book, research, and authorship, nor does it leave space for their ongoing duration. Neither does this current, still predominantly print-based apparatus explore in depth the possibilities to recut our research results in such a way as to experiment with collaboration, updates, versionings, and multimedia enhancements in a digital context. The dominant book-apparatus instead enforces a political economy that keeps books and scholarship closed off from the majority of the world's potential readers, functioning in an increasingly commercial environment (albeit one fueled by public money and free labor), which makes it very difficult to publish specialized scholarship lacking marketable promise. The dominant book-apparatus thus does not take into consideration how the humanist discourse on authorship, quality, and originality that continues to underlie the humanities perpetuates this publishing system in a material sense. Nor does it analyze how the specific print-based materiality of the book and the publishing institutions that have grown around it have likewise been incremental in shaping the discursive formation of the humanities and scholarship as a whole.

Following this chapter's diffractively collected insights on remix and the cut, I want to again underscore the need to see and understand the book as a process of becoming, as an interweaving of plural (human and nonhuman) agencies. The separations or cuts that have been forced out of these entanglements by specific material-discursive practices have created inclusions and exclusions, book-objects and author-subjects, both controlling

On Liquid Books and Fluid Humanities 239

positions.[137] Books as apparatuses are thus performative; they are reality shaping. Not enough responsibility is taken—not by scholars, nor by publishers nor the academic system as a whole—for the specific closures that are enacted with and through the book as an apparatus. Most humanities research—just as this research, to some extent—ends up as a conventional, bound, printed (or, increasingly, hybrid), single-authored book or journal article, published by an established publisher or in an esteemed journal and disseminated mainly to university libraries. These hegemonic scholarly practices are simultaneously affecting scholars and the way they act in and describe the world and/or their object of study—including, as Hayles has argued, the way scholars are "conceptualizing projects, implementing research programs, designing curricula, and educating students."[138] It is important to acknowledge this entanglement, as it highlights the responsibility scholars have for the practices they are very much a part of and for the inclusions and exclusions they enact and enforce (and that are enacted and enforced for them) as part of their book publishing practices. However, this entanglement with the book apparatus also offers opportunities for scholars to recut and (re)perform the book and scholarship, as well as themselves, differently and to experiment with what a *posthumanities* could potentially entail.

Following the insights of Foucault, Deleuze, and Barad discussed earlier, it becomes clear that the book apparatus, of which scholars are a part, also offers new *lines of flight*, or the ability to transform itself.[139] Living Books About Life and *remixthebook* are two book publishing projects, initiated by scholars, that have explored the potential of the cut and remix for an affirmative politics of publishing, to challenge our object-oriented and modular systems. In what sense have they been able to promote, through their specific publishing incisions and decisions, an open-ended politics of the book that enables duration and difference?[140]

At the beginning of August 2011, Mark Amerika launched remixthebook .com (see figure 5.1), a website designed to serve as an online companion to his print volume, *remixthebook*. Amerika is a multidisciplinary artist, theorist, and writer, whose various personas offer him the possibility of experimenting with hypertext fiction and net.art, as well as with more academic forms of theory and artist's writings, and to do so from a plurality of perspectives.[141] *Remixthebook* is a collection of multimedia writings that explore the remix as a cultural phenomenon by themselves referencing

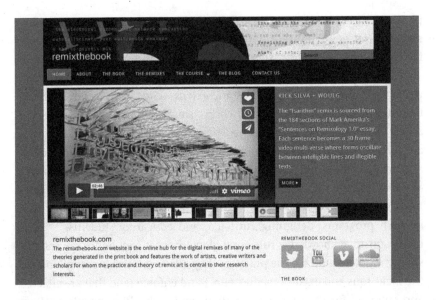

Figure 5.1
remixthebook website

and mashing up curated selections of earlier theory, avant-garde and art writings on remix, collage, and sampling. It consists of a printed book and an accompanying website that functions as a platform for a collaboration between artists and theorists exploring practice-based research.[142] The platform features multimedia remixes from over twenty-five international artists and theorists who were invited to contribute a remix to the project site based on selected sample material from the printed book. Amerika questions the bound nature of the printed book and its fixity and authority by bringing together this community of diverse practitioners performing and discussing the theories and texts presented in the book, via video, audio, and text-based remixes published on the website, opening the book and its source material up for continuous multimedia recutting. Amerika further challenges dominant ideas of authorship by playing with personas and by drawing from a variety of remixed source material in his book, as well as by directly involving his remix community as collaborators on the project.

For Amerika, then, the *remixthebook* project is not a traditional form of scholarship. Indeed, it is not even a book in the first instance. As he states in the book's introduction, it should rather be seen as "a hybridized publication and performance art project that appears in both print and digital

On Liquid Books and Fluid Humanities

forms."[143] Amerika applies a form of patch or collage writing in the twelve essays that make up *remixthebook*. This is part of his endeavor to develop a new form of new media writing, one that constitutes a crossover between the scholarly and the artistic and between theory and poetry, mixing these different modalities.[144] For all that, Amerika's project has the potential to change scholarly communication in a manner that goes *beyond* merely promoting a more fluid form of new media writing, extending the boundaries of the scholarly realm from an artistic viewpoint. What is particularly interesting about his hybrid project, both from the print book side and from the platform network performance angle, is the explicit connections Amerika makes through the format of the remix to previous theories and to those artists/theorists who are currently working in and are theorizing the realm of digital art, humanities, and remix. At the same time, the *remixthebook* website functions as a powerful platform for collaboration between artists and theorists who are exploring the same realm, celebrating the kind of practice-based research Amerika applauds.[145] By creating and performing remixes of Amerika's source material, which is again based on a mash-up of other sources, a collaborative interweaving of different texts, thinkers, and artists emerges, one that celebrates and highlights the communal aspect of creativity in both art and academia.

However, a discrepancy remains visible between Amerika's aim to create a commons of renewable source material along with a platform on which everyone (amateurs and experts alike) can remix his and others' source material, and the specific choices Amerika makes—or that the prestige and market-focused book apparatus with which he is interwoven allows him to make—and the outlets he chooses to fulfill this aim. For instance, *remixthebook* is published as a traditional printed book (in paperback and hardcover); more importantly, it is not published on an open access basis or with a license that allows reuse, which would make it far easier to remix and reuse Amerika's material by copying and pasting directly from the web or a PDF, for instance.

Amerika in many ways tries to evade the bounded nature of the printed edition by creating this community of people remixing the theories and texts presented in the book. He does so not only via the remixes that are published on the accompanying website, but also via the platform's blog and the *remixthebook* Twitter feed to which new artists and thinkers were asked to contribute on a weekly basis. However, here again, the website is

not openly available for everyone to contribute to. The remixes have been selected or curated by Amerika along with his fellow artist and cocurator Rick Silva, and the artists and theorists contributing to the blog and Twitter as an extension of the project have also been selected by Amerika's editorial team. Although people are invited to contribute to the project and platform, then, it is not openly accessible to everyone. Furthermore, although the remixes and blog posts are available and accessible on the website, they are themselves not available to remix, as they all fall under the website's copyright regime, which is licensed under a traditional all rights reserved copyright. Given all the possibilities such a digital platform could potentially offer, the question remains as to how much Amerika (or connected to him, his publisher or editorial team) has really put the source material "out there" to create a "commons of renewable source material" for others to "remix the book."[146]

Notwithstanding the fact that *remixthebook* is based on selections of manipulated and mashed-up source material from all kinds of disparate backgrounds, and to that extent challenges the idea of individual creativity, originality, and authorship, this project, for all its experimental potentiality, also draws on some quite conventional notions of authorship. Theoretically, Amerika challenges such ideas by playing with different personas and by drawing on a variety of source material, which he proceeds to remix in his book. Practically, however, Amerika is still acting very much as a traditional humanist author of his book, of his curated collection of material. Amerika takes responsibility for the project when he signs his name on the cover of the book.[147] He is the book's originator in the sense that he has created an authentic product by selecting and rewriting the material. Moreover, he seeks attribution for this endeavor (it is copyrighted all rights reserved © Mark Amerika), and he wants to receive the necessary credit for this work—a monograph published by an established university press (University of Minnesota Press)—in the context of the artistic and scholarly reputation economies. Amerika and cocurator Rick Silva are also the authors or curators of the accompanying website of remixes—similarly copyrighted with a traditional license—as they commissioned the remixes. Furthermore, all the remixes, which are again based on a variety of remixed (and often unattributed) source material, are attributed to the participating remixers (thus performing the function of quite traditional authors), complete with their bios and artist's statements. Despite its experimental aims

On Liquid Books and Fluid Humanities

related to new forms of authorship, remix, and openness, and the extended duration the website offers to the content in the printed book, it seems that in practice the cuts that have been enacted and performed as part of the *remixthebook* project still adhere in large part to our established humanist and print-based scholarly practices and institutions.

In 2011, the media and cultural theorists Clare Birchall, Gary Hall, and Joanna Zylinska initiated Living Books about Life, a series of open access books about life published by Open Humanities Press and designed to provide a bridge between the humanities and sciences. All the books in this series repackage existing open access science-related research, supplementing it with an original editorial essay to tie the collection together. They also provide additional multimedia material, from videos to podcasts to whole books. The books have been published online on an open source wiki platform, meaning they are themselves "living" or "open on a read/write basis for users to help compose, edit, annotate, translate and remix."[148] Interested potential contributors can also contact the series editors to contribute a new living book. These living books can then collectively or individually be used and/or adapted for scholarly and educational contexts as an interdisciplinary resource bridging the sciences and humanities.

As Hall has argued, this project was designed to, among other things, challenge the physical and conceptual limitations of the traditional codex by including multimedia material and even whole books in its living books, but also by emphasizing its duration by publishing using a wiki platform and thus "rethinking 'the book' itself as a living, collaborative endeavor."[149] Hall points out that wikis offer a potential to question and critically engage issues of authorship, work, and stability. They can offer increased accessibility and induce participation from contributors from the periphery. As he states, "Wiki-communication can enable us to produce a multiplicitous academic and publishing network, one with a far more complex, fluid, antagonistic, distributed, and decentered structure, with a variety of singular and plural, human and non-human actants and agents."[150] However, the MediaWiki software employed by the Living Books About Life project, in common with a lot of wiki software, keeps accurate track of which user is making what changes. This offers the possibility to other users (or bots) to monitor recent changes to pages, to explore a page's revision history, and to examine all the contributions of a specific user. The wiki software thus already has mechanisms written into it to "manage" or fix instances of the

text and its authors by keeping a track record or archive of all the changes that are made.

But the Living Books About Life project also enforces stability and fixity (both of the text and of its users) on the front-end side by clearly mentioning the specific editor's name underneath the title of each collection, as well as on the book's title page; by adding a fixed and frozen version of the text in PDF format, preserving the collection as it was originally created by the editors; and by binding the book together by adding a cover page and following a rather conventional book structure (complete with an editorial introduction followed by thematic sections of curated materials). Mirroring the physical materiality of the book (in its design, layout, and, structuring) in such a way also reproduces the aura of the book, including the discourse of scholarship (as stable and fixed, with clear authority) this brings with it. This might explain why the user interaction with the books in the series has been limited in comparison to some other wikis, which are perhaps more clearly perceived as multiauthoring environments. Here the choice to recut the collected information *as a book*, with clear authors and editors, while and as part of rethinking and reperforming the book as concept and form, might paradoxically have been responsible for both the success and the limitations of the project. These choices meant the project had to conform again to some of the same premises it initially set out to question and critique.

What both the Living Books About Life and OHP's earlier Liquid Books project share, however, is a continued theoretical reflection on issues of fixity, authorship, and authority, both by its editors and by its contributors in various spaces connected to the project.[151] This comes to the fore in the many presentations and papers the series editors and authors have delivered on these projects, engaging people with their practical and theoretical issues. These discussions have also taken place on the blog that accompanied the Living Books About Life series, and in Hall and Birchall's multimodal text and video-based introduction to the Liquid Books series, to give just some examples.[152] It is in these connected spaces that continued discussions are being had about copyright, ownership, authority, the book, editing, openness, fluidity and fixity, the benefits and drawbacks of wikis, quality and peer review, and so on. I would like to argue that it is here, on this discursive level, that the aliveness of these living books is perhaps most ensured. These books live on in continued discussion about

On Liquid Books and Fluid Humanities
245

where we should cut them, and when, and who should be making the incisions, taking into consideration the strategic compromises—which might indeed include a frozen version and a book cover, and clearly identifiable editors—we might have to make due to our current entanglements with certain practices, institutions, and pieces of software, all with their own specific power structures and affordances.

In "Future Books: A Wikipedia Model?," an introduction to one of the books in the Liquid Books series—namely, *Technology and Cultural Form: A Liquid Reader*, which has been collaboratively edited and written by Joanna Zylinska and her MA students (together forming a "liquid author")—the various decisions and discussions that could be made and had concerning liquid, living, and wiki books are considered in depth: "It seems from the above that a completely open liquid book can never be achieved, and that some limitations, decisions, interventions and cuts have to be made to its 'openness.' The following question then presents itself: how do we ensure that we do not foreclose on this openness too early and too quickly? Perhaps liquid editing is also a question of time, then; of managing time responsibly and prudently."[153]

Looking at it from this angle, these discussions are triggering critical questions from a user (writer/reader) perspective, as part of their interconnections and negotiations with the institutions, practices, and technologies of scholarly communication. Within a wiki setting, questions concerning what new kinds of boundaries are being set up are important: Who moderates decisions about what is included or excluded (what about spam?) Is it the editors? The software? The press? Our notions of scholarly quality and authority? What is kept and preserved, and what new forms of closure and inclusion are being created in this process? How is the book disturbed and at the same time recut? It is our continued critical engagement with these kinds of questions in an affirmative manner, both theoretically and practically, that keeps these books open and alive.

To conclude this chapter, I want to return to the issue of the performativity of the stories and discourses that we as scholars weave around the book and the responsibility that comes with this toward the object of our narratives, with which we are always already directly interconnected. Following on from my earlier analysis of Bryant's work on the fluid text, I would like to briefly reexamine theories of *textual criticism*, which as a field has always actively engaged itself with issues concerning the fixity and fluidity of

texts. This is embodied mainly in the search for the ideal text or archetype, but also in the continued confrontation with a text's pluralities of meaning and intentionality, next to issues of interpretation and materiality. In this respect, critical editing, as a means of stabilizing a text, has always revolved around an awareness of the cuts that are made to a text in the creation of scholarly editions. It can therefore be stated that, as Bryant has argued, the task of a textual scholar is to "manage textual fluidity."[154]

One of the other strengths of textual criticism is an awareness on the part of many of the scholars in the field that their own practical and theoretical decisions or cuts influence the interpretation of a text. They can therefore be seen to be mindful of their entanglement with its becoming. As Bryant has put it, "Editors' choices inevitably constitute yet another version of the fluid text they are editing. Thus, critical editing perpetuates textual fluidity."[155] These specific cuts, or "historical write-ups," that textual scholars create as part of their work with critical editions don't only construct the past from a vision of the present; they also say something about the future. As textual scholar Jerome McGann has pointed out:

> All poems and cultural products are included in history—*including* the producers and the reproducers of such works, the poet and their readers and interpreters. . . . To the historicist imagination, history is the past, or perhaps the past as seen in and through the present; and the historical task is to attempt a reconstruction of the past, including, perhaps, the present of that past. But the *Cantos* reminds us that history includes the future, and that the historical task involves as well the construction of what shall be possible.[156]

It is this awareness that a critical edition is the product of editorial intervention—which creates a material-discursive framework that influences future texts' becoming—that I am interested in here, especially in relation to McGann's work on the performativity of texts, which again allows for more agency for the book as a material form itself. For McGann, every text is a social text, created under specific sociohistorical conditions; he theorizes texts not as things or objects, but as events. He argues therefore that texts are not *representations* of intentions but are processual events in themselves. Thus, every version or reading of a text is a performative (as well as a *deformative*) act.[157] In this sense, McGann makes the move in textual criticism from a focus on authorial intention and hermeneutics (or representation) to seeing a text as a performative event and critical editions as performative acts. As part of this, he argues for a different, dynamic

On Liquid Books and Fluid Humanities 247

engagement with texts, not focused on discovering what a text "is" but on an "analysis [that] must be applied to the text *as it is performative.*"[158] This includes taking into consideration the specific material iteration of the text one is studying (and how this functions, as Hayles has argued, as a *technotext*—namely, how its specific material apparatus produces the work as a physical artifact), as well as an awareness of how the scholar's textual analysis is itself part of the iteration and othering of the text.[159] And in addition to this, as Barad has argued, we have to be aware of how the text's performativity shapes us in our entanglement with it.

The question then is: Why can't we be more like critical textual editors (in the style of Jerome McGann) ourselves when it comes to *our own scholarly works*, taking into consideration the various cuts we make and that are made for us as part of the processes of knowledge production? Should assuming responsibility for our own incisions as textual critics of our own work—exploring what I have called in chapter 4 and elsewhere in relation to the work of Joan Retallack the *poethics* of scholarship—in this respect then not involve, in the first instance

- taking responsibility for our involvement as scholars in the production, dissemination, and consumption of the book;
- engaging with the material-discursive institutional and cultural aspects of the book and book publishing; and
- experimenting with an open-ended and radical politics of the book (which includes exploring the processual nature of the book, while taking responsibility for the need to cut; to make incisions and decisions on where to create meaning and difference, where to cleave the flow of book becoming)?[160]

This would involve experimenting with alternative ways of cutting our bookish scholarship together-apart: with different forms of authorship, both human and nonhuman; with the materialities and modalities of the book, exploring multimodal and emergent genres, while continuously rethinking and performing the fixity of the book itself; and with the publishing process, examining ways to disturb the current political economy of the book and the objectification of the book within publishing and research. From where I stand, this would mean a continued experimentation with remixed and living books, with versionings, and with radical forms of openness, while at the same time remaining critical of the alternative incisions that

are made as part of these projects, of the new forms of binding they might weave. This also involves being aware of the potential strategic decisions that might need to be made in order to keep some iterative bindings intact (for reasons of authority and reputation, for instance) and why we choose to do so. As I have outlined in this chapter, it will be more useful to engage with this experimenting not from the angle of the fixed or the fluid book, but from the perspective of the cut that cuts together-apart the emergent book and, when done well, enables its ongoing becoming.

This text, like the projects mentioned previously, has attempted to start the process of rethinking (through its diffractive methodology) how we might start to cut differently when it comes to our research and publication practices. Cutting and stabilizing still needs to be done, but it might be accomplished in different ways, at different stages of the research process, and for different reasons than we are doing now. What I want to emphasize here is that we can start to rethink and reperform the way we publish our research if we start to pay closer attention to the specific decisions we make (and that are made for us) as part of our publishing practices. The politics of the book itself can be helpful in this respect. As Gary Hall and I have argued elsewhere, "If it is to continue to be able to serve 'new ends' as a medium through which politics itself can be rethought . . . then the material and cultural constitution of the book needs to be continually reviewed, re-evaluated and reconceived."[161] The book itself can thus be a medium with the critical and political potential to question specific decisions and to disturb existing scholarly practices and institutions. Books are always a process of becoming (albeit one that is continuously interrupted and disturbed). Books are entanglements of different agencies that cannot be discerned beforehand. In the cuts that we make to untangle them, we create specific material book-objects. In these incisions, the book has always already redeveloped, remixed. It has mutated and moved on. The book is processual, ephemeral, and contextualized; it is a living entity, which we can use a means to critique our established practices and institutions, both through its forms (and the decisions made to create these forms) and its metaphors, and through the practices that accompany it.

Notes

Acknowledgments

1. Barad, *Meeting the Universe Halfway*, ix–x.

Introduction

1. Jacques Derrida, *Paper Machine* (Stanford, CA: Stanford University Press, 2005), 8.

2. Living Books About Life was a collaboration between Open Humanities Press and three academic institutions: Coventry University; Goldsmiths, University of London; and the University of Kent. It was funded by Jisc (formerly the Joint Information Systems Committee). One of the books in this series, *Symbiosis*, was coedited by myself and Peter Woodbridge.

3. Living Books About Life has seen various emulations in different contexts, including Living Books about History (https://livingbooksabouthistory.ch/fr/about), published by infoclio.ch, the Swiss portal for historical sciences; punctum books' *Making the Geologic Now* (http://geologicnow.com); and the University of Strathclyde/British Animal Studies Network's *Living Bibliography of Animal Studies* (http://www.lbanimalstudies .org.uk/index.php?title=Main_Page). Over the last few years, publishers have shown a growing interest in supporting living, processual books. For example, the University of Minnesota Press and CUNY's Digital Scholarship Lab have collaborated on the Manifold Scholarship publishing program and platform for the production of iterative, networked, and processual texts, which are published both in print and online via an interactive, open-source platform; UCL Press has experimented with an innovative new digital format it calls BOOC (Books as Open Online Content; https://ucldigitalpress.co .uk/BOOC); and more recently, the MIT Press, in collaboration with the MIT Media Lab, launched the Knowledge Futures Group. One of its first projects, the PubPub open authoring and publishing platform, aims to make the process of knowledge creation more social, open, and community-driven by integrating technologies for annotation and versioning into its digital publications.

4. A *monograph* is most commonly defined as a self-contained, one-volume, long-form publication, consisting of original research and aimed mainly at an academic audience. Predominantly published by scholarly publishers and acquired by libraries, it remains the preferred means of scholarly research dissemination in the humanities and a prerequisite for career development and tenure in these fields. An extended format is preferred as it allows scholars to develop multiple intricate arguments and narratives or a prolonged set of thoughts, meeting the demand for the complex and sometimes idiosyncratic, multifaceted nature of reasoning. Peter Williams et al., "The Role and Future of the Monograph in Arts and Humanities Research," *Aslib Proceedings* 61, no. 1 (2009): 76–77, https://doi.org/10.1108/00012530910932294. In addition to the monograph's accomplished and complex nature, Thompson argues that it appeals to humanities scholars because it offers more of a space for extensive analysis of large sets of (primary) sources, whereas journal articles serve more as a means to develop critical dialogues. Jennifer Wolfe Thompson, "The Death of the Scholarly Monograph in the Humanities? Citation Patterns in Literary Scholarship," *Libri* 52, no. 3 (2002): 121–136.

5. It is not my intention to single out scholars in this respect, where this responsibility extends toward scholarly institutions, funders, publishers, libraries, and all other entities involved in knowledge production, dissemination, and consumption. However, there is a tendency among these various groups to attribute blame to each other for a lack of movement and mutation in this space. In this respect I want to take this discussion away from "who or what will need to change first" and toward what each group can do at this particular point to experiment with alternative book futures.

6. The death of the (printed) book, as a meme, has occurred several times during the book's more than five hundred years of existence, mostly in reaction to the development of new media (i.e., newspapers, radio, television, CD-ROMs) that were perceived as being bound to replace the book. For one overview of the death of the book through the ages, see Leah Price, "Dead Again," *New York Times*, August 10, 2012, http://www.nytimes.com/2012/08/12/books/review/the-death-of-the-book-through-the-ages.html. See also the first chapter of Alessandro Ludovico's book *Post-Digital Print*, titled "The Death of Paper (which Never Happened)," which looks at the history of threats to the printed medium. Ludovico, *Post-Digital Print: The Mutation of Publishing since 1984* (Eindhoven, Netherlands: Onomatopee, 2012). Nowadays, with the growing popularity of e-books, the debate is rife yet again over whether printed books will start to see a future point of decline—or will perhaps disappear entirely—or whether their stronghold on culture and society is so powerful that they will be able to weather yet another storm. Whether media ever die or continue to live on as residue or in the subconscious archives of our society (from where they get historicized and/or reappropriated) is the question Garnet Hertz and Jussi Parikka approach through their concept of *zombie media*, "media that is not only out of use, but resurrected to new uses, contexts and adaptations." Hertz and Parikka, "Zombie

Media: Circuit Bending Media Archaeology into an Art Method," *Leonardo* 45, no. 5 (2012): 429.

7. Janneke Adema and Eelco Ferwerda, "Peer Review: Open Access for Monographs," *Logos: Journal of the World Publishing Community* 20, no. 1 (March 1, 2009): 176–183, https://doi.org/10.1163/095796509X12777334632708; Janneke Adema, "The Monograph Crisis Revisited," *Open Reflections* (blog), January 29, 2015, https://openreflections.wordpress.com/2015/01/29/the-monograph-crisis-revisited/; Janneke Adema and Gary Hall, "The Political Nature of the Book: On Artists' Books and Radical Open Access," *New Formations* 78, no. 1 (2013): 138–156, https://doi.org/10.3898/NewF.78.07.2013; Geoffrey Crossick, *Monographs and Open Access: A Report to HEFCE* (Bristol, UK: HEFCE, January 2015); Kathleen Fitzpatrick, *Planned Obsolescence: Publishing, Technology, and the Future of the Academy* (New York: NYU Press, 2011); Albert Nicholas Greco, Clara Elsie Rodríguez, and Robert M. Wharton, *Culture and Commerce of Publishing in the Twenty-First Century* (Stanford, CA: Stanford University Press, 2006); Gary Hall, *Digitize This Book! The Politics of New Media, or Why We Need Open Access Now* (Minneapolis: University of Minnesota Press, 2008); John Thompson, *Books in the Digital Age: The Transformation of Academic and Higher Education Publishing in Britain and the United States* (Cambridge: Polity Press, 2005); John Willinsky, *The Access Principle: The Case for Open Access to Research and Scholarship* (Cambridge, MA: MIT Press, 2005).

8. Johanna Drucker, "Pixel Dust: Illusions of Innovation in Scholarly Publishing," *LA Review of Books*, January 16, 2014, https://lareviewofbooks.org/essay/pixel-dust-illusions-innovation-scholarly-publishing/.

9. Janneke Adema, "Embracing Messiness," *Open Reflections* (blog), November 18, 2014, http://openreflections.wordpress.com/2014/11/17/embracing-messiness/; Mark Garrett Cooper and John Marx, "Crisis, Crisis, Crisis: Big Media and the Humanities Workforce," *Differences* 24, no. 3 (January 1, 2014): 127–159, https://doi.org/10.1215/10407391-2391977; Sarah Kember, "Why Write? Feminism, Publishing and the Politics of Communication," *New Formations: A Journal of Culture/Theory/Politics* 83, no. 1 (2014): 99–116.

10. Let me make clear that with my emphasis on affirmative politics and practices throughout this book, I want to focus on the potential of power as a form of empowerment (potentia), by which negative, reactionary politics can be operationalized into *affirmative* alternative practices. As Rosi Braidotti has argued, this does not mean a distancing from critique, nor I would argue should it be perceived as an opposition between critique and praxis. Rosi Braidotti, "On Putting the Active Back into Activism," *New Formations* 68, no. 1 (2010): 42–57, https://doi.org/10.3898/newf.68.03.2009.

11. There is quite a vogue at the moment for short-form monographs, where several presses and publishers are now offering this mid-length format as a publication

option. Most notable are Palgrave Pivot and Minnesota University Press's Forerunners series. Even Cambridge University Press has now started publishing short-form (twenty- to thirty-thousand-word) publications as part of its Cambridge Elements series.

12. Technological change and the development of new media (i.e., the coming of photography, film, digital media) have over the history of the book triggered debates about the book's future and about the possible demise of its printed form. With respect to the scholarly book and scholarly communication, the situation has not been significantly different. The development of e-books has triggered many possible futures for the scholarly book—from pyramidical structures (see Robert Darnton, "The New Age of the Book," *New York Review of Books* 46, no. 5 [March 18, 1999]: 5) to universal libraries (see Kevin Kelly, "Scan This Book!," *New York Times*, May 14, 2006)—but at the same time it has also shown cultural, economic, political, and practical constraints to these utopian visions due to, among other things, the interests surrounding the economics of publishing and distribution and the constructive power of print-based scholarly practices. Christine Borgman, *Scholarship in the Digital Age: Information, Infrastructure, and the Internet* (Cambridge, MA: MIT Press, 2007), 160–161.

13. The scholarly book was an important component of the manuscript tradition. Nonetheless, the history of the scholarly book in its modern form (i.e., as related to forms of modern science and scholarship) for the most part overlaps with the rise and history of print publishing. Even so, the manuscript book continued to play an important role in early modern scholarly communication—and in forms of oral communication. Rosamond McKitterick, "Books and Sciences before Print," in *Books and the Sciences in History*, ed. Marina Frasca-Spada and Nick Jardine (Cambridge: Cambridge University Press, 2000), 25–26.

14. For most people, the book as material form and concept coincides with the codex format (i.e., sheets of paper bound or fastened together on one side). As book historian Roger Chartier writes, regarding the importance of the codex format as a metaphor for our understanding of the world:

> At the same time, the end of the *codex* will signify the loss of acts and representations indissolubly linked to the book as we now know it. In the form that it has acquired in Western Europe since the beginning of the Christian era, the book has been one of the most powerful metaphors used for conceiving of the cosmos, nature, history, and the human body. If the object that has furnished the matrix of this repertory of images (poetic, philosophical, scientific) should disappear, the references and the procedures that organize the "readability" of the physical world, equated with a book in *codex* form, would be profoundly upset as well. (Roger Chartier, *The Order of Books: Readers, Authors, and Libraries in Europe Between the 14th and 18th Centuries* [Stanford, CA: Stanford University Press, 1994], 90–91)

15. I will instead look toward breaking down the binary relationship between print and digital that is repeatedly put forward in narratives related to the future of the book—based on supposedly essential differences between the two. Phil Pochoda's

Notes

work serves as a clear example of this practice when he talks about the distinction between what he calls an *analogue* publishing system ("bounded, stable, identifiable, well ordered, and well policed") and a *digital* publishing system ("relatively unbounded and stochastic, composed of units that are inherently amorphous and shape shifting, and marked by contested authorization of diverse content") in terms of an *epistemic shift*. Phil Pochoda, "The Big One: The Epistemic System Break in Scholarly Monograph Publishing," *New Media & Society* 15, no. 3 (2013): 359–378, https://doi.org/10.1177/1461444812465143.

16. Adrian Johns, *The Nature of the Book: Print and Knowledge in the Making* (Chicago: University of Chicago Press, 1998).

17. Johanna Drucker, *SpecLab: Digital Aesthetics and Projects in Speculative Computing* (Chicago: University of Chicago Press, 2009).

18. Drucker, "Pixel Dust."

19. Gary Hall, "Copyfight," in *Critical Keywords for the Digital Humanities* (Lüneburg: Centre for Digital Cultures, 2014), https://meson.press/keywords/; Florian Cramer, *Anti-Media: Ephemera on Speculative Arts* (Rotterdam: nai010 publishers, 2013).

20. Samuel Moore succinctly defines *commoning* in relation to the commons: "The commons is also a practice or way of relating to fellow commoners and the world more generally (known as 'commoning')." Samuel A. Moore, *Common Struggles: Policy-Based vs. Scholar-Led Approaches to Open Access in the Humanities* (London: King's College London, 2018), 162.

21. More about the book as an apparatus, including a discussion of this concept in the works of Barad, Deleuze, and Foucault, can be found in chapter 5.

22. Maurice Blanchot, *The Book to Come* (Stanford, CA: Stanford University Press, 2003).

23. As Karen Barad eloquently argues: "Which is not to say that emergence happens once and for all, as an event or as a process that takes place according to some external measure of space and of time, but rather that time and space, like matter and meaning, come into existence, are iteratively reconfigured through each intra-action, thereby making it impossible to differentiate in any absolute sense between creation and renewal, beginning and returning, continuity and discontinuity, here and there, past and future." Karen Barad, *Meeting the Universe Halfway: Quantum Physics and the Entanglement of Matter and Meaning* (Durham, NC: Duke University Press, 2007), ix.

24. When I talk about *discourse* in this book, I use it as simultaneously a single and plural concept, as a discourse always already encapsulates several debates and can refer to a single debate on a given topic, as well as to a plurality of interconnected conversations.

25. For more on this, see Johanna Drucker, "Distributed and Conditional Documents: Conceptualizing Bibliographical Alterities," *MATLIT: Revista Do Programa de Doutoramento Em Materialidades Da Literatura* 2, no. 1 (November 8, 2014): 11–29.

26. I am drawing on the work of Judith Butler and her notion of *performativity* as both iteration and transformation here. Performativity as a practice of repetition can then be seen as a (collective, social) reenactment of already socially established and constructed meanings. However, performativity is also antiessentialist and productive, an iterative doing which produces both signification and material effects. We can thus repeat our (scholarly) practices differently, making performativity into an emancipatory concept through which we can change and intervene (through) our practices, even within restraining sociocultural formations. Judith Butler, *Gender Trouble: Feminism and the Subversion of Identity* (New York: Routledge, 2006), 178. Barad reformulates Butler's theory of performativity toward a theory of *posthumanist performativity*, emphasizing the materiality and material dimensions of bodies and discursive practices. Barad, *Meeting the Universe Halfway*.

27. Michel Foucault, *The Archaeology of Knowledge*, 2nd ed. (New York: Routledge, 1969), 5.

28. This shift in Foucault's approach from archaeology to genealogy has been characterized as a move in his work from an emphasis on structuralism to poststructuralism (a characterization Foucault would not use himself; he denied ever having been a structuralist). Hubert L. Dreyfus, Paul Rabinow, and Michel Foucault, *Michel Foucault, beyond Structuralism and Hermeneutics* (Chicago: University of Chicago Press, 1983), xi–xii. On the other hand, it has been emphasized that the narrative of a shift from archaeology to genealogy and structuralism to poststructuralism in Foucault's thought is too simplistic and can even be seen as structuralist (and teleological) itself, arguing that the two strategies cannot be so easily contrasted and opposed. Christopher Green states, for instance, that the shift from archaeology to genealogy did not really constitute a reversal in Foucault's basic stance. Elements of poststructuralism and genealogy are already identifiable in Foucault's supposedly structuralist and archaeological works. Green, "Digging Archaeology: Sources of Foucault's Historiography," *Journal of Interdisciplinary Crossroad*, no. 1 (2004): 121–141. As Foucault once said in an interview: "My archaeology owes more to Nietzschean genealogy than to structuralism properly called" (Michel Foucault, "The Discourse of History: Interview with Raymond Bellour," in *Foucault Live: Collected Interviews 1961–1984*, ed. Sylvère Lotringer, trans. John Johnston [New York: Semiotext(e), 1996], 31). Green refers to the works of Davidson, who sees the supposed shift not as a replacement but as an integration of the archaeology in a wider genealogical framework, and Mahon, who sees the relationship between archaeology and genealogy as one of a method and its goal. A. Davidson, "Archaeology, Genealogy, Ethics," in *Foucault: A Critical Reader*, ed. D. C. Hoy (London: Basil Blackwell, 1986), 221–233; M. Mahon, *Foucault's Nietzschean Genealogy: Truth, Power, and the Subject* (Albany: State University of New York Press, 1992).

Notes

29. Michel Foucault, *Power/Knowledge: Selected Interviews and Other Writings, 1972–1977*, ed. Colin Gordon (New York: Vintage, 1980), 83.

30. In "Two Lectures," Foucault gives a definition of both the archaeological and the genealogical method, which emphasizes their integration and complementarities: "If we were to characterize it in two terms, then 'archaeology' would be the appropriate methodology of this analysis of local discursivities, and 'genealogy' would be the tactics whereby, on the basis of the descriptions of these local discursivities, the subjected knowledges which were thus released would be brought into play." Michel Foucault, "Two Lectures," in *Power/Knowledge*, 85.

31. More recently, Grusin has focused on processes of premediation, wherein the future is increasingly already premediated and constructed through (online, social) media, which remediate future media practices and technologies. Richard Grusin, *Premediation: Affect and Mediality after 9/11* (New York: Palgrave Macmillan, 2010).

32. Sarah Kember and Joanna Zylinska, *Life after New Media: Mediation as a Vital Process* (Cambridge, MA: MIT Press, 2012), 8.

33. Jay David Bolter and Richard Grusin, *Remediation: Understanding New Media* (Cambridge, MA: MIT Press, 1999), 15.

34. See, for instance, the alternative genealogy of openness discussed in chapter 3, which aims to break down binaries between open and closed and open and secret, as well as the perception that the discourse on openness is not heterogeneous and critical enough.

35. Iris Van der Tuin, "'A Different Starting Point, a Different Metaphysics': Reading Bergson and Barad Diffractively," *Hypatia* 26, no. 1 (February 2011): 22, https://doi.org/10.1111/j.1527-2001.2010.01114.x.

36. Van der Tuin, "'A Different Starting Point, a Different Metaphysics,'" 26.

37. Van der Tuin, "'A Different Starting Point, a Different Metaphysics,'" 27.

38. N. Katherine Hayles, "Print Is Flat, Code Is Deep: The Importance of Media-Specific Analysis," *Poetics Today* 25, no. 1 (March 1, 2004): 72, https://doi.org/10.1215/03335372-25-1-67.

39. Hayles, "Print Is Flat, Code Is Deep," 71. For Hayles, MSA is then "a mode of critical interrogation alert to the ways in which the medium constructs the work and the work constructs the medium." N. Katherine Hayles, *Writing Machines* (Cambridge, MA: MIT Press, 2002), 6.

40. D. F. McKenzie, *Bibliography and the Sociology of Texts* (Cambridge: Cambridge University Press, 1999); N. Katherine Hayles, "Translating Media: Why We Should Rethink Textuality," *Yale Journal of Criticism* 16, no. 2 (2003): 277, https://doi.org/10.1353/yale.2003.0018.

41. Elizabeth Grosz, "Bodies and Knowledges: Feminism and the Crisis of Reason," in *Feminist Epistemologies*, ed. Linda Alcoff and Elizabeth Potter (New York: Routledge, 1993), 187–216; Terry Threadgold, *Feminist Poetics: Poiesis, Performance, Histories* (London: Routledge, 1997), 65; Judith Butler, *Bodies That Matter: On the Discursive Limits of "Sex"* (London: Psychology Press, 1993).

42. These elements cannot be ontologically separated, only temporarily severed when, for example, we distinguish between a book-object and an author-subject. I therefore claim that in order to say things about the book's future, we need to explore the material-discursive development of the book, wherein the book, as stated previously, should be seen as a form of interaction between different agents and constituencies. Barad, *Meeting the Universe Halfway*; Karen Barad, "Posthumanist Performativity: Towards an Understanding of How Matter Comes to Matter," in *Material Feminisms*, ed. Stacy Alaimo and Susan Hekman (Bloomington: Indiana University Press, 2008); Donna Haraway, "Situated Knowledges: The Science Question in Feminism and the Privilege of Partial Perspective," *Feminist Studies* 14, no. 3 (1988): 575–599.

43. However, in two of the main anthologies on new materialism—Alaimo and Hekman, *Material Feminisms*; and Diana H. Coole and Samantha Frost, eds., *New Materialisms: Ontology, Agency, and Politics* (Durham, NC: Duke University Press, 2010)—the emphasis is on seeing new materialism as a distancing and even a denouncing of the linguistic turn in postmodern philosophy and the lack of attention to the material in social constructivist theories. Here new materialism is presented as a material turn, as a returned attention to matter and bodies, in an almost linear, causal way. This is also the basis of the critiques of new materialism put forward by Sarah Ahmed and Dennis Bruining: Ahmed, "Open Forum Imaginary Prohibitions: Some Preliminary Remarks on the Founding Gestures of the 'New Materialism,'" *European Journal of Women's Studies* 15, no. 1 (February 1, 2008): 23–39, https://doi.org/10.1177/1350506807084854; Bruining, "A Somatechnics of Moralism: New Materialism or Material Foundationalism," *Somatechnics* 3, no. 1 (March 1, 2013): 149–168, https://doi.org/10.3366/soma.2013.0083. I want to make clear that I do not agree with this positioning of new materialism in opposition to linguistic or postmodern movements (creating a new form of oppositional thinking). Instead, I would like to emphasize the diversity of postmodern thought in combination with a continuous tradition of attention to the material (Foucault, Haraway). Hence, I tend to side with the more nuanced reading Dolphijn and Van der Tuin give as part of their description of new materialism as a form of diffractive rereading of these linguistic and materialist traditions, without abandoning them straight away. In this respect, new materialism is not "new" but a continuity of thought, a reevaluation of these traditions that "allows for the study of the two dimensions in their entanglement." Rick Dolphijn and Iris Van der Tuin, *New Materialism: Interviews & Cartographies* (Ann Arbor, MI: Open Humanities Press, 2012), 91, http://hdl.handle.net/2027/spo.11515701.0001.001; Iris Van der Tuin, "'New Feminist Materialisms,'" *Women's*

Studies International Forum 34, no. 4 (July 2011): 271–277, https://doi.org/10.1016/j.wsif.2011.04.002; Iris Van der Tuin, "Deflationary Logic Response to Sara Ahmed's 'Imaginary Prohibitions: Some Preliminary Remarks on the Founding Gestures of the 'New Materialism,'" *European Journal of Women's Studies* 15, no. 4 (November 1, 2008): 411–416, https://doi.org/10.1177/1350506808095297.

44. Coole and Frost, *New Materialisms*, 7–8.

45. Barad, *Meeting the Universe Halfway*; Donna Haraway, "Otherworldly Conversations; Terran Topics; Local Terms," in *The Haraway Reader* (New York: Routledge, 2004).

46. Here matter and discourse/semiosis are no longer seen as oppositional and dualistic but as monistic productive entities. Haraway for one insists on the join between materiality and semiosis, stating that "both are discourses of productivities and efficiencies." Donna Haraway and Thyrza Goodeve, *How Like a Leaf: An Interview with Donna Haraway* (New York: Routledge, 1999), 26.

47. Eduardo Navas has done an in-depth exploration of the cover version and versioning in music and performance, drawing on the works of Veal, Hebdige, Sullivan, and Borschke, among others. As he explains with respect to the origin of the practice, "it was in early dubbing techniques where the term 'version' was used to describe alternate recordings of the same song that would be released for sound systems and dancehalls throughout the late 1960s and 1970s. This process of creating alternate mixes of an initial recording in postproduction is known as 'versioning.'" Eduardo Navas, "The Originality of Copies: Cover Versions and Versioning in Remix Practice," *Journal of Asia-Pacific Pop Culture* 3, no. 2 (2018): 169–170. Looking at the tradition of versioning within music to explore and experiment with how to do versioning within scholarly communication might be relevant here, as "music producers don't think of versions as final works, but as productions meant to keep being versioned for the dancefloor" (Navas, private correspondence). However, from the perspective of music—and art in general—the notion of the *original* (especially also in terms of copyright) can be seen to take in a similar privileged position as the final or authoritative (or published) version in publishing does. This notwithstanding, Navas argues instead that copies, or (cover) versions of an original, should be seen as "the source for the ongoing process of creative production" (Navas, "The Originality of Copies," 173), while the notion of what makes something an original should be critically questioned (especially in our networked environment, which increasingly privileges the circulation and prevalence of copies—and with that their value). Thanks to Eduardo Navas for highlighting the importance of this genealogy of versioning in music to me.

48. Within computing and software engineering, versioning is related to processes of *software evolution* and *software maintenance*. *Versioning* can be defined here as "the management of multiple copies of the same evolving resource, captured at

different stages of its evolution"; see Fabio Vitali, "Versioning Hypermedia," *ACM Computing Surveys* 31, no. 4es (December 1, 1999): 24–es, https://doi.org/10.1145/345966.346019. Versioning within software engineering mostly takes place with the aid of a *version control system* (VCS)—otherwise known as a *revision control system* or *source control system*—which stores version information, distinguishes between series of drafts or versions, and provides an audit trail for revision and collaborative authoring. The first version control systems were introduced in the 1960s to manage updates to decks of punch cards (e.g., PATCHY at CERN), and version control was still a manual process at this point. Rahul Gopinath, "Version Control Systems," December 30, 2011, https://rahul.gopinath.org/post/2011/12/30/version-control-systems/. These first VCSs were built as support technology for computer programmers, such as the Source Code Control System (SCCS), developed at Bell Labs in 1972 by Marc J. Rochkind. Nayan B. Ruparelia, "The History of Version Control," *ACM SIGSOFT Software Engineering Notes* 35, no. 1 (January 25, 2010): 5–9, https://doi.org/10.1145/1668862.1668876. As Eric Raymond explains, "SCCS, originally written in an IBM mainframe environment, was distinct from earlier mainframe-based change-tracking systems in that it was specifically designed to manage software and had a well-defined notion of revision history with a unique identifier for each revision." Raymond, *Understanding Version-Control Systems (DRAFT)*, accessed January 4, 2021, http://www.catb.org/esr/writings/version-control/version-control.html.

49. Matthew G. Kirschenbaum, *Track Changes* (Cambridge, MA: Harvard University Press, 2016); Graham Law, *Serializing Fiction in the Victorian Press* (New York: Palgrave Macmillan, 2001); David Payne, *The Reenchantment of Nineteenth-Century Fiction: Dickens, Thackeray, George Eliot and Serialization* (New York: Palgrave Macmillan, 2005). Editorial theory has traditionally mostly assigned value to particular versions—for example, those that are the most authoritative or that show the most authorial control over a text (see also the production of a critical edition). However, in practice, distinguishing an authoritative version is difficult because the existence of multiple versions of works and poems has been quite common throughout the literary tradition (see romantic literature and poetry, for example). Since the 1970s, the focus within textual criticism has shifted from authoritative textual objects to textual process and multiplicity and toward versioning, fluidity, instability, and genetic texts. See, for example, Donald H. Reiman, *Romantic Texts and Contexts* (Columbia: University of Missouri Press, 1987); Jack Stillinger, *Coleridge and Textual Instability: The Multiple Versions of the Major Poems* (New York: Oxford University Press, 1994); and Jerome J. McGann, *A Critique of Modern Textual Criticism* (Charlottesville: University of Virginia Press, 1992), accounts of textual pluralism that hold that there can exist more than one authoritative version of a literary work. Donald H. Reiman highlights the process of versioning in this context, a method Leah Marcus describes as "an editorial method that produces a modern version of a single historically specific form, whether in manuscript or in print, of a given text or two or more versions printed separately for comparative purposes, instead of attempting

Notes 259

a single definitive composite edition in the manner of the new bibliography." Leah S. Marcus, "Textual Scholarship," in *Women Editing/Editing Women: Early Modern Women Writers and the New Textualism*, ed. Ann Hollinshead Hurley and Chanita Goodblatt (Newcastle upon Tyne, UK: Cambridge Scholars Publishing, 2009), 85.

50. Lev Manovich, *Software Takes Command*, draft version, 2008, 1. http://softwarestudies.com/softbook/manovich_softbook_11_20_2008.pdf. Another well-known example of a versioned academic book is McKenzie Wark's *GAM3R 7H30RY*, first developed online in collaboration with the Institute for the Future of the Book in 2006. McKenzie Wark, *Gamer Theory* (Cambridge, MA: Harvard University Press, 2007), https://web.archive.org/web/20081024225357/http://www.futureofthebook.org:80/mckenziewark/gamertheory/.

51. Within humanities fields, scholars are increasingly experimenting with conducting their research in a more open way, following the idea of open research or open notebook science. This involves publishing research as it evolves (including, in some cases, as drafts and raw data) on blogs, personal websites, and wikis, or on platforms such as Academia.edu or Humanities Commons—to name just a few examples—instead of only publishing the research *results* formally in scholarly journals, edited collections, and monographs. Notable early examples of scholars who are or have been experimenting with open, online publishing (in addition to Manovich and Wark, mentioned in the previous note) include Ted Striphas, who posts his working papers online on his Differences and Repetitions wiki, and Gary Hall, through his openly produced series of performative media projects, or *media gifts*. Meanwhile, Kathleen Fitzpatrick put the draft version of her books *Planned Obsolescence* and *Generous Thinking* online for open review using the CommentPress plugin for WordPress, which allows readers to comment on paragraphs of the text in the margins. Notable early examples of (ex-)PhD students involved in open research include librarian Heather Morrison, who posted the chapters of her thesis as they evolved online, and English scholar Alex Gil, who has put his work for his thesis online at elotroalex.com, also using the CommentPress plugin. See http://wiki.diffandrep.org/, http://www.garyhall.info/open-book/, http://mcpress.media-commons.org/plannedobsolescence, https://generousthinking.hcommons.org/, http://pages.cmns.sfu.ca/heather-morrison/open-thesis-draft-introduction-march-2011/, and https://web.archive.org/web/20120510152156/http://www.elotroalex.com:80/atelier/.

52. Fitzpatrick, *Planned Obsolescence*, 70.

53. In this sense, it might be useful to explore the concept of the *differential text*, a term coined by the poetry critic Marjorie Perloff. Perloff has called these "texts that exist in different material forms, with no single version being the definitive one." Marjorie Perloff, "Screening the Page/Paging the Screen: Digital Poetics and the Differential Text," in *New Media Poetics: Contexts, Technotexts, and Theories*, ed. Adelaide Morris and Thomas Swiss (Cambridge, MA: MIT Press, 2006), 146, http://marjorieperloff.blog/essays/digital-poetics-and-the-differential-text/. This notion of the differential

text becomes ever so important in an environment in which even our so-called fixed published objects, our articles or monographs, exist in different material versions sitting alongside versions in other media, from paperbacks and hardcovers to PDFs, HTML, EPUBs, and digital interactive versions. These different versions all have different impacts, and this raises questions about the agency of print and of the various other digital platforms and software that we use, as the various multimodal remixed iterations of our publications will also be differently received and interacted with by readers. What the "real" publication is here becomes hard to determine, where it stresses the differences between each medium's materiality and its cultural connotations. What is clear is that at the moment, when it comes to the publications of books in the humanities, a clear cultural fetish for the printed object, for seeing our books published in print, continues to prevail.

54. It might be useful to highlight here the linear fixation that the concept and practice of versioning within publishing brings with it, as often versions are even numbered sequentially (e.g., first edition, second edition). There is the idea of an endpoint here, of the final publication, and its further adaptations from that point. Within processual publishing as commonly conceived, issues of linearity and registration of research claims remain important; here versions turn research iterations into objects again and encourage us to focus on research's linear development instead of focusing on, for example, the relationalities of publishing or the interactions between texts in different contexts. Research rarely develops linearly, of course; versions or parts of versions get abandoned, are taken up in different contexts, get remixed and remediated in different forms and media, and are mashed up with other projects and within different contexts—we often also return to previous versions and pick up from there. The idea that there is or has been a logical linear development to a piece of scholarship, developed by a single author, is something we often construct in retrospect and does not necessarily reflect the actual practice of doing research.

55. This might similarly provide an opportunity to market, brand, and sell research in a continuous way, as we do with new editions of books.

56. Fitzpatrick, *Planned Obsolescence*, 72.

57. Living Books developed among others as part of the academic research blog *Open Reflections* (www.openreflections.wordpress.com), where first ideas, sketches of arguments, and subsequently draft chapters of this book were published in the form of (versioned) blog posts. This blog has also archived and collated talks, papers, and online preprint and postprint versions presented and published in the course of this ongoing research, and further extended connections were mainly made via Twitter and Zotero (an online open source reference system enabling people to collect and share references and resources). Versions of Living Books were presented as papers and presentations at more than twenty conferences, seminars, symposia, and summer schools (see https://openreflections.wordpress.com/presentations/) and published as part of articles, book chapters, translations, and remixes, including the following: Janneke Adema, "CREATIVITY (Capital C) Has Been Hijacked by the

Artists," www.remixthebook.com, June 7, 2011, remix of Mark Amerika, *remixthebook* (Minneapolis: University of Minnesota Press, 2011); Adema, "On Open Books and Fluid Humanities," *Scholarly and Research Communication* 3, no. 3 (December 21, 2012), http://src-online.ca/index.php/src/article/view/92; Adema, "Mettre en pratique ce que l'on prêche. La recherche en sciences humaines et sa praxis critique," in *Read/Write Book 2* (OpenEdition, 2012), 99–104, https://doi.org/10.4000/books.oep .254; Adema, "Practise What You Preach: Engaging in Humanities Research through Critical Praxis," *International Journal of Cultural Studies* 16, no. 5 (2013): 491–505, https://doi.org/10.1177/1367877912474559; Adema, "Open Access," in *Critical Keywords for the Digital Humanities* (Lüneburg: Centre for Digital Cultures, 2014), https:// meson.press/keywords/; Adema, "Cutting Scholarship Together/Apart: Rethinking the Political Economy of Scholarly Book Publishing," in *The Routledge Companion to Remix Studies*, ed. Eduardo Navas, Owen Gallagher, and xtine burrough (New York: Routledge, 2015), 258–269; Adema, "Embracing Messiness"; Adema and Hall, "Political Nature of the Book"; Adema and Hall, *La Naturaleza Politica del Libro: Sobre Libros de Artista y Acceso Abierto Radical* (Mexico: Taller de Ediciones Económicas, 2016). *Living Books* has also been previously published as a thesis (https://curve.coventry.ac .uk/open/items/8222ccb2-f6b0-4e5f-90de-f4c62c77ac86/1/), in a print and PDF version (open access online), in a CommentPress version (http://www.openreflections .org/), and as a wiki version (http://www.openreflections.org/wiki/)—both openly available and, in the case of the wiki, openly editable. For more information on these specific versions, please see Adema, "Knowledge Production Beyond the Book? Performing the Scholarly Monograph in Contemporary Digital Culture" (PhD diss., Coventry University, 2015), 31–39.

58. Janneke Adema, "Practise What You Preach." Paolo Freire has developed praxis as a concept and methodology throughout his work. See Freire, *Pedagogy of the Oppressed* (New York: Herder and Herder, 1970). For more on the origins of the philosophy of praxis in Marxism, see Andrew Feenberg, *The Philosophy of Praxis: Marx, Lukács and the Frankfurt School*, rev. ed. (Brooklyn: Verso, 2014).

59. Henry A. Giroux, "Cultural Politics and the Crisis of the University," *Culture Machine* 2 (January 1, 2000), https://culturemachine.net/the-university-culture-machine /cultural-politics-and-the-crisis-of-the-university/.

60. This aligns with the broader project of cultural studies, in which, as cultural studies scholar Handel Wright has argued, "doing cultural studies" means most importantly an "intervention in institutional, socio-political and cultural arrangements, events and directions." This is consistent with the stress Wright places on the importance of addressing one's own practices and institutions as sites of critical praxis: "In addition, I want to reiterate that the university itself must not be overlooked as a site of praxis, a site where issues of difference, representation and social justice, and even what constitutes legitimate academic work are being contested." Handel Kashope Wright, "Cultural Studies as Praxis: (Making) an Autobiographical Case," *Cultural Studies* 17, no. 6 (2003): 806, 808, https://doi.org/10.1080 /0950238032000150039.

61. Ted Striphas, "Acknowledged Goods: Cultural Studies and the Politics of Academic Journal Publishing," *Communication and Critical/Cultural Studies* 7, no. 1 (March 2010): 4, https://doi.org/10.1080/14791420903527798.

62. Striphas, "Acknowledged Goods," 19.

63. Angelique Bletsas has explored this discursive power with respect to the thesis as a specific communication format. Producing a thesis, she argues, is not only about finishing a static text but also about finishing as a person: the accepted thesis completes the student as a discoursing "subject." In other words, the PhD student as a discoursing subject is being (re)produced in and by these dominant discourses; and with that, a certain kind of scholar, and a certain kind of scholarly communication system, are also reproduced. Angelique Bletsas, "The PhD Thesis as 'Text': A Post-Structuralist Encounter with the Limits of Discourse," *New Scholar* 1, no. 1 (September 7, 2011), https://web.archive.org/web/20170302222657/http://www.newscholar.org.au/index.php/ns/article/download/2/10.

64. Alan O'Shea, "A Special Relationship? Cultural Studies, Academia and Pedagogy," *Cultural Studies* 12, no. 4 (1998): 515, https://doi.org/10.1080/09502386.1998.10383118.

65. Foucault scholar Eric Paras sums up these changes in Foucault's work as follows: "The individual, no longer seen as the pure product of mechanisms of domination, appears as the complex result of an interaction between outside coercion and techniques of the self." Paras, *Foucault 2.0: Beyond Power and Knowledge* (New York: Other Press, 2006), 94–95. As Paras states, becoming a subject is in Foucault's later thought less "an affirmation of an identity than a propagation of a creative force" (Paras, *Foucault 2.0*, 132). It is a creative effort rather than a defensive one. In this sense, Paras emphasizes the potential in the later Foucault for the subject to reflect upon its own practices and to choose among and modify them following techniques of the self, those specific practices that enable subjects to constitute themselves both within and through systems of power. It has to be noted though that from a feminist perspective, the productive character of technologies of the self needs to be questioned, in the sense that Foucault disconnects the self and the body from any social and economic relations and is oblivious to how power relations structure sexual differentiation, positioning the body "from the viewpoint of a universal, abstract, asexual subject" instead of emphasizing how disciplinary techniques and power relations produce the body and the self differently. Silvia Federici, *Caliban and the Witch: Women, the Body and Primitive Accumulation* (New York: Autonomedia, 2004), 16.

66. Ted Striphas, "Performing Scholarly Communication," *Text and Performance Quarterly* 32, no. 1 (2011): 79, https://doi.org/10.1080/10462937.2011.631405.

67. Let me emphasize: I am not claiming that critical praxis can *only* be achieved or learned through experimenting with *digital* projects, methods, and tools. Rather, I am arguing that at this specific moment these tools and methods can be employed

Notes

263

to trigger critique and rethink some of our established notions concerning scholarship and scholarly communication—including authorship, peer review, copyright, and the political economy surrounding scholarly publishing. What is more, this critical praxis should be applied just as much to digital methods and to how research is being carried out within the digital humanities, especially insofar as digital projects uncritically reproduce notions and values from dominant, established discourses. Not all digital projects are inherently and necessary critical, experimental; they just have the potential to be so. In order to establish where the importance of experimental digital work for humanities scholarship lies, it would be useful to explore how we can use digital tools and technologies in a critical way to potentially enhance and improve our scholarship and our communication systems. Through the digital, we have an opportunity to critically investigate the value of our established institutions and practices and vice versa; critique gives us the potential means to analyze and transform the digital to make it adhere to a more progressive and open ethics, one that remains critical of itself. In this respect, experimenting with open, processual, online books can be seen as the beginning of an exploration of what digital scholarship could look like and, with that, what a posthumanities could potentially entail.

68. Hall, *Digitize This Book!*

69. Perloff, "Screening the Page/Paging the Screen," 146.

70. Nonetheless, it could of course be argued that I am still the one gathering this disassembled work together again, citing the work of other authors to ensure credit is given where it is due, and rewriting these versions and structuring them anew for this specific instantiation, the published book—thus making it a new and "original" piece of work once more.

71. Barad, *Meeting the Universe Halfway*, x.

72. Even though in *Living Books* I highlight our responsibility as scholars to critically explore how and where we publish our research, at the same time I want to acknowledge the multiple constraints that exist in this environment (and these are unfortunately broad and often overarching). One of these relates back to the principle of "academic freedom" to disseminate and publish one's research findings. AAUP's 1940 Statement of Principles on Academic Freedom and Tenure (https://www.aaup .org/report/1940-statement-principles-academic-freedom-and-tenure) outlines how academic freedom in the context of publishing relates to scholars' (full) freedom in the choice of where to publish, to decide how publication shall happen. More than an actual legal right, academic freedom mainly functions as rhetoric or as a cultural tradition or understanding, which implies that there shouldn't be any institutional restrictions on where to publish research. However, academic freedom in publication is often construed as a right nonetheless (albeit one always under attack). From a critical theory and feminist perspective, it has been scrutinized thoroughly as being an inherently elitist ideal, as a right that seems to apply mainly to white Western

males from reputable institutions (and even then, various restrictions remain) and less to marginalized and underrepresented global scholars, for example. In this respect, I would like to downplay the rhetoric of academic freedom as presenting an illusion of choice delimited by strong institutional and geopolitical restrictions, among others. Consider, for example, first-time book authors. In the UK, promotion and assessment requirements related to the REF, but more importantly to an author's university's interpretation of the REF criteria, can severely limit an author's choices for where to publish—with esteemed university presses, for example, or with those presses that are assumed to publish research that is at least of three- or four-star quality, even though the REF regulations themselves outline that it only assesses the quality of a publication, not where it was published, and universities are increasingly signing onto the San Francisco Declaration on Research Assessment (DORA). Full open access book publishers are, unfortunately and unwarrantably, not always seen as prestigious enough to have a brand that would satisfy funders and institutions (perhaps due to many of them being not-for-profit and scholar-led endeavors that have only relatively recently been established, meaning their brand in some cases still needs to develop). At the same time, the idea that a first-time author gets to choose which publisher to publish with, in a highly competitive environment in which they do not necessarily have an established name or brand to which publishers would respond, is of course severely flawed. However, we need to be aware of the tendency to then, as Joanna Williams has argued, simply "self-censor and fall in line with regulations" and need to explore what opportunities we do have within these constraining systems to push things forward—for example, to refuse to publish with certain commercial presses (e.g., see the Cost of Knowledge campaign). Joanna Williams, *Academic Freedom in an Age of Conformity: Confronting the Fear of Knowledge* (New York: Palgrave Macmillan, 2016), 196.

73. Gary Hall, *Pirate Philosophy: For a Digital Posthumanities* (Cambridge, MA: MIT Press, 2016), 237. For an overview of the other media gifts that make up this network, see http://www.garyhall.info/about/.

74. In a partnership between the Press and the author and with the support of programs including TOME, The Andrew W. Mellon Foundation Humanities Open Books, and funding from the MIT Libraries. See https://direct.mit.edu/books/pages/Open_Access.

75. Similar consortial funding models have been pioneered by scholar-led presses such as Open Book Publishers (The Open Book Publishers' Library Membership Programme; see https://www.openbookpublishers.com/section/44/1) and punctum books (Supporting Library Membership Program; see https://punctumbooks.com/supporting-library-membership-program/), and in 2020 the COPIM project announced the launch of Opening the Future, a collective subscription model similar to D2O (also developed with the support of the Arcadia Fund) in that it funds open access to new books from the revenue gathered from library subscriptions to a press's backlist (see https://openingthefuture.net/).

Notes 265

76. Ronald Snijder, "The Deliverance of Open Access Books: Examining Usage and Dissemination" (PhD diss., Leiden University, 2019), https://openaccess.leidenuniv.nl/handle/1887/68465. As many scholar-led presses have highlighted as part of their commitment to transparency into publishing costs, BPCs are not the only model available to support open access books, and BPCs can be much lower than the prices charged currently by many commercial and university presses. See, among others, Rupert Gatti, "Introducing Some Data to the Open Access Debate: OBP's Business Model (Part One)," *Open Book Publishers* (blog), October 15, 2015, http://blogs.openbookpublishers.com/introducing-some-data-to-the-open-access-debate-obps-business-model-part-one/; Gary Hall, "Open Humanities Press: Funding and Organisation," Media Gifts, June 13, 2015, http://www.garyhall.info/journal/2015/6/13/open-humanities-press-funding-and-organisation.html; Sebastian Nordhoff, *Cookbook for Open Access Books* (Berlin: Language Science Press, 2018), https://doi.org/10.5281/zenodo.1286925.

77. As Frances Pinter has outlined with respect to the BPCs of commercial presses, beyond a need to provide a profit, "in these cases there is an assumption that there will be no further sales from other formats to cover the full costs of publishing." Frances Pinter, "Why Book Processing Charges (BPCs) Vary So Much," *Journal of Electronic Publishing* 21, no. 1 (2018), https://doi.org/10.3998/3336451.0021.101.

78. Especially since, as Pinter shows, "at this point in time Humanities and Social Science (HSS) publishers of English-language books still derive approximately 80% of their sales from printed books, though this is expected to drop at some point—though perhaps not as great a drop as was predicted a few years ago." Pinter, "Why Book Processing Charges (BPCs) Vary So Much." Print sales then become pure profit, Eve argues: "if book publishers are basing their prices on the return they want, then any print sales are pure profit and they totally eradicate risk." Martin Paul Eve, "On Open-Access Books and 'Double Dipping,'" *Martin Paul Eve* (blog), January 31, 2015, https://eve.gd/2015/01/31/on-open-access-books-and-double-dipping/; Marcus Burkhardt, "Open Access (Books) vs. Double Dipping: An Ongoing Struggle," *Hybrid Publishing Lab Notepad* (blog), August 6, 2013, https://web.archive.org/web/20161018063700/http://hybridpublishing.org/2013/08/open-access-books-vs-double-dipping/.

79. Especially when, for example, the various shadow libraries (e.g., Aaaaarg, Memory of the World) that play such an important role in curating and making available research can provide this access without a fee to the author(s) or their institution(s). They can do this without, as I would like to emphasize, necessarily harming the profits of publishers, who do not automatically lose out on this model, as their open availability might actually drive sales of printed books.

80. Hall, *Pirate Philosophy*, 153.

81. Important open access and experimental publications include (more recently) Peter Suber's *Open Access* and Burdick et al.'s *Digital_Humanities*. And back in 1995, MIT Press published William Mitchell's *City of Bits*, which was published both in

print and as a dynamic, open web edition. In 2011, MIT Press published Alexandra Juhasz's video book, *Learning from YouTube*. Peter Suber, *Open Access* (Cambridge, MA: MIT Press, 2012); Anne Burdick et al., *Digital_Humanities* (Cambridge, MA: MIT Press, 2012); William J. Mitchell, *City of Bits: Space, Place, and the Infobahn* (Cambridge, MA: MIT Press, 1995); Alexandra Juhasz, *Learning from YouTube* (Cambridge, MA: MIT Press, 2011).

82. Emmanuel Levinas, *Totality and Infinity: An Essay on Exteriority* (Pittsburgh: Duquesne University Press, 1969); Jacques Derrida, *Adieu to Emmanuel Levinas* (Stanford, CA: Stanford University Press, 1999).

83. Jessica Pressman, "The Aesthetic of Bookishness in Twenty-First-Century Literature," *Michigan Quarterly Review* 48, no. 4 (Fall 2009), http://hdl.handle.net/2027/spo.act2080.0048.402.

84. As Christine Borgman argues, although digital publications have fewer material constraints, their form remains relatively stable or continuous to the printed book. In Borgman's vision, this is not a rejection of technology but a reflection of the constructive power of scholarly practices. Even though, as she states, the existing forms might not necessarily serve scholars well or best, new genres that take advantage of the fluid and mobile nature of the medium are only slow to emerge. Hence today's online books look identical to print books in many respects. Borgman, *Scholarship in the Digital Age*, 160.

Chapter 1

1. Donna Jeanne Haraway, "A Game of Cat's Cradle: Science Studies, Feminist Theory, Cultural Studies," *Configurations* 2, no. 1 (January 1, 1994): 60, https://doi.org/10.1353/con.1994.0009.

2. For an overview of the development of book history and its different strands, see, among others, Robert Darnton, "What Is the History of Books?," *Daedalus* 111, no. 3 (1 July 1982): 65–83. See also the introductions to Sabrina Alcorn Baron, Eric N. Lindquist, and Eleanor F. Shevlin, eds., *Agent of Change: Print Culture Studies after Elizabeth L. Eisenstein* (Amherst, MA: University of Massachusetts Press, 2007); David Finkelstein and Alistair McCleery, eds., *The Book History Reader*, 2nd ed. (New York: Routledge, 2006); David D. Hall, *Cultures of Print: Essays in the History of the Book* (Amherst, MA: University of Massachusetts Press, 1996); Leslie Howsam, *Old Books and New Histories: An Orientation to Studies in Book and Print Culture* (Toronto: University of Toronto Press, 2006); Leslie Howsam, *The Cambridge Companion to the History of the Book* (Cambridge: Cambridge University Press, 2014); Michelle Levy and Tom Mole, *The Broadview Introduction to Book History* (Peterborough, Ontario, Canada: Broadview Press, 2017).

3. See https://web.archive.org/web/20140617072438/http://www.gutenberg.org/wiki/Michael_S._Hart.

Notes

267

4. Alan Kay, "The Dynabook Revisited: A Conversation with Alan Kay," *The Book and the Computer*, 2002, accessed April 11, 2017, http://www.squeakland.org/content/articles/attach/dynabook_revisited.pdf.

Some even place the invention of the e-book in the 1940s, with Ángela Ruiz Robles's *Mechanical Encyclopedia* and Robert Busa's electronic *Index Thomisticus*. For more information on the history of the e-book, see http://en.wikipedia.org/wiki/E-book; Laura Manley and Robert P. Holley, "History of the Ebook: The Changing Face of Books," *Technical Services Quarterly* 29, no. 4 (October 2012): 292–311, https://doi.org/10.1080/07317131.2012.705731; Simon Peter Rowberry, "Ebookness," *Convergence* 23, no. 3 (June 1, 2017): 289–305, https://doi.org/10.1177/1354856515592509.

5. Although book historians increasingly draw on media theory and history, the relationship up to now has not exactly been mutual. Whitney Trettien argues that this might be due to the continuing digital divide between English and literary studies on the one hand and media and communication studies on the other. She states that although "the two disciplines operate along parallel axes, studying similar phenomena but rarely intersecting," much can be gained by integrating the disciplines' methodologies and theories, drawing on their similarities. Whitney Trettien, "Media Studies and the History of the Book," *Comparative Media Studies* (blog), January 22, 2009, http://cmsw.mit.edu/media-studies-history-of-the-book/. Katherine Hayles and Jessica Pressman have both actively investigated textual media from a media standpoint, most recently in their coedited collection; similarly, Lisa Gitelman has been an important voice in bringing media studies and book history closer together. N. Katherine Hayles and Jessica Pressman, *Comparative Textual Media: Transforming the Humanities in the Postprint Era* (Minneapolis: University of Minnesota Press, 2013); Lisa Gitelman, *Paper Knowledge: Toward a Media History of Documents* (Durham, NC: Duke University Press, 2014). Sarah Werner and Matthew Kirschenbaum have penned an important state-of-the-discipline study, which provides an overview of where book history and digital humanities overlap, arguing that it is book history that finds itself in a privileged position to productively nuance what they call the "tired, reductive binaries around the paragone between print and the digital," since books as hybrid artifacts are increasingly "migrating back and forth between digital and analog states." Matthew Kirschenbaum and Sarah Werner, "Digital Scholarship and Digital Studies: The State of the Discipline," *Book History* 17, no. 1 (October 24, 2014): 440, 452, https://doi.org/10.1353/bh.2014.0005.

6. See also Borgman's remarks on the stabilization of the book, discussed in note 84 in the introduction.

7. Kember and Zylinska offer a valuable reading on how these dichotomies or *binary oppositions* that structure debates on new media are actually false divisions. Although often identified as false, new media debates tend to perpetuate these divisions anyway. Kember and Zylinska, *Life after New Media*, 2.

8. David Finkelstein and Alistair McCleery, *An Introduction to Book History*, 2nd ed. (New York: Routledge, 2005), 3; Darnton, "What Is the History of Books?," 67.

9. Darnton's model was based on the specificities of an eighteenth-century European printing and publishing system.

10. See, for instance, Joseph Esposito, "Disintermediation and Its Discontents: Publishers, Libraries, and the Value Chain," *Scholarly Kitchen* (blog), April 18, 2011, http://scholarlykitchen.sspnet.org/2011/04/18/disintermediation-and-its-discontents -publishers-libraries-and-the-value-chain/; Eoin Purcell, "No New Normal—the Value Web," *Eoin Purcell's Blog*, May 24, 2011, http://eoinpurcellsblog.com/2011/05/24/no -new-normal-the-value-web/; Thompson, *Books in the Digital Age*, 309–310.

11. Darnton, "What Is the History of Books?," 67.

12. Nicolas Barker and Thomas R. Adams, "A New Model for the Study of the Book," in *A Potencie of Life: Books in Society: The Clark Lectures, 1986–1987*, ed. Nicolas Barker, 2nd ed. (New Castle, DE: Oak Knoll Press, 2001).

13. Paul Duguid, "Material Matters: The Past and Futurology of the Book," in *The Future of the Book*, ed. Geoffrey Nunberg (Berkeley: University of California Press, 1996), 79.

14. Although the book as a material object is added to this model to make it more inclusive, it is still only a construction that aides us in getting a clearer overview of the debate. Much valuable research is excluded from this model—something already remarked upon by Darnton himself in a revision of his communication circuit in 2007, in which he emphasizes the omission of some crucial agents and functions from the communication chain, from literary agents to piracy. Hence it does not aim to cover the debate in its entirety, but tries to focus on some of its main focal points.

15. Fredson Thayer Bowers, *Principles of Bibliographical Description* (Princeton, NJ: Princeton University Press, 1949); W. W. Gregg, *W. W. Gregg: Collected Papers*, ed. J. C. Maxwell (Oxford: Clarendon Press, 1966); Ronald Brunlees McKerrow, *An Introduction to Bibliography for Literary Students*, new ed. (New Castle, DE: Oak Knoll Press, 2002). See also Elizabeth L. Eisenstein, *The Printing Press as an Agent of Change*, 2 vols. (Cambridge: Cambridge University Press, 1979); Marshall McLuhan, *The Gutenberg Galaxy: The Making of Typographic Man* (Toronto: University of Toronto Press, 1962); Walter J. Ong, *Orality and Literacy: The Technologizing of the Word*, new ed. (New York: Routledge, 2002).

16. Darnton, "What Is the History of Books?"; Thompson, *Books in the Digital Age*; Chartier, *The Order of Books*; Lucien Febvre and Henri-Jean Martin, *The Coming of the Book: Impact of Printing, 1450–1800*, trans. David Gerard (Atlantic Highlands, N.J., Humanities Press, 1976); D. F. McKenzie, *Making Meaning: "Printers of the Mind" and Other Essays*, ed. Peter D. McDonald and Michael F. Suarez (Amherst: University of Massachusetts Press, 2002).

17. Roland Barthes, "The Death of the Author, " *Aspen*, no. 5–6 (1967); Michel Foucault, "What Is an Author?," in *Aesthetics, Method, and Epistemology*, ed. James D. Faubion, vol. 2, Essential Works of Foucault, 1954–1984 (New York: The New Press,

Notes

1998), 205–222; Carla Hesse, *Publishing and Cultural Politics in Revolutionary Paris, 1789–1810* (Berkeley: University of California Press, 1992); Mark Rose, *Authors and Owners: The Invention of Copyright* (Cambridge, MA: Harvard University Press, 1993); Martha Woodmansee and Peter Jaszi, *The Construction of Authorship: Textual Appropriation in Law and Literature* (Durham, NC: Duke University Press, 1993).

18. In *Book Was There*, Andrew Piper gives a good overview of book historical studies that focus on readership, to which I would like to add Adrian Johns's *The Nature of the Book* and Rolf Engelsing's work on the nineteenth-century reading revolution. Andrew Piper, *Book Was There: Reading in Electronic Times* (Chicago: University of Chicago Press, 2012); Rolf Engelsing, *Analphabetentum Und Lektüre. Zur Sozialgeschichte Des Lesens in Deutschland Zwischen Feudaler Und Industrieller Gesellschaft* (Stuttgart: J. B. Metzlersche Verlag, 1973); Johns, *The Nature of the Book*.

19. The importance of Eisenstein's thought for the book historical discourse and scholarly inquiry more generally has been called "undeniably enormous," and her seminal work, *The Printing Press as an Agent of Change*, has been seen as "more than any other work . . . responsible for the rise of . . . print culture studies" (Baron, Lindquist, and Shevlin, *Agent of Change*, 1).

20. In this sense, the French historian Roger Chartier has been very important for the development of Johns's argument. Chartier recognizes ways of reading as social and cultural practices with a historical character. As such, an authoritative text, however fixed, cannot compel uniformity in the cultures of its reception. Chartier, *Order of Books*, x.

21. Elizabeth L. Eisenstein, "An Unacknowledged Revolution Revisited," *American Historical Review* 107, no. 1 (February 1, 2002): 87–105; Adrian Johns, "How to Acknowledge a Revolution," *American Historical Review* 107, no. 1 (February 1, 2002): 106–125.

22. Evgeny Morozov is someone who, following Adrian Johns and Mark Warner, argues that Eisenstein privileges print over culture: "Eisenstein's account holds only if one accepts a sharp separation between technology on the one hand and society and culture on the other—and then assumes that the former shapes the latter, never the other way around." Evgeny Morozov, *To Save Everything, Click Here: The Folly of Technological Solutionism* (New York: Public Affairs, 2013), 54.

23. Eisenstein, *Printing Press as an Agent of Change*, 4.

24. Eisenstein, *Printing Press as an Agent of Change*, xvi.

25. Eisenstein, *Printing Press as an Agent of Change*, xv.

26. Eisenstein, *Printing Press as an Agent of Change*, xvi.

27. Johns, *Nature of the Book*, 2.

28. Johns, "How to Acknowledge a Revolution," 110.

29. Johns, "How to Acknowledge a Revolution," 123.

30. Johns, *Nature of the Book*, 628.

31. Theorists who emphasize the continuation of the manuscript tradition after the invention of print are detailed in David Finkelstein and Alistair McCleery's *An Introduction to Book History* and include Harold Love and David McKitterick. Finkelstein and McCleery, *An Introduction to Book History*, new ed. (New York: Routledge, 2005), 18. The discussion on the speed and nature of media change comes to the fore again in the debate on printed books and e-books, culminating in continuing forecasts of the e-book revolution and the death of the printed book in the digital age.

32. Eisenstein, "Unacknowledged Revolution Revisited," 90.

33. Elizabeth L. Eisenstein, *The Printing Revolution in Early Modern Europe*, 2nd ed. (Cambridge: Cambridge University Press, 2005), 318.

34. Eisenstein, *Printing Press as an Agent of Change*, 32.

35. This struggle to control the past will be discussed in more depth in the next section. Johns's account of this struggle can be seen as a historical example of something I described earlier: namely, how a reinterpretation of the past directly influences the way we perceive the present and the future and, with that, how we shape and structure that future. The representations of print's history were founded on the differing accounts of contemporaries of what printing was and should be. Debate, dispute, and struggle thus constructed and constituted print culture. As Johns puts it, "Societies therefore structure and legitimate themselves through knowledge of the past, creating present and future order out of an ordered representation of history." Johns, *Nature of the Book*, 325.

36. Johns, *Nature of the Book*, 324.

37. Eisenstein, "Unacknowledged Revolution Revisited," 90.

38. Johns, *Nature of the Book*, 59.

39. Eisenstein, *Printing Press as an Agent of Change*, 138–140.

40. *Bookfuturism* is a term invented by science and technology writer Joanne McNeill for a Twitter list that followed book aficionados. The term also shows similarities with *bookfutures*, used in the blog of the same name and written by Chris Meade, founder of *if:book London*, a think tank for the future of the book. The term *bookfuturism* was given theoretical grounding by Tim Carmody, self-proclaimed bookfuturist and writer on book technology and digital media. Carmody started a group blog called *Bookfuturism* (https://web.archive.org/web/20091213134329/http://bookfuturism.com/) and wrote "A Bookfuturist Manifesto" for the *Atlantic*. As he explains, bookfuturism plays with two dialectical oppositions, *bookservatism* and *technofuturism*:

Notes

271

> Now, even bookservatives acknowledge that things are changing. But they fear that these changes will result in catastrophe, for some part or whole of the culture they love. Because of that, they would prefer that book tech and book culture stop, slow down, or go back. . . . On the other side of the aisle are technofuturists. They're winning most of the arguments these days when it comes to ebooks, so their rhetoric isn't as wild. Technofuturists are technological triumphalists, or at least quasi-utopian optimists. These are the folks who believe that technology can solve our political, educational, and cultural problems. At an extreme, they don't care about books at all: they're just relics of a happily closing age of paper, and we should embrace the future in the form of multimedia and the networked web. (Tim Carmody, "A Bookfuturist Manifesto," *Atlantic*, August 11, 2010, http://www.theatlantic.com/technology/archive/2010/08/a-bookfuturist-manifesto/61231/)

Bookfuturists, in Carmody's vision, refuse both viewpoints. He sees this as a way of thinking about the book that is critical toward either position.

41. Famously, Plato had Socrates argue in the *Phaedrus* that writing is unresponsive and is bad for one's memory as it will make one forgetful. Plato, *Phaedrus*, trans. Christopher Rowe, rev. ed. (London: Penguin Classics, 2005). Similarly, in Victor Hugo's *Notre Dame de Paris*, a scholar states, "The printed book will destroy the building." Here, the cathedral as a physical, pictorial embodiment of the fortress of the mind is seen as becoming obsolete with the coming of the printed book. Victor Hugo, *Notre-Dame de Paris*, trans. John Sturrock, new ed. (London: Penguin Classics, 1978).

42. Ludovico, *Post-Digital Print*.

43. Although his book has been classified by some—unfairly, in my opinion—as a "book length attack on Eisenstein." See Adriaan Van der Weel, *Changing Our Textual Minds: Towards a Digital Order of Knowledge* (Manchester: Manchester University Press, 2012), 81.

44. Johns, "How to Acknowledge a Revolution," 124.

45. Johns, *Nature of the Book*, 20.

46. Barad, *Meeting the Universe Halfway*, 46.

47. Kember and Zylinska, *Life after New Media*, 31; italics in the original.

48. Barad, "Posthumanist Performativity," 822.

49. Jay David Bolter, *Writing Space: Computers, Hypertext, and the Remediation of Print* (New York: Routledge, 2001), 19.

50. Dolphijn and Van der Tuin, *New Materialism*.

51. Haraway, "Otherworldly Conversations," 127.

52. Donna Haraway, "Situated Knowledges: The Science Question in Feminism and the Privilege of Partial Perspective," *Feminist Studies* 14, no. 3 (1988): 579.

53. For more on Johns's sensitivity and perceptiveness toward this point, see "Gutenberg and the Samurai: Or, the Information Revolution Is History," *Anthropological Quarterly* 85, no. 3 (2012): 859–883, https://doi.org/10.1353/anq.2012.0039.

54. See, for instance, *The Medium is the Massage*, the book Marshall McLuhan cowrote with graphic designer Quentin Fiore. McLuhan and Fiore, *The Medium Is the Massage: An Inventory of Effects* (New York: Bantam Books, 1967).

55. Kember and Zylinska, *Life after New Media*, 2.

56. Claire Colebrook, *New Literary Histories: New Historicism and Contemporary Criticism* (Manchester: Manchester University Press, 1997), 139; Judith Newton, "History as Usual? Feminism and the 'New Historicism,'" *Cultural Critique*, no. 9 (April 1, 1988): 87–121, https://doi.org/10.2307/1354235; Mark Nixon, "Figuring the Past: New Historicism and Modern Historiography" (social theory MPhil seminar, Glasgow University, 2004), 6; Jürgen Pieters, "New Historicism: Postmodern Historiography Between Narrativism and Heterology," *History and Theory* 39, no. 1 (2000): 21, https://www.jstor.org/stable/2677996.

57. Louis Montrose, "Professing the Renaissance: The Poetics and Politics of Cultures," in *The New Historicism*, ed. H. Aram Veeser (New York: Routledge, 1989), 23.

58. Chung-Hsiung Lai, "Limits and Beyond: Greenblatt, New Historicism and a Feminist Genealogy," *Intergrams* 7.1–7.2 (2006): 8.

59. Lynn Hunt, ed., *The New Cultural History* (Berkeley: University of California Press, 1989); F. R. Ankersmit, *History and Tropology: The Rise and Fall of Metaphor* (Berkeley: University of California Press, 1994).

60. Pieters, "New Historicism," 21.

61. Derek Attridge, Geoff Bennington, and Robert Young, *Post-Structuralism and the Question of History* (Cambridge: Cambridge University Press, 1989), 2.

62. It is similarly interesting to note, as Mark Nixon has done, that new historicism is an (almost) uniquely Anglo-American phenomenon, whereas in Europe, this break with history was never that strongly felt. Through the emphasis on deconstruction and cultural materialism, and the *Annales* school tradition, they never abandoned but always sought out a broad concept of culture in European literary traditions. Nixon, "Figuring the Past."

63. Pieters, "New Historicism," 21.

64. Lai, "Limits and Beyond," 17–18; Alan Liu, "The Power of Formalism: The New Historicism," *ELH* 56, no. 4 (1989): 754–755, https://doi.org/10.2307/2873158.

65. Newton, "History as Usual?"

66. Newton, "History as Usual?," 102.

Notes 273

67. Lai, "Limits and Beyond," 22; Newton, "History as Usual?,'" 118.

68. Michel Callon, "What Does It Mean to Say That Economics Is Performative?," in *Do Economists Make Markets? On the Performativity of Economics*, ed. Donald MacKenzie, Fabian Muniesa, and Lucia Siu (Princeton, NJ: Princeton University Press, 2008), 316, 318.

69. Bolter, *Writing Space*, 19.

70. Historian Leslie Howsam has been a proponent of a more feminist-oriented book studies, one that doesn't simply focus on writing women into book history but also draws on our responsibility as historians to gender both the book and book history. "I would like to see book historians focus on the gender identity of the book itself, both as physical object and as cultural product. We have seen the implications of a feminist analysis—in terms of patriarchy, power, discipline, possession, and other dimensions–on literary studies and on social history, as well as on the other humanities disciplines and on the social and physical sciences. Why should book history be immune?" Leslie Howsam, "In My View: Women and Book History," *SHARP News* 7, no. 4 (autumn 1998): 1. Another great resource is Women in Book History's bibliography (http://www.womensbookhistory.org/). Women in Book History is a platform that "promotes ongoing work in women's book history by providing a hub where scholarship and resources on women's writing and labor is made visible." Edited by Cait Coker and Kate Ozment, this platform includes a bibliography (of secondary sources on women's writing and labor), a blog (http://www.womensbookhistory.org /sammelband), and a Twitter network (@GrubStreetWomen). Also see Kate Ozment, "Book History, Women, and the Canon: Theorizing Feminist Bibliography" (presented at the ASECS Annual Conference, March 30–April 2, 2017, Minneapolis, Minnesota), accessed August 31, 2020, https://hcommons.org/deposits/item/hc:11751/; Kate Ozment, "Rationale for Feminist Bibliography," *Textual Cultures* 13, no. 1 (April 15, 2020): 149–178, https://doi.org/10.14434/textual.v13i1.30076.

71. Jussi Parikka, *What Is Media Archaeology?* (Malden, MA: Polity, 2012), 12–14.

72. Erkki Huhtamo and Jussi Parikka, *Media Archaeology: Approaches, Applications, and Implications* (Berkeley: University of California Press, 2011), 3.

73. Geert Lovink, interview with German media archeologist Wolfgang Ernst, Nettime mailing list, February 26, 2003, http://www.nettime.org/Lists-Archives/nettime -1-0302/msg00132.html. Cf. Phil Bevis, Michele Cohen, and Gavin Kendall, "Archaeologizing Genealogy: Michel Foucault and the Economy of Austerity," *Economy and Society* 18, no. 3 (August 1, 1989): 324, https://doi.org/10.1080/03085148900000015.

74. As Jussi Parikka has emphasized, *archaeology* also refers to the actual excavation of media objects, of "going under the hood" or exploring the inside of media to examine the interior of media machines and circuits by forms of hardware hacking and circuit bending. Parikka, *What Is Media Archaeology?*, 83.

75. Garnet Hertz and Jussi Parikka, "Zombie Media: Circuit Bending Media Archaeology into an Art Method," *Leonardo* 45, no. 5 (2012): 424–430. The Media Archaeology Lab (MAL), founded in 2009 by Lori Emerson, is a prime example of this practice. Emerson describes MAL as "a place for cross-disciplinary experimental research and teaching using obsolete tools, hardware, software and platforms, from the past." Similarly, the Media Archaeological Fundus (MAF), is described by its director, Wolfgang Ernst, as going "beyond bare historiography": "The Media Archaeological Fundus (MAF) is a collection of various electromechanical and mechanical artefacts as they developed throughout time. Its aim is to provide a perspective that may inspire modern thinking about technology and media within its epistemological implications beyond bare historiography." See http://loriemerson.net/media-archaeology-lab/ and http://www.medienwissenschaft.hu-berlin.de/medientheorien/fundus/media-archaeological-fundus.

76. Parikka, *What Is Media Archaeology?*, 2.

77. Huhtamo and Parikka, *Media Archaeology*, 325.

78. Parikka, *What Is Media Archaeology?*, 12. There exist a lot of similarities and overlaps between media archaeological and book historical approaches—especially in the case of historians like Adrian Johns and Roger Chartier, who have tried to emphasize different readings of book history (readings going against the grain of the dominant book historical visions of Elizabeth Eisenstein, among others) based on the importance of the construction of fixity by historically situated persons and institutions and on the active role of the reader in constructing meaning through their multiple readings. However, within the current heightened attention surrounding media archaeology, a focus on books and book history has been curiously lacking. For example, although there is an emphasis on archives and on writing systems and their cognitive-psychological influences, books and book history get no significant attention in two of the main media archaeological overviews, neither in Parikka's *What Is Media Archaeology?* nor in the collection *Media Archaeology: Approaches, Applications, and Implications*, edited by Huhtamo and Parikka. But book historians have started to take on this discourse (if they haven't been influencing it at the same time); see, for example, some of the recent works of Lori Emerson, Lisa Gitelman, and Matthew Kirschenbaum. Lori Emerson, *Reading Writing Interfaces: From the Digital to the Bookbound* (Minneapolis: University of Minnesota Press, 2014); Gitelman, *Paper Knowledge*; Huhtamo and Parikka, *Media Archaeology*; Kirschenbaum, *Track Changes*; Parikka, *What Is Media Archaeology?*

79. Especially because most media archaeological research is heavily theory-based and communicated predominantly in a conventional manner through book-bound publications. It can be argued though that the current Lab Book project (in process during the writing of this book), led by Parikka and Emerson, is exactly the kind of intervention wanting to point out the practice-led work lying at the basis of media archaeology. The fact that the authors are creating and publishing their work at the same time in a processual manner using the Manifold platform developed by the

Notes

University of Minnesota Press shows exactly how media archaeological scholarship has the potential to position itself clearly as a "doing," in which by publishing in an experimental way they also provide an inspiring example of how scholarship can be performed differently. See http://whatisamedialab.com/.

80. Barad, "Posthumanist Performativity," 822.

81. In her posthumanist performative reformulation of the notions of discursive practices and materiality, Barad also extends and reformulates Judith Butler's theory of performativity. One might argue, however, that a concern for non- or posthuman object materiality is already apparent in Foucault's thought (most obviously in *The Order of Things*). Michel Foucault, *The Order of Things: An Archaeology of the Human Sciences* (New York: Routledge, 1966).

82. Barad, *Meeting the Universe Halfway*, 214.

83. The same is pointed out by Elisabeth Grosz when she states, "Nature or materiality have no identity in the sense that they are continually changing, continually emerging as new." Katve-Kaisa Kontturi and Milla Tiainen, "Feminism, Art, Deleuze, and Darwin: An Interview with Elizabeth Grosz," *NORA—Nordic Journal of Feminist and Gender Research* 15, no. 4 (November 2007): 248, https://doi.org/10.1080 /08038740701646739.

84. N. Katherine Hayles, "Print Is Flat, Code Is Deep: The Importance of Media-Specific Analysis," *Poetics Today* 25, no. 1 (March 1, 2004): 72, https://doi.org/10 .1215/03335372-25-1-67.

85. Barad, "Posthumanist Performativity."

86. Barad, *Meeting the Universe Halfway*, 393.

87. There is no external position in this vision: we enact and create the book though our discursive practices and vice versa.

88. Joanna Zylinska, *Minimal Ethics for the Anthropocene* (Ann Arbor, MI: Open Humanities Press, 2014), http://www.openhumanitiespress.org/books/titles/minimal-ethics -for-the-anthropocene/.

89. Karen Barad, "Quantum Entanglements and Hauntological Relations of Inheritance: Dis/Continuities, SpaceTime Enfoldings, and Justice-to-Come," *Derrida Today* 3, no. 2 (2010): 242.

90. Levinas, *Totality and Infinity*.

91. As Joanna Zylinska stresses, though, Levinas's thinking here is very much humanist, where for him "the other" is always a human other. Zylinska, *Minimal Ethics for the Anthropocene*, 16–17.

92. Derrida, *Adieu to Emmanuel Levinas*, 23.

93. Zylinska, *Minimal Ethics for the Anthropocene*, 68.

94. Here I argue against thinkers who, for instance, follow a McLuhanite tradition and focus on the salient features of a medium. For example, book historian Adriaan Van der Weel, writing in this tradition, argues that the interface of the book, in comparison to a digital interface, is finished. He also states the book's interface is hierarchical, orderly, and linear throughout (Van der Weel, *Changing Our Textual Minds*, 189, 198). Instead, I will argue here that the book keeps reinventing itself, both with respect to its materiality and to the discourse accompanying it, which continually (re)determines the book's meaning and identity. As becomes clear more practically from, for example, the history of artists' books and the various experiments with the book's materiality, the (printed) book's interface is not (is never) finished. As Johanna Drucker has argued very clearly in this respect:

> Interfaces are ubiquitous . . . A book is an interface, for instance, though its reified condition is equally pernicious, persistent and difficult to dislodge. We are aware that digital interface seems more mutable and flexible than that of a book, but is this really true? The interface is not an object. Interface is a space of affordances and possibilities structured into organization for use. An interface is a set of conditions, structured relations, that allow certain behaviors, actions, readings, events to occur. This generalized theory of interface applies to any technological device created with certain assumptions about the body, hand, eye, coordination, and other capabilities. (Johanna Drucker, "Performative Materiality and Theoretical Approaches to Interface," *Digital Humanities Quarterly* 7, no. 1 [2013], http://www.digitalhumanities.org /dhq/vol/7/1/000143/000143.html)

The literary market also keeps reinventing the book in response to changing (reading) practices. See the introduction of new formats such as the *dwarsligger* (a book form in which the layout of a page from a conventional book is printed sideways on two pages of eight to twelve inches—pocket size), which has become highly popular in the Netherlands. Besides that, we are increasingly seeing hybrids of print and e-books, such as augmented books. An interesting example of a hybrid book was created as part of the Elektrolibrary project, in which a paper book was connected to a computer in order for the book to become a printed interface to the digital world. See Filip Visnjic, "Electrolibrary by Waldek Węgrzyn—Paper Book as Interface," CreativeApplications. Net, August 28, 2012, http://www.creativeapplications.net/objects/electrolibrary-by -waldek-wegrzyn-paper-book-as-interface/ and http://vimeo.com/47656204. In this respect, I will follow Johanna Drucker's critique of (too much) media specificity from the context of performative materiality. As she states, "When attention to media specificity slips into a literal approach to the interpretation of materiality it falls short of providing an adequate basis for critical analysis of the ways materiality works." Instead of a literal approach, she follows a performative approach towards analysis, in which a work is no longer seen as static but as processual. Here, media are seen as being produced out of an intra-action or an affectual relationship between the medium's affordances and its uses as part of interpretative processes. Drucker, "Performative Materiality and Theoretical Approaches to Interface."

95. Although one could argue that the web has a (hyper)textual basis and that its design was clearly influenced by the book—for instance, in its use of book metaphors, such as pages, browsing, bookmarking, scrolling, and so on.

Notes 277

96. Scientists are currently experimenting with storing data in DNA molecules. See, among others, Douglas Heaven, "Long-Term Storage of Information in DNA," *Science* 293, no. 5536 (August 16, 2012), https://doi.org/10.1126/science.293.5536 .1763c; Geraint Jones, "Book Written in DNA Code," *Guardian*, August 16, 2012, http://www.guardian.co.uk/science/2012/aug/16/book-written-dna-code.

97. Kember and Zylinska, *Life after New Media*, 4. See also Adema and Hall, "Political Nature of the Book."

98. Kember and Zylinska, *Life after New Media*, 4.

99. Karen Barad, "Reconceiving Scientific Literacy as Agential Literacy: Or, Learning How to Intra-Act Responsibly within the World," in *Doing Science +Culture*, ed. Roddey Reid and Sharon Traweek (New York: Routledge, 2000), 222.

100. Johanna Drucker, *The Century of Artists' Books*, 2nd ed. (New York: Granary Books, 2004).

101. Donna Haraway and Thyrza Goodeve, *How Like a Leaf: An Interview with Donna Haraway* (New York: Routledge, 1999), 101.

102. Barad, *Meeting the Universe Halfway*, 30.

Chapter 2

1. Foucault, "What Is an Author?," 222.

2. Mark Fisher, "Anti-Humanism and the Humanities in the Era of Capitalist Realism," *Open! Platform for Art, Culture & the Public Domain* (blog), October 1, 2013, http://www.onlineopen.org/essays/anti-humanism-and-the-humanities-in-the-era -of-capitalist-realism/; Samuel Weber, "The Future of the Humanities: Experimenting," *Culture Machine* 2 (January 1, 2000), https://culturemachine.net/the-university -culture-machine/the-future-of-the-humanities/.

3. Hall, *Pirate Philosophy*, 129.

4. Michael Nielsen, *Reinventing Discovery: The New Era of Networked Science* (Princeton, NJ: Princeton University Press, 2011).

5. Chartier, *Order of Books*, 24–25.

6. Chartier, *Order of Books*, 25–26.

7. Chartier, *Order of Books*, 27–29.

8. Chartier, *Order of Books*, 55.

9. Ong, *Orality and Literacy*, 128.

10. McLuhan, *Gutenberg Galaxy*, 104.

11. McLuhan, *Gutenberg Galaxy*, 130.

12. Ong, *Orality and Literacy*, 130–31.

13. Eisenstein, *Printing Press as an Agent of Change*, 18.

14. Eisenstein, *Printing Press as an Agent of Change*, 119–122.

15. Eisenstein, *Printing Press as an Agent of Change*, 121.

16. Eisenstein, *Printing Press as an Agent of Change*, 124.

17. Eisenstein, *Printing Press as an Agent of Change*, 192–193.

18. Eisenstein, *Printing Press as an Agent of Change*, 186.

19. Johns, *Nature of the Book*, 105.

20. Johns, *Nature of the Book*, 105.

21. Foucault, "What Is an Author?," 211–212.

22. Chartier, *Order of Books*, 50.

23. Johns, *Nature of the Book*, 138.

24. Febvre and Martin, *Coming of the Book*, 162.

25. Johns, *Nature of the Book*, 159–160.

26. Johns, *Nature of the Book*, 246.

27. Johns, *Nature of the Book*, 247.

28. Martha Woodmansee, "The Genius and the Copyright: Economic and Legal Conditions of the Emergence of the 'Author,'" *Eighteenth-Century Studies* 17, no. 4 (1984), https://doi.org/10.2307/2738129; Martha Woodmansee and Peter Jaszi, *The Construction of Authorship: Textual Appropriation in Law and Literature* (Durham, NC: Duke University Press, 1993).

29. Johns, *Nature of the Book*, 271.

30. Johns, *Nature of the Book*, 445.

31. Febvre and Martin, *Coming of the Book*, 159–160.

32. Johns, *Nature of the Book*, 632.

33. Chartier, *Order of Books*, 59.

34. Rosi Braidotti, *The Posthuman* (Cambridge: Polity Press, 2013), 26.

35. For more on the authorial *I* and communal *we* used throughout this book, see the introduction.

36. Kathleen Fitzpatrick, "The Digital Future of Authorship: Rethinking Originality," *Culture Machine* 12 (February 18, 2011): 3, https://culturemachine.net/wp-content /uploads/2019/01/6-The-Digital-433-889-1-PB.pdf.

Notes

37. Fitzpatrick, "The Digital Future of Authorship," 4.

38. Jacques Derrida, *Dissemination*, ed. Barbara Johnson (Chicago: University of Chicago Press, 1983), 3.

39. Merton talks about four sets of institutional imperatives, which together compromise the ethos of modern science: communism, universalism, disinterestedness, and organized skepticism (also known together as CUDOS). *Communism*, better known as *communality* or *communalism*, refers to the common ownership by the scientific community of the findings of science, which are a product of social collaboration. However, priority disputes abound in scholarly communication, partly through what Merton calls the *institutional norms of science*, of which *originality* is one. He states that "it is through originality, in greater or smaller increments, that knowledge advances." Robert K. Merton, *The Sociology of Science: Theoretical and Empirical Investigations* (Chicago: University of Chicago Press, 1973), 293.

40. Roland Barthes, "The Death of the Author."

41. Foucault, "What Is an Author?"

42. Foucault, "What Is an Author?"

43. Andrew Bennett, *The Author* (New York: Routledge, 2004), 3.

44. Barthes did however experiment with a different "language," a different style of writing, in his novel *Lover's Discourse: Fragments*, published in 1977. Foucault has discussed anonymous authorship in his writings (among others, in his essay "What Is an Author?" and in his interviews). Foucault, "What Is an Author?," 211. He has also conducted an anonymous interview with Christian Delacampagne for the French newspaper *Le Monde*, in which he states: "Why did I suggest that we use anonymity? Out of nostalgia for a time when, being quite unknown, what I said had some chance of being heard. With the potential reader, the surface of contact was unrippled. The effects of the book might land in unexpected places and form shapes that I had never thought of. A name makes reading too easy." Michel Foucault, "The Masked Philosopher," in *Politics, Philosophy, Culture: Interviews and Other Writings, 1977–1984*, new ed. (New York: Routledge, 1990), 323–324. Foucault also expressed his disappointment with the fact that, due to his fame and the immense popularity of his Collège de France seminars, he couldn't discuss and develop his work in progress further in a more interactive and collaborative (and less one-dimensional) setting. Michel Foucault, *"Society Must Be Defended": Lectures at the Collège de France, 1975–1976*, reprint ed. (New York: Picador, 2003), 1–3.

45. Ted Nelson coined the term *hypertext* in the early 1960s. See http://www2.iath.virginia.edu/elab/hfl0037.html.

46. George P. Landow, *Hypertext 3.0: Critical Theory and New Media in an Era of Globalization: Critical Theory and New Media in a Global Era*, 3rd ed. (Baltimore: Johns Hopkins University Press, 2006), 126.

47. Landow, *Hypertext 3.0*; Bolter, *Writing Space*.

48. Landow, *Hypertext 3.0*, 126.

49. Hayles, "Print Is Flat, Code Is Deep"; Jerome McGann, *Radiant Textuality: Literature after the World Wide Web* (New York: Palgrave Macmillan, 2004), 25.

50. Available at http://directory.eliterature.org/.

51. See http://directory.eliterature.org/basic-page/4579#overlay-context=consortium.

52. Ursula K. Heise, "Hypertext and the Limits of Interactivity," *21stC* 2, no. 3 (Spring 1998), http://www.columbia.edu/cu/21stC/issue-3.2/heise.html.

53. Bolter, *Writing Space*, 44; Fitzpatrick, *Planned Obsolescence*.

54. Todd Presner and Jeffrey Schnapp, "The Digital Humanities Manifesto 2.0," 2009, www.humanitiesblast.com/manifesto/Manifesto_V2.pdf. Similarly, Jamie "Skye" Bianco has emphasized that there is not one but there are many different digital humanities; as a discipline, digital humanities is thus multiple. Bianco, "This Digital Humanities Which Is Not One," in *Debates in the Digital Humanities*, ed. Matthew K. Gold (Minneapolis: University of Minnesota Press, 2012).

55. Fitzpatrick, *Planned Obsolescence*, 99.

56. Nielsen, *Reinventing Discovery*.

57. Blaise Cronin, "Hyperauthorship: A Postmodern Perversion or Evidence of a Structural Shift in Scholarly Communication Practices?," *Journal of the American Society for Information Science and Technology* 52 (May 2001): 559, https://doi.org/10.1002/asi.1097.

58. Jeremy P. Birnholtz, "What Does It Mean to Be an Author? The Intersection of Credit, Contribution, and Collaboration in Science," *Journal of the American Society for Information Science and Technology* 57 (November 2006): 1758–1770, https://doi.org/10.1002/asi.20380.

59. See Davide Castelvecchi, "Physics Paper Sets Record with More than 5,000 Authors," *Nature News*, May 15, 2015, https://doi.org/10.1038/nature.2015.17567. The hyperauthorship trend has been spreading to other fields too, including global epidemiology and climate science. See Dalmeet Singh Chawla, "Hyperauthorship: Global Projects Spark Surge in Thousand-Author Papers," *Nature*, December 13, 2019, https://doi.org/10.1038/d41586-019-03862-0.

60. Cronin, "Hyperauthorship," 562.

61. Birnholtz, "What Does It Mean to Be an Author?," 1764.

62. See https://github.com/akenall/Open-Contributorship-Badges/blob/master/Badge%20Files.md.

Notes 281

63. For the difference in the way authorship is constructed and functions within biomedicine and HEP, for instance, see Cronin, "Hyperauthorship."

64. Dorte Henriksen has analyzed the occurrence of collaborative authorship within thirty-four years of social sciences publication data. According to her findings, the more "science-like" fields (using large datasets, project teams, and statistical methods) show the highest rise in coauthorship, but overall coauthorship has risen in most areas of the social sciences regardless of research approach or method. Dorte Henriksen, "The Rise in Co-authorship in the Social Sciences (1980–2013)," *Scientometrics* 107, no. 2 (2016): 455–476. For instance, Cronin has shown how, with the growth in scale and complexity of psychological research, the need for formal and informal collaboration has grown, leading to changing disciplinary practices in relation to authorship. This can be evidenced by the growing importance of what is called *subauthorship collaboration*, collaboration that is made visible through acknowledgments in academic writing. This form of collaboration is visible in the rise and gradual establishment of acknowledgements as a constitutive element in the scholarly journal literature in the fields of psychology and philosophy. Blaise Cronin, Debora Shaw, and Kathryn La Barre, "A Cast of Thousands: Coauthorship and Subauthorship Collaboration in the 20th Century as Manifested in the Scholarly Journal Literature of Psychology and Philosophy," *Journal of the American Society for Information Science and Technology* 54 (June 2003): 855–871, https://doi.org/10.1002/asi.10278.

65. Willard McCarty and Marilyn Deegan, *Collaborative Research in the Digital Humanities* (New York: Routledge, 2016).

66. Lisa Spiro, "Examples of Collaborative Digital Humanities Projects," *Digital Scholarship in the Humanities* (blog), June 1, 2009, http://digitalscholarship.wordpress.com/2009/06/01/examples-of-collaborative-digital-humanities-projects/.

67. Michael Simeone et al., "Digging into Data Using New Collaborative Infrastructures Supporting Humanities-Based Computer Science Research," *First Monday* 16, no. 5 (May 2, 2011), https://firstmonday.org/ojs/index.php/fm/article/view/3372.

68. Anne Burdick et al., *Digital_Humanities* (Cambridge, MA: MIT Press, 2012), 124; Darren Wershler, Lori Emerson, and Jussi Parikka, *The Lab Book: Situated Practices in Media Studies* (Minneapolis: University of Minnesota Press, forthcoming).

69. Nicholas Bauch's interactive digital monograph *Enchanting the Desert* emerged from a collaboration between Stanford University's Center for Spatial and Textual Analysis and Stanford University Press and credits a team of nearly thirty contributors. As Bauch explains: "The crediting for this project draws from the film industry, which has a more nuanced method of acknowledging individual contributions than does academia. It serves as a potential model for born-digital scholarship." See http://enchantingthedesert.com/credits/. Although by now more than ten years old, for a good and extensive overview of the types and forms of collaboration in

the (digital) humanities, see Spiro, "Examples of Collaborative Digital Humanities Projects."

70. As Bethany Nowviskie describes it: "Alt-ac is the neologism and singularly-awkward Twitter hashtag we use to mark conversations about 'alternative academic' careers for humanities scholars. Here, 'alternative' typically denotes neither adjunct teaching positions nor wholly non-academic jobs." Nowviskie, "Introduction: Two Tramps in Mud Time," in *#Alt-Academy: 1 Alternative Academic Careers for Humanities Scholars* (MediaCommons, 2011), 7; Nowviskie, "Where Credit Is Due: Preconditions for the Evaluation of Collaborative Digital Scholarship," *Profession* 2011, no. 1 (November 2011): 169–181, https://doi.org/10.1632/prof.2011.2011.1.169; McCarty and Deegan, *Collaborative Research in the Digital Humanities*, 3.

71. Endre Danyi, "Samizdat Lessons for Mattering Press," *Installing (Social) Order* (blog), December 3, 2014, http://installingorder.org/2014/03/12/samizdat-lessons-for-mattering-press/.

72. Peter Verhaar, "Sharing Tales of the Dutch Revolt in a Virtual Research Environment," *Logos* 20, no. 1–4 (2009): 1–13.

73. Simeone et al., "Digging into Data Using New Collaborative Infrastructures Supporting Humanities-Based Computer Science Research."

74. On the development of this image and the continued importance of the myth of the lone genius and creativity in present day culture, see Alfonso Montuori and Ronald E. Purser, "Deconstructing the Lone Genius Myth: Toward a Contextual View of Creativity," *Journal of Humanistic Psychology* 35, no. 3 (July 1, 1995): 69–112, https://doi.org/10.1177/00221678950353005.

75. Fitzpatrick, "The Digital Future of Authorship," 9.

76. For a survey of social media use in research, see Cassidy R. Sugimoto et al., "Scholarly Use of Social Media and Altmetrics: A Review of the Literature," *Journal of the Association for Information Science and Technology* 68 (2017): 2037–2062, https://doi.org/10.1002/asi.23833; Ian Rowlands et al., "Social Media Use in the Research Workflow," *Learned Publishing* 24, no. 3 (2011): 183–195, https://doi.org/10.1087/20110306.

77. See http://www.livingbooksaboutlife.org/; https://manifold.umn.edu/; http://mcpress.media-commons.org/; http://futureofthebook.org/commentpress/; https://www.pubpub.org/; and https://web.hypothes.is/, respectively.

78. Susan Brown et al., "Published Yet Never Done: The Tension Between Projection and Completion in Digital Humanities Research," *Digital Humanities Quarterly* 3, no. 2 (2009), http://www.digitalhumanities.org/dhq/vol/3/2/000040/000040.html.

79. David Sewell, "It's For Sale, So It Must Be Finished: Digital Projects in the Scholarly Publishing World," *Digital Humanities Quarterly* 3, no. 2 (2009), http://www.digitalhumanities.org/dhq/vol/3/2/000039/000039.html.

Notes 283

80. Fitzpatrick, "The Digital Future of Authorship," 10.

81. See http://mcpress.media-commons.org/offthetracks/part-one-models-for-collabo-ration-career-paths-acquiring-institutional-support-and-transformation-in-the-field/a-collaboration/collaborators%E2%80%99-bill-of-rights/.

82. Julianne Nyhan and Oliver Duke-Williams, "Joint and Multi-Authored Publication Patterns in the Digital Humanities," *Literary and Linguistic Computing* 29, no. 3 (September 1, 2014): 387–399, https://doi.org/10.1093/llc/fqu018.

83. Fitzpatrick, *Planned Obsolescence*, 52.

84. Fitzpatrick, *Planned Obsolescence*, 56.

85. Hall, *Pirate Philosophy*, 131; Stanley Fish, "The Digital Humanities and the Transcending of Mortality," *Opinionator* (blog), *New York Times*, January 9, 2012, https://opinionator.blogs.nytimes.com/2012/01/09/the-digital-humanities-and-the-transcending-of-mortality/.

86. Hall, *Pirate Philosophy*, 132.

87. Nielsen, *Reinventing Discovery*.

88. Janneke Adema, "Reviving the Undead Book," *Cultural Studies* 28, no. 2 (2014): 346–349, https://doi.org/10.1080/09502386.2013.839728.

89. Fitzpatrick, *Planned Obsolescence*, 42–43. In her latest book, *Generous Thinking*, Fitzpatrick engages extensively with this issue and with how to enable dissensus, agonism, and internal difference within community, while also building shared forms of solidarity. As she argues:

> One key aspect of the problem with "the community," that is, might be less about "community" than about "the"; it's possible that acknowledging and foregrounding the multiple and multifarious communities with which all of us engage might help us avoid the exclusions that the declaration of groupness is often designed to produce, the "us" that inevitably suggests a "them." My hope is that my uses of the notion of community throughout this book might benefit from a variant on Gayatri Spivak's "strategic essentialism," a recognition that our definitions of community are always reductive, but also at least potentially useful as organizing tools. In this sense, "community" might serve not to evoke a dangerous, mythical notion of organic unity, but instead a form of solidarity, of coalition-building. (Kathleen Fitzpatrick, *Generous Thinking: A Radical Approach to Saving the University* [Baltimore: Johns Hopkins University Press, 2019], 11)

90. Sven Birkerts, *The Gutenberg Elegies: The Fate of Reading in an Electronic Age* (London: Faber & Faber, 1994); Andrew Keen, *The Cult of the Amateur: How Today's Internet Is Killing Our Culture and Assaulting Our Economy* (London: Nicholas Brealey Publishing, 2007).

91. See https://en.wikipedia.org/wiki/Reliability_of_Wikipedia#Expert_opinion.

92. Brown et al., "Published Yet Never Done"; Andrew Keen, "Why Google's Universal Library Is an Assault on Human Identity," *The Great Seduction* (blog), ZDNet,

March 6, 2007, http://www.zdnet.com/blog/keen/why-googles-universal-library-is-an-assault-on-human-identity/107; Claire Warwick, "Print Scholarship and Digital Resources," in *Companion to Digital Humanities*, ed. Susan Schreibman, Ray Siemens, and John Unsworth (Oxford: Blackwell Publishing Professional, 2004), http://www.digitalhumanities.org/companion/.

93. Eduardo Navas, *Remix Theory: The Aesthetics of Sampling* (New York: Springer, 2012), 136.

94. Eduardo Navas, "The Author Function in Remix," Remix Theory, May 22, 2008, http://remixtheory.net/?p=309.

95. Mark Rose, *Authors and Owners: The Invention of Copyright* (Cambridge, MA: Harvard University Press, 1993).

96. Bill D. Herman, "Scratching Out Authorship: Representations of the Electronic Music DJ at the Turn of the 21st Century," *Popular Communication* 4, no. 1 (2006): 24.

97. Herman, "Scratching Out Authorship," 23. Similarly, David Berry and James Boyle have argued that contemporary authorship and related notions of "creativity" are being "reconfigured to meet the needs of capital." Berry, *Copy, Rip, Burn: The Politics of Copyleft and Open Source* (London: Pluto Press, 2008), 42; Boyle, *Shamans, Software, and Spleens: Law and the Construction of the Information Society* (Cambridge, MA: Harvard University Press, 2009).

98. Herman, "Scratching Out Authorship," 34. It would be interesting to extend this analysis to the academic publishing industry and the role authorship plays here in commodification processes, something I touched upon earlier but will not discuss further in this context.

99. Gary Hall, "Fluid Notes on Liquid Books," in *Putting Knowledge to Work and Letting Information Play: The Center for Digital Discourse and Culture*, ed. Timothy W. Luke and Jeremy Hunsinger (Blacksburg, VA: Center for Digital Discourse and Culture, 2009).

100. For an overview of this controversy and the ensuing debate, see http://en.wikipedia.org/wiki/Reliability_of_Wikipedia#Comparative_studies.

101. See https://en.wikipedia.org/wiki/Wikipedia_talk:Etiquette.

102. For more on Jimmy Wales's push toward a flagged revisions moderation system, see https://bits.blogs.nytimes.com/2009/01/23/wikipedia-may-restrict-publics-ability-to-change-entries/. For more on Wikipedia admins, bureaucrats, or sysops, see https://en.wikipedia.org/wiki/Wikipedia:Administrators and https://en.wikipedia.org/wiki/Wikipedia:Bureaucrats.

103. Ayelet Oz, "'Move Along Now, Nothing to See Here': The Private Discussion Spheres of Wikipedia" (paper presented at Wikimania 2009, Buenos Aires, Argentina, August 26–28, 2009), http://papers.ssrn.com/abstract=1726450.

Notes

104. In many ways, Google Docs works according to a wiki format, in that it allows multiple authors to directly work on and edit a document. Yet Google Docs clearly distinguishes the edits made by each author by using different icons and text colors for each contributor, and it keeps a backup of all previous edits made.

105. Dakuo Wang, Haodan Tan, and Tun Lu, "Why Users Do Not Want to Write Together When They Are Writing Together: Users' Rationales for Today's Collaborative Writing Practices," *Proceedings of the ACM on Human-Computer Interaction* 1, no. CSCW (December 2017): 107, https://doi.org/10.1145/3134742.

106. Lawrence Lessig, *Remix: Making Art and Commerce Thrive in the Hybrid Economy* (New York: Penguin Press, 2008), xix.

107. David M. Berry, "On the 'Creative Commons': A Critique of the Commons without Commonalty," *Free Software Magazine*, July 15, 2005, http://freesoftwaremagazine.com/articles/commons_without_commonality/.

108. See http://creativecommons.org/licenses/ and http://creativecommons.org/about/cc0.

109. Niva Elkin-Koren, "Exploring Creative Commons: A Skeptical View of a Worthy Pursuit," in *The Future of the Public Domain*, ed. P. Bernt Hugenholtz and Lucie Guibault (Alphen aan den Rijn, Netherlands: Kluwer Law International, 2006), 2, http://papers.ssrn.com/abstract=885466.

110. Niva Elkin-Koren, "Exploring Creative Commons," 2.

111. Lessig, *Remix*. See in the UK, for instance, Sarah Marsh, "Cheating at UK's Top Universities Soars by 40%," *Guardian*, April 29, 2018, https://www.theguardian.com/education/2018/apr/29/cheating-at-top-uk-universities-soars-by-30-per-cent; Billy Kenber and Alexi Mostrous, "Universities Face Student Cheating Crisis," *Times*, January 2, 2016, https://www.thetimes.co.uk/article/universities-face-student-cheating-crisis-9jt6ncd9vz7.

112. Eduardo Navas, *Art, Media Design, and Postproduction: Open Guidelines on Appropriation and Remix* (New York: Routledge, 2018).

113. Rebecca Moore Howard, "Plagiarisms, Authorships, and the Academic Death Penalty," *College English* 57, no. 7 (November 1995): 708–736.

114. Kenneth Goldsmith, *Uncreative Writing: Managing Language in the Digital Age* (New York: Columbia University Press, 2011).

115. Kenneth Goldsmith, "It's Not Plagiarism: In the Digital Age, It's 'Repurposing,'" *Chronicle of Higher Education*, September 11, 2011, https://chronicle.com/article/Uncreative-Writing/128908/.

116. Goldsmith, *Uncreative Writing*, 12. See also Florian Cramer, "Post-Digital Writing," *Electronic Book Review*, December 12, 2012, http://electronicbookreview.com/essay/post-digital-writing/.

117. In *Uncreative Writing*, Goldsmith lists projects that have engaged with what in other circles or contexts might be seen as plagiarism:

Over the past five years we have seen works such as a retyping of Jack Kerouac's *On the Road* in its entirety, a page a day, every day, on a blog for a year; an appropriation of the complete text of a day's copy of the *New York Times* published as a nine-hundred-page book; a list poem that is nothing more than reframing a listing of stores from a shopping mall directory into a poetic form; an impoverished writer who has taken every credit card application sent to him and bound them into an eight-hundred-page print-on-demand book so costly that even he can't afford a copy; a poet who has parsed the text of an entire nineteenth-century book on grammar according to its own methods, even down to the book's index; a lawyer who re-presents the legal briefs of her day job as poetry in their entirety without changing a word; another writer who spends her days at the British Library copying down the first verse of Dante's *Inferno* from every English translation that the library possesses, one after another, page after page, until she exhausts the library's supply; a writing team who scoops status updates off social networking sites and assigns them to names of deceased writers ("Jonathan Swift has got tix to the Wranglers game tonight"), creating an epic, never-ending work of poetry that rewrites itself as frequently as Facebook pages are updated; and an entire movement of writing, called Flarf, that is based on grabbing the worst of Google search results: The more offensive, the more ridiculous, the more outrageous the better. (Goldsmith, *Uncreative Writing*, 3–4)

118. Kenneth Goldsmith, *Day* (New York: Figures, 2003).

119. Although it was actually Geoffrey Gatza, the editor of *Day*'s publisher, BlazeVox Books, who made the book, according to the production video that accompanied the publication. Johnson retracted his claims to authorship and to the originality of *Day* as a work completely. As reviewer Bill Freind writes in a review of *Day* in *Jacket Magazine*: "In fact, Johnson emailed me to say: 'After viewing Geoffrey Gatza's video, I realized that *Day* was no longer mine. I now fully disown my 'original' idea and separate myself completely from the book. *Day* now belongs to Geoffrey Gatza.' However, Gatza himself doesn't seem particularly eager to claim ownership of the text, since *BlazeVox Books* has a special Goldsmith-to-Johnson conversion kit. It's a free PDF file that includes the fake jacket blurbs and Johnson's name that you can download here." Bill Freind, "In the Conceptual Vacuum: On ~~Kenneth Goldsmith's~~ Kent Johnson's «Day»," *Jacket* 40 (Late 2010), http://jacketmagazine.com/40/freind-johnson-day.shtml.

120. Vanessa Place, "A Poetics of Radical Evil," *Lana Turner: A Journal of Poetry and Opinion* 3 (2010): 97–99.

121. Edmund Hardy, "'Nothing That's Quite Your Own': Vanessa Place Interviewed," *Intercapillary Space*, August 2011, http://www.intercapillaryspace.blogspot.co.uk/2011 /08/that-quite-your-own-interview-with.html.

122. Howard, "Plagiarisms, Authorships, and the Academic Death Penalty," 791.

123. Howard, "Plagiarisms, Authorships, and the Academic Death Penalty," 793.

124. Freind, "In the Conceptual Vacuum."

125. Place, "Poetics of Radical Evil."

Notes

126. Foucault, "What Is an Author?," 211–212.

127. Chartier, *Order of Books*, 49.

128. Uncertain commons, *Speculate This!* (Durham, NC: Duke University Press, 2013).

129. Uncertain commons, *Speculate This!*

130. Scott Drake, "Departure Acts: Anonymous Authorship in the Late Twentieth Century" (PhD diss., Simon Fraser University, 2011), 31–32.

131. Uncertain commons, *Speculate This!*

132. Drake, "Departure Acts," iii.

133. Drake, "Departure Acts," 32.

134. Nicholas Thoburn, *Anti-Book: On the Art and Politics of Radical Publishing* (Minneapolis: University of Minnesota Press, 2016), 187, https://muse.jhu.edu/book/49350.

135. Nicholas Thoburn, "To Conquer the Anonymous: Authorship and Myth in the Wu Ming Foundation," *Cultural Critique* 78, no. 1 (2011): 120, https://doi.org/10.1353/cul.2011.0016.

136. Thoburn, "To Conquer the Anonymous," 131.

137. This situation can also lead to *double dipping*, in which institutions end up paying twice in practice for a publication in hybrid journals, through APCs for individual articles *and* through subscriptions to the journal.

138. Neil Badmington, *Posthumanism* (New York: Palgrave, 2000), 9–10; Stefan Herbrechter, *Posthumanism: A Critical Analysis* (London: Bloomsbury, 2013).

139. N. Katherine Hayles, *How We Became Posthuman: Virtual Bodies in Cybernetics, Literature and Informatics* (Chicago: University of Chicago Press, 1999), 3.

140. Fisher, "Anti-Humanism and the Humanities in the Era of Capitalist Realism."

141. Barad, *Meeting the Universe Halfway*, 32.

142. Hanna Kuusela, "On the Materiality of Contemporary Reading Formations: The Case of Jari Tervo's Layla," *New Formations* 78, no. 1 (July 1, 2013): 65–82, https://doi.org/10.3898/NeWf.78.03.2013.

143. Janneke Adema and Gary Hall, "Posthumanities: The Dark Side of 'The Dark Side of the Digital,'" *Journal of Electronic Publishing* 19, no. 2 (Fall 2016), http://dx.doi.org/10.3998/3336451.0019.201.

144. Braidotti, *Posthuman*.

145. Gary Hall, "What Are the Digital Posthumanities?," Media Gifts, August 31, 2013, http://www.garyhall.info/journal/2013/8/31/what-are-the-digital-posthumanities.html.

146. Lesley Gourlay, "Posthuman Texts: Nonhuman Actors, Mediators and the Digital University," *Social Semiotics* 25, no. 4 (August 8, 2015): 1–2, https://doi.org/10.1080/10350330.2015.1059578.

147. Gourlay, "Posthuman Texts"; Bruno Latour, *Reassembling the Social: An Introduction to Actor-Network-Theory* (Oxford: Oxford University Press, 2005).

148. Gourlay, "Posthuman Texts," 2.

149. Fitzpatrick, *Planned Obsolescence*, 42–43.

150. Julia Flanders, "Collaboration and Dissent: Challenges of Collaborative Standards for Digital Humanities," in *Collaborative Research in the Digital Humanities*, ed. Willard McCarty and Marilyn Deegan (New York: Routledge, 2016), 67.

151. Flanders, "Collaboration and Dissent," 68.

152. Flanders, "Collaboration and Dissent," 79.

153. Hall, *Pirate Philosophy*, 8–9.

154. Uncertain commons, *Speculate This!*

155. Gary Hall explains this as follows: "Nor should the relationship between explicitly multiple and single forms of authorship be seen in either-or terms. Depending on the particular persona, voice, or semiotic function employed, I [. . .] at times put my name on the cover and spine of a print-on-paper codex book, even though I am aware it is written by the other in me, and that there are, as I say, multiple 'I's." Hall, *Pirate Philosophy*, 240.

156. Christian Bök, "The Piecemeal Bard Is Deconstructed: Notes toward a Potential Robopoetics," in "Object 10: Cyber Poetics," ed. Kenneth Goldsmith, *UbuWeb Papers*, Winter 2002, 10–18, http://ubu.com/papers/object/03_bok.pdf.

157. Bök, "Piecemeal Bard Is Deconstructed."

158. Goldsmith, *Uncreative Writing*, 13.

159. Google Poetics consists of poems based on Google autocomplete suggestions. See https://web.archive.org/web/20160316064438/http://www.googlepoetics.com/post/35060155182/info. Flarf poetry has been described as the "heavy usage of Google search results in the creation of poems." See http://www.poets.org/poetsorg/text/brief-guide-flarf-poetry. The Postmodernism Generator is a computer program that automatically creates random "postmodernist essays," written by Andrew. C. Bulhak, using the Dada Engine. See http://www.elsewhere.org/pomo/.

160. Hall, "Fluid Notes on Liquid Books," 40.

Notes

289

Chapter 3

1. Foucault, *Archaeology of Knowledge*, 25.

2. When I write about the book as an *object* here, I am referencing in the main Foucault's notion of *discursive objects*, as "it would be the interplay of the rules that make possible the appearance of objects during a given period of time" (Foucault, *Archaeology of Knowledge*, 36). Objects are thus not static entities but emerge out of or as part of certain discursive formations. At the same time, and as Barad has argued—extending her critique of Foucault—objects, in their process of materialization, are instrumental in shaping and influencing discourses. Hence discourse and materiality are ontologically inseparable. Barad, *Meeting the Universe Halfway*, 204.

3. Lisa Gitelman, *Always Already New: Media, History and the Data of Culture* (Cambridge, MA: MIT Press, 2006) , 2.

4. Fitzpatrick, *Planned Obsolescence*.

5. What I mean by this is that the system of scholarship as we know it today, including peer review, authorship, and copyright, is not and has never been a static institution but is historically contingent.

6. As Christine Borgman makes clear, "Scholarly communication is a rich and complex sociotechnical system formed over a period of centuries" (Borgman, *Scholarship in the Digital Age*, 48). This system takes on many forms, both formal and informal, and is best understood, Borgman states, "as a complex set of interactions among processes, structures, functions, and technologies" (Borgman, *Scholarship in the Digital Age*, 73). But as Borgman also points out, as a system, it builds upon a certain tradition in Western thought based on the free flow of information and quality control and the functions the system needs to fulfill in order to stimulate this. These functions ensure, among other things, quality, preservation and trust, access and dissemination, reputation and reward structures, and the efficiency and effectivity of the system as a whole. Janneke Adema and Paul Rutten, *Digital Monographs in the Humanities and Social Sciences: Report on User Needs* (Amsterdam: OAPEN Project, 2010).

7. See John Lechte, "The *Who* and the *What* of Writing in the Electronic Age," *Oxford Literary Review* 21, no. 1 (July 1, 1999): 140, https://doi.org/10.3366/olr .1999.008. Similarly, Chad Wellmon has extensively analyzed the relationship and coemergence of print and the modern research university. As he and Andrew Piper argue: "Over the course of the nineteenth century in Germany and the United States, the research university emerged as a system of paper and publishing. Its advocates, from Humboldt in Berlin to Gilman in Baltimore, cast its relationship to print as a primary source of its objectivity and, thus, the internal and external marker of prestige." Wellmon and Piper, "Publication, Power, and Patronage: On Inequality and Academic Publishing," *Critical Inquiry: A Journal of Art, Culture and Politics*, July 21,

2017; Chad Wellmon, *Organizing Enlightenment: Information Overload and the Invention of the Modern Research University* (Baltimore: Johns Hopkins University Press, 2015).

8. As with the discourse on the presumed fixity of the scholarly book—is fixity an intrinsic element of printed books, for instance, as Eisenstein suggests, or has it been imposed on the printed object by historical actors in their intentions with and uses of books, as Johns has pointed out (for more on this, see chapters 1 and 5)—a similar discussion has taken place with respect to the rise of the book as a knowledge object and a commodity within larger networks of trade and scholarly publishing. Was the process of commodification and object formation a direct effect of print technology, or an effect of the system of material production that arose around the book, turning it *into* a fixed commodity that could be sold and bartered?

9. See Matthew Arnold and Jane Garnett, *Culture and Anarchy* (Oxford: Oxford University Press, 2006); F. R Leavis, *Education & the University: A Sketch for an "English School"* (Cambridge: Cambridge University Press, 1979).

10. Bill Readings, *The University in Ruins* (Cambridge, MA: Harvard University Press, 1996), 17–18.

11. Stefan Collini, *What Are Universities For?* (London: Penguin, 2012), 21.

12. For instance, see George Monbiot's attack on commercial publishers: George Monbiot, "Academic Publishers Make Murdoch Look like a Socialist," *Guardian*, August 29, 2011, http://www.guardian.co.uk/commentisfree/2011/aug/29/academic-publishers-murdoch-socialist.

13. Thompson, *Books in the Digital Age.*

14. This does not mean that specific, targeted, and localized forms of critique, focused on reforming the copyright system, creating alternative economic models for publishing, or engaging in experiments to rethink our scholarly practices—such as this book is attempting to do—are not on their own important steps toward change. In their efforts to tip the balance of power and enable visions of the book and scholarship different from those based predominantly on the market, these endeavors should be encouraged. However, what I want to emphasize in this book, and in this chapter in particular, is that these localized interventions are capable of having consequences for the system as a whole. When developing progressive, affirmative strategies, I therefore want to argue that we need to take into account the genealogy of the book and our scholarly practices and should analyze and critique particular aspects of the book and book production as part of their wider entanglement with the academic communication system. This also does not mean we have to rethink everything all the time. Rather, it involves making specific decisions about what will be the most appropriate, responsible, effective, or strategic parts of the system to rethink at any particular time and in each specific historical or cultural situation. As I will explore in more detail in chapter 4, this involves a plea for forms

Notes

291

of experimental and relational publishing and for radical forms of open access that go beyond mere provision of access and argue for a continued rethinking of the whole system of scholarly communication, starting with the scholarly monograph.

15. See, among others, Bernard Houghton, *Scientific Periodicals: Their Historical Development, Characteristics, and Control* (Hamden, CT: Linnet Books, 1975); David A. Kronick, *Scientific and Technical Periodicals of the Seventeenth and Eighteenth Centuries: A Guide* (Metuchen, NJ: Scarecrow Press, 1991); Alan G. Gross, Joseph E. Harmon, and Michael S. Reidy, *Communicating Science: The Scientific Article from the 17th Century to the Present* (Oxford: Oxford University Press, 2002); Melinda Baldwin, *Making Nature: The History of a Scientific Journal*, illustrated edition (Chicago: University of Chicago Press, 2015); Alex Csiszar, *The Scientific Journal: Authorship and the Politics of Knowledge in the Nineteenth Century*, illustrated edition (Chicago: University of Chicago Press, 2018).

16. See Chartier, *Order of Books*; Eisenstein, *Printing Press as an Agent of Change*; Febvre and Martin, *Coming of the Book*; Johns, *Nature of the Book*; McLuhan, *Gutenberg Galaxy*; Ong, *Orality and Literacy*.

17. See Lewis A. Coser, Charles Kadushin, and Walter W. Powell, *Books: The Culture and Commerce of Publishing* (Chicago: University of Chicago Press, 1985); Thompson, *Books in the Digital Age*.

18. See, for example, Gene R. Hawes, *To Advance Knowledge* (New York: American University Press Services, 1967).

19. Ong, *Orality and Literacy*, 74, 89–91.

20. Ong, *Orality and Literacy*, 116.

21. McLuhan, *Gutenberg Galaxy*, 138; Febvre and Martin, *Coming of the Book*, 260.

22. Eisenstein, *Printing Press as an Agent of Change*, 168.

23. Eisenstein, *Printing Press as an Agent of Change*, 50.

24. Ong, *Orality and Literacy*, 120.

25. Eisenstein, *Printing Press as an Agent of Change*, 45.

26. Eisenstein, *Printing Press as an Agent of Change*, 478.

27. Eisenstein, *Printing Press as an Agent of Change*, 487–488.

28. Eisenstein, *Printing Press as an Agent of Change*, 560–561.

29. Eisenstein, *Printing Press as an Agent of Change*, 88.

30. Eisenstein, *Printing Press as an Agent of Change*, 140.

31. Eisenstein, *Printing Press as an Agent of Change*, 136.

32. Febvre and Martin, *Coming of the Book*, 109.

33. Eisenstein, *Printing Press as an Agent of Change*, 229.

34. Johns, *Nature of the Book*, 30–31.

35. Chartier, *Order of Books*, 9.

36. Chartier, *Order of Books*, 21.

37. Johns, *Nature of the Book*, 34.

38. Johns, *Nature of the Book*, 447.

39. Febvre and Martin, *Coming of the Book*, 109.

40. Febvre and Martin, *Coming of the Book*, 170.

41. Johns, *Nature of the Book*, 454.

42. Johns, *Nature of the Book*, 147.

43. Johns, *Nature of the Book*, 187.

44. Johns, *Nature of the Book*, 222.

45. Johns, *Nature of the Book*, 222.

46. Johns, *Nature of the Book*, 190.

47. Kronick, *Scientific and Technical Periodicals of the Seventeenth and Eighteenth Centuries*, 57.

48. Kronick, *Scientific and Technical Periodicals of the Seventeenth and Eighteenth Centuries*, 59–61. Not unlike blogposts today, Kronick mentions that in the seventeenth century, the journal was probably not accepted as a formal, definitive form of publication. These articles frequently were collected later by publishers and published in books.

49. Johns, *Nature of the Book*, 44.

50. Johns, *Nature of the Book*, 54–55; Steven Shapin, *A Social History of Truth: Civility and Science in Seventeenth-Century England* (Chicago: University of Chicago Press, 1994), 182–183.

51. Johns, *Nature of the Book*, 465.

52. Johns, *Nature of the Book*, 470, 480.

53. Jean-Claude Guédon, *In Oldenburg's Long Shadow: Librarians, Research Scientists, Publishers, and the Control of Scientific Publishing* (Washington, DC: Association of Research Libraries, 2001); Johns, *Nature of the Book*, 497. These were indeed learned *men*, it has to be noted. The Royal Society did not publish a paper by a woman until

Notes

1787: astronomer Caroline Herschel's description of a comet. For more on female fellows at the Royal Society, see Aileen Fyfe and Camilla Mørk Røstvik, "How Female Fellows Fared at the Royal Society," *Nature* 555, no. 7695 (March 2018): 159–161, https://doi.org/10.1038/d41586-018-02746-z.

54. Johns, *Nature of the Book*, 499.

55. Johns, *Nature of the Book*, 322.

56. Johns, *Nature of the Book*, 307.

57. Johns, *Nature of the Book*, 325.

58. Johns, *Nature of the Book*, 541.

59. Guédon, *In Oldenburg's Long Shadow*, 10.

60. Mario Biagioli, "From Book Censorship to Academic Peer Review," *Emergences: Journal for the Study of Media & Composite Cultures* 12, no. 1 (May 2002): 23, https://doi.org/10.1080/1045722022000003435.

61. Biagioli, "From Book Censorship to Academic Peer Review," 14.

62. Biagioli, "From Book Censorship to Academic Peer Review," 20.

63. Biagioli, "From Book Censorship to Academic Peer Review," 11–12.

64. Guédon, *In Oldenburg's Long Shadow*, 10.

65. To find an overview of the early history of the university press, one has to go back to 1967, to Gene Hawes's handbook on university press publishing—yet this is a narrative that focuses mainly on the United States. Hawes does provide a thorough history of the development of the university press in the US here, including the rapid growth of the sector until the end of the 1960s (especially after WWII). The next paragraphs, based on Hawes, will mostly concentrate on developments in these regions. Hawes, *To Advance Knowledge*, 11. Separate authoritative histories of individual university presses do exist, including those on Oxford University Press and Cambridge University Press in the UK. See David McKitterick, *A History of Cambridge University Press*, 3 vols. (Cambridge: Cambridge University Press, 2004); Ian Gadd, Simon Eliot, and Wm Roger Louis, eds., *The History of Oxford University Press*, 3 vols. (Oxford: Oxford University Press, 2013).

66. Thompson, *Books in the Digital Age*, 108.

67. Hawes, *To Advance Knowledge*, 30–31.

68. Hawes gives the following numbers: in 1870, there were only 560 colleges and universities with 5,600 professors and 52,000 students, which grew in size to some 24,000 professors and 240,000 students by 1900, and to 950 institutions, 36,000 teaching faculty, and 355,000 students by 1910.

69. Hawes, *To Advance Knowledge*, 33.

70. Hawes, *To Advance Knowledge*, 34.

71. Hawes, *To Advance Knowledge*, 38.

72. Hawes, *To Advance Knowledge*, 65.

73. Hawes, *To Advance Knowledge*, 126–127.

74. Janneke Adema, *Open Access Business Models for Books in the Humanities and Social Sciences: An Overview of Initiatives and Experiments (OAPEN Project Report)* (Amsterdam: OAPEN Project, 2010); John Brown, "University Press Publishing," *Journal of Scholarly Publishing* 1, no. 2 (January 1970): 134; Lindsay Waters, *Enemies of Promise: Publishing, Perishing, and the Eclipse of Scholarship* (Chicago: University of Chicago Press, 2004), 5.

75. Brown, "University Press Publishing," 134.

76. Thompson, *Books in the Digital Age*, 108; Brown, "University Press Publishing," 135.

77. Thompson, *Books in the Digital Age*, 98.

78. Albert Nicholas Greco, Clara Elsie Rodríguez, and Robert M. Wharton, *Culture and Commerce of Publishing in the Twenty-First Century* (Stanford, CA: Stanford University Press, 2006), 58.

79. William B. Harvey et al., "The Impending Crisis in University Publishing," *Journal of Scholarly Publishing* 3, no. 3 (April 1972): 196–198.

80. Greco, Rodríguez, and Wharton, *Culture and Commerce of Publishing in the Twenty-First Century*, 62.

81. Thompson, *Books in the Digital Age*, 109, 88–89.

82. Thompson, *Books in the Digital Age*, 125.

83. Hall, *Digitize This Book!*, 6.

84. Thompson, *Books in the Digital Age*, v.

85. Vincent Larivière, Stefanie Haustein, and Philippe Mongeon, "The Oligopoly of Academic Publishers in the Digital Era," *PLOS ONE* 10, no. 6 (June 10, 2015): e0127502, https://doi.org/10.1371/journal.pone.0127502. Also see Alejandro Posada and George Chen, "Inequality in Knowledge Production: The Integration of Academic Infrastructure by Big Publishers" (paper presented at ELPUB 2018, Toronto, Canada, June 2018), https://doi.org/10.4000/proceedings.elpub.2018.30.

86. Willinsky, *Access Principle*, 19.

87. Jean-Claude Guédon, *Between Excellence and Quality: The European Research Area in Search of Itself* (February 3, 2009), http://eprints.rclis.org/12791/. For a sustained

Notes

critique of the excellence narrative, also see Samuel Moore et al., "'Excellence R Us': University Research and the Fetishisation of Excellence," *Palgrave Communications* 3 (January 19, 2017): palcomms2016105, https://doi.org/10.1057/palcomms.2016.105.

88. Thompson, *Books in the Digital Age*, 61–63.

89. Waters, *Enemies of Promise*, 5.

90. Waters, *Enemies of Promise*, 6.

91. For a summary of what this "neoliberal turn" in higher education consists of, see Hall, *Digitize This Book!*, 1–2.

92. Waters, *Enemies of Promise*, 11.

93. Readings, *University in Ruins*, 3.

94. Readings, *University in Ruins*, 11.

95. Readings, *University in Ruins*, 91.

96. Waters, *Enemies of Promise*, 24.

97. Hall, *Digitize This Book!*, 11–12, 42.

98. Hall, *Digitize This Book!*; Readings, *University in Ruins*; Waters, *Enemies of Promise*.

99. As Thompson makes clear in one of his footnotes, his field logics draws selectively on Bourdieu's theory of fields, and Thompson extends Bourdieu's approach considerably. Thompson, *Books in the Digital Age*, 30.

100. Thompson, *Books in the Digital Age*, 7.

101. In Thompson's vision, academic publishing—that is, university press publishing—finds itself somewhere in between these two competing logics of the university and commercial scholarly publishing. Thompson, *Books in the Digital Age*, 175.

102. Whereas according to Thompson, the market logic structuring the publishing field "would tend to override any obligation they might feel to the scholarly community." Thompson, *Books in the Digital Age*, 98.

103. Collini, *What Are Universities For?*, 171.

104. Hall, *Digitize This Book!*, 43; Thompson, *Books in the Digital Age*, 177.

105. See, among others, "The Disposable Academic," *Economist*, December 16, 2010, http://www.economist.com/node/17723223; Aditya Chakrabortty and Sally Weale, "Universities Accused of 'Importing Sports Direct Model' for Lecturers' Pay," *Guardian*, November 16, 2016, https://www.theguardian.com/uk-news/2016/nov/16/universities-accused-of-importing-sports-direct-model-for-lecturers-pay; Koos Couvée, "Postgraduate Students Are Being Used as 'Slave Labour,'" *Independent*, May 27, 2012, http://www.independent.co.uk/news/education/education-news/postgraduate-students-are-being

-used-as-slave-labour-7791509.html; A. Lopes and I. Dewan, "Precarious Pedagogies? The Impact of Casual and Zero-Hour Contracts in Higher Education," *Journal of Feminist Scholarship* 7, no. 8 (2014): 28–42; Harriet Swain, "Zero Hours in Universities: 'You Never Know If It'll Be Enough to Survive,'" *Guardian*, September 16, 2013, http://www.theguardian.com/education/2013/sep/16/zero-hours-contracts-at-universities.

106. Thompson, *Books in the Digital Age*, 175. For an in-depth analysis, see Darnton, "New Age of the Book," 5.

107. Thompson, *Books in the Digital Age*, 177.

108. David Prosser, "The Next Information Revolution—How Open Access Repositories and Journals Will Transform Scholarly Communications," *LIBER Quarterly* 14, no. 1 (September 22, 2003), https://web.archive.org/web/20150912081322/http://liber.library.uu.nl/index.php/lq/article/view/URN:NBN:NL:UI:10-1-113359. For more on this, see https://roarmap.eprints.org/. In the European context, see also Plan S or cOAlition S (a group of national research funders, European and international organizations, and charitable foundations) and the adoption of ten principles toward the target of "full open access" by 2021: https://www.coalition-s.org/about/.

109. Berry, *Copy, Rip, Burn*, 39. See also, among others, Martin Eve, "Open Access, 'Neoliberalism,' 'Impact' and the Privatisation of Knowledge," *Martin Paul Eve* (blog), March 10, 2013, https://www.martineve.com/2013/03/10/open-access-neoliberalism-impact-and-the-privatisation-of-knowledge/; John Holmwood, "Commercial Enclosure: Whatever Happened to Open Access?," *Radical Philosophy* 181 (October 2013), http://www.radicalphilosophy.com/commentary/commercial-enclosure; Nathaniel Tkacz, "From Open Source to Open Government: A Critique of Open Politics | Ephemera," *Ephemera: Theory in Politics & Organization* 12, no. 4 (November 2012): 386–405. Sarah Kember refers in this respect to *policy-driven* open access, related to an economic agenda that is focused on research as innovation. Sarah Kember, "Opening Out from Open Access: Writing and Publishing in Response to Neoliberalism," *Ada: A Journal of Gender, New Media, and Technology*, no. 4 (April 21, 2014), http://adanewmedia.org/2014/04/issue4/.

110. Also see Stevan Harnad's "Subversive Proposal": https://en.wikipedia.org/wiki/Subversive_Proposal.

111. See Peter Suber, "Open Access Overview," December 29, 2004, http://legacy.earlham.edu/~peters/fos/overview.htm.

112. Although divided in its views on what openness is and should be, and how we should go about *achieving* open access, one can argue that there is such a thing as an open access movement. As Guédon has put it: "Open access became a movement after a meeting was convened in Budapest in December 2001 by the Information Program of the Open Society Institute. That meeting witnessed a vigorous debate about definitions, tactics, and strategies, and out of this discussion emerged two

approaches which have become familiar to all observers, friends, or foes." Jean-Claude Guédon, "The 'Green' and 'Gold' Roads to Open Access: The Case for Mixing and Matching," *Serials Review* 30, no. 4 (2004): 315, https://doi.org/10.1016/j.serrev.2004.09.005. And as Leslie Chan further outlines: "It was largely a grass roots movement, driven by librarians and academics and smaller independent publishers." Paula Clemente Vega, "Open Insights: An Interview with Leslie Chan," Open Library of Humanities, December 10, 2018, https://www.openlibhums.org/news/314/. To further the promotion of open access and achieve higher rates of adoption and compliance within the academic community, a number of strategic alliances have been forged between the various proponents of open access. It can be claimed that these alliances (those associated with green open access, for instance) have focused mostly on making the *majority* if not indeed *all* of the research *accessible* online without a paywall (*gratis open access*) as their priority. Although they cannot be simply contrasted with and opposed to the former (often featuring many of the same participants), other strategic alliances have focused more on gaining the trust of the academic community, trying to take away some of the fears and misunderstandings that exist concerning open, online publishing.

113. Stevan Harnad et al., "The Access/Impact Problem and the Green and Gold Roads to Open Access," *Serials Review* 30, no. 4 (2004): 310–314, https://doi.org/10.1016/j.serrev.2004.09.013; Guédon, "The 'Green' and 'Gold' Roads to Open Access."

114. For a more detailed description of the reasons that books and book publishing were slow to adopt to open access and open access publishing, see Adema and Hall, "Political Nature of the Book," 138–156.

115. Library spending on e-books has gone down, due to acquisition budget cuts and decisions to buy journals in STEM instead, which have seen rising subscription costs. This drop in library demand for HSS monographs has led university presses to produce smaller print runs and focus on marketable titles. This has been threatening the availability of specialized humanities research and has led to related problems for (mostly early-career) scholars, for whom career development within the humanities is directly coupled to the publishing of a monograph by a reputable press. For more on this, see, for example, Darnton, "New Age of the Book." As already discussed in the introduction to this book, this narrative of crisis can be misleading, presupposing an idealized past and the possibility of a teleological move beyond or out of this "crisis." In saying this, I do not intend to dismiss the dire situation in which book publishing finds itself, but I want to emphasize that the scholarly book has never been sustainable and in this sense would be in a perpetual crisis. Adema, *Open Access Business Models for Books in the Humanities and Social Sciences: An Overview of Initiatives and Experiments (OAPEN Project Report)*; Janneke Adema, "Embracing Messiness"; Garrett Cooper and Marx, "Crisis, Crisis, Crisis." In this respect, Sarah Kember's insights are valuable. She prefers instead to "recognise the genealogy of crisis that is, in effect, no crisis at all, but rather

an ongoing, dynamic and antagonistic encounter with all that is considered to be external to the humanities—digitisation and marketisation included." Kember, "Why Write?," 107. At the same time, however, we need to take heed of narratives that downplay the existence of a (recent, critical, current) crisis, to argue that the situation in book *publishing* (i.e., focusing predominantly on the production side) is actually better than it seems. When we focus more on the number of monographs being published than on the larger problems around marketization that the monograph crisis signals (affecting the kinds of books that increasingly *cannot* be published), we are in danger of dismissing what is in essence an ongoing and systemic situation, making it ever more urgent, a "chronic illness." Janneke Adema, "Monograph Crisis Revisited"; Sanford G. Thatcher, "Thinking Systematically about the Crisis in Scholarly Communication," in *The Specialized Scholarly Monograph in Crisis: Or How Can I Get Tenure If You Won't Publish My Book?*, ed. Mary Case (Washington DC: Association of Research Libraries, 1999).

116. Since 2015, I have been involved in Open Humanities Press as a board member.

117. For more on the rise of new university presses and academic-led presses, see Janneke Adema and Graham Stone, *Changing Publishing Ecologies: A Landscape Study of New University Presses and Academic-Led Publishing* (London: Jisc, June 30, 2017), http://repository.jisc.ac.uk/6666/; Janneke Adema and Graham Stone, "The Surge in New University Presses and Academic-Led Publishing: An Overview of a Changing Publishing Ecology in the UK," *LIBER Quarterly* 27, no. 1 (August 1, 2017), https://doi.org/10.18352/lq.10210.

118. Sigi Jöttkandt and Gary Hall, "Beyond Impact: OA in the Humanities" (Open Humanities Press Presentation, Brussels, February 13, 2007).

119. Adema, *Open Access Business Models for Books in the Humanities and Social Sciences*; Hall, *Digitize This Book!*; John Houghton, Bruce Rasmussen, and Peter Sheehan, *Economic Implications of Alternative Scholarly Publishing Models: Exploring the Costs and Benefits: A Report to the Joint Information Systems Committee* (London: JISC, January 2009).

120. Hall makes a subdivision in discourses concerning open access publishing motives. He distinguishes the liberal, democratizing approach; the renewed public sphere approach; and the gift economy approach. Hall, *Digitize This Book!*, 197.

121. Ernesto Laclau, *On Populist Reason* (London: Verso, 2005), 129–155. In a similar vein, Samuel Moore analyzes open access as a "boundary object": Samuel A. Moore, "A Genealogy of Open Access: Negotiations between Openness and Access to Research," *Revue Française Des Sciences de l'information et de La Communication*, no. 11 (August 1, 2017), https://doi.org/10.4000/rfsic.3220.

122. Tkacz, "From Open Source to Open Government: A Critique of Open Politics," 386.

Notes

299

123. Nathaniel Tkacz, *Wikipedia and the Politics of Openness* (Chicago: University of Chicago Press, 2014), 14.

124. Tkacz, "From Open Source to Open Government," 400.

125. Tkacz, "From Open Source to Open Government," 403.

126. Tkacz, "From Open Source to Open Government," 403.

127. Tkacz, "From Open Source to Open Government," 393.

128. Tkacz, "From Open Source to Open Government," 399. An argument can be made here, based on the work of Wendy Brown, that it is not so much an *open* politics as it is the logic of the free or open economy that underlies this governmentality. For one could assert that it is not an *open* politics that stimulates a neoliberal rhetoric, but the fact that there is *a lack of* politics altogether within neoliberalist forms of governmentality—following Brown's analysis of the waning of homo politicus and the rise of homo economicus in neoliberal systems. In this sense, the destruction of the democratic imaginary is again not based on an open politics, but on a lack of politics, on the demise of the idea of the demos. Wendy Brown, R. Celikates, and Y. Jansen, "Reclaiming Democracy: An Interview with Wendy Brown on Occupy, Sovereignty and Secularism," *Krisis* 2012, no. 3 (2012): 68–77.

129. Tkacz, "From Open Source to Open Government," 395, 399.

130. Tkacz, "From Open Source to Open Government," 386, 399.

131. The list of people critiquing or being critical of "openness" is actually quite extensive (and has grown significantly since Tkacz made this claim), especially if we expand it to works that focus on discourses related to cognitive capitalism and knowledge work. Some early critical explorations of openness can be found in the following works, among others: Pauline van Mourik Broekman, Michael Corris, and Josephine Berry Slater, eds., *Proud to Be Flesh: A Mute Magazine Anthology of Cultural Politics after the Net* (London: Mute Publishing, 2009); Hall, *Digitize This Book!*; Timothy W. Luke and Jeremy Hunsinger, eds., *Putting Knowledge to Work and Letting Information Play: The Center for Digital Discourse and Culture* (Blacksburg, VA: Center for Digital Discourse and Culture, 2009), http://www.cddc.vt.edu/10th-book/; Gaelle Krikorian and Amy Kapczynski, *Access to Knowledge in the Age of Intellectual Property* (Cambridge, MA: MIT Press, 2010).

132. Hall, *Digitize This Book!*, 197.

133. For two very different genealogies of openness and open access, see Samuel A. Moore, "Revisiting 'the 1990s Debutante': Scholar-Led Publishing and the Prehistory of the Open Access Movement," *Journal of the Association for Information Science and Technology* 71, no. 7 (2020): 856–866, https://doi.org/10.1002/asi.24306; Rebekka Kiesewetter, "Undoing Scholarship: Towards an Activist Genealogy of the OA Movement,"

Tijdschrift Voor Genderstudies 23, no. 2 (June 1, 2020): 113–130, https://doi.org/10.5117/TVGN2020.2.001.KIES.

134. Tkacz, "From Open Source to Open Government," 403.

135. Paul A. David, "The Historical Origins of 'Open Science': An Essay on Patronage, Reputation and Common Agency Contracting in the Scientific Revolution," *Capitalism and Society* 3, no. 2 (2008), http://papers.ssrn.com/abstract=2209188; Pamela O. Long, *Openness, Secrecy, Authorship: Technical Arts and the Culture of Knowledge from Antiquity to the Renaissance* (Baltimore: Johns Hopkins University Press, 2001); Koen Vermeir and Dániel Margócsy, "States of Secrecy: An Introduction," *British Journal for the History of Science* 45, no. 2 (2012): 153–164, https://doi.org/10.1017/S0007087412000052; Koen Vermeir, "Openness versus Secrecy? Historical and Historiographical Remarks," *British Journal for the History of Science* 45, no. 2 (2012): 165–188, https://doi.org/10.1017/S0007087412000064.

136. Long, *Openness, Secrecy, Authorship*, 102.

137. Long, *Openness, Secrecy, Authorship*, 180.

138. Long, *Openness, Secrecy, Authorship*, 209.

139. Long, *Openness, Secrecy, Authorship*, 243.

140. Long, *Openness, Secrecy, Authorship*, 250.

141. This coexistence and entanglement of open and secret knowledge right up to the eighteenth century has been corroborated by historian Paul David, among others. David, "Historical Origins of 'Open Science,'" 9.

142. Long, *Openness, Secrecy, Authorship*, 250.

143. Long, *Openness, Secrecy, Authorship*, 4.

144. Robert K. Merton, *The Sociology of Science: Theoretical and Empirical Investigations* (Chicago: University of Chicago Press, 1973); Derek J. de Solla Price, *Little Science, Big Science* (New York: Columbia University Press, 1969).

145. Vermeir and Margócsy, "States of Secrecy."

146. David, "Historical Origins of 'Open Science,'" 14–16.

147. Long, *Openness, Secrecy, Authorship*, 5.

148. Vermeir, "Openness versus Secrecy?," 165.

149. The same argument can be made with respect to the current method of hierarchization according to "impact factors" as part of our modern journal system, in which "indexed," high-impact journals are those that will be bought by libraries, while others mostly fall by the wayside. As Guédon explains:

Notes

301

> No longer was it sufficient to be a good scientist in order to do research; one also had to be part of an institution that could afford to buy the record of the "Great Conversation," i.e. to subscribe to the set of journals defined by SCI. And if one wanted to join the "Great Conversation," simply publishing in a journal recognized as scientific was no longer enough; it had to be a journal included in the SCI set of journals. All the other journals simply disappeared from most radar screens, particular when they could not be ranked according to a new device based on citation counts: the impact factor (IF). (Jean-Claude Guédon, "Sustaining the 'Great Conversation': The Future of Scholarly and Scientific Journals," in *The Future of the Academic Journal*, ed. Angus Phillips and Bill Cope, 2nd ed. [Oxford: Elsevier, 2014], 90–91.)

150. This entanglement of openness and secrecy continued throughout history and is visible, as Vermeir and Margócsy have argued, in the discrepancies between the Mertonian norms of communism and the security concerns of the McCarthy era, as well as in modern biotechnology, a scientific field communicating its findings amid a context of trade secrets and strict confidentiality. Vermeir and Margócsy, "States of Secrecy."

Chapter 4

1. Barad, *Meeting the Universe Halfway*, 393.

2. Adema and Hall, "Political Nature of the Book"; Eve, "Open Access, 'Neoliberalism,' 'Impact' and the Privatisation of Knowledge"; Benedikt Fecher and Sascha Friesike, *Open Science: One Term, Five Schools of Thought*, SSRN scholarly paper (Rochester, NY: Social Science Research Network, May 30, 2013), http://papers.ssrn.com/abstract=2272036; Hall, *Digitize This Book!*; John Holmwood, "Markets versus Dialogue: The Debate over Open Access Ignores Competing Philosophies of Openness," *Impact of Social Sciences* (blog), London School of Economics and Political Science, October 21, 2013, http://blogs.lse.ac.uk/impactofsocialsciences/2013/10/21/markets-versus-dialogue/; Kiesewetter, "Undoing Scholarship"; Moore, "Genealogy of Open Access."

3. As Tkacz states: "Rather than using the open to look forward, there is a pressing need to look more closely at the specific projects that operate under its name—at their details, emergent relations, consistencies, modes of organizing and stabilizing, points of difference, and forms of exclusion and inclusion." Tkacz, *Wikipedia and the Politics of Openness*, 38. For example, Tkacz has been doing this extensively for Wikipedia; see Nathaniel Tkacz and Geert Lovink, eds., *Critical Point of View: A Wikipedia Reader* (Amsterdam: Institute of Network Cultures, 2011); Tkacz, *Wikipedia and the Politics of Openness*.

4. Leslie Chan, "Platform Capitalism and the Governance of Knowledge Infrastructure," Zenodo, April 30, 2019, https://doi.org/10.5281/zenodo.2656601. Similarly, diverse schools of thought exist in relation to the concept and practice of open science, as Fecher and Friesike have argued on the basis of an extensive literary analysis. Fecher and Friesike, "Open Science."

5. The Working Group on Expanding Access to Published Research Findings, an independent group chaired by Professor Dame Janet Finch, was set up in October 2011 to examine how UK-funded research can be made more accessible. It released a report, *Accessibility, Sustainability, Excellence: How to Expand Access to Research Publications* (see https://web.archive.org/web/20191118174116/http://www.researchinfonet.org/publish/finch/), also known as the Finch report, in June 2012. On July 16, 2012, the UK government announced that it had accepted the report's recommendations (see https://www.gov.uk/government/news/government-to-open-up-publicly-funded-research). Janet Finch, *Accessibility, Sustainability, Excellence: How to Expand Access to Research Publications*, report of the Working Group on Expanding Access to Published Research Findings (June 18, 2012), https://www.sconul.ac.uk/sites/default/files/documents/finch-report-executive-summary.pdf. See also Kember, "Opening Out from Open Access"; Aguado López Eduardo and Becerril García Arianna, "Latin America's Longstanding Open Access Ecosystem Could Be Undermined by Proposals from the Global North | LSE Latin America and Caribbean," *LSE Latin America and Caribbean Blog*, November 6, 2019, https://blogs.lse.ac.uk/latamcaribbean/2019/11/06/latin-americas-longstanding-open-access-ecosystem-could-be-undermined-by-proposals-from-the-global-north/; Moore, "Common Struggles."

6. These radical open access experiments, albeit neither homogeneous nor predefined, tend to focus on both access *and* reuse, on a critique of the overly commercial political economy surrounding publishing, and on establishing both a practical and an experimental publishing practice. Radical open access can thus be seen as theories or practices of open access that are focused on openness as a means to critique established systems; rethink the book and the humanist understandings that accompany it; change scholarly practices by focusing on "doing" scholarship differently; explore experimentation; and finally—and perhaps most importantly in this context—critique the concept and practices of openness, as well as the dichotomies between closed and open and between the book and the net that keep being (re) introduced. The term *radical open access* was first introduced by Gary Hall during a talk at Columbia University, entitled "Radical Open Access in the Humanities" (Research without Borders, Columbia University, New York, 2010), but it draws inspiration from a wide-ranging set of practices and histories, from the groundbreaking community-led initiatives set up in Latin America to the early experiments with open-access journals in the HSS and a continuous tradition of grassroots activist work within academia and publishing. Dominique Babini, "Open Access Initiatives in the Global South Affirm the Lasting Value of a Shared Scholarly Communications System," *Impact of Social Sciences* (blog), London School of Economics and Political Science, October 23, 2013, https://blogs.lse.ac.uk/impactofsocialsciences/2013/10/23/global-south-open-access-initiatives/; Kiesewetter, "Undoing Scholarship"; Moore, "Revisiting 'the 1990s Debutante.'" For more on the radical open access philosophy, see Janneke Adema and Samuel Moore, "The Radical Open Access Collective: Building Alliances for a Progressive, Scholar-Led Commons," *Impact of*

Social Sciences (blog), London School of Economics and Political Science, October 27, 2017, http://blogs.lse.ac.uk/impactofsocialsciences/2017/10/27/the-radical-open -access-collective-building-alliances-for-a-progressive-scholar-led-commons/; James Smith, "Open Insights: An Interview with Janneke Adema and Sam Moore," Open Library of Humanities," April 16, 2018, https://www.openlibhums.org/news/278/; Janneke Adema and Samuel A. Moore, "Collectivity and Collaboration: Imagining New Forms of Communality to Create Resilience in Scholar-Led Publishing," *Insights* 31 (March 5, 2018), https://doi.org/10.1629/uksg.399.

7. By *cutting* things *together and apart*, I refer to Barad's use of the phrase *cutting together-apart*, meaning that a cut will not enact permanent boundaries but functions as a reconfiguring, an alternative, rearranged form of "cleaving." As Barad puts it: "As I have explained elsewhere, intra-actions enact agential cuts, which do not produce absolute separations, but rather cut together-apart (one move). Diffraction is not a set pattern, but rather an iterative (re)configuring of patterns of differentiating-entangling. As such, there is no moving beyond, no leaving the 'old' behind. There is no absolute boundary between here-now and there-then. There is nothing that is new; there is nothing that is not new." Karen Barad, "Diffracting Diffraction: Cutting Together-Apart," *Parallax* 20, no. 3 (2014): 168, https://doi.org /10.1080/13534645.2014.927623.

8. David Harvey, *A Brief History of Neoliberalism* (Oxford: Oxford University Press, 2007), 2.

9. Wendy Brown, "Neo-Liberalism and the End of Liberal Democracy," *Theory & Event* 7, no. 1 (2003), https://doi.org/10.1353/tae.2003.0020.

10. Hall, *Digitize This Book!*

11. Mark Olssen and Michael A. Peters, "Neoliberalism, Higher Education and the Knowledge Economy: From the Free Market to Knowledge Capitalism," *Journal of Education Policy* 20, no. 3 (2005): 313–345, https://doi.org/10.1080/02680930500108718.

12. Stuart Lawson, Kevin Sanders, and Lauren Smith, "Commodification of the Information Profession: A Critique of Higher Education under Neoliberalism," *Journal of Librarianship and Scholarly Communication* 3, no. 1 (March 10, 2015), https:// doi.org/10.7710/2162-3309.1182.

13. For more on the relationship between transparency and neoliberalism, see Clare Birchall, "Transparency, Interrupted: Secrets of the Left," *Theory, Culture & Society* 28, no. 7–8 (December 1, 2011): 60–84, https://doi.org/10.1177/0263276411423040; Clare Birchall, "Radical Transparency?," *Cultural Studies* ↔ *Critical Methodologies* 14, no. 1 (February 1, 2014): 77–88, https://doi.org/10.1177/1532708613517442.

14. Hall, *Digitize This Book!*

15. Eve, "Open Access, 'Neoliberalism,' 'Impact' and the Privatisation of Knowledge."

16. For instance, the protest of diverse groups of humanities scholars in the UK—such as the Council for the Defence of British Universities, the Royal Historical Society, the Political Studies Association, and the editors of twenty-one history journals attached to the Institute of Historical Research—was directly connected to the implementation of open access in the UK, as set out in the Finch report, among other places. Daniel Boffey, "Historians Warn Minister: Hands Off Our Academic Freedoms," *Guardian*, January 26, 2013, http://www.theguardian.com/education/2013/jan/26/historians-warn-minister-over-academic-freedom; Meera Sabaratnam and Paul Kirby, "Open Access: HEFCE, REF2020 and the Threat to Academic Freedom," *The Disorder Of Things* (blog), December 4, 2012, http://thedisorderofthings.com/2012/12/04/open-access-hefce-ref2020-and-the-threat-to-academic-freedom/. See also https://web.archive.org/web/20130117173147/http://www.history.ac.uk/news/2012-12-10/statement-position-relation-open-access. More recently, announcements from HEFCE (now Research England) about extending open access to monographs for the next REF (REF2027) led to further concern, protest, and critique by academics, among others, as set out in a position paper by the British Academy: "Open Access and Monographs: Where Are We Now?" (London: British Academy for the Humanities and Social Sciences, May 2018), https://www.britac.ac.uk/sites/default/files/British_Academy_paper_on_Open_access_and_monographs-May_2018.pdf.

17. Sabaratnam and Kirby, "Open Access."

18. For instance, Holmwood sees this as being imminent in the CC BY license promoted by RCUK (and Finch). For him, an alternative would be a noncommercial share-alike license. See Holmwood, "Commercial Enclosure: Whatever Happened to Open Access?," *Radical Philosophy* 181 (September/October 2013), http://www.radicalphilosophy.com/commentary/commercial-enclosure. See also Vincent W. J. van Gerven Oei, "Why CC BY-NC Licenses Are Still Necessary in Open Access Book Publishing," Punctum Papers, Punctum Books (PubPub), February 14, 2020, https://punctumbooks.pubpub.org/pub/creative-commons-by-nc-licensing-open-access/release/9.

19. As well as more regionally or globally with the development of Plan S, which has been criticized for "shifting funds from subscriptions towards article processing charges (APCs), whilst leaving the current communication system largely intact." Eduardo Aguado López and Arianna Becerril García, "The Commercial Model of Academic Publishing Underscoring Plan S Weakens the Existing Open Access Ecosystem in Latin America," *Impact of Social Sciences* (blog), London School of Economics and Political Science, May 20, 2020, https://blogs.lse.ac.uk/impactofsocialsciences/2020/05/20/the-commercial-model-of-academic-publishing-underscoring-plan-s-weakens-the-existing-open-access-ecosystem-in-latin-america/.

20. It does not have to be this way. The OAPEN-NL project, for instance, was heavily involved in experimenting with an author-pays model for books. However, their attempts were accompanied by an extensive study on the costs of monographs to

make these prices more transparent and to distinguish costs from profits, in order to promote a fairer subsidy system. Eelco Ferwerda, Ronald Snijder, and Janneke Adema, *OAPEN-NL: A Project Exploring Open Access Monograph Publishing in the Netherlands: Final Report* (The Hague: OAPEN Foundation, October 2013). Many scholar-led presses have also provided transparent information on their business models and costing structures. See, among others, Rupert Gatti, "Introducing Some Data to the Open Access Debate: OBP's Business Model (Part One)," *Open Book Publishers* (blog), October 15, 2015, http://blogs.openbookpublishers.com/introducing-some-data-to -the-open-access-debate-obps-business-model-part-one/; Gary Hall, "Open Humanities Press: Funding and Organisation," Media Gifts, June 13, 2015, http://www .garyhall.info/journal/2015/6/13/open-humanities-press-funding-and-organisation .html; Sebastian Nordhoff, "What's the Cost of an Open Access Book?," Language Science Press Blog, September 29, 2015, https://userblogs.fu-berlin.de/langsci-press /2015/09/29/whats-the-cost-of-an-open-access-book/; Sebastian Nordhoff, "Calculating the Costs of a Community-Driven Publisher," Language Science Press Blog, April 18, 2016, https://userblogs.fu-berlin.de/langsci-press/2016/04/18/calculating-the-costs -of-a-community-driven-publisher/; Martin Paul Eve, "How Much Does It Cost to Run a Small Scholarly Publisher?," *Martin Paul Eve* (blog), February 13, 2017, https://eve.gd /2017/02/13/how-much-does-it-cost-to-run-a-small-scholarly-publisher/; Lucy Barnes and Rupert Gatti, "The Cost of Open Access Books: A Publisher Writes," *Open Book Publishers* (blog), May 28, 2020, https://doi.org/10.11647/OBP.0173.0143; Vincent W. J. van Gerven Oei, Eileen Joy, and Dan Rudmann, "We Got the Receipts: The Punctum Books Financial and Activity Report 2016–2019," Punctum Papers, Punctum Books (PubPub), July 7, 2020, https://punctumbooks.pubpub.org/pub/punctum-books -financial-activity-report-2016-2019/release/5.

21. Richard Van Noorden, "Britain Aims for Broad Open Access," *Nature* 486, no. 7403 (June 19, 2012): 302–303, https://doi.org/10.1038/486302a.

22. Stevan Harnad, "Finch Report, a Trojan Horse, Serves Publishing Industry Interests Instead of UK Research Interests," *Open Access Archivangelism* (blog), June 19, 2012, http://openaccess.eprints.org/index.php?/archives/904-Finch-Report,-a-Trojan-Horse, -Serves-Publishing-Industry-Interests-Instead-of-UK-Research-Interests.html.

23. Finch, *Accessibility, Sustainability, Excellence*, 11. This increased role of universities in the publishing process will potentially have further consequences. There is a risk that BPCs or APCs risk disenfranchising independent, nonaffiliated, early career researchers and PhD students (or so-called para-academics), and those on casualized contracts, next to scholars from the Global South or in less wealthy institutions and those who create the kind of research that critiques the institutions of which we are a part, expressing viewpoints that don't meet with institutional approval. With APCs, a new set of gatekeepers—funders and institutions—will have to be navigated, and it is unclear how this dynamic will play out within the humanities especially. There are huge issues around governmentality here, and there is a risk that, similar

to the subscription system, we will be creating a market for APCs and BPCs based on the brand of the publisher. Taking a wider systemic perspective, for example, Martin Eve has estimated that implementing a BPC model for books in the UK following current market rates for BPCs (i.e., £11,000 in BPC at Palgrave Macmillan) would cost more than the entire SCONUL purchasing budget for all types of books. Eve, "Some Numbers on Book Processing Charge Scalability," *Martin Paul Eve* (blog), November 17, 2015, https://www.martineve.com/2015/11/17/some-numbers-on-book -processing-charge-scalability/.

24. Lawson, Sanders, and Smith, "Commodification of the Information Profession," 9.

25. Martin Paul Eve, *Open Access and the Humanities: Contexts, Controversies and the Future* (Cambridge: Cambridge University Press, 2014), 14.

26. Martin Eve, "Consortial Funding and Downward Price Pressure for Open Access," *Martin Paul Eve* (blog), June 16, 2016, https://www.martineve.com/2016/06 /16/consortial-purchasing-and-downward-price-pressure-for-open-access/.

27. Finch, *Accessibility, Sustainability, Excellence*, 5.

28. Finch, *Accessibility, Sustainability, Excellence*, 5.

29. As he states: "The broader matter at issue here is two competing philosophies of openness. One operates under a neo-liberal theory of knowledge, where the market serves to maximise the production and distribution of knowledge. The other is where the market is part of the problem and public institutions like universities serve democracy by facilitating debate and dialogue." Holmwood, "Markets versus Dialogue."

30. An important project to mention in this context—which I have been involved in as part of the ScholarLed collective of open access book presses, in collaboration with a consortium of libraries, universities, and technology providers—is the Community-led Open Publication Infrastructures for Monographs (COPIM) project (https://www.copim.ac.uk), which has as its main aim to deliver major improvements in the infrastructures used by open access book publishers and those publishers making a transition to open access books. As a project, it builds on theories that emphasize the political and sociotechnical nature of our publishing tools and infrastructure; for example, see Angela Okune et al., "Whose Infrastructure? Towards Inclusive and Collaborative Knowledge Infrastructures in Open Science," in *Connecting the Knowledge Commons—From Projects to Sustainable Infrastructure: The 22nd International Conference on Electronic Publishing—Revised Selected Papers*, ed. Pierre Mounier, Laboratoire d'idées (Marseille: OpenEdition Press, 2019), http://books.openedition .org/oep/9072. It does so within a context in which the takeover of community-built platforms by commercial entities is becoming ever more common, and we run the risk that "everything we have gained by opening content and data will be under threat if we allow the enclosure of scholarly infrastructures" (Geoffrey Bilder, Jennifer Lin, and

Cameron Neylon, *Principles for Open Scholarly Infrastructures—V1*, February 23, 2015, https://doi.org/10.6084/m9.figshare.1314859.v1). See also the Invest in Open Infrastructure statement at https://web.archive.org/web/20200917141622/https://investino pen.org/docs/statement0.2.

31. One of these groups, which was initiated after the first conference on radical open access, organized at Coventry University in 2015, is the Radical Open Access Collective (www.radicaloa.co.uk), a community of over seventy scholar-led, not-for-profit presses, journals, and other open access projects, which I have been involved in and have co-organized together with Samuel Moore from its inception.

32. More recently, Fitzpatrick has published *Generous Thinking: A Radical Approach to Saving the University*, which she has also developed in an open way by a process of community review—still using the CommentPress plug-in, but now on the Humanities Commons platform: http://generousthinking.hcommons.org/.

33. Jöttkandt and Hall, "Beyond Impact."

34. Sigi Jottkandt, "No-Fee OA Journals in the Humanities, Three Case Studies: A Presentation by Open Humanities Press" (paper presented at Berlin 5 Open Access: From Practice to Impact: Consequences of Knowledge Dissemination, Padua, Italy, September 19–21, 2008), 3–4, http://eprints.rclis.org/13121/.

35. Striphas, "Performing Scholarly Communication," 82.

36. Kathleen Fitzpatrick, "Introducing MediaCommons," *if:book* (blog), July 17, 2006, https://web.archive.org/web/20130911133628/http://www.futureofthebook.org/blog /archives/2006/07/introducing_mediacommons_or_ti.html.

37. Fitzpatrick, *Planned Obsolescence*, 156.

38. Jöttkandt and Hall, "Beyond Impact."

39. Striphas, "Acknowledged Goods," 18; italics in the original.

40. Gary Hall, "Liquid Theory" (paper presented at HumaniTech Conference, University of California, Irvine, US, April 3, 2008).

41. Jöttkandt and Hall, "Beyond Impact: OA in the Humanities."

42. Striphas, "Performing Scholarly Communication," 80.

43. Fitzpatrick, *Planned Obsolescence*, 10.

44. Jöttkandt and Hall, "Beyond Impact."

45. Fitzpatrick, *Planned Obsolescence*, 11.

46. Striphas, "Performing Scholarly Communication."

47. Hall, "Liquid Theory."

48. Kathleen Fitzpatrick, "Giving It Away: Sharing and the Future of Scholarly Communication," *Journal of Scholarly Publishing* 43, no. 4 (July 1, 2012): 347–362, https://doi.org/10.3138/jsp.43.4.347.

49. Striphas, "Performing Scholarly Communication," 82.

50. Etienne Balibar, "Historical Dilemmas of Democracy and Their Contemporary Relevance for Citizenship," *Rethinking Marxism* 20, no. 4 (2008): 522–538, https://doi.org/10.1080/08935690802299363.

51. Mark Poster, "Cyberdemocracy: Internet and the Public Sphere," in *Internet Culture*, ed. David Porter (London: Routledge, 1997), 205.

52. Hall, *Digitize This Book!*, 36.

53. Hall, *Digitize This Book!*, 179–180.

54. Hall, *Digitize This Book!*, 158–159.

55. Hall, *Digitize This Book!*, 178.

56. Hall, *Digitize This Book!*, 197–198.

57. Hall, *Digitize This Book!*, 195.

58. Chantal Mouffe, *Agonistics: Thinking the World Politically* (London; New York: Verso Books, 2013); Ernesto Laclau and Chantal Mouffe, *Hegemony and Socialist Strategy: Towards a Radical Democratic Politics*, 2nd rev. ed. (London: Verso Books, 2001), xi; Derrida, *Adieu to Emmanuel Levinas*; Jacques Derrida, *On Cosmopolitanism and Forgiveness* (London: Routledge, 2001); Barad, *Meeting the Universe Halfway*.

59. Hall, *Digitize This Book!*, 196–197; Mouffe, *Agonistics*.

60. Readings, *University in Ruins*, 11.

61. Readings, *University in Ruins*, 90–91; italics in the original.

62. Readings, *University in Ruins*, 167.

63. Readings, *University in Ruins*, 134.

64. Readings, *University in Ruins*, 160.

65. Readings, *University in Ruins*, 177.

66. Readings, *University in Ruins*, 187.

67. Hall, *Digitize This Book!*, 203.

68. Kember, "Opening Out from Open Access."

69. Joseph Alois Schumpeter, *The Theory of Economic Development: An Inquiry into Profits, Capital, Credit, Interest, and the Business Cycle* (London: Transaction Publishers, 1983), 66.

Notes

70. Schumpeter is also known for his adaptation of the concept of *creative destruction*, which stands at the base of current theories around *disruption*. As part of those theories, Clayton Christensen's take on *disruptive technologies*—that is, technologies that disrupt an already established market and value network—is perhaps most well-known. For an interesting intervention into this debate, see Pauline van Mourik Broekman et al., *Open Education: A Study in Disruption* (London: Rowman & Littlefield International, 2014).

71. Henry A. Giroux, "The University Debate: Public Values, Higher Education and the Scourge of Neoliberalism: Politics at the Limits of the Social," *Culture Machine: InterZone*, November 30, 2010), https://culturemachine.net/wp-content/uploads/2019/05/426-804-1-PB.pdf.

72. Henry A. Giroux, "The Terror of Neoliberalism: Rethinking the Significance of Cultural Politics," *College Literature* 32, no. 1 (2005): 10.

73. Kathleen Fitzpatrick, "Neoliberal," *Kathleen Fitzpatrick* (blog), December 12, 2012, http://www.plannedobsolescence.net/blog/neoliberal/.

74. Luigi Pellizzoni and Marja Ylönen, *Neoliberalism and Technoscience: Critical Assessments* (Farnham, UK: Ashgate Publishing, 2012).

75. Peter Roberts and Michael A. Peters, *Neoliberalism, Higher Education and Research* (Rotterdam: Sense Publishers, 2008).

76. Wendy McGuire, "Innovation Policy as Neoliberal Discourse and Strategy and the (Re) Stratification of the Scientific Field" (paper presented at 4S Annual Meeting, Washington, DC, October 28–31, 2009).

77. Joanna Zylinska, *The Ethics of Cultural Studies* (New York: Continuum, 2005), 38–39.

78. Raymond Williams, *Keywords: A Vocabulary of Culture and Society* (Oxford: Oxford University Press, 1976); Gregory J. Seigworth, "Cultural Studies and Gilles Deleuze," in *New Cultural Studies: Adventures in Theory*, ed. Clare Birchall and Gary Hall (Edinburgh: Edinburgh University Press, 2006).

79. Seigworth, "Cultural Studies and Gilles Deleuze."

80. Seigworth, "Cultural Studies and Gilles Deleuze"; Raymond Williams, *Marxism and Literature* (Oxford: Oxford University Press, 1977).

81. Weber, "Future of the Humanities: Experimenting."

82. Weber, "Future of the Humanities: Experimenting."

83. Simon O'Sullivan, "Cultural Studies as Rhizome—Rhizomes in Cultural Studies," in *Cultural Studies, Interdisciplinarity, and Translation*, ed. Stefan Herbrechter (Leiden, Netherlands: Brill, 2002), 81–93.

84. Barad, *Meeting the Universe Halfway*, 55–56.

85. Striphas, "Acknowledged Goods."

86. Striphas, "Performing Scholarly Communication," 82.

87. Tara McPherson, "Scaling Vectors: Thoughts on the Future of Scholarly Communication," *Journal of Electronic Publishing* 13, no. 2 (Fall 2010), http://dx.doi.org/10.3998/3336451.0013.208.

88. McPherson, "Scaling Vectors."

89. McPherson, "Scaling Vectors."

90. The CSeARCH archive was hosted by Teesside University and the landing page is archived via the Wayback Machine at https://web.archive.org/web/20150408114751/http://arc.tees.ac.uk:80/VLE/DOMAIN/CSEARCH/TABS/Search.asp.

91. Earlier experiments in the 1990s mainly took the form of open-access scholar-led journals. For an overview of this development, see Moore, "Common Struggles," 73–76.

92. Hall, *Digitize This Book!*, 19.

93. Hall, *Digitize This Book!*, 10.

94. I provide a more in-depth exploration of one of these projects, Living Books About Life, in the next chapter.

95. For example, it can be argued that it's hard to attribute ownership to a text that is collaboratively written—in a wiki environment, for instance. This in turns makes it harder for any of its authors to sell it, as they'd need approval from all others. Which in turns makes it harder for the forces of neoliberalism to privatize and commodify it (contingent on the copyright or left license used, of course).

96. Hall, *Digitize This Book!*, 207.

97. Hall, *Digitize This Book!*, 227.

98. Also see in this context (albeit without additional networking functionalities) MediArXiv, the open archive for media, film, and communication studies: https://mediarxiv.com/.

99. Alison Mudditt, "Humanities Commons: Networking the Humanities through Open Access, Open Source and Not-for-Profit," interview with Kathleen Fitzpatrick, *The Scholarly Kitchen*, December 21, 2016, https://scholarlykitchen.sspnet.org/2016/12/21/humanities-commons-networking-the-humanities-through-open-access-open-source-and-not-for-profit/.

100. Hall, *Digitize This Book!*, 76. As Derrida argues, with respect to deconstruction: "If there were continual stability, there would be no need for politics, and it is to the extent that stability is not natural, essential or substantial, that politics exists

Notes 311

and ethics is possible. Chaos is at once a risk and a chance, and it is here that the possible and the impossible cross each other." Jacques Derrida, "Remarks on Deconstruction and Pragmatism," in *Deconstruction and Pragmatism*, ed. Chantal Mouffe (London: Routledge, 2003), 86.

101. Think, for example, of how most openly available scholarly publications are either made available as PDFs or through Google Books' "limited preview" feature, both mimicking closed print formats online; of how many open licenses don't allow for reuse and adaptations; of how the open access movement has strategically been more committed to gratis than to libre openness; of how commercial publishers are increasingly adopting open access as just another profitable business model, retaining and further exploiting existing relations instead of disrupting them; of how new commercial intermediaries and gatekeepers parasitical on open forms of communication are mining and selling the data around our content to further their own pockets—like commercial SSRNs, such as Academia.edu and ResearchGate. In addition to all this, open access can do very little to further experimentation if it is met by a strong conservatism from scholars, their communities, and institutions, involving fears about the integrity of scholarly content and historical preferences for established institutions and brands and for the printed monograph and codex format in assessment exercises. These are just a few examples of how openness does not necessarily warrant progressive change and can even effect further closures.

102. The strategies described herein that seek to attain critical mass for open access and to stimulate open access book publishing and accessibility by focusing on print-based values and practices seem hard to combine with a simultaneous critical reflection on these practices. Conducting experiments with the form of electronic books in the digital age might be hard to do if at the same time we might not want to push too far, given this might risk estranging the average humanities scholar from the open access project.

103. For more on an ethics of care in relationship to open access and scholar-led publishing, see Stuart Andrew Lawson, "Open Access Policy in the UK: From Neoliberalism to the Commons" (PhD diss., Birkbeck, University of London, 2018); Moore, "Common Struggles."

104. Sebastian Abrahamsson et al., "Mattering Press: New Forms of Care for STS Books," *EASST Review* 32, no. 4 (December 2013), http://easst.net/easst-review-volume -32-4-december-2013/mattering-press-new-forms-of-care-for-sts-books/.

105. Julien McHardy, "Why Books Matter: There Is Value in What Cannot Be Evaluated.," *Impact of Social Sciences* (blog), London School of Economics and Political Science, September 30, 2014, http://blogs.lse.ac.uk/impactofsocialsciences/2014/09 /30/why-books-matter/.

106. Julien McHardy, "Like Cream: Valuing the Invaluable," *Engaging Science, Technology, and Society* 3 (February 17, 2017): 79.

107. McHardy, "Why Books Matter."

108. Joe Deville, quoted in Kember, "Why Write?"

109. Endre Danyi, "Samizdat Lessons for Mattering Press"; Susan Leigh Star, "The Sociology of the Invisible: The Primacy of Work in the Writings of Anselm Strauss," in *Social Organization and Social Process: Essays in Honor of Anselm Strauss*, ed. David R. Maines (New York: Transaction Publishers, 1991).

110. Tahani Nadim, "Friends with Books," in *The Commons and Care*, ed. Samuel Moore and Mattering Press (Coventry: Post Office Press and Rope Press, 2018), 29.

111. Nadim, "Friends with Books," 28.

112. Bunz, quoted in Kember, "Why Write?"

113. Jussi Parikka, "A Mini-Interview: Mercedes Bunz Explains Meson Press," *Machinology* (blog), July 11, 2014, https://jussiparikka.net/2014/07/11/a-mini-interview -mercedes-bunz-explains-meson-press/.

114. Sarah Kember, "Why Publish?," *Learned Publishing* 29 (October 1, 2016): 348–353, https://onlinelibrary.wiley.com/doi/full/10.1002/leap.1042.

115. Hall, *Pirate Philosophy*, 115.

116. Samuel Moore, "The 'Care-Full' Commons: Open Access and the Care of Commoning," in *The Commons and Care*, ed. Samuel Moore and Mattering Press (Coventry: Post Office Press and Rope Press, 2018), 23, https://hcommons.org/deposits /item/hc:19817/.

117. Terry Threadgold, *Feminist Poetics: Poiesis, Performance, Histories* (London: Routledge, 1997), 3.

118. Threadgold, *Feminist Poetics*, 16. For Threadgold, a poetics of rewriting goes beyond a passive analysis of texts as autonomous artifacts; the engagement with and appraisal of a text is actively performed, becoming performative, becoming itself a poiesis, a making; the "analyst" is embodied, becoming part of the complex socio-cultural context of meaning-making. Threadgold, *Feminist Poetics*, 85.

119. Mouffe, *Agonistics*, 17. For Retallack, a poethical attitude necessarily comes with the "courage of the swerve," in which "swerves (like antiromantic modernisms, the civil rights movement, feminism, postcolonialist critiques) are necessary to dislodge us from reactionary allegiances and nostalgias." In other words, they allow change to take place in already determined situations. A poetics of the swerve, of change, thus continuously unsettles our familiar routes and notions; it is a poetics of conscious risk, of letting go of control, of placing our inherited conceptions of ethics and politics at risk, and of questioning and experimenting with them. For Retallack, taking such a wager as a writer or an artist is necessary to connect our aesthetic registers to the "character of one's time," acknowledging the complexities

Notes

and changing qualities of life and the world. Joan Retallack, *The Poethical Wager* (Berkeley: University of California Press, 2004), 3, 18.

120. Drucker, *Century of Artists' Books*.

Chapter 5

1. John Updike, "The End of Authorship," *New York Times*, June 25, 2006, http://www.nytimes.com/2006/06/25/books/review/25updike.html.

2. Florian Cramer, "Unbound Books: Bound Ex Negativo" (The Unbound Book Conference, The Hague, 2011); Eisenstein, *The Printing Press as an Agent of Change*; Fitzpatrick, *Planned Obsolescence*.

3. Gary Hall, "Force of Binding: On Liquid, Living Books (Version 2.0: Mark Amerika Mix) | remixthebook," 2011, http://www.remixthebook.com/force-of-binding-on -liquid-living-books-version-2-0-mark-amerika-mix.

4. Blanchot, *Book to Come*; Derrida, *Paper Machine*. *Un Coup de Dés* is a modernist poem by the French poet Stéphane Mallarmé, using experimental forms of typography and typographical layout and free verse.

5. Johns, *Nature of the Book*.

6. A good visual and material example of the problems this creates is a work published by artist and writer James Bridle, *The Iraq War: A Historiography of Wikipedia Changelogs*. Bridle published the complete history of (every edit to) the English Wikipedia article on the Iraq War from December 2004 to November 2009, which resulted in a twelve-volume print publication. What this conceptual art project shows is, on the one hand, the incredible potential we now have in the digital age to indeed archive almost everything. On the other hand, it shows the futility and the impossibility of trying to preserve in a static form (both material and digital) the flows of information generated on the internet. See http://booktwo.org/notebook/wikipedia-historiography/.

7. This kind of temporal fixity can become very problematic where it concerns personal data, which the European Court ruling on the right to be forgotten responds to. See http://curia.europa.eu/jcms/upload/docs/application/pdf/2014-05/cp140070en.pdf.

8. Barad, *Meeting the Universe Halfway*, 139.

9. McPherson, "Scaling Vectors."

10. Tara McPherson, *Feminist in a Software Lab: Difference +Design* (Cambridge, MA: Harvard University Press, 2017), 19.

11. Johanna Drucker, "Mimicry or Invention?" (paper presented at FUTURES!, the 53rd Annual Rare Book and Manuscript Section [RBMS] Preconference, San Diego, CA, June 19–22, 2012), 3.

12. Drucker, "Mimicry or Invention?," 3.

13. Eisenstein, *Printing Press as an Agent of Change*.

14. Eisenstein, *Printing Press as an Agent of Change*, 52; Ong, *Orality and Literacy*, 121–123.

15. McLuhan, *Gutenberg Galaxy*, 78; Ong, *Orality and Literacy*, 124. McLuhan further argued that print enhanced visuality over audile-tactile culture, creating a predominantly visual-based world, thus promoting homogeneity, uniformity, and repeatability. McLuhan speaks in this respect of the frontier of two cultures and of conflicting technologies, which have led to the typographic and electronic revolutions, as he calls them. McLuhan, *Gutenberg Galaxy*, 141.

16. Ong, *Orality and Literacy*, 11. In oral culture, Ong explains, language is fluid and stories are adapted according to the situation and the specific audience, knowledge being stored in mnemonic formulas of repetition and cliché. With writing, these elaborate techniques were no longer necessary, freeing the mind for more abstract and original thinking. Ong, *Orality and Literacy*, 24, 59.

17. Eisenstein, *Printing Press as an Agent of Change*, 16.

18. As Eisenstein states, hand copying of manuscripts was based on luck or chance as the survival of a book or text depended on the shifting demand for copies by local elites, on copies being made by interested scholars, and on the availability and skills of scribes. Copies were also not always identical or identically multiplied, as hand-copying often led to variants in the text copied. Eisenstein, *Printing Press as an Agent of Change*, 46.

19. Eisenstein, *Printing Press as an Agent of Change*, 114.

20. Eisenstein, *Printing Press as an Agent of Change*, 170–172.

21. Febvre and Martin, *Coming of the Book*, 9.

22. Febvre and Martin, *Coming of the Book*, 320.

23. Eisenstein, *Printing Press as an Agent of Change*, 432. Although the early modern hand press did not, of course, meet modern standards of duplication, its development still meant that early print books were more fixed and standardized than hand-copied manuscripts. Eisenstein, *Printing Press as an Agent of Change*, 322.

24. Eisenstein, *Printing Press as an Agent of Change*, 80.

25. Eisenstein, *Printing Press as an Agent of Change*, 454.

26. Eisenstein, *Printing Press as an Agent of Change*, 124. Classical texts were recovered through print, offering adequate equipment to systematically explore and classify antiquity.

Notes

27. McLuhan, *Gutenberg Galaxy*, 126–127.

28. Eisenstein, *Printing Press as an Agent of Change*, 8.

29. This proved of the utmost importance for the commercial book trade, Eisenstein points out. Bookseller's lists were created to promote works and attract customers, for instance.

30. Eisenstein, *Printing Press as an Agent of Change*, 326.

31. Johns, *Nature of the Book*, 5–6.

32. Johns, *Nature of the Book*, 19–20.

33. Chartier, *Order of Books*, ix. According to Chartier, books aim at installing an order during their whole production process: there is the order of the author's intentions, of the institution or authority that sponsored or allowed the book, and the order imposed by the materiality or the physical form of the book via its diverse modalities.

34. Chartier, *Order of Books*, 10. In this respect, Chartier is interested in the relationship between the text, the book, and the reader. As he argues, reception and decipherment of material forms again take place according to the mental and affective schemes that make up the culture of communities of readers.

35. Johns, *Nature of the Book*, 36.

36. Johns, *Nature of the Book*, 31.

37. Johns, *Nature of the Book*, 35–36.

38. Johns, *Nature of the Book*, 32–33. Charges of piracy could lead to allegations of plagiarism (as Johns notes, "they were seldom *just* claims of piracy"), which meant that such charges had direct implications for the reputation of authors, as well as threatening the credibility attributed to their ideas, Johns argues. Piracy, he states, was always in a way accompanied by accusations of appropriation and (textual) corruption, meaning the violation of virtues and propriety, which would put at risk a scholar's authorship, knowledge, and livelihood, as well as those of a publisher or bookseller. Piracy, according to Johns, thus affected both "the structure and content of knowledge." Johns, *Nature of the Book*, 460, 33.

39. Johns, *Nature of the Book*, 147.

40. Johns, *Nature of the Book*, 167.

41. Johns, *Nature of the Book*, 624.

42. Johns, *Nature of the Book*, 188.

43. Johns, *Nature of the Book*, 542.

44. Johns, *Nature of the Book*, 188.

45. Johns, *Nature of the Book*, 259.

46. Howsam, *Old Books and New Histories*. We can see this focus on the malleability of texts in textual critics and book historians such as McGann, Marcus, McKenzie, and others too (including Johns, to some extent). McGann, *Radiant Textuality*; Leah Marcus, *Unediting the Renaissance: Shakespeare, Marlowe and Milton* (London: Routledge, 2002); McKenzie, *Bibliography and the Sociology of Texts*; David McKitterick, *Print, Manuscript, and the Search for Order, 1450–1830* (Cambridge: Cambridge University Press, 2003).

47. Bolter, *Writing Space*, 16.

48. Johns, *Nature of the Book*.

49. Janneke Adema, *Open Access Business Models for Books in the Humanities and Social Sciences*, 60. I am invoking here what Lawrence Lessig refers to as a *Read/Write* (RW) culture, as opposed to a *Read/Only* (RO) culture. Lessig, *Remix*, 28–29.

50. Janneke Adema, "Cut-Up," in *Keywords in Remix Studies* (New York: Routledge, 2017), 104–114, https://hcommons.org/deposits/item/hc:16745/.

51. Whereas open access (in its weak version) can be seen to focus mainly on accessibility (and in many cases wants to preserve the integrity of the work), open content includes the right to *modify* specifically. The problem is that when it comes to open access definitions and providers, some permit derivative works and some do not. The open knowledge definition encompasses both, as does the Budapest-Bethesda-Berlin (or BBB) definition of open access.

52. Foucault, "What Is an Author?," 218–220.

53. Fitzpatrick, "Digital Future of Authorship," 2.

54. In the United States, the Copyright Act defines *derivative work* in 17 USC § 101: "A 'derivative work' is a work based upon one or more preexisting works, such as a translation, musical arrangement, dramatization, fictionalization, motion picture version, sound recording, art reproduction, abridgment, condensation, or any other form in which a work may be recast, transformed, or adapted. A work consisting of editorial revisions, annotations, elaborations, or other modifications, which, as a whole, represent an original work of authorship, is a 'derivative work.'" See http://www.copyright.gov/title17/92chap1.html.

55. More ethical interventions in scholarly communication might start with—but are not limited to—a critical involvement with the various relationships in academic publishing by, for example: exercising an ethics of care with respect to the various (human and nonhuman) agencies involved in the publication process; a focus on the excessive amount of free and volunteer labor sustaining commercial publishing

and a concern with power and difference in academic life; experimenting with alternatives, such as new economic models and fair pricing policies, to counter exploitative forms of publishing; exploring how we can open up the conventions of scholarly research (from formats to editing, reviewing, and revising); and critically reflecting on the new potential closures we enact. Abrahamsson et al., "Mattering Press: New Forms of Care for STS Books"; Adema and Moore, "Collectivity and Collaboration"; Danyi, "Samizdat Lessons for Mattering Press"; Kember, "Why Write?"

56. Lev Manovich, *The Language of New Media* (Cambridge, MA: MIT Press, 2002).

57. Lev Manovich, *Remixing and Remixability*, October 2005, https://web.archive.org/web/20110323003009/http://www.manovich.net:80/DOCS/Remixability_2.doc.

58. Lev Manovich, *Software Takes Command* (New York: Bloomsbury, 2013), 46.

59. Manovich, *Remixing and Remixability*.

60. A *triplet* or *assertion* is the shortest meaningful sentence or statement: a combination of subject, predicate, and object. A *nanopublication* is the smallest unit of publishable information: an assertion about anything that can be uniquely identified and attributed to its author. See http://nanopub.org/wordpress/?page_id=65.

61. Joost G. Kircz, "Modularity: The Next Form of Scientific Information Presentation?," *Journal of Documentation* 54, no. 2 (May 1, 1998): 210–235, https://doi.org/10.1108/EUM0000000007185.

62. Barend Mons and Jan Velterop, "Nano-Publication in the e-Science Era" (paper presented at Workshop on Semantic Web Applications in Scientific Discourse [SWASD], 2009), 523, https://www.w3.org/wiki/images/4/4a/HCLS%24%24ISWC2009%24%24Workshop%24Mons.pdf.

63. McPherson argues that we can see this focus on the discreet in, among other things, digital technologies, in UNIX, and in languages like C and C++.

64. Tara McPherson, "Why Are the Digital Humanities So White? Or, Thinking the Histories of Race and Computation," in *Debates in the Digital Humanities*, ed. Matthew K. Gold (Minneapolis: University of Minnesota Press, 2012), 151, http://www.upress.umn.edu/book-division/books/debates-in-the-digital-humanities.

65. McPherson, "Why Are the Digital Humanities So White?," 144.

66. Tara McPherson, "Designing for Difference," *Differences: A Journal of Feminist Cultural Studies* 25, no. 1 (January 1, 2014): 179, https://doi.org/10.1215/10407391-2420039.

67. Manovich, *Remixing and Remixability*.

68. John Bryant, *The Fluid Text: A Theory of Revision and Editing for Book and Screen* (Minneapolis: University of Michigan Press, 2002), 2.

69. For the fluid text edition of Melville's *Typee*, see http://rotunda.upress.virginia.edu/melville/.

70. Bryant, *Fluid Text*, 174.

71. Bryant, *Fluid Text*, 113.

72. See http://liquidpub.org/.

73. Fabio Casati et al., *Liquid Publications: Scientific Publications Meet the Web*, May 13, 20011, http://citeseerx.ist.psu.edu/viewdoc/summary?doi=10.1.1.108.6070.

74. Bryant, *Fluid Text*, 85.

75. See http://www.futureofthebook.org/gamertheory2.0/?page_id=2. This refers mostly to *GAM3R 7H30RY 1.1*, which can be seen, as stated on the website, as a first stab at a new sort of *networked book*, a book that actually contains the conversation it engenders and, in turn, engenders it. Wark, *Gamer Theory*.

76. McKenzie, *Bibliography and the Sociology of Texts*, 4.

77. Eduardo Navas, "Regressive and Reflexive Mashups in Sampling Culture, 2010 Revision," *Remix Theory* (blog), August 13, 2010, http://remixtheory.net/?p=444.

78. Navas, "Regressive and Reflexive Mashups in Sampling Culture."

79. Navas, "Regressive and Reflexive Mashups in Sampling Culture"; Eduardo Navas, "Modular Complexity and Remix: The Collapse of Time and Space into Search," *Anthrovision: Vaneasa Online Journal*, no. 1.1 (July 1, 2013), https://doi.org/10.4000/anthrovision.324.

80. Navas has further developed and updated his position on the archive since his original blog post on regressive and reflexive mashups in sampling culture to further highlight how critical distance is difficult to achieve within current online forms of communication based on constant updating. See Eduardo Navas, "Regenerative Culture," *Norient*, March 27, 2016, http://norient.com/academic/regenerative-culture-part-15; Navas, *Art, Media Design, and Postproduction*. However, his analysis still implies that establishing critical distance through the archive is something that was possible (or easier to achieve) in predigital times, a position that I critique through my analysis of the politics of the archive, which complicates the idea that the archive has ever been able to provide "critical distance."

81. Jacques Derrida, *Archive Fever: A Freudian Impression* (Chicago: University of Chicago Press, 1996), 10.

82. Derrida, *Archive Fever*, 12–14.

83. Derrida, *Archive Fever*, 17.

84. On December 26, 2017, the Library of Congress announced it will no longer archive every tweet. As of January 1, 2018, the library has only been acquiring tweets

"on a very selective basis." See Gayle Osterberg, "Update on the Twitter Archive at the Library of Congress," *Library of Congress Blog*, December 26, 2017, https://blogs .loc.gov/loc/2017/12/update-on-the-twitter-archive-at-the-library-of-congress-2/.

85. Derrida, *Archive Fever*, 45. Derrida gives the example of Freud's archive and how, with the coming of digital media, a new vision of what constitutes an archive comes into being, which in turn will create a new vision of psychoanalysis.

86. Foucault, *Archaeology of Knowledge*, 146.

87. Matthew Kirschenbaum, "The .Txtual Condition: Digital Humanities, Born-Digital Archives, and the Future Literary," *Digital Humanities Quarterly* 7, no. 1 (2013), http:// www.digitalhumanities.org/dhq/vol/7/1/000151/000151.html; italics in the original.

88. Kirschenbaum, ".Txtual Condition."

89. Abby Smith, "Preservation in the Future Tense," *CLIR Issues*, no. 3 (May/June 1998): 1, 6, https://cool.culturalheritage.org/byorg/abbey/an/an22/an22-2/an22-202 .html.

90. Wolfgang Ernst, "Media Archaeography: Method and Machine versus History and Narrative of Media," in *Media Archaeology: Approaches, Applications, and Implications*, ed. Erkki Huhtamo and Jussi Parikka (Berkeley: University of California Press, 2011), 242.

91. Ernst, "Media Archaeography," 239; Kirschenbaum, ".Txtual Condition."

92. See the introduction and chapter 1 for a detailed discussion of diffraction as a methodology.

93. By engaging in a diffractive reading, this is a performative text too. This means that it is not only a piece of writing on the topic of remix and on "cutting things together and apart," but through its methodology it also affirmatively "remixes" a variety of theories from seemingly disparate fields, locations, times, and contexts. This might enable us to understand both the practice and concept of the cut and the entangled theories themselves better. This is akin to what the net artist Mark Amerika calls "performing theory." As a "remixologist," Amerika sees data as a renewable energy source; ideas, theories, and samples become his source material. By creating and performing remixes of this source material, which is again based on a mash-up of other source material, a collaborative interweaving of different texts, thinkers, and artists emerges, one that celebrates and highlights the communal aspect of creativity in both art and academia. Mark Amerika, *remixthebook* (Minneapolis: University of Minnesota Press, 2011).

94. In which apparatuses are conceptualized as specific material configurations that effect an agential cut between, and hence produce, subject and object. Barad, *Meeting the Universe Halfway*, 148.

95. Kember and Zylinska, *Life after New Media*.

96. Eduardo Navas, *Remix Theory*, 3.

97. For example, Henry Jenkins and Owen Gallagher talk about remix *cultures* and Lessig refers to remix as an R/W (Read/Write) *culture*, although they all see these cultures as embedded in technology and encapsulated by powers of material economic production. Lessig, *Remix*; Henry Jenkins, "Is It Appropriate to Appropriate?," in *Reading in a Participatory Culture: Remixing Moby-Dick in the English Classroom*, ed. Henry Jenkins and Wyn Kelley (New York: Teachers College Press, 2013); Henry Jenkins and Owen Gallagher, "'What Is Remix Culture?': An Interview with Total Recut's Owen Gallagher (Part One)," *Confessions of an Aca-Fan* (blog), June 2, 2008, http://henryjenkins.org/2008/06/interview_with_total_remixs_ow.html. An exception is Elisabeth Nesheim. In her talk "Remixed Culture/Nature," she argues for a different conception of remix, one that goes beyond seeing it as a cultural concept and explores principles of remix in nature. Although still starting from a position of *human agency*, she talks about bioengineering as a form of genetic remixing and about bioartists who remix nature/culture as a form of critique and reflection. Elisabeth Nesheim, "Remixed Culture/Nature. Is Our Current Remix Culture Giving Way to a Remixed Nature?" (paper presented at UIB: DIKULT 303 Remix Culture, November 2009).

98. Navas, *Remix Theory*, 12.

99. Navas, *Remix Theory*, 11–16.

100. Barad, "Posthumanist Performativity," 802.

101. See also Matthew Kirschenbaum's arguments on how digital copying equals preservation equals creation, as discussed in the previous section.

102. I am talking here about the fact that there is no onto-epistemological distinction between cutting and copying. From an ethical perspective, however, one might argue, as Navas has done extensively, that making a distinction between referencing ideas in conceptual and in material form might help us in our aim toward copyright reform. Eduardo Navas, "Notes on Everything Is a Remix, Part 1, 2, and 3," *Remix Theory* (blog), March 9, 2011, http://remixtheory.net/?p=480.

103. Barad, *Meeting the Universe Halfway*, 37.

104. Barad, *Meeting the Universe Halfway*, 23.

105. Barad, *Meeting the Universe Halfway*, 393.

106. Barad, *Meeting the Universe Halfway*, 178–179.

107. Karen Barad, Rick Dolphijn, and Iris Van der Tuin, "Interview with Karen Barad," in *New Materialism: Interviews & Cartographies* (Ann Arbor, MI: Open Humanities Press, 2012), 52, http://hdl.handle.net/2027/spo.11515701.0001.001.

108. Barad, *Meeting the Universe Halfway*, 348.

Notes

109. Kember and Zylinska, *Life after New Media*, 18.

110. Kember and Zylinska, *Life after New Media*, xvi. Akin to what the sociologist and feminist theorist Vicki Kirby calls "the cut of difference." Kirby, *Quantum Anthropologies: Life at Large* (Durham, NC: Duke University Press, 2011), 101.

111. Kember and Zylinska, *Life after New Media*, 168.

112. Kember and Zylinska, *Life after New Media*, 81–82.

113. Barad, "Posthumanist Performativity," 816.

114. Navas, *Remix Theory*, 61.

115. Navas, *Remix Theory*, 160.

116. Navas, *Remix Theory*, 92–93.

117. Navas, *Remix Theory*, 109.

118. Francesca Coppa, "An Editing Room of One's Own: Vidding as Women's Work," *Camera Obscura* 26, no. 2 (January 1, 2011): 123, https://doi.org/10.1215/02705346-1301557.

119. Kristina Busse and Alexis Lothian, "Scholarly Critiques and Critiques of Scholarship: The Uses of Remix Video," *Camera Obscura* 26, no. 2 (January 1, 2011): 141, https://doi.org/10.1215/02705346-1301575.

120. Coppa, "Editing Room of One's Own," 124, 128.

121. Elisa Kreisinger and Francesca Coppa, "Interview with Elisa Kreisinger," *Transformative Works and Cultures* 5 (July 15, 2010), https://journal.transformativeworks.org/index.php/twc/article/view/234/170.

122. Renee Slajda, "'Don't Blame the Media, Become the Media': Feminist Remix as Utopian Practice," *Barnard Centre for Research on Women Blog* (blog), May 30, 2013, http://bcrw.barnard.edu/blog/dont-blame-the-media-become-the-media-feminist-remix-as-utopian-practice/.

123. Elisa Kreisinger, "Queer Video Remix and LGBTQ Online Communities," *Transformative Works and Cultures* 9 (March 15, 2012), https://doi.org/10.3983/twc.2012.0395.

124. Martin Leduc, "The Two-Source Illusion: How Vidding Practices Changed Jonathan McIntosh's Political Remix Videos," *Transformative Works and Cultures* 9 (March 15, 2012), https://doi.org/10.3983/twc.2012.0379.

125. Paul D. Miller, *Rhythm Science* (Cambridge, MA: MIT Press, 2004), 37.

126. Miller, *Rhythm Science*, 24.

127. Miller, *Rhythm Science*, 61.

128. Amerika, *remixthebook*, 26.

129. Amerika, *remixthebook*, 28.

130. Amerika, *remixthebook*, 16, 63.

131. Amerika, *remixthebook*, 58, 40.

132. Foucault, *Power/Knowledge*, 194–195. "Apparatus" first appeared as a concept in Foucault's *History of Sexuality* (1976).

133. Foucault, *Power/Knowledge*, 195. In Agamben's vision, on the other hand, the apparatus is an all-oppressive formation, one that human beings stand outside of. Agamben here creates new binaries between inside/outside and material/discursive that might not be helpful for the posthuman vision of the apparatus I want to explore here. Giorgio Agamben, *What Is an Apparatus? And Other Essays* (Stanford, CA: Stanford University Press, 2009), 14.

134. Gilles Deleuze, "What Is a Dispositif?," in *Michel Foucault, Philosopher: Essays*, ed. Timothy J. Armstrong (Hemel Hempstead: Harvester Wheatsheaf, 1992).

135. Barad, *Meeting the Universe Halfway*, 141–142.

136. Barad, *Meeting the Universe Halfway*, 334.

137. See, for example, the way the PhD student as a discoursing subject is being (re) produced by the dissertation and by the dominant discourses and practices accompanying it. Janneke Adema, "Practise What You Preach."

138. N. Katherine Hayles, *How We Think: Digital Media and Contemporary Technogenesis* (Chicago: University of Chicago Press, 2012), 1.

139. Matt Fournier defines the term *line of flight* quite succinctly as follows: "*Line of flight*, a term developed by Gilles Deleuze and Félix Guattari in *A Thousand Plateaus* (1987), designates an infinitesimal possibility of escape; it is the elusive moment when change happens, as it was bound to, when a threshold between two paradigms is crossed." Matt Fournier, "Lines of Flight," *Transgender Studies Quarterly* 1, no. 1–2 (May 1, 2014): 121–122, https://doi.org/10.1215/23289252-2399785.

140. I have contributed texts/books/remixes to both projects, and my analysis ahead is thus partially written from a participant's perspective.

141. Amerika wrote the hypertext trilogy *GRAMMATRON*, *PHON:E:ME*, and *FILM-TEXT* and founded one of the oldest online net.art networks, Alt-X, in 1992. His various personas include remix artist, author, and professor of art and art history at the University of Colorado, Boulder.

142. Amerika, *remixthebook*, xiv–xv.

143. Amerika, *remixthebook*, xi.

Notes

323

144. *Patch* or *collage writing*, consisting of disconnected bits of writing pasted together in one work or collage, is relatively common in works of remix and appropriation art and theory and is explored in Jonathan Lethem's essay "The Ecstasy of Influence: A Plagarism" (*Harpers*, no. 1881 (2007): 59–72), David Shield's *Reality Hunger* (*Reality Hunger: A Manifesto* (New York: Vintage, 2011).), and Paul D. Miller's *Rhythm Science* (Miller, *Rhythm Science*). It is a practice that can be traced at least as far back as the cut-up methods applied by William Boroughs and the Dadaists.

145. Amerika, *remixthebook*, xiv–xv.

146. Amerika, *remixthebook*, xv.

147. Derrida remarks in his discussion of the significance of the signature that, although we cannot perceive it as a literal stand-in for an authentic and, with that, authoritative source, it does still function as and imply both the presence and the nonpresence of the signing subject. Derrida argues for a nonessentialist notion of the signature; the singularity of the event of signing is maintained (and with that the presence of the subject is maintained) in what Derrida calls a *past* and a *future now*. Through the signature as a performative act, the singularity of the original signing event is thus forever maintained in the signature and becomes iterative in every copy. Jacques Derrida, *Margins of Philosophy*, trans. Alan Bass (Chicago: University of Chicago Press, 1985).

148. Gary Hall, "Better Living through Sharing: Living Books About Life and Other Open Media Projects," Media Gifts, June 17, 2012, http://garyhall.squarespace.com /journal/2012/6/17/better-living-through-sharing-living-books-about-life-and-ot.html.

149. See the description of the Living Books About Life series on the Open Humanities Press website at http://www.openhumanitiespress.org/labs/living-books-about -life/.

150. Hall, "Fluid Notes on Liquid Books," 32.

151. The Open Humanities Press and Culture Machine Liquid Books series is a series of experimental digital "books" published under the (gratis/libre) conditions of both open editing and free content. See http://liquidbooks.pbworks.com/w/page /11135951/FrontPage.

152. See http://www.livingbooksaboutlife.org/blog/.

153. Liquid Author, "Future Books: A Wikipedia Model?," in *Technology and Cultural Form: A Liquid Reader* (Ann Arbor, MI: Open Humanities Press, 2010).

154. Bryant, *Fluid Text*, 26.

155. Bryant, *Fluid Text*, 26.

156. Jerome J. McGann, *Social Values and Poetic Acts: A Historical Judgment of Literary Work* (Cambridge, MA: Harvard University Press, 1988), 239–240.

157. McGann, *Radiant Textuality*, 225.

158. McGann, *Radiant Textuality*, 206; italics in the original.

159. Hayles, *Writing Machines*; McGann, *Radiant Textuality*, 206.

160. Janneke Adema, "The Poethics of Openness," in *The Poethics of Scholarship*, ed. Post Office Press (Coventry: Post Office Press and Rope Press, 2018), https://hcommons.org/deposits/item/hc:19815/; Retallack, *The Poethical Wager*.

161. Adema and Hall, "Political Nature of the Book," 138.

Index

Academic freedom, 164, 263–264n72, 304n16

Actor-network theory (ANT), 115

Aesthetics of bookishness, 15, 34, 186–187

Affirmative politics, 161, 239, 251n10

Agonism/antagonism, 35, 42, 117, 127, 149, 151, 177, 243, 283n89, 297–298n115. *See also* Mouffe, Chantal

Alternative academic (alt-ac), 92, 95, 282n70

Amerika, Mark, 231, 236, 239–243, 319n93, 322n141. See also *remixthebook* (book); Shareware

Ankersmit, Frank, 57

Annotation, 22, 29, 31, 89, 92, 93, 101, 243, 249n3, 316n54. *See also* Hypothesis

Apparatus (dispositif), 11, 19–20, 26, 35, 39, 114, 185, 230–231, 237–239, 241, 247, 253n21, 319n94, 322nn132–133

Appropriation, 66, 77, 78, 84, 89, 105–108, 208, 234, 286n117, 315n38, 323n144

Archive, 24, 39, 91, 187–188, 200, 203, 216, 224–228, 229, 231, 243–244, 250–251n6, 274n78, 310nn90, 98, 313n6, 318n80, 318–319n84, 319n85

Association of American University Presses (AAUP), 137, 138, 263–264n72

Attribution, 49, 81, 84, 87, 97, 100, 102, 124, 242

Audit criteria, 123, 142, 158, 159–163, 164

Author
 authorial civility, 78
 authorial *I* and communal *we*, 12, 278n35 (*see also I*s and *We*s)
 author-subject, 9, 10, 20, 79–81, 87, 114, 115, 117, 121, 159, 238, 256n42
 death of the, 72, 83–85, 98, 225
 name (brand) of, 82–83, 112, 99, 101, 110
 proprietary, 9, 77, 80, 81

Author function, 37, 46, 66, 71, 73–74, 79, 85, 88, 98–99, 101, 106, 108, 111, 119, 215, 222, 236

Authorship
 anonymous, 9, 37, 73, 98, 104, 108–112, 119, 222, 279n44
 antiauthorship (critique), 37, 103–112, 115, 117, 121
 autonomous, 9, 68, 69, 75, 80, 104, 115, 197, 229
 collaborative, 9, 21, 22–23, 24, 28, 29–30, 33, 37, 72–73, 77, 82–83, 86, 88, 102, 107, 109–111, 115–117, 169–170, 186, 221–222, 245, 257–258n48, 281n64, 310n95
 constrained, 74
 distributed, 10, 77

Authorship (cont.)

humanist, 1, 9, 27, 29, 37, 70, 72–73, 79, 81, 85, 95–97, 103–104, 114, 117, 159, 216, 229, 242

hyper, 72, 86, 90, 280n59

non-, 81

posthumanist, 12, 37, 83, 113, 115, 117, 121

rights and responsibilities model of, 90, 93

romantic, 9, 71, 74, 78, 80, 82–83, 85–87, 89, 91, 97, 103

single, 5, 25, 72, 89, 90, 94, 98, 186, 196, 222, 260n54

subauthorship collaboration, 281n64

Babini, Dominique, 302n6

Balibar, Étienne, 172–173, 174, 175

and democracy as model, 172–173

Barad, Karen, 14, 16, 19–20, 30, 35, 53, 54, 59, 61–65, 68, 70, 113, 157, 176, 177, 182, 185, 202, 219, 230, 232–233, 234, 236, 237, 239, 247, 253n21, 253n23, 254n26, 256n42, 275n81, 289n2, 303n7

and agential realism, 14, 19, 62–63

and entanglement, 3, 13–14, 19–20, 30, 35, 43, 55, 61, 64, 65, 119, 126, 136, 202, 224, 230, 238–239, 245, 246, 247, 248, 256–257n43, 290–291n14, 300n141, 301n150

and intra-action, 29, 63, 121–122, 157, 185, 196, 202, 212, 223, 234, 237, 253n23, 276n94, 303n7

and matter-in-the-process-of-becoming, 63

and mattering, 38, 64, 160, 191

and phenomena, 54, 62–63, 185, 202, 232

Barthes, Roland, 83–85, 86, 96, 99, 279n44

Benjamin, Walter, 182

Bergson, Henri, 182, 188

Biagioli, Mario, 135. *See also* Peer review

Bibliography, 41, 42, 46, 73, 204, 258–259n49, 273n70. *See also* Editorial theory; Textual criticism

Binaries (dichotomies), 6, 10, 11, 13, 14, 17, 20, 35, 44, 47, 60, 52, 54–55, 56–59, 60, 61, 63, 69, 74, 79, 81, 88, 115, 124, 125–127, 149–152, 157, 161, 168, 183, 196–197, 205, 211, 232, 235, 252–253n15, 255n34, 267n5, 302–303n6, 322n133

false divisions, 267n7

Birchall, Clare, 243–244, 303n13

Blanchot, Maurice, 13, 200

Blissett, Luther, 109, 111

Bök, Christian, 118

Bolter, Jay David, 16, 54, 59, 88, 212, 213

Book (monograph, scholarly book)

book-object, 3, 10, 14, 20, 110, 114–115, 121–123, 126, 127, 157, 159, 197, 204, 230, 238, 248, 256n42

codex format, 1, 5, 18, 38, 73, 199, 200, 203, 243, 254n14, 288n155, 311n101

as commodity, 6, 9, 36, 38, 68–70, 111–112, 115, 122–124, 128, 157, 158, 160, 162, 179, 194, 197, 203, 219, 237, 290n8

death of, 4, 6, 250n6, 270n31

definition of, 3

digital, 6–8, 18, 41–42, 43, 52, 69, 93, 146, 250–251n6, 252n12, 267n4, 270n31, 276n94, 297n115

and forms of (un)binding, 35–39, 202, 248

geography of, 51–52

incunabula, 128

intrinsic properties of, 9, 48–50, 63–64, 66–68, 74, 78, 205, 208–211, 290n8, 276n94

liquid or living, 1–2, 9, 27, 36–37, 39, 69, 93, 117, 122, 168, 172,

188, 200–201, 219–224, 228, 231, 239, 243–245, 247, 248, 249nn2–4, 310n94, 323n149, 323n151

manuscript, 8, 15, 18, 42, 50, 52, 74–77, 94, 128–129, 205, 206, 252n13, 258–259n49, 270n31, 314n18, 314n23

material formation of, 2–3, 5, 17–19, 60–65, 223, 276n94, 289n2, 315n33

networked, 213, 223, 318n75

politics of, 34, 36, 145, 148, 159, 162, 173, 197, 198, 234, 237, 239, 247–248

Bookfuturism, 270n40

Book history

Annales school, 41, 46, 47, 56, 57, 60, 74, 272n62

debate over the future of the book, 3, 5–6, 42–44, 59–61, 67, 144–145, 158, 198, 252–253n15

diffractive reading of, 16–17, 19, 44, 69–70, 230, 238, 248, 256–257n43, 319n93

discourse, 14, 17, 19, 20, 35, 36, 39, 42–60, 64–65, 69, 73–74, 79, 124, 128, 158, 205, 211–212, 269n19, 274n78

feminist-oriented, 59–60, 273n70

and historiography/genealogy, 14, 35, 41, 42–43, 53, 56–57, 66, 126, 134, 202, 211–212, 213

and manuscript culture, 74–77, 128–129, 206, 252n13, 270n31, 314n18, 314n23

performative, 17, 20, 158, 245–246

and reception history, 46, 74, 269n20, 315n34

and scribal culture, 75, 76, 206

and social constructionism, 48–49, 52, 54, 61–62

and technological determinism, 48–49, 52, 54, 61–62

teleological and antiteleological strands, 16, 52, 60, 254n28

Bourbaki, Nicolas, 109

Bourdieu, Pierre, 74, 142, 295n99

Braidotti, Rosi, 81, 114, 251n10

Brown, Wendy, 163, 299n128

Bryant, John, 216, 219–224, 245–246

and fluid texts, 216, 219–224, 245–246, 318n69

Butler, Judith, 27, 63, 254n26, 275n81

Calculative logics, 162, 164, 191, 197

Callon, Michel, 59

Care, 38, 160, 190–194, 197, 311n103, 316–317n55

CD-ROM, 87, 250n6

Censorship, 74, 108, 126, 130, 135

Chan, Leslie, 161, 296–297n112

Chartier, Roger, 19, 73, 74, 77, 78, 79, 82, 130, 208, 211, 252n14, 269n20, 274n78, 315nn33–34

Cognitive rationality, 141

Collaborators' Bill of Rights, 94

Collage, 236, 240, 323n144. *See also* Remix

Collini, Stefan, 125, 144

CommentPress, 33, 93, 169–170, 259n51, 260–261n57, 307n32

Commoning, 9, 194, 253n20

Commonwealth of learning, 47. *See also* Public sphere

Community, 12, 21, 23, 33–34, 74, 92–96, 101, 116, 117, 129, 132, 133, 135, 168–170, 172, 176, 190, 194, 210, 240–241, 249n3, 279n39, 283n89, 295n102, 296–297n112, 302–303n6, 306–307n30, 307nn31–32

Computational culture, 219

COPIM-project, 147, 306n30

Opening the Future, 264n75

Copy, 24, 75, 76, 77, 92, 131, 134, 204, 209, 228, 231, 286n117. *See also* Copyright; Cut

Copyright, 1, 5, 8, 9, 10, 11, 20, 22, 38, 43, 46, 68, 75–80, 102–104, 115, 134–136, 145, 146, 158, 171–172, 196–199, 203–204, 210, 217, 235, 237, 238, 242, 244, 257n47, 262–263n67, 289n5, 290n14, 310n95, 320n102. *See also* Creative Commons Licenses; Cut; DRM
Creative Commons Licenses, 8, 97, 102–103, 110. *See also* Copyright
Creative destruction, 309n70
Credentiality, 76–77, 97
Critical praxis, 25–27, 261n58, 261n60, 262–263n67
CSeARCH e-archive, 187–188, 310n90
Cultural studies, 26, 56, 177, 178, 181–185, 187, 188, 261n60
Culture Machine Liquid Books series, 1, 323n151
Cut. *See also* Copy
 affirmative, 26, 216, 230, 233, 234–235, 237, 239
 agential, 20, 64, 157, 219, 230, 232, 235, 237, 303n7, 319n94
 cutting together-apart, 37, 64, 162, 202, 232, 237, 247–248, 303n7, 319n93
 cutting well, 39, 231, 233–234, 235
 differential cutting, 230, 233
 historiographical, 212
 material-discursive, 158, 231–232
Cyberdemocracy, 173–174
 hypercyberdemocracy, 174

Darnton, Robert, 19, 44–46, 53, 252n12, 268nn9, 14. *See also* Publishing communication/value chain
Deformative act, 246
Deleuze, Gilles, 182, 237, 239, 253n21, 322n139
Derivative work, 215, 224, 316n51, 316n54

Derrida, Jacques, 1, 11, 65, 82, 174, 175, 176, 200, 226, 227, 233, 310–311n100, 319n85, 323n147
 and *différance*, 57, 233
Differences & Repetitions wiki, 169–170, 172, 186. *See also* Striphas, Ted
Differential text, 28, 259–260n53
Digital humanities, 10, 28, 42, 73, 86, 89, 91–95, 103, 110, 116, 121, 262–263n67, 267n5, 280n54, 281–282n69
Discourse (use of), 253n24
 discursive objects, 289n2
Dissensus, 110, 117, 176, 283n89
DJ figure, 99
DNA (as storage medium), 67, 194, 277n96
Drake, Scott, 110–111, 115
DRM, 8, 43, 68, 203. *See also* Copyright
Drucker, Johanna, 7–8, 116, 204, 254n25, 276n94
Dwarsligger, 276n94
Dynabook (Alan Kay), 41

Editorial theory, 224, 245–246, 258–259n49. *See also* Bibliography; Textual criticism
Eisenstein, Elisabeth
 debate with Johns, 35, 47, 48–56
 and importance to book history, 47–48, 269n19
 Printing Press as an Agent of Change (book), 47–48, 205, 269n19
Electronic Literature Directory (ELD), 87
Electronic Literature Organization, 87
Elektrolibrary, 276n94
Elkin-Koren, Niva, 103
Emergent genres, 186, 203, 247
Encyclopedia Britannica, 100
End/footnotes, 29–30, 205
Ernst, Wolfgang, 60, 228, 274n75
Espaces lisibles, 209

Index　　　　　　　　　　　　　　　　　　**329**

Esprit de système, 129, 207
Eve, Martin, 164, 265n78, 305–306n23
Experimentation
　as counterpoint to narratives of
　　innovation, 59, 178–180, 184,
　　185
　and cultural studies, 181–185
　in cultural studies publishing,
　　185–190, 239–245
　and experience, 180–183, 185
　as form of intervention and critique,
　　59, 178, 180, 183, 184–185

Febvre, Lucien, 41, 74, 78, 128, 129,
　131, 206
Feminist new materialism, 11, 14, 19,
　38, 58, 204, 237, 256–257n43
Finch report, 145, 161, 162, 164,
　165–169, 188, 302n5, 304n16,
　304n18
Fitzpatrick, Kathleen, 24, 25, 82, 89,
　93, 94, 95–96, 101, 116, 169–172,
　179, 188–189, 215, 259n51, 283n89,
　307n32
Fixity (also stability)
　inherent or transitive, 36, 43, 48, 51,
　　53, 67, 122, 202, 205–206, 208, 211,
　　220, 223
　and orality, 74–75, 122, 200, 205–206,
　　314nn15–16
Flanders, Julia, 116–117
Flarf, 118, 286n117, 288n159
Floating signifier, 148, 160
Foucault, Michel, 14–15, 19, 57, 58–59,
　60, 71, 83–86, 96, 108, 121, 163,
　215, 227, 237, 239, 253n21, 254n28,
　255n30, 256–257n43, 262n65,
　275n81, 279n44, 289n2. *See also*
　Penal appropriation
　and archaeology and genealogy,
　　14–15, 60
　and techniques of the self, 262n65
Frabetti, Federica, 116

Gathering, 200
Giroux, Henri, 179
Goldsmith, Kenneth, 105–107, 118,
　286n117, 286n119
Google, 149, 225, 226–227, 286n117
　Google Books, 226–227, 311n101
　Google Docs, 92, 101, 285n104
　Google poetics, 118, 288n159
Gourlay, Lesley, 115–116
Grusin, Richard, 16, 255n31
Guédon, Jean-Claude, 134–135, 136,
　296–297n112, 300–301n149

Hall, Gary, 27, 31, 71, 95, 114, 117, 119,
　139, 147, 148, 150, 171–172,
　173–177, 188, 243–244, 248, 259n51,
　264n73, 288n155, 298n120, 302n6
Haraway, Donna, 16, 19, 20, 35, 41, 55,
　59, 61, 256n43, 257n46
　and semiosis, 257n46
Harvey, David, 162
Hawes, Gene, 137–138, 293n65, 293n68
Hayek, Friedrich, 127, 149, 150
Hayles, Katherine, 18, 63, 113, 239, 247,
　255n39, 267n5
Herman, Bill, 99
Heteroglossia, 84
High-energy physics (HEP), 89–92,
　281n63
Holmwood, John, 165, 168, 304n18,
　306n29
Howsam, Leslie, 211, 273n70
Humanities Commons, 188, 214,
　259n51, 307n32. *See also* Social
　research sharing networks
Hyperpolitics, 175
Hyperspecialization, 143–144, 218
Hypertext, 18, 30, 37, 41, 67, 72, 73,
　85–89, 93, 100, 103, 107, 117, 121,
　200, 203, 279n45, 322n141
　hypertext fiction or hyperliterature,
　　87–88, 239
Hypothesis, 93, 101. *See also* Annotation

if:book London, 270n40
Index Thomisticus (Robert Busa), 267n4
Innovation, 7, 76, 159, 163–167, 178–181, 185, 189, 296n109
Intentionality, 46, 74, 98, 154, 223, 224, 246
Internet Archive, 225
Intertextuality, 75, 84
Is and *wes*, 12, 118, 278n35. *See also* Author, authorial *I* and communal *we*

Johns, Adrian, 48
 debate with Eisenstein, 35, 47, 48–56
 and importance to book history, 19, 35, 47, 48–51
 Nature of the Book (book), 48–53, 59, 269n18
Johnson, Kent, 106, 286n119

Kember, Sarah, 16, 54, 55, 67, 178, 192, 233–234, 267n7, 296n109, 297–298n115
Kierkegaard, Søren, 184,
Kirschenbaum, Matthew, 227–228, 267n5, 320n101
Kittler, Friedrick, 60
Kreisinger, Elisa, 235
Kronick, David A., 132, 134, 292n48

Laclau, Ernesto, 148, 176, 196
Lai, Chung-Hsiung, 57–60
Landow, George, 86
Latour, Bruno, 115
Lawson, Stuart, 166, 311n103
Lessig, Lawrence, 97, 102, 104, 316n49, 320n97
Levinas, Emmanuel, 65, 175, 275n91
Liberal humanism, 1, 9, 27, 68, 73, 80–81, 96, 100, 102–103, 112, 114, 117, 121, 216, 222, 229, 236
Library of Congress, 225
Licensing, 132, 133, 135, 145, 146, 210

LiquidPub project, 221–222
Liu, Alan, 116
Living Books About Life (book series), 1–2, 39, 231, 239, 243–245
Long, Pamela, 152–155

Mallarmé, Stéphane, 200, 313n4
Manifold platform, 93, 101, 249n3, 274–275n79
Manovich, Lev, 22, 97, 216–219, 222, 259n51
Martin, Henri-Jean, 41, 74, 78, 128, 129, 131, 206
Mattering Press, 118, 190–192
McGann, Jerome, 223, 224, 246–247, 258n49, 316n46
McLuhan, Marshall, 47, 48, 53, 55, 75, 128, 205, 207, 272n54, 314n15
McPherson, Tara, 116, 186–187, 203–204, 218–219, 317n63
Mechanical Encyclopedia (Ángela Ruiz Robles), 267n4
Media Archaeological Fundus (MAF), 274n75
Media archaeology, 14, 33, 42, 60–61, 273n74, 274n75, 274n78, 274–275n79
Media Archaeology Lab (MAL), 274n75
MediaCommons, 169–170
MediaCommons Press, 93, 169–170
MediArXiv, 310n98
Media-specific analysis (MSA), 18, 255n39
Merton, Robert, 82, 134, 153, 279n39, 301n150
 and institutional norms of science, 82, 134, 153, 279n39, 301n150
Metadata, 91, 228
Miller, Paul, 236, 323n144
Ming, Wu, 109–111
Minimal ethics, 65
MIT Press, 31–32, 33, 34
 Direct to Open (D2O), 31–32, 264n75
 MIT Press Direct platform, 31–32

Index 331

Modularity, 216–219, 221–222
Monograph. *See* Book (monograph, scholarly book)
Monograph crisis, 4, 138–139, 146–147, 297–298n115
Moore, Samuel, 194, 253n20, 294–295n87, 298n121, 299–300n133, 307n31, 310n91, 311n103
Mouffe, Chantal, 176, 196. *See also* Agonism/antagonism
Multimodal scholarship, 4–5, 25–26, 29, 31, 33, 73, 186–187, 189, 203–204, 213–214, 244, 247, 259–260n53

Nanopublications, 218, 317n60
Navas, Eduardo, 97–98, 216, 224–228, 231, 234, 235, 257n47, 318n80, 320n102
Neoliberalism, 4, 38, 110, 111, 115, 127, 141–144, 145, 147, 148–151, 159–168, 172, 175, 178–181, 183, 184, 185, 188, 190, 197, 299n128, 303n13, 310n95
Networked science, 72, 89, 95–96
New cultural history (or new historiography), 56
New historicism, 35, 43, 56–60, 61, 74, 272n62
Newton, Judith, 58
Nielsen, Michael, 96

Oldenburg, Henry, 133
Ong, Walter, 48, 74–75, 128, 205–206, 314n16
Open access
 archiving, 25, 146–147, 175, 177, 187–188, 214, 310n90
 author-pays model (APC/BPC), 31–32, 160, 164, 165–166, 265nn76–78, 287n137, 304n19, 304–305n20, 305–306n23

Budapest-Bethesda-Berlin (or BBB) definition of, 296–297n112, 316n51
business models, 4, 6, 169, 189, 297–298n115, 304–305n20
 and double-dipping, 32, 265n78, 287n137
gold, 146, 164, 165, 214
gratis, 214, 296–297n112, 311n101, 323n151
green, 146, 165–166, 214, 296–297n112
libre, 169, 214–215, 311n101, 323n151
movement, 145–146, 155, 167, 190, 296–297n112, 299–300n133, 311n101
publishing, 9, 33, 37, 127, 145, 148, 152, 162, 163, 165, 166, 167, 168, 169, 175, 177, 185, 188, 189, 184, 195, 214, 297n114, 298n120
radical, 36, 37, 38, 158, 159, 160–162, 168–169, 171–172, 173, 177–178, 180, 189–191, 194–195, 197, 247, 290–291n14, 302–303n6, 307n31
Open Book Publishers, 193, 265n76
Open Humanities Press, 1, 146, 147, 169, 171–172, 188, 193, 243, 244, 249n2, 298n116, 323n149, 323n151
Open(ness)
 definition of, 154, 214–215, 316n51
 infrastructure, 147, 168, 192–193, 306–307n30
 liberal, democratizing approach to, 150, 298n120
 libre, 215, 311n101
 open-closed dichotomy, 125–126, 127, 148, 152, 157, 183, 197, 229, 255n34, 302n6
 peer review, 9, 23–24, 169–170, 171–172
 politics, 27–28, 34, 36, 38, 145, 148–152, 155, 159, 160–162, 172–177, 180–181, 198, 204, 234, 235, 237, 239, 247, 248, 299n128, 310–311n100

Open(ness) (cont.)
 and secrecy, 127, 151–155, 160, 197, 255n34, 300n141, 301n150
 source movements, 145, 149
O'Shea, Alan, 27
O'Sullivan, Simon, 184–185
Othering, 10, 81, 142, 247
Oz, Ayelet, 100–101

Paratexts, 46
Parikka, Jussi, 250–251n6, 273–275n74–79
Patch or collage writing, 105, 107, 241, 323n144
Peer review, 9, 20, 23–24, 92, 114, 126, 135–136, 146, 157, 160, 169, 170, 171–172, 186, 192, 244, 262–263n67, 289n5. *See also* Biagioli, Mario
Penal appropriation, 77, 84, 108. *See also* Foucault, Michel
Performative materiality, 276n94
Performativity, 14–17, 20, 23, 33, 59, 62, 158, 182, 232, 245–247, 254n26, 275n81
Perloff, Marjorie, 28, 259–260n53
Persistent identifiers, 24, 43
Personas, 236, 239–240, 242, 322n141
PhD students, 144, 259n51, 262n63, 305–306n23, 322n137
Philosophical Transactions (journal), 132–134, 210
Piracy, 10, 78, 81, 102, 130–133, 209–210, 265n79, 268n14
Place, Vanessa, 106, 108
Plagiarism, 10, 37, 73, 75, 81, 83, 103–108, 112, 209, 286n117, 315n38
Planned Obsolescence (book), 95, 101, 169–170, 259n51. *See also* Fitzpatrick, Kathleen
Plan S, 296n108, 304n19
Poiesis, 195–196, 312n118
Popper, Karl, 127, 148–151
 and the open society, 148

Postdigital, 5, 8, 52, 68
Poster, Mark, 173–175, 177
Posthumanities, 9–12, 17, 73, 114, 193, 231, 239, 262–263n67
 digital, 114
Postmodernism Generator, 118, 288n159
Print
 intrinsic properties of, 9, 48–50, 63–64, 66–68, 74, 78, 205, 208–211, 276n94, 290n8
 print-based forms/conceptions, 2–3, 5, 6, 7–8, 11, 24, 25, 27, 36, 67, 68–69, 72, 80, 83, 93–94, 95, 100, 101, 107, 119, 178, 186, 190, 196, 197, 210, 212, 216, 228–230, 238, 243, 252n12, 311n102
 print-disciplining regime, 126, 132, 133–134
Print evolution or revolution, 35, 47–48, 50–51, 52–53, 206–208, 270n31, 314n15
Print paradigm, 33, 203, 215, 216
Print technology, 48, 76, 128–130, 205, 290n8
Project Gutenberg, 41
Propriety, 80, 126, 131–132, 133, 134, 157, 170, 172, 209, 210, 315n38
Prosumer, 87
Public sphere, 47, 147, 173, 175, 298n120. *See also* Commonwealth of learning
Publishing
 commercial, 4, 7, 23, 32, 37–38, 78–79, 80, 83, 112, 124–125, 127, 128, 129–132, 136–143, 145–148, 159, 168, 170–171, 189, 191, 195, 203, 213, 238, 263–264n72, 265nn76–77, 290n12, 295n101, 302–303n6, 311n101, 315n29, 316–317n55
 community-led, 147, 168, 302–303n6, 306–307n30
 corporate concentration of, 139–140

Index 333

fluid or processual, 1, 9, 14, 22, 23, 25, 27, 28, 29, 33, 34, 35, 37, 39, 43, 60, 68, 93–94, 101, 115, 117, 118, 123, 159, 161, 188, 193, 201, 203, 204, 212–216, 219, 222–224, 230–231, 238, 246–248, 249n3, 260n54, 262–263n67, 274–275n79, 276n94

and international book trade, 51, 54, 79–80, 123–124, 129–132, 315n29

and modern system of scholarly communication, 122, 124, 126–141, 154, 160, 186

modular, 39, 202–203, 217–219, 221–222, 223, 228, 229, 239

new university press, 298n117

not-for-profit, 142, 167–173, 188, 191, 194, 214, 263–264n72, 307n31

as relational practice, 13, 20, 28, 38, 63, 121, 122–123, 159–160, 162, 190, 193–194, 197–198, 260n54, 290–291n14

scholar/academic-led, 1, 38, 146, 160, 167–171, 188, 190–191, 195, 263–264n72, 265n76, 298n117, 304–305n20 306–307nn30–31, 310n91, 311n103

university press, 32, 126, 136–144, 146, 263–264n72, 265n76, 293n65, 295n101, 297–298n115, 298n117

Publishing communication/value chain, 44–46, 268n14. *See also* Darnton, Robert

Publishing function, 23, 125, 137, 142–143

PubPub, 92, 93, 249n3

RACTER, 118

Reading practices, 74, 200, 209, 276n94

Readings, Bill, 125, 176–177

and University of Excellence, 141–142, 159, 176–178

Reformation, 47–48, 206, 207–208

Remediation, 14, 16, 66, 213

Remix. *See also* Collage; Sampling

and mash-up, 99, 217, 222, 224, 225, 240, 241, 242, 260n54, 318n80, 319n93

reflexive, 234, 318n80

regressive, 234, 318n80

remixer/selector/curator/moderator, 8, 86, 97–100, 102, 105, 224, 242

remixthebook (book), 39, 231, 239–243. *See also* Amerika, Mark

Remix videos, 234–235

Representationalism, 14, 53, 62, 232

Reputation economy, 87, 89, 90, 94, 97, 102, 104, 105, 115, 197

Research Excellence Framework (REF), 30, 71, 164, 263–264n72, 304n16

Research impact, 71, 81, 82, 143–144, 147, 159, 163–164, 300–301n149

impact factors, 300–301n149

Retallack, Joan, 196, 247, 312–313n119

poetics of the swerve, 312–313n119

Robopoetics, 118

Rose, Mark, 74

Royal Society, 126, 130, 133–135, 143, 310, 292–293n53

R/W (Read/Write) culture, 86, 172, 243, 316n49, 320n97

Sampling, 98, 224–225, 231, 234, 236, 240, 318n80, 319n93. *See also* Remix

San Francisco Declaration on Research Assessment (DORA), 263–264n72

ScholarLed collective, 306–307n30

Scholarly poethics, 12, 26, 28, 38, 194–197, 247

Schumpeter, Joseph, 179, 309n70

Secrecy, 127, 129, 151–155, 160, 197, 255n34, 300n141, 301n150

Seigworth, Gregory, 182–183, 185

Shadow libraries, 265n79

Shapin, Steven, 130
Shareware, 236. *See also* Amerika, Mark
Signature, 106, 242, 323n147
Smith, Abby, 228
Social Research Sharing Networks (SRSNs), 22, 83, 92, 101, 188, 214, 259n51, 307n32, 311n101. *See also* Humanities Commons
Social text, 18, 220, 223, 246
Speculate This! (book), 109–112. *See also* uncertain commons
Spiro, Lisa, 91, 281–282n69
Standardization, 48, 66–67, 124, 132, 163, 205–207, 211, 217, 218
Star, Susan Leigh, 192
Stationers' Company, 75, 130, 132–134, 136, 210
Stiegler, Bernard, 11, 114, 174–175
Striphas, Ted, 26–27, 169–172, 185–186, 195, 259n51

Têchne, 152
Technotext, 247
TEI (Text Encoding Initiative), 116
Textual criticism, 224, 245–247, 258–259n49. *See also* Editorial theory
Thesis, 262n63
Thoburn, Nick, 111–112, 115
Thompson, John, 46, 125, 127, 136, 139, 140, 142–144, 295n99, 295n101–102
Threadgold, Terry, 195–196, 312n118
Tkacz, Nate, 127, 148–151, 160, 172, 299n131, 301n3
Transparency, 145, 149, 160, 163–164, 167, 178, 180, 265n76, 303n13
Trettien, Whitney, 267n5
Trust, 6, 90–91, 124, 126, 130, 132, 133, 202, 209–210, 214–215, 289n6, 296–297n112
Typography, 75, 76, 313n4

uncertain commons, 109–112, 117. *See also Speculate This!* (book)
Uncreative writing, 105–108, 286n117
University, 4, 10, 20, 38, 114, 124, 125, 126–127, 136–138, 140, 141–146, 159, 164, 176–178, 180, 183, 188, 189, 194, 198, 218, 239, 261n60, 289–290n7
extension work, 126, 138, 140
modern research, 289–290n7
neoliberal, 4, 141

Van der Tuin, Iris, 16–17, 54, 256–257n43
Van der Weel, Adriaan, 271n43, 276n94
Vectors (journal), 186
Versioning, 9, 21–25, 28, 29, 30, 31, 34, 36, 93, 203, 238, 247, 249n3, 257n47, 258–259n49, 260n54
in music and performance, 257n47
revision or source control system, 257–258n48
software evolution, 257–258n48
version of record, 22, 30
Vidding, 234–235
Virtual research environments (VREs), 92

Wark, McKenzie, 223, 259n50–51, 318n75
Gamer Theory (book), 223, 259n50, 318n75
Waters, Lindsay, 141–142
Weber, Samuel, 183–185, 188
Wikis, 1, 8, 21, 24, 31, 33, 89–93, 97, 100–102, 107, 119, 168–169, 170, 172, 186, 201, 213, 222, 243–245, 259n51, 260–261n57, 285n104, 310n95
wiki books, 1–2, 31, 33, 93, 168, 172, 188, 243–245, 260–261n57

Wikipedia, 97, 100–101, 149, 201, 213, 245, 284nn100, 102, 301n3, 313n6

Williams, Raymond, 181–183, 185
and structures of feeling, 182

Wolfe, Cary, 114

Women in Book History platform, 273n70

Woodmansee, Martha, 78

Writing practices, 26, 95, 96, 110, 169, 186

Zombie media, 250–251n6

Zylinska, Joanna, 16, 54, 55, 65, 67, 181, 184, 185, 233–234, 243, 245, 267n7, 275n91